MECHADEMIA 6

User Enhanced

Mechademia
An Annual Forum for Anime, Manga, and Fan Arts

FRENCHY LUNNING, EDITOR

Mechademia is a series of books published by the University of Minnesota Press devoted to creative and critical work on anime, manga, and the fan arts. Linked through their specific but complex aesthetic, anime, manga, and the fan arts have influenced a wide array of contemporary and historical culture through design, art, film, and gaming. This series seeks to examine, discuss, theorize, and reveal this unique style through its historic Japanese origins and its ubiquitous global presence manifested in popular and gallery culture. Each book is organized around a particular narrative aspect of anime and manga; these themes are sufficiently provocative and broad in interpretation to allow for creative and insightful investigations of this global artistic phenomenon.

Mechademia 1 *Emerging Worlds of Anime and Manga*
Mechademia 2 *Networks of Desire*
Mechademia 3 *Limits of the Human*
Mechademia 4 *War/Time*
Mechademia 5 *Fanthropologies*
Mechademia 6 *User Enhanced*

MECHADEMIA 6

User Enhanced

Frenchy Lunning, Editor

UNIVERSITY OF MINNESOTA PRESS MINNEAPOLIS • LONDON

http://www.mechademia.org

Spot illustrations by Barbara Guttman

Published by the University of Minnesota Press
111 Third Avenue South, Suite 290
Minneapolis, MN 55401-2520
http://www.upress.umn.edu

Printed in the United States of America on acid-free paper

The University of Minnesota is an equal-opportunity educator and employer.

17 16 15 14 13 12 11 10 9 8 7 6 5 4 3 2 1

Mechademia Editorial Staff

Contents

ix Introduction
 THOMAS LAMARRE

Countering Domestication

3 Under the Ruffles: Shōjo and the Morphology of Power
 FRENCHY LUNNING

21 Girliness Next to Godliness: Lolita Fandom as Sacred Criminality
 in the Novels of Takemoto Novala
 BRIAN BERGSTROM

39 Beyond Domesticating Animal Love
 CHRISTINE L. MARRAN

52 Exploited and Mobilized: Poverty and Work in Contemporary Manga
 MATTHEW PENNEY

Commodity-Life

69 Tezuka Is Dead: Manga in Transformation and Its Dysfunctional
 Discourse
 ITŌ GŌ
 TRANSLATED AND WITH AN INTRODUCTION BY MIRI NAKAMURA

84 How Characters Stand Out
MIYAMOTO HIROHITO
TRANSLATED BY THOMAS LAMARRE

93 Manga Translation and Interculture
CATHY SELL

110 Speciesism, Part III: Neoteny and the Politics of Life
THOMAS LAMARRE

Photo Play

139 Out of the Closet: The Fancy Phenomenon
PHOTOGRAPHY BY RIO SAITŌ
INTRODUCTION BY FRENCHY LUNNING

Desiring Economies

153 Anatomy of Permutational Desire, Part II: Bellmer's Dolls
and Oshii's Gynoids
LIVIA MONNET

171 Desire in Subtext: Gender, Fandom, and Women's Male–Male
Homoerotic Parodies in Contemporary Japan
KUMIKO SAITO

193 The Sacrificial Economy of Cuteness in *Tamala 2010:
A Punk Cat in Space*
EMILY RAINE

211 Flower Tribes and Female Desire: Complicating Early Female
Consumption of Male Homosexuality in Shōjo Manga
JAMES WELKER

Untimely Effects

231 Transformation of Semantics in the History of Japanese Subcultures since 1992
MIYADAI SHINJI
TRANSLATED BY SHION KONO
INTRODUCTION BY THOMAS LAMARRE

260 The Logic of Digital Gaming
ADEN EVENS

271 Tsuge Yoshiharu and Postwar Japan: Travel, Memory, and Nostalgia
YOSHIKUNI IGARASHI

287 Implicational Spectatorship: Hara Setsuko and the Queer Joke
YUKA KANNO

..

Review and Commentary

304 War for Entertainment: *The Sky Crawlers*
ANDREA HORBINSKI

306 Volition in the Face of Absurdity
BRIAN RUH

309 The Past Presents the Future: *Toward the Terra*
PAUL JACKSON

トレンド **Torendo**

312 Wherein the Author Documents Her Experience as a Porcelain Doll
LISA BLAUERSOUTH

..

317 Contributors

319 Call for Papers

Introduction

THOMAS LAMARRE

Everybody is making things today. Cosplayers are making costumes, book readers are writing and sharing fictions, gamers are making mods and machinima, manga readers are producing "amateur" manga or scanlations, and anime viewers are fansubbing and even making animations. Everybody is exchanging opinions, writing reviews, and making or contributing to databases. Under such circumstances it is not surprising that the term "consumer" has begun to drop out of use. Or, when it is used, rather than carry connotations of passivity, "consumer" has come to feel somehow active or at least neutral, akin to "receiver" or "user." And, even though a great deal of this "user activity"—fan fiction, fansubs, scanlations, amateur manga, mods, machina, fan forums, and databases—appears organized around a product or commodity, everyone knows that buying the product is not the point, not the beginning and end of things. Rather it is the product world that counts, the worlds that unfold from the product. Consequently, the term "product" also begins to feel inadequate to this situation. It's not a matter of commodity-objects to be consumed and then forgotten, but of commodity-events to be dwelled on, lingered over, prolonged, enhanced. And this is what everyone is doing today: prolonging worlds from commodity-events in circulation.

At the same time, unless you've mastered easy flight to other planets, you've surely run up against signs of increasing anxiety about the effects of capitalism in today's world: wealth disparity, poverty, unemployment, war for profit, environmental degradation, and criminalization of immigration. Regardless of what you think about capitalism, it's hard to escape a sense of disparity between the genuine creativity of consumer activity

today—prolonging events, carving out worlds, doing things yourself—and the contemporary crises of capitalism. And, even though it is always tempting to think that more and better consumption will resolve the problems of capitalist production, the relation between consumption and production today is just too complicated for simple answers. Their relation has always been complicated, but today has its added wrinkles, so to speak.

Such are the questions that motivated the topic for *Mechademia 6: User Enhanced.* In the context of editing *Mechademia 5: Fanthropologies,* a volume that proposed not merely to conduct an anthropology of fans but more importantly to ask what was at stake in studying fans today, we were surprised, given the range of concerns evidenced in the submissions, by the scarcity of discussions looking at otaku in terms of consumerism, commodification, ideology, capitalism, or hegemony, which had long been key terms in cultural critique. Rather, where sociological description gave way to critical concern, submitted essays tended to gravitate toward problems of identity, toward the marginalization of fans, negotiations of gender and sexuality, or cultural difference and national identity. The same is true for discussions of otaku in Japan, albeit in a different register: even though the terms "consumption" and "consumer" are generally used in Japanese accounts of otaku, the overall emphasis is more sociological than economic. The trend is to speak of social transformations across different generations in Japan, rather than to link otaku consumers to transformations in capitalism or to a critique of capital.

The general critical focus on negotiating identities and characterizing generations (rather than resisting ideologies or exposing the social contradictions of capitalism) seemed to us in keeping with the general transformation described above. Because the consumer today is user, negotiator, prosumer, interactor, or creator, our discussions of consumers, our discussions of fans, have shifted dramatically. It no longer seems possible to assume that fans are passive recipients, duped by ideology, deceived by mass cultural industries, or unilaterally shaped by capitalism. Still, new questions arise. Without wishing to force analysis back into received frameworks for understanding consumption and production, and adopting the somewhat neutral term "user" instead of consumer or creator, we nonetheless wished to address some fundamental questions: "How do commodities work today, now that we have become active users (transformers or even creators) of culture rather than passive consumers of it?" and "What are the implications of this transformation?" Thus we arrived at "the user enhanced," which refers at once to "user-enhanced commodities" (commodity worlds) and to "the enhancement of the user" (at once the cultural enrichment and the social empowerment of consumers).

There is a simplistic and rather cynical way of understanding the user enhanced. One might conclude that, because it is after all the producers, usually corporations, who turn a profit and accrue capital, the intense activity of users in, say, fansubbing, scanlating, reviewing, exchanging, circulating, and modifying commodities, ultimately amounts to nothing more than promoting or adding value to commodities, at the expense of consumers and for the ultimate profit of producers. In other words, corporations are profiting from the consumer's self-deception of being a creator, when in fact the consumer is an unpaid marketer and distributor. Simply put, the user is used, working for free. The user enhanced is but value added to the commodity. This is a sort of "mass deception" theory.

There is some truth in this understanding of user activity, or at least something crucial to be gleaned from it. For instance, in the wake of government policies in Japan promoting Akihabara as a tourist destination and championing otaku culture as a new national paradigm for economic prosperity, some otaku were quick to point out that the prosperity of otaku culture was built by otaku, not by government policy makers or corporations. It was otaku prosperity, and otaku wanted not only credit for it but also their share of it. Such a response returns to and deflates the mass deception theory. It demonstrates not only the increased significance of user activity but also an increasing awareness on the part of consumers about their role in the generation of value in the context of commodity-worlds. As such, even as user enhancement results in value-added commodities, the value of those commodities, taking the form of commodity-worlds prolonged both by producers and consumers, is not solely the property of corporations. And the questions of "To whom does a commodity-world belong?" and "Who belongs to it?" are becoming a site for the construction and contestation of social paradigms. It was in the hope of addressing such transformations that we wished to extend the insights of *Mechademia 5: Fanthropologies* into *Mechademia 6: User Enhanced.*[1]

There are a number of ways to approach these questions. The essays under the heading "Commodity-Life" approach user-enhanced commodity-worlds from the angle of the commodity itself, finding in the form and structure of commodity the key to understanding the ground for the user enhancement of products into worlds.

Itō Gō explores how manga characters lend themselves to the production of worlds. Challenging the received emphasis on story manga and Tezuka Osamu, Itō's work has offered a complete reconsideration of the relation between narrative and character, showing that Tezuka's story manga and the

associated lineage of shōnen manga tend to subordinate character to narrative. But Itō sees this lineage as the exception rather than the rule, arguing that because manga criticism is biased toward such manga, it cannot deal with the actual dynamics of manga form and reception today, which entails expanded media worlds. In this excerpt from his influential book *Tezuka Is Dead*, Itō looks at current trends in manga, in particular its implication in the worlds of anime and video games, to highlight how manga criticism has tended to enclose manga within a literary paradigm of understanding, thus avoiding the broader field of character-based interaction.

Miyamoto Hirohito's entry traces the dynamics of contemporary manga characters back to a specific set of relations between manga readers and characters that emerged in the 1920s, which paved the way for the production of characters with a sense of autonomous existence and life. In the form of manga characters, he finds the sources for the contemporary user-enhanced manga-character worlds. My own essay also considers of the vitality of manga characters, situating their sense of life in the context of wartime ideologies of racial cooperation and harmony in order to address the politics of animal characters in Tezuka's postwar manga. It is in the cuteness of little animal characters that we find a catalyst not only for user interaction but also for a politics of life, where commodity-worlds become entangled in biopolitical formations. Cathy Sell's essay presents a shift in emphasis from character to other features of manga. Beginning with the difficulties in translating manga into European languages, and analyzing non-Japanese-language manga that strive to prolong the world of manga, Sell calls attention to the persistence of nonlinguistic structures and a-signifying forms across manga in different languages. In such features, Sell detects the emergence of an interculture, the evolution of something new that is not wholly attributable either to a Japanese cultural field or the local culture.

Across these essays, we see various ways in which the manga commodity is organized around formally or structurally open elements that serve to catalyze user enhancement. Exploring such features of manga, these essays find not the inertia of a commodity-object but the stirrings of a commodity-life that sparks interactions that may be prolonged into a cultural paradigm or social field. As such, they also contribute to delineating the specific features of the media mixes, patterns of serialization, and forms of reception and power related to Japanese cultural industries.

The essays in the section "Desiring Economies" approach the user enhanced from the perspective of desire. Emily Raine considers how the animated film *Tamala 2010* extends the critique of consumerism beyond the

realm of economics, narrowly defined in terms of the exchange of money or political economy, into the realm of communication networks, violence, and sacrifice. Rather than dwell on capitalist modes of production, the film shows us capitalist modes of destruction, and Raine examines how social reproduction then settles on the endless destruction and rebirth of the cute. Similarly, looking at how the animated film *The Ghost in the Shell 2: Innocence* reworks Han Bellmer's dolls, Livia Monnet investigates the logic of permutation through which the feminine body is continually unmade and remade. As a result of such permutations, even though the gynoids in the film function as prostitutes (sexroids), these feminine bodies do not only function as objects of exchange (sex for money) but also incite a generalized perversion, an economy of desire in which any part of the body can substitute for the whole, and maybe any body for any other.

Both Kumiko Saito and James Welker stress the active role of "users" in the production of meaning. Saito looks at the world of "amateur" (*dōjinshi*) artists, especially at boys' love (BL) manga written by women that rework stories from popular shōnen manga, frequently transforming male rivalry or friendship into male–male love stories. Saito argues that, while such "BL parodies" (*yaoi*) do not necessarily entail compliance with mainstream norms of gender and sexuality, they may nevertheless reproduce received social values. In other words, rather than resistance or compliance, amateur parody manga afford a site for complex negotiations of social values. Where Saito focuses on parody writers (narrative and graphic devices), James Welker looks closely at fan commentary, at how readers understand and use stories. In sharp contrast to the received wisdom that the female readership of male–male love manga tends to distance itself from genuine homosexuality, Welker shows how female readers made connections between boys' love and existing male homosexual practices and lives, even expressing their own nonnormative desires.

In sum, by looking at anime and manga in terms of violence, desire, sexuality, and social norms, these essays uncover the workings of "desiring economies" wherein the logic of exchange (producer–product–consumer) and simple models of communication (sender–message–receiver) prove inadequate to understanding the complex field of negotiations of value and meaning that arises around commodities. In very different ways, each essay discovers a field of ceaseless variation that appears to offer potentially infinite permutation or multiplicity. These essays thus raise the question of what limits this multiplicity. And read in conjunction with the essays on "commodity-life," we begin to see that limits can be imposed on permutation

from without (received gender norms, for instance) but can also be unfolded from within (the formal and structural limits associated with cute little girl kittens, beautiful boys, or gynoids).

The section of essays that open the volume, under the rubric "Countering Domestication," addresses this tension between outside and inside, between material constraint and potentialization as it arises in user-enhanced commodity-worlds. Frenchy Lunning highlights how the physical constraints implicit in the very fashions adopted in shōjo-Lolita-related cosplay result in a potentialization of the body—a sort of fashion potentiality or even empowerment. This is dramatically illustrated in the volume's center section, where Lunning and Rio Saitō document the subcultural fashions of the "Fancy Movement." At the same time, Lunning's "Under the Ruffles" shows that shōjo potentiality runs the risk of collapsing back into the social regulations that historically shaped those fashions. The result is a shōjo whirlwind spinning outward and inward as cosplayers dance between potentialization and reification of Lolita forms. Brian Bergstrom explores the objects of fascination that catalyze the dynamic interplay of the girly, the criminal, and the sacred, in the Lolita-laced novels of Takemoto Novala. Looking at the tendency to criminalize consumption (and conversely to idealize production) that emerged in discourses on shōjo and otaku in Japan, Bergstrom shows how Takemoto's novels work through such criminalization to imagine (and indeed to produce) new worlds beyond this one.

Christine Marran's and Matthew Penney's essays shift analysis to very different sites of domestication. Following the media frenzy and fandom that arose around a bearded seal who temporarily left the ocean to dwell in the Tama River, Marran shows how love for animals can result in domestication, a reduction of animals to what they are for their human fans, even as those human fans disavow their anthropocentricism by laying claim to something beyond the human. Yet, in the desire that drives the anthropocentric disavowal of animal fandom, Marran finds something that potentially opens out beyond domesticating love toward an ecological future. In contrast, Matthew Penney takes up the problematic of domestication in the context of the exploitation and mobilization of labor as depicted in contemporary manga. Contesting discourses prevalent in contemporary Japan that tend to blame Japan's economic difficulties on youth by characterizing them as lazy or selfish, Penney looks at manga that provide a more realistic portrait of the aspirations and difficulties of youth seeking work today. Looking at the critique of labor exploitation in *Helpman!* and the critique of the social mobilization in *Ikigami,* he not only shows how recent manga directly address social

unevenness in contemporary Japan but also demonstrates how the enhanced commodity-worlds of manga enable a sort of recursive public for readers to grapple actively and publicly with issues omitted in mainstream media.

Each of these essays counters domestication in very different registers of fandom and youth cultures—abjection of bodies, criminalization of girls' consumption, domestication of animals, criminalization of youth and poverty. Yet, as a whole, in contrast to Azuma Hiroki's notion of "animalization" (*dōbutsuka*), which implies the advent of a thoroughly desubjectified and materialist society at the end of history, these essays converge on the problematic of the domestication of desire in the context of expanded commodity-worlds. Each entails a confrontation with a desire that threatens to become folded back on itself due to the social mobilization of the most intimate aspects of daily life—a desire to work that risks alignment with mass mobilization, a desire to challenge urban human confinement that risks extending the same confinement to animals, a desire to live fully and creatively that risks fetishization, abjection of the body, and an utter loss of stability and security. These are the risks faced today by the user enhanced as it straddles the dynamics of "value added" and "user empowered."

The essays in the final section, "Untimely Effects," introduce questions of temporality to the problematic of commodity-worlds. In his critical overview of the career of manga artist Tsuge Yoshihara, Yoshikuni Igarashi offers a parable for the radical economic transformation of postwar Japan: as Tsuge traveled to remote parts of Japan in his flight from progress and commercialization, he eventually found his escape cut off, as the countryside became exoticized for tourism. Deprived of an outside by commercialization, Igarashi explains, Tsuge's manga turned back on themselves, hinging on the author rather than the countryside, transforming Tsuge into a specter of capitalist society. Conversely, in the context of Ozu's films, Yuka Kanno argues that scholarship has tended to dwell thematically and temporally on the loss of tradition, especially as figured in ideal daughters of postwar middle-class families. But, in the figure of Noriko, played by Hara Setsuko, Kanno finds a temporality at odds with the emphasis on vanishing traditions and 1950s audiences. In the timing of jokes about Noriko's interest in Audrey Hepburn, Kanno finds another temporality that punctures and disrupts the received infatuation with the traditions embodied in heteronormative families, that of the queer joke, which makes for new connections between women in the film and contemporary spectators.

While Aden Evens does not broach temporality as such, his analysis of video games in terms of appearance and behavior (rather than representation)

shows how video games effectively create and eliminate disjuncture (sensory and temporal) within the gamer's experience, which results in an intensified object-orientation that seals off the world of the game from other worlds at the level of experience. Just as Evens doesn't see the experience of video games in terms of how they represent the external world, he does not see the problem of game violence as one of inciting violence in gamers beyond the game. Instead he provocatively suggests that violence in the game may become acerbated in an effort to remind viewers that there is a world out there. In other words, Evens challenges us to address the possibility of the elimination of the user enhanced through user interaction itself. The result is pure extension, a world without time, and a quasi-autistic self. And it is a similar relation between world and self that Miyadai Shinji parses in his overview of his work on subcultures in Japan. Tracking shifts in subculture from the early 1990s to the present, Miyadai strives to delineate the transformations that have led to a formation in which the end of the world (the destruction of reality) becomes a precondition for, or a corollary to, the stabilization of the self. As a result, he argues, not only has the distinction between fiction and reality become obsolete but also the stabilization of the self flips easily into scenarios of a war of all against all.

Such essays sound a note of warning, namely, that user-enhanced commodity-worlds can function to eliminate any sense of disjuncture and thus any engagement with social unevenness. And therein lies the challenge of the volume as a whole, as it poses a new question to the user enhanced: how to transform the productivity and creativity of user activities into genuine social engagement, in a world that today presents such a proliferation of potential worlds, both utopic and dystopic, that it is easy to forget that another world is possible.

...

Note

1. In this context, Wendy Goldberg joined us as submissions editor, and in appreciation, we'd like to say that her contribution has not only added to the value of these two volumes but also made her belong to them and they to her.

Countering Domestication

FRENCHY LUNNING

Under the Ruffles: Shōjo and the Morphology of Power

Caught staring, dead in the center of what has become a whirling global maelstrom, is the Japanese shōjo character. She has emerged from manga: a character that appears as a young and innocent girl-child with certain magical and powerful fantasy elements that allow her to unfold into a unique and curiously powerful cultural formation. She has spawned a cornucopia of fan practices spilling over national boundaries and across the world. Paradoxically, shōjo is a phenomenon that goes largely unacknowledged. Or, when acknowledged, it is usually disregarded as childish, creepy, or trivial by the standards of mainstream culture. Yet the massive and expanding quantum of shōjo commercial products and fan practices that have emerged from manga and anime—including cosplay and especially the Lolita; fan-fiction; *yaoi,* BL (boys' love) and other narratives written and read by girls and women; J-drama; Dollphie dolls and doll-play; and a massive accumulation of merchandise and franchises in the form of stuffed animals, key chains, *keitei* phone charms, Kewpie charms, and other talismans—all spiral around this enigmatic and seemingly singular center: the shōjo character.

What does shōjo mean? Depending on the length of the initial vowel, shojo/shōjo means either "virgin" or "girl" in Japanese. This compelling

association is the key to understanding the meanings that constellate around the expanding galaxy of *shōjo culture*; for that is what shōjo has become, a culture. Shōjo is a complex, multilayered, transnational compendium of commodities that circulate in the realms of advertising and packaging, illustration and art, toys and girls' accessories, clothing and luggage. Virtually anything that might appeal to especially young women may be marked by this aesthetic that refers back to the shōjo of Japanese anime and manga. This proliferation of commodities is so pervasive, so uniquely adaptable to global cultures and subjects, that it has saturated global markets. Yet her "meaning" remains elusive. Her appeal in all her multitudinous manifestations is instant, her form and visage ubiquitous, and her recognition immediate; and yet there is an uncanny sense of absence in her presence, a lack of a center to this constellation, an uneasy sense of a ghostly presence lurking behind the mask of her frivolous ubiquity and cloying innocence. As her constellation expands to Internet "girly" sites that are multiplying daily, she spreads her revolutionary aesthetic of "cute" beyond mere aesthetics to lifestyles and subjectivities. Those of us who know the power of her centrifugal expansion, then, feel the need to counter it, pirouetting to face inward, to confront historic formations, social constructs, and the problem of her abject position—the central mysteries of her construction—in the hope that under those ruffles and ribbons we might catch a glimpse of her mysterious center.

CIRCLING THE EDGE . . .

Whether it deploys pretty-boys with long lashes on their slyly slanted eyes (*bishōnen*) or plucky heroines, the shōjo culture is dominated by a feminine presence, cast and costumed by the normative popular cultures, yet somehow twinkling with something else, something weirdly historical, something a bit subversive. The immense eyes signal it, with pupils that glisten with moisture, reflections of incomprehensible sights, black spikes of eyelash, and bubbles of light. They remain strangely inert, like giant lamps illuminating an uncanny past with their glassy present. The characters develop as if from the eyes outward, unfolding into costumes that adorn a mannequin body of long, impossibly slender limbs and an indeterminate yet graceful torso. Although costumes can echo the clothing of readers, it is not unusual for costumes to present an overly articulated, childlike version of a never-realized historic style. The bows and flowers and details that proliferate on these costumes add a sort of narrative subtext, adding layers that further invest the

character's designation as *kawaii* or "cute." These characters emerge upon an ever-changing abstract background, sometimes called "wallpaper," that surrounds and suspends them in a cloying miasma of roses of symbolic love, flower petals for happiness, and puffs of delicate feelings. These wallpapers act as an emotional chorus, overcoding the narrative with an effusion of emotion and signification.

FIGURE 1. Taniguchi Tomoko, *Miss Me?* book 1 (CPM Manga, 2004). Courtesy of Central Park Media.

Amid this effusion, the characters ripple through the narrative, swiveling on gendered *punctums,* moments of shifting identity, contrary indications, ambiguous affections and representations. It becomes apparent, however, that the subjects of these manga are girls, both lesbian and straight, or at the very least feminized males. The "guy's guy," so dominant in patriarchal cultures, is a strange and rare occurrence in shōjo. His predominance in shōnen manga serves to establish the categories. Shōnen manga is indeed the realm of the male, its scenes set in the seeable and sayable within the proscenium of the heterosexual matrix. Heterosexual males perform deeds of valor for the benefit of girls who behave in the predictable ways of modern narratives. The stories progress across panels that are logically positioned for meaning, providing the sets and costumes adequate to the received fictions of contemporary everyday life.

In contrast to this structure there is the shōjo manga, whose panels tend to follow the shape and trajectory of the overpowering emotional drive of the narrative. Characters are suddenly afloat in an abstraction of time and place, specific only to their own emotional states. Drama occurs not primarily through deeds of valor but through intense interpersonal conflict and resolution by girl groups, families, and partners in both heterosexual and homosexual love and sex. The shōjo stories are less a fiction of reality than an idealized and traumatized psychic drama, complete in its odd timelessness, its campy theatrical artifacts and erotic marginal subjects. And suddenly it becomes clear: shōjo is a culture of an abject femininity.

PEEKING BENEATH THE RUFFLES . . .

There is a way to understand the feminine in shōjo culture as an expression not only of Kristevan abjection but also of abjection in the everyday poignant sense of the word. In its most basic meaning, abjection indicates a position of extreme wretchedness, a low-to-the-ground profile and groveling misery, which, in the case of the feminine, has pushed itself inward and sideways, encouraging a denial of its presence and an impulse to hide the offending aspect from view. Julia Kristeva has characterized this movement of abjection as a thrusting aside of "otherness"—not the otherness of the object but the otherness of the subject or I. Abjection entails a denial of an aspect of self, a denial that appears desirable within a regime that expects it. Abjection generates a phantom, an ever-present shadow dogging the subject's every move and disturbing its identity, system, and order, without respect

for borders, positions, or rules.[1] It conjures forth the place, says Kristeva, that harkens back to the earliest stage of development (*chora*) and the establishment of boundaries and borders that demark our selves from the maternal and from the moment of "the pure materiality of existence, or what Lacan terms 'the Real.'"[2] It is a state in which meaning breaks down, in which we are left trying to locate the boundaries of self and other, subject and object. It is before language, before words can comfort with their defining and naming functions, thus removing the dread of the drifting amorphous state between abjection and language. In Kristeva's formation, the mother, the defining subject position for females, is necessarily thrust aside, leaving the emerging female subject in a rather sticky spot, especially under patriarchal conditions. For under patriarchy, women are reduced to images of their singular and necessary function of reproduction: not just the mother but also the bodacious babe who is codified and commodified in terms of breeding potential. As such, women are abjected and degraded as subjects, and so is any linkage with the maternal and the feminine. The coded trappings of the feminine, and especially extreme manifestations of the feminine, are thus regarded as cloying, obnoxious, and disgusting. What of the shōjo? She is perhaps the most cloying and obnoxious of all feminine subjects, but here we begin to see the contradictions inscribed in her powerful yet paradoxical position.

> UNDER PATRIARCHY, WOMEN ARE REDUCED TO IMAGES OF THEIR SINGULAR AND NECESSARY FUNCTION OF REPRODUCTION: NOT JUST THE MOTHER BUT ALSO THE BODACIOUS BABE WHO IS CODIFIED AND COMMODIFIED IN TERMS OF BREEDING POTENTIAL.

The shōjo may be the most complex and profound of possible feminine subjects. As we approach her through her most obvious manifestation, she reveals her abject state through the visual morphology of her representations. Those representations extend to various forms of fan behavior and to the narratives created within the shōjo culture. Her morphology is extracted from the body *of* manga and anime, and from the bodies represented *in* manga and anime. These bodies are in no way stabilized and in no way actual. To the extent that gender becomes a fictive notion in favor of a magical state of shape-shifting, they swivel and switch dangerously, as if announcing the absence of an original gender state. For the creators of manga and anime, the shōjo body offers a substrate upon which is inscribed the tension between a desire to do away with gender and the inability to express gender conflict without gender. As a representation of the abject, the shōjo character becomes a thing of phantasm: she has the ability to evoke something beyond

the reach of cultural imaginings, beyond the utopic and dystopic potentials of desire. She wears her cultural abjection on the surface. As the most vulnerable and undervalued of feminine subjects, she is easily lured, easily convinced of the illusion of romance, easily transformed into other genders and beings that appear inconsequential to mainstream cultural meanings and agendas. Representing lived states of women, she utterly fictionalizes the inner/outer dichotomy in a manner that typifies the boundary issues of the abject subject. Ultimately, however, both come down to the same thing: the shōjo body is a work of art that attempts to profess the narrative of abjection by providing a fantasy of endless diversion, a fantasy of that which repulses us, by way of that which we desire.

Abjection is evidenced in the fear of seepage between the inner psychic states and the outer body. For shōjo bodies, the menstrual blood of the mature female body represents this seepage. As the "threat that seems to emanate from an exorbitant outside or inside," menstrual blood represents within the heterosexual matrix the cultural onset of the heavy responsibilities of sexual maturity and maternity for females, which results in the threat of being "ejected beyond the scope of the possible, the tolerable, the thinkable."[3] That inner state is signified on the shōjo through a figuration that is understood to reside within the body and is "signified through its inscription *on* the body."[4] It is this signification through the various objects of abjection, chosen from within the very particular constellation of shōjo objects, that provides a structure for the identity of the self, contained or enclosed within the body. Identity is, in a sense, a label that is inscribed on the body: the container of the self.

For the shōjo, the response to the abjection of maturity and the consequent desire for agency and power are both configured through a masquerade of innocence and purity: the infantilized signs of *kawaii* or cute in shōjo heroines. Yet, even as heroines imply power and agency, little girls are notoriously considered the weakest human subjects. This seeming contradiction is answered in Anne McClintock's explanation of sadomaschochism as "a historical subculture that draws its symbolic logic from the changing social contradictions." McClintock also quotes G. W. Levi Kamel: "The desire for submission represents a peculiar transposition of the desire for recognition."[5]

An idealized form has been set aside for her, one that was valorized in the Victorian period, one that evokes a particular "scene" of innocence, purity, sweetness, and a femininity whose power is derived not from her ability to reproduce, but from her power as an image of a potentially "pure and innocent" sexuality. As McClintock comments, "power through being the

FIGURE 2. Taniguchi Tomoko, *Princess Prince* (CPM Manga, 2002). Courtesy of Central Park Media.

IN A PASTICHE OF
HISTORICAL AND CULTURAL
CONSTRAINTS, THE MANGAKA
(ARTIST) HAS CLOAKED THE
SHŌJO BODY IN VARIOUS
SARTORIAL IMPLEMENTATIONS
OF VICTORIAN CULTURE.

spectacle of another's gaze is an ambiguous power. It allows one to internalize the gaze of the voyeur and participate in the vicarious enjoyment of their power."[6] This is the key to the revolutionary and paradoxical power of the shōjo.

As the pivotal defense against the threatening sexuality of a mature woman, the shōjo persona effects a "sealing up" of the body surfaces against the confrontation with the materiality of the Real, to secure the subject with an armor constructed from the safe costumes and totems of childhood. But not just any childhood. In a pastiche of historical and cultural constraints, the *mangaka* (artist) has cloaked the shōjo body in various sartorial implementations of Victorian culture. The key to the shōjo effect lies in the way in which clothes, wallpapers and the image of the shōjo body are articulated: shōjo is constructed of layers of fetish.

DEEP WITHIN THE RUFFLES . . .

We can read the paradox of the shōjo in the various permutations of Lolita ("Loli") cosplay[7]—a fan practice that is primarily the creation of female designers. The process of "dressing-up" is a variation on the popular pastime of little girls and explains something of the allure of the shōjo culture. Yet, insofar as shōjo is a fashion of abject excess, it accepts and recognizes all body forms, genders, and sexualities: all members of the fan community can participate in this practice. Adopting the morphology of the abject state through Loli cosplay, the body is supplanted by an imaginary identity and body form through the application of a costume and character from one of the Loli genres, a process which also serves to elide the founding condition of the abject body. In Loli cosplay, these obsessions also proliferate around the form and fabric details of Victorian fashions and subject positions, which in contemporary culture are understood as decidedly fetishistic.

The origins of the Loli, and of many other cosplay identities, lie in the styles of the Victorian period. In practice, however, cosplay has also generated myriad creative nonhistorical subsets and categories reprising aspects of Victorian and Rococo fashions. Neither contemporary Japanese nor American cultures share the cultural structures of the Victorian or Rococo eras, and yet the popularity of those fashions, both actual and fictionalized (as

FIGURE 3. Taniguchi Tomoko, *Princess Prince* (CPM Manga, 2002). Courtesy of Central Park Media.

with steampunk[8] fashions), evokes a set of conditions that apparently resonate with the contemporary global fan communities. The selection of these eras, then, is not arbitrary. It suggests the perception of a mirrored reality. British Victorians developed a dual aspect to their culture: a proper bourgeois surface of morality with rigid proper family values stood in contrast to the gothic demimonde, eccentric social practices and obsessions, and a welter of landmark pornography: "A characteristic feature of the Victorian middle class was its peculiarly intense preoccupation with rigid boundaries . . . crisis and boundary confusion were warded off and contained by fetishes, absolution rituals and liminal scenes."[9]

> FOR WOMEN AND ESPECIALLY FOR LITTLE GIRLS, THE FLURRY OF SKIRTS AND PETTICOATS, FLOWERS AND RIBBONS BECAME, THEN AS NOW, A CLOSETED CULTURE OF HYPERFEMININITY AND A SPACE OF IMAGINED SAFETY AND DELIGHT-FILLED NARCISSISM FOR THE ABJECT GENDER TO CREATE AN ABJECT COMMUNITY.

The obsessive concern over deployments of purity and cleanliness signified the culture's intense abjection of the contamination represented by foreign and feminine bodies. The association of these with bodily fluids and excrement spurred a cultural fetishizing of vestments that provided not only protection for the body from outside contamination but also a way to constrain, manipulate, and label female bodies. The image of the Victorian bourgeois woman was fully "pictured" by the end of the eighteenth century: "the triumph of the useless woman was complete. Robbed of her productive labor, the middle-class woman became fitted . . . only for an ornamental place in society. There drooping prettily in the faded perfume of watercolors and light embroidery, she lived only to adorn the worldly ambition of her husband."[10]

This "picturing" entailed a theatrical performance of respectability and leisure ensuring the perception of success. The costumes for this drama bristled with specific details. Women's clothes were heavily layered with undergarments, corsets and bustles, gloves, skirts, and a collection of small accessories. All were obsessively detailed: lined with laces, ruffles, and trim in accordance with a rigidly specific and heavily coded fashion. Undergarments were white or the natural muslin color as a boundary of cleanliness protecting against the female body: the source of feminine fluids, especially menstrual blood. Foucault, in his work on the repressive regimes of the Victorian era, reminds us that "the body [became] a mode of specification of individuals,"[11] and the female individual thus created was, in its mythic

bourgeois form, a femininity of purity, pink-tinged delicacy, and virginal sexuality. For women and especially for little girls, the flurry of skirts and petticoats, flowers and ribbons became, then as now, a closeted culture of hyperfemininity and a space of imagined safety and delight-filled narcissism for the abject gender to create an abject community.

Yet like most cultural artifacts from the Victorian period, and in fact like most artifacts of shōjo culture, this image of femininity is full of contradictions and ambiguities, hidden powers and subversive sexualities. The artifacts of this feminine culture were structured through the eccentricities of the male gaze, under the overrationalized and instrumental patriarchy of the time. Then as now, whether the designers were male or female, the effect and form were dictated by popular images of the "ideal woman." The highly eroticized hourglass figure, made possible by the ingenious and complex construction of the corset, was likened at the time to bees or wasps, with the insect queen the very model of the hyper*maternal* female. Like

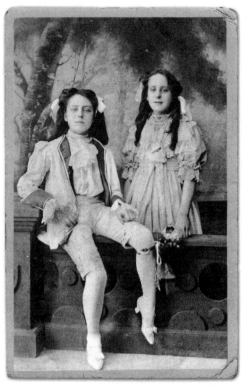

FIGURE 4. A photograph showing two young girls in costume: one as a girl, the other as a boy, revealing the prevalence of cross-dressing in "dressing-up" girl culture from the Victorian period. This postcard-backed photograph, dated 1903, is a bit after the Victorian era but well within its profound influence, particularly since in the practice of playing "dress-up," children tended to use old clothes. Studio portrait by J. Hunt, Nottingham, England; from the collection of Sarah Norris.

Queen Victoria herself, who reveled in and celebrated the role of the maternal as the ideal female, this image overemphasized a generous bust, a tiny waist, and a protuberant behind, accentuating and situating ideal femininity in the reproductive mode. Yet, in a subversive turn, women may have appropriated the corset not as a punitive restriction but as a source of individual desire. Art historian David Kunzle suggests that "far from being oppressed by their corsets, nineteenth century tight-lacers were sexually liberated female fetishists who found physical pleasure in the embrace of the corset."[12]

But it is not the fashions of the adult female that have captured the cult of the shōjo; it is a feminine subject residing at an even deeper level of paradox: the Victorian girl-child who is positioned as presexual and hypersexual, virginal but seductive, innocent but dangerous. The premenstrual little girl

FOLLOWING THIS TURN, THE PROFILE OF THE SHŌJO OFFERS A PARADOXICAL APPEARANCE: SHE IS THE INNOCENT AND NAÏVE LITTLE GIRL AND AT THE SAME TIME THE HIGHLY EROTIC AND SEXUALLY SUGGESTIVE ADULT WOMAN. SUCH IS THE SHŌJO'S "MO."

presents the ideal female form in which the boundaries of bourgeois hygienic regimes and moralistic sexual restrictions come together in one subject under the patriarchy. Even more than her adult form, the Victorian bourgeois "little girl" is swaddled in white and pastel-colored dresses with flowers, ribbons and lace, and ruffles upon ruffles. Her puffed sleeves stand in for a large bust, her waist made smaller through the wide dimensions of her petticoats and puffed sleeves. The erogenous zone of her legs is exposed yet encased in white stockings that purify and amplify the insinuation of sexual presence. She sports hats, gloves, and other adult accessories, but in a miniaturized and consequently fetishized version of the adult model. Following this turn, the profile of the shōjo offers a paradoxical appearance: she is the innocent and naïve little girl and at the same time the highly erotic and sexually suggestive adult woman. Such is the shōjo's "MO."

Other forms of and variations on the "little girl" in shōjo culture are the schoolgirl—a decidedly Japanese contribution—and the maid, an adult model dressed as a child to accentuate her low position and utter lack of power in society. The combination of maid and bourgeois Victorian little girl accentuates the way in which the shōjo serves as a *constellation* of abject objects surrounding the female subject. Whether privileged or servant, the shōjo is able to shift in signification, for the vortex of her manifestation turns around the vacillating masquerade of power and submission.

For both the Victorian little girl and the shōjo, such fabrications not only supply the armor of a gender identity but also create a cultural space that nurtures and reiterates the missing *jouissance* of a mythical memory or history of girlhood. In addition, there is yet another step in defining shōjo identity, and that is the step onto the stage. In the dialogue between the inner and outer aspects of identity, in her different manifestations, the shōjo enacts, embodies, and performs an identity through a *role* scripted from the narratives of popular culture and the gender anxieties of fans. As McClintock suggests, "Staging gender ambiguity under controlled circumstances [such as convention cosplay and masquerade] allows [the subject] to master the ambiguities."[13]

Whether evoking the Victorian little girl, or a shōjo character from anime or manga, or both, the Loli performer draws on an idealized and consequently

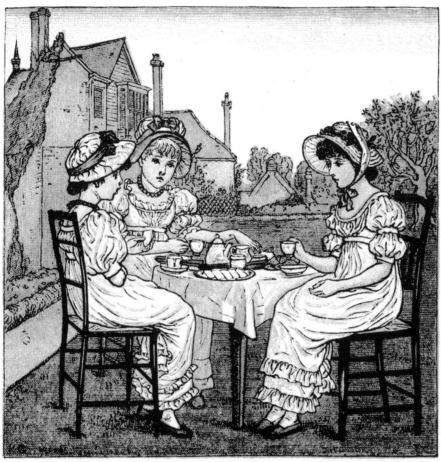

FIGURE 5. Kate Greenaway's illustrations of the lives of girls in the late nineteenth century became wildly popular fashions for children. She is generally credited with the invention of clothing specifically for children, especially for girls. *Three Girls Having Tea in a Garden*, Kate Greenaway (Great Britain, 1846–1901), color lithograph. Used by permission of Auckland Art Gallery Toi o Tamaki.

universalized notion of feminine performativity, modeled from popular cultural sources. As popular cultural artifact, the character presents feminine identity as a classification: a type and a totality that come complete with sets, lights, and costumes, an identity that encloses and shuts down any deconstruction of meaning. The Loli performer emerges from the great constellation of shōjo culture but constitutes a pastiche of mythic idealized femininities from modern patriarchic culture. As an imagined gender pastiche, the Loli deploys the overcoded Victorian feminine costume as a constructed feminine identity that, in being a child, paradoxically becomes seductive as a subversively sexual subject, while being socially situated as asexual or

> IF WE LOOK DEEP UNDER THE RUFFLES, WITHIN THE SWIRL OF CONSTELLATED OBJECTS AND THE MYRIAD SIGNS OF THIS HYPERBOLIC FEMININE CHARACTER, WE FIND A DARK SPACE OF PARADOX, AMBIGUITY, AND LOSS.

presexual. These two possibilities oscillate in a very satisfying way for the subject: "she" can secure her identity as a desirable female and yet keep the abject content of the mature feminine sexuality at bay. The morphology of representation thus segues into a morphology of power.

The Loli is but one of the images of the feminine produced during the long history of patriarchy. At once affirming and denying her historicity as a Victorian ideal, she has become a key subject in the transnational and transcultural shōjo phenomenon. Her proliferation as character and costume has swept into other Victorian-influenced styles such as steampunk, Gothic Lolita, and Aristocrat. A diverse series of other objects are also entangled with the family

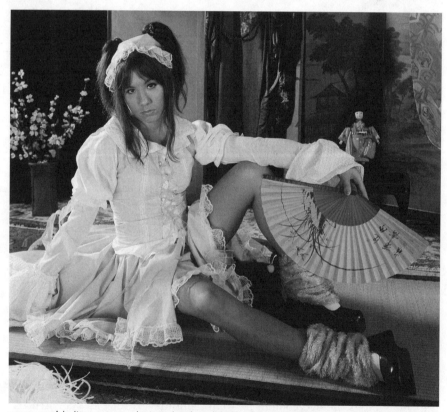

FIGURE 6. A Lolita costume, designed and modeled by Sroechinee Sangswangwatana for the Fruits Basket Fashion Show at the 2007 Schoolgirls and Mobile Suits conference. Photograph by Joe Kramm. Courtesy of the Minneapolis College of Art and Design.

of shōjo forms. For example, the Kewpie doll (often dressed in cosplay) can appear on *keitai* phone charms and in other miscellaneous toy-like objects. Her resemblance to a feminized Buddha is unmistakable, yet her subject position is also unmistakably that of the shōjo.

Appearing on souvenirs in arcades and stores everywhere, even outside temples, the Kewpie face conjures forth an American history, while meshing with the face of the shōjo. The Kewpie reinforces the shojo's *kawaii* power through the proliferation of objects, through her flexible and adaptable singularity, and through her ubiquitous image. These images or signs proliferate with such abandon that the space under the ruffles becomes cluttered with

FIGURE 7. Kewpie as geisha, Kyoto, Japan, 2008.

an abundance of regulatory and seductive objects. If we look deep under the ruffles, within the swirl of constellated objects and the myriad signs of this hyperbolic feminine character, we find a dark space of paradox, ambiguity, and loss.

DEEP UNDER THE RUFFLES . . .

Ultimately, at the center of this swirling universe of objects, at the still point of the turning vortex, is the black hole that is the shōjo: she is the point of gravity where all shōjo culture is merged into meanings through extreme pressure. She is the sign where the deconstruction of signification ceases, yet paradoxically, she is also the origin of the feverish proliferation and manic repetition of objects. She is at once a singular image of the little girl and a complex of concepts, conditions, and commodities. Although she may be denigrated as childish and cloyingly feminine, she also wields significant power in her capacity as a truly transnational, transgendered cultural symbol and aesthetic commodity. She is significant at an even more subversive and consequent level. As Livia Monnet puts it elsewhere in this volume (citing Jérémie Valentin to discuss analogous female formations), the shōjo "searches constantly for strategies to escape dominant currents, and to 'evade the ascriptions of the self' by becoming-liquid." Shōjo is constructed of the fetish that is the detritus of abjection: the abjection of the feminine

ejected from patriarchal institutions, all that is devalued and feared, the product of horror, disgust, and denigration. Having expunged the feminine from its hegemonic structures, the patriarchal culture attempts to naturalize the illusions of the masculinist regime as the Real. Yet—and here is the true center under the ruffles—she is missed.

Patriarchal cultures—unbalanced, and moving at a run to keep from falling over, to keep from having to see themselves—nevertheless reveal their loss of the feminine by admitting the shōjo into their universe of forms and objects, secretly adoring her cuteness under the guise of transnational marketing strategies. The profile of a sweet, endearing, but utterly disposable commodity form allows for a denial of value and meaning, at the same time it allows her to monopolize commercial constructions and advertising. She is a Trojan horse: she has appeared at the gates of the patriarchal fortress not as the grown and terrifying Amazon of the women's movement but as a guileless and powerless little girl of popular culture. We are ensorcelled, and we have let her in. She is now ubiquitous, transnationally exchanged, and she has begun to inject the feminine into culture. Having gained admittance, she has stealthily brought in her siblings—the adult female heroines of gaming, the gay guys of *yaoi*, and the transgendered hero/heroines of manga—all as subjects in her family of forms. Although still reviled as valueless in patriarchal culture, the denials have become less shrill, the acceptance grudging but evident. She has put her dainty foot in the door, and as she passes through into the culture, she signifies her presence with the rustling *sarasara* of ruffles slipping through the gates!

..

Notes

1. Julia Kristeva, *Powers of Horror: An Essay on Abjection,* trans. Leon S. Roudiez (New York: Columbia University Press, 1982), 4.

2. Dino Felluga, "Modules on Kristeva: On Psychosexual Development," in *Introductory Guide to Critical Theory,* Purdue University, November 2003, http://www.cla.purdue.edu/academic/engl/theory/psychoanalysis/kristevadevelop.html (accessed January 30, 2010).

3. Kristeva, *Powers of Horror,* 1.

4. Ibid.

5. Anne McClintock, *Imperial Leather* (New York: Routledge, 1995), 155.

6. Ibid., 157.

7. The word *cosplay* refers to the practice of the constructing and wearing the costume of, and performing a character from a popular culture source—in this sense, from a manga or anime. Otaku culture has brought this practice into mainstream culture in the form of fashion design, merchandise, toys, games, and other practices wherein the origin of these

forms is all but forgotten. Loli (*Rori*) refers to a particular cosplay genre that has focused on the shōjo little girl and has also expanded to a multiplicity of forms.

8. According to the *New York Times*, "the vision of steampunk, [is] a subculture that is the aesthetic expression of a time-traveling fantasy world, one that embraces music, film, design and now fashion, all inspired by the extravagantly inventive age of dirigibles and steam locomotives . . . First appearing in the late 1980s and early '90s, steampunk has picked up momentum in recent months, making a transition from what used to be mainly a literary taste to a Web-propagated way of life. To some, 'steampunk' is a catchall term, a concept in search of a visual identity. 'To me, it's essentially the intersection of technology and romance,' said Jake von Slatt, a designer in Boston and the proprietor of the Steampunk Workshop . . . In aggregate, steampunk is a trend that is rapidly outgrowing niche status." Ruth La Ferla, "Steampunk Moves Between 2 Worlds," *New York Times* Web site, May 8, 2008, http://www.nytimes.com/2008/05/08/fashion/08PUNK.html (accessed May 2, 2009).

9. McClintock, *Imperial Leather*, 33.

10. Ibid., 160.

11. Michel Foucault, *The History of Sexuality, Volume 1: An Introduction* (New York: Vintage Books, 1990), 47.

12. Valerie Steele, *Fetish: Fashion, Sex & Power* (Oxford: Oxford University Press, 1996), 47.

13. McClintock, *Imperial Leather*, 103.

BRIAN BERGSTROM

•••

Girliness Next to Godliness: Lolita Fandom as Sacred Criminality in the Novels of Takemoto Novala

It begins with an awakening. Something is encountered—a person, an image, a song, an outfit—that throws into relief the protagonist's unique sensibility. This apparent uniqueness is felt as a dislocation in era, the consequence of an existence carried out crosswise to history and society. The object of fascination shimmers in the protagonist's imagination, catalyzing a reorganization of priorities, compelling acts commensurate with the intensity of the emotions it evokes. This is a desire that communicates solely through the language of extremity, the center of a sensibility that disdains the ordinary for being ordinary, that values only the extraordinary. The protagonist becomes extraordinary through criminal acts, acts that prove the protagonist to be worthy of the fascinating object, worthy of the nearly religious ecstasy of fascination itself. This is less about possession than proximity, a pilgrimage toward an indifferent idol, an escalating series of demonstrations of the intensity of the protagonist's fascination that inevitably explodes, shattering the narrative at its climax: murder is committed, or infidelity, or incest, or simply thoroughgoing refusal. But however it ends, the narrative always runs along a line of flight, describing an ecstatic escape that doubles as a kind of self-immolating revenge against society as norm, history as progress.

These are the stories spun by Takemoto Novala,[1] perhaps the most famous cultural figure in Japan associated with Lolita fandom. Frequently called a "Lolita Superstar" (*Roriita Karisuma*), he is an author who has positioned himself as both a spokesman for and embodiment of a subculture most visible as a fashion choice but which has also been instantiated in a variety of ways: as a literature; as a genre of manga, anime, and pop music; as a theatrical and community-forming social practice; and as an aesthetic choice imagined as able to infiltrate every level of one's life. He is perhaps most well known for writing the novel *Kamikaze Girls* (2002, *Shimotsuma monogatari*), a comic story of the unlikely friendship between a devotee of Lolita fashion and a tough female "Yankee," or motorcycle gang member, which was subsequently adapted into a popular movie, then a manga, of the same name.[2] Before this success, his debut fictional work, two novellas collected in 2000 under the title *Mishin* (Missin'), became a bestseller that featured an effusive blurb by Yoshimoto Banana on its jacket, reading:

> These stories made me cry. Was it because of the writing's unparalleled skill-fulness? Or because it evoked the inexpressible feelings I had at that age? No, it was more than just that. It was the very fact that the immaculate nobility displayed by the characters in the book could exist in an age as degraded as this that brought me to tears. Novala-chan, you're the best![3]

This endorsement is also meaningful due to Yoshimoto Banana's status as the most famous practitioner of Japanese "girls' literature" (*shōjo bungaku*) in the late 1980s and early 1990s, starting with the phenomenal success of her novel *Kitchen* (1988, *Kitchin*). Indeed, her prominence during that time is hard to overestimate, as her work was seen to signal not only a new frontier in girls' literature but a mainstreaming of the shōjo sensibility into Japanese literature and popular culture in general. This early endorsement of Takemoto and its use in promotional materials for his work thus implies a positioning of this work within a genealogy of girls' literature that aspires to a similar cultural prominence. Takemoto's work connects Yoshimoto's shōjo sensibility, which she refers to as "immaculate nobility" in her endorsement, to the anachronistic (yet modish) fashions known as Lolita, or, in some instances, Gothic Lolita. He describes these fashions in breathless detail in his novels, the names of real-life clothing designers and brands like Vivienne Westwood, MILK, Jane Marple, and Baby, the Stars Shine Bright decorating nearly every page. Rather than using the term "shōjo" to name the girly sensibility the Lolita look expresses, though, Takemoto uses the term "*otome*," or "maiden;" he calls his explorations "*otomegaku*,"

or "maidenology," and everything he says or writes is ostensibly related to this project of epistemology founded on a hypothetical girlish ontology.

This article reads Takemoto's *otomegaku* as a theory of fandom and girlhood that emerges from his fiction and other writings. In particular, I wish to highlight how he phrases this fandom and girlhood as a mode of subversive embodiment. On the surface, his project involves a negotiation with various parts of a genealogy of Japanese girl culture and literature: not only that of Yoshimoto Banana but also that of the much earlier Taishō period (1912–1926). Accounts of Taishō girl culture routinely cite the importance of the works of Yoshiya Nobuko (1896–1973). Starting in the late 1910s, Yoshiya rose to prominence with her bestselling, breathlessly melodramatic girl-centric fiction, and not only does Takemoto cite her work explicitly as a precedent for his own, but he also edited reissued editions of some of her Taishō novels as a part of an "*otome* literature collection" (*otome shōsetsu korekushon*). These editions include annotations that translate some of the more obscure references and turns of phrase into the updated (yet still frequently anachronistic) slang favored by the young heroines of his own novels.[4]

But Takemoto's work seems to add to this Taishō paradigm even as he positions himself as "translating" it into the contemporary idiom of Lolita fandom. Takemoto's *otomegaku* brings out the subversive, even antisocial or criminal aspects of girlhood that Yoshiya's work exemplifies only obliquely. Specifically, I want to trace Takemoto's debt to the literary counterculture of 1960s Japan, especially the fascination with French literature, existentialist thought, and experimental narrative forms that authors like Mishima Yukio, Shibusawa Tatsuhiko, and Kurahashi Yumiko displayed during that time. Indeed, Kurahashi Yumiko's works in particular frequently focus on the subversive aspects of girlhood,[5] and in 1965 she published her most explicitly phrased treatment of the subject, *Seishōjo* (Saint girl), a novel she called her "final [or 'ultimate'] girls' novel" (*saigo no shōjo shōsetsu*). This novel explores the shōjo sensibility as a form of "sacred" criminality, bringing it into direct contact with ideas drawn from the work of French philosophers and novelists like Jean-Paul Sartre and Jean Genet. Her formulation of girliness as a type of criminal godliness goes beyond the simple rejection of adult responsibility routinely ascribed to shōjo; instead, it posits girlhood as a state of willful antisociality, as a fraught expression of agency. The commonalities between Kurahashi's work and Takemoto's thus map a space within which to imagine Lolita fandom as a kind of existentially conceived antisocial criminality, which may have larger implications for the theorization of gendered subcultures in contemporary Japan.

"S"-SHAPED DESIRE: MISHIN

How does Takemoto's fascination with Taishō girl culture condition his portrayals of *otome* in present-day Japan, where his stories are set? One answer may be found in the title story of his fictional debut, *Mishin,* published in 2000. The story is told in the first person by a young girl who feels misunderstood by everyone around her and is fascinated by artifacts from the past, a fascination that leads her to conclude that she was born in the wrong era. Crystallizing these feelings is her discovery of Yoshiya Nobuko's *Hana monogatari* (1916–24, Flower tales) and the chaste, yet emotionally intense, "S" relationships between schoolgirls they portray, which to her exemplify the ultimate *otomegokoro*, or "*otome* heart/essence." As she puts it, "As I read this collection, I vowed to live my life as if living within these *Flower Tales*. For to live within these stories was to live as an *otome*."[6] She fantasizes starting such a relationship with a classmate of the same sex, carefully delineating the particular contours of her desire:

> [In the Taishō Period], boys went to boys' schools and girls went to girls'.
> And then, just as now, a girl's desire at some point began to bloom, some-
> times even taking over her whole life. These schoolgirls had only other girls
> to use as objects for these desires. Younger students fell in love with more
> mature upperclasswomen, while these upperclasswomen would make eyes
> at their cute young counterparts. And of course, sometimes schoolgirls
> the same age would fall in love. The love such girls shared is called "S." If I
> were to use contemporary language, I guess I'd have to call them lesbians.
> But I think there's a big difference between "S" feelings and lesbianism. "S"
> couples do other things to demonstrate their feelings, like write joint diaries
> or carry matching handkerchiefs. [...] One needs fantasies to sustain love.
> I've found I can't fantasize about boys. But that doesn't mean that I want
> to kiss or hug members of my own sex either. I want to share something
> platonic with them instead. I simply want to write joint diaries with them,
> carry matching handkerchiefs or exchange notebooks.[7]

This initial encounter with "S"-centered girl culture in books by Yoshiya Nobuko sets up the crucial second encounter Takemoto's story describes, the one that allows the protagonist's anachronistic, "S"-shaped desire to find expression in the mode of fashion and fascination represented by contemporary Lolita fandom.

Though she claims to be completely uninterested in popular culture, the

protagonist nonetheless wanders into her living room while the television is on and catches her first sight of "you," to whom the rest of the story is addressed. This "you" turns out to be Mishin, whose name is spelled using the characters for "beautiful" and "heart/essence"; he is the lead singer of a band called Sid Vicious. The protagonist watches Mishin being interviewed, fascinated by him and declaring that he is "the *otome* of all *otome*."[8] This high praise seems founded primarily on his clothing (lovingly described as a tartan-checked jacket over a ruffled shirt and skull-printed tie atop a mid-length skirt of matching tartan finished off with black stockings and strappy white shoes), as well as the dismissive, imperious tone he takes with his interviewer. The interview consists of Mishin professing an indifference to his popularity, his fans, even the content of his music, claiming to enjoy only the energy and sound of punk bands like The Clash, not their message. The culmination of this captivating encounter between the fascinated protagonist and the indifferent, televised Mishin is the performance of Sid Vicious's new single, "I Am Lolita" *(Roriita desu),* which includes lyrics like "I don't believe in the future / I expect nothing from the present / only the past can soothe me" and "if you really want an endless love / you'd die right now, you'd die right now." The song closes with the declaration "I am Lolita, destroy!"[9]

The protagonist's fascination with Mishin leads her to venture for the first time into the world of contemporary popular culture. Skimming music magazines, she discovers the secret behind his wonderful clothing: brand names, specifically MILK, which he mentions in an interview. Becoming more and more obsessed, the protagonist starts a routine of daily dual pilgrimages, one to a shrine where she prays that she and Mishin will someday enter into an "S" relationship, and one to the MILK boutique in Harajuku. The MILK boutique is just as religious a space as the shrine, if not more so, as it allows the protagonist to satisfy her desire for quiet, enraptured contemplation of Mishin even amid the "hateful" crowds of Tokyo's most fashionable district. Correspondingly, the clothing and the store act as metonymic substitutes for the missing rock star just as the architecture and objects of the shrine substitute for the transcendent, absent god or *kami.* She soon spends her entire savings on these expensive clothes, but still she goes at least three times a week to bask in the beauty of the store and hear the clerks' eager tales of Mishin's visits to the shop.

She subsequently finds out that Mishin is already in a relationship with his male guitarist, Ryūnosuke, and this leads the protagonist to add a new wish to her prayers: for Ryūnosuke to die. She informs the reader that folklorists like Yanagita Kunio have written that because women have been

traditionally forbidden from more straightforward exercises of social power to fulfill their desires, they have historically relied on more roundabout methods, like curses, and therefore have become the stronger sex within this shadowy realm. And sure enough, this feminine aptitude for Shintō-inflected hexing bears fruit when Ryūnosuke dies in a car accident.

After a period of mourning, Sid Vicious's management decides to hold auditions for a new guitarist. The protagonist uses a tape purchased from a group of street musicians as her demo tape, which qualifies her for the final round of auditions; she buys a children's Hello Kitty guitar that she can barely play to bring along, since she knows that the auditions will be conducted in person. The management is understandably enraged when her incompetence and deception are exposed during the audition, but Mishin himself is entranced by those very things, declaring that she will be his new guitarist. After the interview, Mishin leans over and whispers to her, "I love the sheer absurdity [detaramesa] of you making it this far without being able to play the guitar at all."[10] This coming together of the protagonist's perversity with Mishin's fulfills the protagonist's every wish: she and Mishin embark on a chaste yet intense "S" relationship as she joins the band.

But this happiness proves unsustainable. Though it seems that she has replaced Ryūnosuke, before long Mishin confesses that when Ryūnosuke died, so did he, and that though chaste ("We never even kissed. It's true we shared a bed, but all we did was hold hands as we slept."),[11] he and Ryūnosuke's "S" relationship defined him as an artist and a person, to the point that his current life is meaningless. As the story ends, the protagonist imagines fulfilling Mishin's request that she use her Hello Kitty guitar to bludgeon him to death onstage during Ryūnosuke's memorial concert the next day:

> I'll do it. Even if your survival instinct kicks in as I start to hit you and you
> try to run away, even if you tell me you didn't mean it, tell me to stop,
> tell me not to kill you, I'll keep my word. I will beat you to death with my
> Hello Kitty guitar. I'll keep hitting you in front of all those people without
> a second thought, until your skull is in pieces, until I'm bathed in your
> blood. With these hands, I'll make you eternal.[12]

In this way, Takemoto's earliest fiction provides a clear blueprint for how desire imagined as ritualistic, implicitly religious fascination can transform readers' inner alienation into participation in the contemporary consumer subculture of Lolita fandom. His protagonists encounter a fascinating, will-ful, and ambiguously gendered person and then embark on a (usually) chaste but intense relationship with him or her, founded on a shared dislike of the contemporary world ameliorated by the consumption of specific brand-name designer clothing. The encounters are usually doubled and frequently inter-twined: there is an encounter with a resonant object or idea, like the *Flower Tales* in "Mishin" and the "S" culture they describe, and one with a person who shares this interest and becomes a conduit for channeling it into a relation with the contemporary world, usually through consumption and fashion.

But the question remains: why would the translation of "S" aesthetics into a contemporary idiom necessitate the collapse of the "S" relation as soon as it is achieved? Or, put more succinctly, why does the purity and beauty of the object of fascination necessitate its destruction as its ultimate expres-sion? Is this why on the cover of the collection containing "Mishin," the word is glossed not with the Chinese characters for "beautiful heart/essence," as it is in the story, but with the English word *missin'*?

SAINT LOLITA: READING TAKEMOTO THROUGH KURAHASHI YUMIKO

The answer to these questions lies in translating "*otome*" and the "S" dynam-ics of chaste but intimate spiritual connection found in Yoshiya's stories into a model for Lolita fandom.[13] This translation seems to necessitate the transformation of the "S" relation from one between equal partners into a reflexive one that values its object only insofar as he or she resonates with the protagonist's abstracted, antisocial fascination with literal objects. This fascination then becomes aligned with independence and even freedom, the extent of one's devotion paradoxically becoming the measure of one's ability to think for oneself.

The literary critic Takahara Eiri, in his book *Shōjo ryōiki* (1999, Girl ter-ritory),[14] asserts that girls' literature in Japan exists to elaborate the two qualities he sees forming "girl consciousness" (*shōjo ishiki*) in their conjunc-tion: willfulness (*gōman*) and freedom (*jiyū*). Most intriguingly, Takahara uses Kurahashi Yumiko's novel *Seishōjo* as an example of the "willful" aspect of girl consciousness expressed in its purest form—that is, as the kind of

taboo-taunting perversity that animates Takemoto's *otome* novels. As Kurahashi herself puts it in a typically idiosyncratic yet evocative description of her own novel:

> In this novel, I have attempted to sanctify as chosen love the impossible
> love of incest. The two youths who appear in the novel are like a cancer that
> is both produced by reality and consumes it, evil and holiness locked in a
> Siamese embrace. I wanted to deliver a novel that was like a mollusk melting
> into a bad summer, like the view from the far side of a looking glass.[15]

Kurahashi, like Takemoto, is fascinated by youth culture as a realm diametrically opposing normative society. And indeed, Takemoto's first full-length novel, *Uroko-hime* (2001, Princess of scales), like Kurahashi's *Seishōjo*, shows its characters breaking taboos not only speculatively but also literally, ending with the incestuous carnal embrace of the female protagonist and her brother: "We will become enemies of the world," she declares ecstatically in the novel's closing lines.[16] The striking instability and perversity that culminates in destructive extremity in Takemoto's work finds precedent in Kurahashi's more explicitly philosophical novel, shedding light on why Takemoto's *otomegaku* so often reads like a brand of demonology.

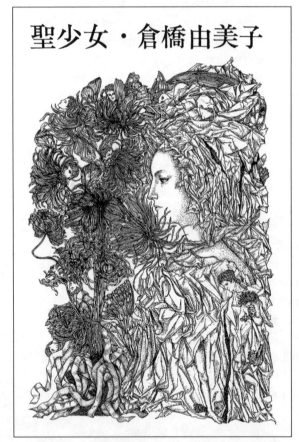

聖少女・倉橋由美子

FIGURE 1. Cover of *Seishōjo*, artwork by Murakami Yoshimasa, who also drew covers for contemporaneous Japanese translations of Jean Genet and the Marquis de Sade. *Seishōjo* (Saint girl) by Kurahashi Yumiko, (*Shinchōsha*, 1965).

Much of Kurahashi's novel consists of passages from the salacious diary of her female protagonist, Miki. A male character named "K" is reading the diary as Miki recovers from a car accident that killed her mother and apparently rendered her an amnesiac. The diary tells of Miki's scandalous

affair with a dentist whom she believes to be her real father and whom she calls "Papa." K, for his part, confesses at one point to committing incest with his own sister, "L," when he was young, which resulted in her running away from home. As K reveals more and more about his own checkered past, which also includes an armed robbery and gang rape, it becomes clear that he feels drawn to Miki because of the criminality of her diary, especially her description of incest. But at the end of the novel, Miki reveals that the diary was

> THE ELABORATE COSTUMING, OSTENTATIOUS USE OF OUTDATED VERB FORMS, AND CLOYINGLY HYPERFEMININE MANNERISMS OF THE LOLITA SUBCULTURE FUNCTION AS A WAY TO REIMAGINE THE VERY ASPECTS OF GIRLISHNESS THAT RENDER THEM A "CRIME" AGAINST SOCIALITY AND PRODUCTIVITY.

actually filled with lies, that her amnesia was feigned, and that the incestuous affair with "Papa" never happened. The last scene in the novel is a telephone conversation in which K tells Miki that he wants to marry her, while Miki explains that she is checking herself into a mental institution. K insists that marriage would be a better option, to which Miki replies:

> I wouldn't mind offering you my body. I wouldn't mind even if you devoured it whole. But remember that my body gained its shape from the bony lattice of my spirit, so once that's gone, all that'll be left is a lump of sour meat. Meat that rots so easily even vultures and hyenas hesitate to taste it. I want to shed this flesh, leave it behind and fly away somewhere like a bird made of transparent bones.[17]

Passages like these make clear the depth of Kurahashi's debt to the existentialist philosophers and novelists her characters namedrop throughout the text. In particular, the idea that true freedom resides in libertinism and criminality resonated not only with the newly translated and celebrated works of the Marquis de Sade but also with the works of Jean Genet and Sartre. (The title of Kurahashi's novel seems to reference Sartre's analysis of Genet's life and work, *Saint Genet*,[18] and one of her minor characters is named after Sade.) Indeed, we see in the end of *Seishōjo* a dramatization of Sartre's insight in *Saint Genet*, at the beginning of the chapter called "The Eternal Couple of the Criminal and the Saint."

> A mirror is a consciousness in reverse. To the right-thinking man, it reveals only the appearance it offers to others. Sure of possessing the truth, concerned only with being reflected in his undertaking, he gives the mirror only

this carcass to gnaw at. But for the woman and for the criminal, for all relative beings, this carcass is what is essential.[19]

K's passage from heroic criminal action to self-domestication can be seen as a revelation that, for all his criminality, he has always been a "right-thinking man" in the way Sartre uses the term. He has always assumed that the "carcass" in the mirror could not contain the whole truth of his being, and therefore his being is not "relative" in the sense that Miki's is by virtue of her femininity. But just as in a Genet novel, the beloved, unreflecting criminal hero in the end must always be betrayed by the guilty criminal who loves him; this destruction of what she desires is what transforms her abject criminality into sainthood. K falls slowly from grace as Miki performs the ultimate betrayal, which is also the ultimate crime, the one that K himself is unable to perform: she reveals that her very criminality is a lie. This is the final, perverse exercise of her agency, one that annihilates her true being while leaving her carcass behind, thereby martyring and sanctifying her.

While not as explicitly philosophical as Kurahashi's work, Takemoto's novels nonetheless engage similar issues relating to the exercise of agency in relation to corporeal being. His works do not simply cling to the trappings of girlhood as a sentimental refusal to take on adult responsibilities; rather, his characters embrace rejection from a social world that they find coded into their very being. These perverse decisions are made in the name of an elusive but compelling "purity" that resides precisely in their antisociality. The elaborate costuming, ostentatious use of outdated verb forms, and cloyingly hyperfeminine mannerisms of the Lolita subculture function as a way to reimagine the very aspects of girlishness that render them a "crime" against sociality and productivity. The implication is that these are strategies whereby the disciplinary machine of normative embodiment is preempted through covering the body in exaggerated signs of its inability ever to be anything but what girlhood has made of it.

Unlike Kurahashi, though, Takemoto habitually ends his narratives in the moment of impossible bliss that occurs just before the collapse of this paradoxical agency predicated on the hyperembodiment of these social codes. While *Seishōjo's narration* is frequently retrospective and nonlinear, Takemoto's narratives are structured like crescendos leading up to moments of narrative-annihilating bliss. These moments are unsustainable and therefore "pure" (like the Sartrean "sacred" or "saintly" aspects of Kurahashi's criminal girl protagonist). Such a narrative structure is highly conducive to portraying a self performed through fashion, a performance dramatized as a decision to

be the carcass one is relegated to inhabiting instead of trying to overcome it. Fashion allows this decision to be performed in the ecstatic instant one goes out in the world and is seen wearing the Lolita look, or even just in the moment one looks in the mirror and catches sight of oneself gazing out at the world from its far side.

THE CRIMINALITY OF INNOCENCE: *OTOME* VERSUS SHŌJO

Positioning himself as a spokesman for the rarefied sensibility embodied by Lolita fashion and fandom, Takemoto at first glance certainly seems to be rather cynically appropriating the voice of young girlhood, using essays and fiction to promote his writings and the clothing brands he cites in his texts (some of which have employed him as model and spokesman). These suspicions deepen when one considers the complex gender identification of Takemoto's public persona, a heterosexual male "Lolita Superstar" decked out in the skirts and ruffles of the brands he celebrates. While I have focused on the young characters and narrators in Takemoto's fiction, it is impossible to ignore the frequent appearance of older men, characters seemingly modeled on the image Takemoto has cultivated for himself. Many of his narratives contain pretentious Socratic dialogues in which a bashful young woman is educated by an older, alluringly girly and fashionable man, who gives her an appreciation for high fashion, esoteric art, obscure French pop music, and the like. Pygmalion-like, these encounters unlock the girl's hidden capacity for self-realization through consumption, a change that conveniently coincides with the girl's growing fascination with her wearily worldly interlocutor. Such scenes seem to facilitate Takemoto's capitalist agenda through a particular form of gender performance, revising a form of girl culture (Taishō-era "S" culture) originally founded on girls' desire for other girls into one centered around fascination with girly yet worldly men who resemble no one so much as Takemoto himself.

On top of this, while the chastity of the "S" model as exemplified in *Mishin* is paradigmatic in his work, many stories actually include explicit portrayals of genital sexuality. For example, there is the brother–sister incest already mentioned that occurs at the end of *Uroko-hime*. Further, the semi-autobiographical novel *Roriita* (2004, Lolita) includes frequent mentions of the Takemoto-esque hero's promiscuity, which not only establishes his unassailable heterosexuality but also provides a foil for the chastity of the central

relationship within the narrative between him and a young model.[20] The 2002 story "Emily" opens with a graphic molestation flashback that sets up the female protagonist's subsequent friendship and infatuation with a fashionable gay man, while in the story "Corset," included in the same collection as "Emily," the male protagonist embarks on an explicitly sexual affair with a young woman who is affianced to another (after first taking her to a traveling Museum of Modern Art exhibit on fashion, then to an Issey Miyake outlet).[21] In that story's resolution, they decide that it would be better if she were to go through with her marriage, since it will make their continued affair all the more constrained and beautiful, much as a corset makes a body more beautiful by constricting it.

The critical edge of the *otome* ideal for Takemoto thus resides not in chastity's alignment with girly innocence and subservience but in its rejection of normativity. The devotion to an abstract conception of desire is predicated on its impossibility and antisociality—it is not of this world, which means it exists entirely in the mind of the willful girly subject and is therefore hers or his alone. This translates into a frequent rejection of genital sexual practices as being much too worldly, conventional, or revolting to represent anything but the offensiveness of the banal. But as the above examples demonstrate, certain kinds of genital contact can be woven into this fantasy of world-rejecting transcendence. What is primary is not the rejection of sexuality per se, but the sacred space of criminality this rejection frequently, but not always, signifies.

Takemoto's work is thus situated in a larger cultural field of power within which representations of gender, capitalist agendas, and genital sexuality are negotiated both textually and metatextually. Gendered identification, both his and his characters', provides characters and readers with a particular understanding of their own alienation and how to deal with it through consumption, often of products that Takemoto has a direct or indirect stake in selling. Along with this, though, comes the demonization of normative genital sexuality in favor of intense but chaste modes of devotion (frequently to girly men who resemble Takemoto's own public persona) or expressions of genital sexuality that are impossible, taboo, or illegitimate.

The stakes of these aspects of Takemoto's *otomegaku* become clearer if compared to the discourse on Japanese consumer culture as shōjo culture that scholar and manga author Ōtsuka Eiji, among others, promulgated during the late 1980s and early 1990s in books like *Shōjo minzokugaku* (1991, Girl ethnography). Ōtsuka's theory is founded on two assumptions relevant to the present discussion. The first is that the shōjo represents a mode of consumption predicated on a refusal to grow up and an attendant rejection of

production, in both the economic and biological (reproductive) sense. Shōjo buy things of "symbolic" rather than actual value. The second is that while this shōjo mode of consumption fits fairly naturally into the lives of young girls, problems occur when this mode comes to dominate the daily life of Japan *in general*. Ōtsuka expresses this in a quote from *Shōjo minzokugaku* that John Treat uses to frame his own insightful English-language discussion of shōjo discourse:

> The Japanese are no longer producers. Our existence consists solely of the distribution and consumption of "things" brought to us from elsewhere, "things" with which we play. Nor are these "things" actually tangible, but are instead only signs without direct utility in life. None of what we typically purchase would, were we deprived of it, be a matter of life or death. These "things" are continually converted into signs without substance, signs such as information, stocks, or land. What name are we to give this life of ours today?
>
> The name is shōjo.[22]

This kind of rhetoric was part of a very specific understanding of postmodernism as a kind of infantilizing, unproductive mode of capitalism during the "bubble economy" of the 1980s. In this sense, even as it frequently used "girls' literature" like Yoshimoto Banana's as a starting point, this discussion of shōjo is less about girls themselves or the specifics of girly subjectivity than about the apparent weakness or immaturity of the (paradigmatically male) Japanese national subject.[23]

Takemoto's formulation of girly criminality thus becomes an important intervention into the theorization of girl culture within the context of Japanese popular culture. When he posits his version of Lolita fandom as a perverse and insistently *active* rejection of the normative, Takemoto seems to be avoiding the conundrums of earlier shōjo theory by reaching back to Taishō Japan for the term *otome* and back to a postwar language of sacred criminality as an exercise of agency. Takemoto's heroines choose to experience their girlishness and its relation to consumer society as agency, through a fandom conceived as implicit critique and explicit criminality.

At first glance, Takemoto seems to be just another example of what Sharalyn Orbaugh calls "cognitive transvestitism," which she defines as "a cross-gender identification or disguise for the purpose of exemplifying or thinking through a social conundrum."[24] Yet, despite Takemoto's cognitive and literal cross-dressing, one finds in his work not a repetition but a reversal

> OTOME ARE GIRLY NOT
> BECAUSE THEY ARE GIRLS, AND
> NOT BECAUSE THE CONDITIONS
> OF POSTMODERNITY HAVE
> TRANSFORMED EVERYONE INTO
> GIRLS, BUT BECAUSE THEY
> CHOOSE GIRLINESS AS A
> STRATEGY FOR PRESERVING A
> MEANINGFUL SENSE OF SELF.

of the displacements structuring earlier shōjo theory. Shōjo theory posits a definition of shōjo that ostensibly distinguishes it from femininity, sometimes calling it a separate gender altogether, other times an empty sign. The sign is not precisely empty, though; it is more like a sign *of* emptiness, a way to imagine the free play of capitalist exchange as a series of central lacks: lack of maturity, meaning, narrative, identity, history, value, productivity . . . you name it, shōjo lack it.

Takemoto's work attempts to reclaim this space of symbolic lack as one representing a *choice* on the part of those who take on its hyperbolic signifiers as a strategy for escape. Replacing this concept of shōjo with *otome* can be read as a rejection of the euphemistic naturalization of the shōjo's sexlessness. Takemoto's *otome*, by contrast, make choices that reject a numbingly dull sexualized world in favor of an intellectualized, subversive life in which the hyperfeminine is a strategy for control. Refusal is one method of control, but not the only one: the most *otome* of Takemoto's *otome* are defined by the magnitude of their perversity, not their chastity. The gendered nature of being an *otome* is denaturalized but never forgotten or assumed, which means that it can be embodied by individual biological men and women, young and old, but it cannot be laminated a priori onto any of them, nor onto all of Japanese society. *Otome* are girly not because they are girls, and not because the conditions of postmodernity have transformed everyone into girls, but because they choose girliness as a strategy for preserving a meaningful sense of self.

Even consumption, which is aligned so closely to shōjo in Ōtsuka's formulation, is coded this way by Takemoto. Near the end of the novel *Shimotsuma monogatari*, the Lolita narrator, Momoko, a skillful sewer and designer, has been offered a job at the fashion house she favors most, Baby, the Stars Shine Bright. She reflects on her decision thus:

> I love doing embroidery, and I learned how rewarding it is to do embroidery for others, but I get the feeling that if I'm on the side that makes the Lolita clothing I love so much, instead of the side that buys it, the thrill I get when I encounter new clothes will fade. And above all, if I start working for Baby, the Stars Shine Bright, I'll have to forfeit my standing as a Baby customer. I think I'd rather stay a pure fan of Baby, the Stars Shine Bright and nothing more.[25]

While not as shocking as the other methods examined earlier through which Takemoto articulates the perverse agency of the *otome*, it is important to recognize that consumption (as opposed to production) is aligned with these more obviously criminal or taboo-breaking acts, if only because consumption is a primary mode, both within the texts and outside them, through which the Lolita subculture as a practice of fandom is conducted. It is therefore important for Takemoto to portray Momoko's relation to capitalism as specifically perverse, of a piece with her earlier method of making money to feed her addiction to expensive Lolita clothes: the surreptitious resale over the Internet of imitation brand-name goods her father attempted and failed to sell himself. Unlike the pure capitalist play of the shōjo as sign of emptiness, Takemoto's *otome* reappropriate that space of lack as hyperfemininity and turn its presumed innocence into a sign of willful antisociality, aligning consumption with the other choices his heroes and heroines make in the name of preserving their innocence: incest, adultery, theft, murder.

Takemoto's *otome* literature thus phrases the assumption of girliness as a revelation followed by a reappropriation. In so doing, it also recognizes the transgressive subtext that was present even within Yoshimoto Banana's shōjo literature of the 1980s and 1990s, but which was discounted in its marketing and critical reception, both of which highlighted its relation to postmodernism and lack. Yoshimoto's novels came to symbolize this supposedly postmodern shōjo, but she seems to find in Takemoto an articulation of willfulness that generally went unrecognized within her own work, which may help explain her enthusiastic endorsement of *Mishin*. As the title character in her 1989 novel *Tsugumi* puts it, talking about her dog, Pooch:

> I want to be the type of person who, if a famine came and there was nothing to eat, could kill and eat Pooch without a second thought. And of course I don't mean I want to be some half-hearted twit who afterward would shed quiet tears and murmur, "On behalf of everyone, thank you, and I'm sorry," as I set up his tombstone and make one of his bone fragments into a pendant to wear around my neck; I want to be someone who could, without a hint of regret or compunction, just calmly say, "Boy, that Pooch sure was tasty!" with a smile.[26]

Ultimately, Tsugumi is not this type of person, but the novel emphasizes that Tsugumi's *desire* to be perverse constitutes her shōjo-ness, as well as her interest as a character. And in light of Yoshimoto's endorsement of Takemoto's ability to "evok[e] the inexpressible feelings I had at that age," it should

be noted that Yoshimoto also claimed that "Tsugumi is me. The evil of her nature (*seikaku no warusa*) makes any other interpretation unthinkable."[27] Takemoto Novala's work is an attempt to recover this "bad" desire as a way to talk about the subversive agency structuring girls' literature and culture from Yoshiya onward, including Yoshimoto, and to reinvest girliness with the sense of agency that threatened to remain unrecognized. Like Kurahashi's birds made of transparent bones, Takemoto's *otome* experience this agency as a kind of deep, invisible structure that might allow them to fly away, escape this world entirely, and make a new one on the far side of the looking glass.

. .

Notes

I would like to acknowledge my great debt to those who provided their generous feedback as I presented this paper in various forms in a variety of forums: Kotani Mari, Sharalyn Orbaugh, Anne McKnight, Yukiko Hanawa, Margherita Long, Frenchy Lunning, Livia Monnet, Mamiko Suzuki, Mika Endo, Anup Grewal, and Thomas Lamarre. I would also like to thank Christopher Bolton for his astute and thoroughgoing editorial help as I prepared it for publication. Research for this article was financed in part by a grant from the Japan Foundation.

1. I am choosing in this article to use the idiosyncratic romanization Takemoto himself favors for writing his name, rather than the more standard "Nobara." In either case, this pen name means "wild rose," which may allude to Yoshiya Nobuko's *Hana monogatari* (Flower tales), cited below.

2. Takemoto Novala, *Shimotsuma monogatari* (Tale of Shimotsuma) (Tokyo: Shōgakukan Bunko, 2004 [2002]); translated by Akemi Wegmüller as *Kamikaze Girls* (San Francisco: VIZ Media, 2006).

3. Unless otherwise indicated, all translations from the Japanese are my own.

4. These annotated republications were published by the Kokusho Kankōkai starting in 2003.

5. For a thorough exploration of Kurahashi's works and their contexts, see Atsuko Sakaki, "The Intertextual Novel and the Interrelational Self: Kurahashi Yumiko, a Japanese Postmodernist" (PhD diss., University of British Columbia, 1992); see also Sakaki's collection of Kurahashi's stories translated into English, *The Woman with the Flying Head and Other Stories* (Armonk, N.Y.: M. E. Sharpe, 1998).

6. Takemoto Novala, "Mishin," in *Mishin* (Missin') (Tokyo: Shōgakukan, 2000), 87. This and all subsequent translations of passages from *Mishin* are my own; for an English version of the complete text, see Anne Ishii's translation, *Missin'* (San Francisco: VIZ Media, 2009).

7. Ibid., 86–89.

8. Ibid., 91.

9. Ibid., 93–94. In Japanese, the final line functions as a kind of associative rhyme/pun, as the "*desu*" in "*Roriita desu!*" ("I am Lolita") is repeated in the first syllable of the transliterated English word "destroy" (*desutoroi*).

10. Ibid., 126.

11. Ibid., 132.

12. Ibid., 134.

13. For scholarship in English on Yoshiya Nobuko and Japanese "S" culture, see Jennifer Robertson, *Takarazuka: Sexual Politics and Popular Culture in Modern Japan* (Berkeley and Los Angeles: University of California, 2003); Sarah Frederick, "Yoshiya Nobuko's Good Girls," in *Bad Girls of Japan,* ed. Laura Miller and Jan Bardsley, 65–79 (New York: Palgrave, 2005); Gregory M. Pflugfelder, "'S' Is for Sister: Schoolgirl Intimacy and 'Same-Sex Love' in Early Twentieth-Century Japan," in *Gendering Modern Japanese History,* ed. Barbara Molony and Kathleen Uno, 133–90 (Cambridge, Mass.: Harvard University Press, 2005); and Michiko Suzuki, *Becoming Modern Women: Love and Female Identity in Prewar Japanese Literature and Culture* (Stanford, Calif.: Stanford University Press, 2009).

14. Takahara Eiri, *Shōjo ryōiki* (Girl territory) (Tokyo: Kokusho Kankōkai, 1999).

15. Quoted from the novel's jacket.

16. Takemoto Novala, *Uroko-hime* (Princess of scales) (Tokyo: Shōgakukan, 2001).

17. Kurahashi Yumiko, *Seishōjo* (Saint girl) (Tokyo: Shinchōsha, 1965), 226.

18. *Saint Genet* was translated into Japanese as *Seijune,* using the same character, *sei,* as a prefix for Genet's name that Kurahashi uses as a prefix for *shōjo* in her title.

19. Jean-Paul Sartre, *Saint Genet,* trans. Bernard Frechtman (1952; New York: George Brazilier, 1963), 86.

20. Takemoto Novala, *Roriita* (Lolita) (Tokyo: Shinchōsha, 2004).

21. Takemoto Novala, "Emily" and "Corset," in *Emirii* (Emily) (Tokyo: Shūeisha, 2002), 94–196, 18–91.

22. Ōtsuka Eiji, *Shōjo minzokugaku* (Girl ethnography) (Tokyo: Kōbunsha, 1991), 18, quoted in John Whittier Treat, "Yoshimoto Banana Writes Home: *Shōjo* Culture and the Nostalgic Subject," *The Journal of Japanese Studies* 19, no. 2 (1993): 353. For a slightly different account of the same phenomenon in English, see Sharalyn Orbaugh, "Busty Battlin' Babes: The Evolution of the *Shōjo* in 1990s Visual Culture," in *Gender and Power in the Japanese Visual Field*, ed. Joshua S. Mostow, Norman Bryson, and Marybeth Graybill, 200–28 (Honolulu: University of Hawai'i Press, 2003).

23. For a good example of Yoshimoto Banana's work being used explicitly to theorize transformations in Japanese literature and culture along these lines, see Mitsui Takayuki and Washida Koyata, *Yoshimoto Banana shinwa* (The Yoshimoto Banana myth) (Tokyo: Seikyūsha, 1989).

24. Orbaugh, "Busty Battlin' Babes," 206.

25. Takemoto, *Kamikaze Girls,* 210; in Japanese, see Takemoto, *Shimotsuma monogatari,* 305.

26. Yoshimoto Banana, *Tsugumi* (Tokyo: Chūō Kōronsha, 1989), 72–73. For a more vernacular but less exact version, see Michael Emmerich's translation of the novel as *Goodbye, Tsugumi* (New York: Grove Press, 2002).

27. Yoshimoto makes these comments in the afterword to *Tsugumi,* 236.

CHRISTINE L. MARRAN ● ● ●

Beyond Domesticating Animal Love

In the sky, gray clouds effervesce, float and fizzle
In them, Tama, I search for your visage.

<div align="right">—Horie Noriko, a Tama-chan fan</div>

I went to see Tama-chan at the Tsurumi River. He was adorable and I watched
him endlessly (zutto mite imashita). I bought a Tama-chan nightie and sleep with
him now! Stay healthy Tama! I love you, Tama-chan.

<div align="right">—Minato Yurina, a Tama-chan fan</div>

FAN LOVE

The animal fan poses an interesting problem for environmentalism and consumption. An exploration of the animal fan can lead us beyond the room of the sequestered "train man" out into a world of politics and nature, beyond the fetishized human subject of the otaku to the environmental and zoological. What does the zoological mean to fans and the fans to the zoological? This essay takes up the challenge of this volume of *Mechademia* to

unfix the "otaku" as an object of knowledge by suggesting the importance of looking beyond the human subject (endlessly defining the characteristics of the "otaku," for example) and looking at the kinds of relationships and desires posed by the fan, especially with regard to animals. There are two kinds of animal fans—those who exhibit a domesticating animal love that essentially replicates anthropocentric culture and power structures involving humans and animals, and those who do not. The latter instance of fandom would be an embrace of the animal other that gives expression to the desire for a different way of being in this world for the human through, and with, the animal.

On August 7, 2002, a bearded seal, soon christened "Tama-chan," was discovered in the Tama River (the Tamagawa). For reasons unknown, it had left its cold sea home to swim up the temperate and murky Tamagawa and other rivers in the Tokyo-Yokohama area. A crowd gradually formed and within a few days the onlookers reached into the hundreds. Newspaper reporters, television crews, and local merchants selling food and wares flooded the area. The bearded seal had become a media sweetheart.[1] When Tama-chan swam from the Tamagawa to the Tsurumigawa in late August, hundreds more flocked to the riverside. Eventually the hordes of television and newspaper reporters disappeared, but fans remained to videotape, photograph, draw, and write about Tama as he moved to the Katabiragawa, the Ōtsunagawa, back to the Katabiragawa, and then to the Nakagawa and the Arakawa in April 2003. Thousands of Web pages were dedicated to Tama and included maps tracking the seal's whereabouts; printed conversations of couples and friends watching Tama-chan from the riverbanks; and photos, prints, drawings, and written memories of journeys to the river by captivated humans hoping for a glimpse of the plump, doe-eyed darling.

Tama disappeared in 2004, but he remained a ghostly presence. After Tama's final disappearance, blog writer Miyazaki Shinpei visited the riversides where Tama had sunbathed and asked local residents to speak about their Tama-chan experience. Commenting on his interview with a resident at Tsurumigawa who knew that the river was too dirty to support wildlife but hoped and imagined that one day it would be possible, Miyazaki wrote:

> Looking at it from others' perspectives, it may seem that the kind of [vibrant] river, with a seal and other creatures, that this woman hopes for is perhaps hard to realize (*jitsugen no muzukashii*), and hers is just a way of dealing with it through simple imagination (*tannaru sōzō*). But I want to support this imagination. The ability to imagine takes us one step closer to the

possibility of realizing [a healthy river]. So I decided to emulate this lady and dream of such a river.[2]

The degree to which Tama captured the imagination of city dwellers is vividly expressed in the thousands of contributions to the Keihin River Bureau Tama-chan Memory Gallery. People of all ages contributed art, essays, and poetry after Tama's disappearance in 2004. Some were simple drawings by elementary school children, others woodblock prints, and others were poignant thoughts on Tama-chan's appearance in the rivers. Contributor Kawakami Etsuko wrote the following essay for this Memory Gallery:

> In the summer of Tama-chan, I followed television and newspapers and studied the relationship between humans and animals and the problem of protecting plants and animals. During that time, my family's radishes disappeared overnight. The culprit was deer. So my mother-in-law stretched out a net, hung a clapper, and planned to borrow the big dog next door [to keep the deer away]. When she did this, I grew indignant at the Japan that exterminates deer who lay waste to farm fields, and felt that my own home standing before my very eyes should not exist. How to protect our human lifestyle while living together and cooperating with the plants and animals is a big subject. As I pray that my beloved Tama-chan survives each day, I also want to consider this big question. I am grateful to Tama-chan who created the occasion to make good relations between animals and humans.[3]

> **"ALL OF JAPAN WAS SURPRISED, LAUGHED, AND THEN WAS *CURED* (IYASARETA)."**

Like Miyazaki, Kawakami's experience of Tama encouraged her to consider the impact of human dwellings on the suburban animals that must make forage through fences, cement ditches, and school yards.

On the Tama memory gallery and elsewhere, Tama-chan has been credited with healing people suffering from *hikikomori*—a condition of sequestering oneself at home and considered a growing social problem in Japan—by unwittingly drawing them out of their rooms.[4] In another contribution to the memory gallery, "grandmother Kobayashi Hiroko" expressed her gratitude to Tama-chan who coaxed her out of her home and reminded her to "treat nature well, enjoy living, and be grateful for being alive." A year after Tama-chan's disappearance, contributor to the gallery Hayashi Akiko confessed that she still talks to Tama-chan every day. One line of a poem on the appearance of Tama-chan by another contributor to the memory gallery, Nishiwaki Matsuko,

reads: "All of Japan was surprised, laughed, and then was *cured (iyasareta)*."[5] This "curing" of the *hikikomori* does not signal a return to business as usual. It suggests not that she is freshly socialized or rehabilitated but only out of her room seeking some other kind of therapeutic transformation in postindustrial Japan. Even if the *hikikomori* emerges from her room, she does so only to gaze upon the river and wait for a glimpse of the slick-headed angel. If Japan was temporarily "cured" of its ills, it was because the acknowledgment of Tama's presence put a brake on business as usual. And it literally did. Construction near Tama's whereabouts stopped. Children left their indoor video screens for the river. The seminal figure that incited this new, if temporary, human behavior was a sympathetic seal whose appearance produced a new fandom around animal celebrity.

DOMESTICATING ANIMAL LOVE

Most animal fandoms are likely to be intrinsically domesticating and anthropocentric. This means that even in loving animals, the fan often unconsciously reduces the animal to anthropomorphizing claims, a collection of drives, or a simple lack vis-à-vis the human. And curiously, this intrinsically anthropocentric fandom often enjoys imagining that it somehow challenges the premises of the very actions it performs. That is, the fan will imagine that his loving an animal, doting on an animal, or watching an animal is a biocentric act—an act of putting the nonhuman biological entity at the center of thinking rather than peripheral to human interests, as in anthropocentrism. However, we know that there is a long practice of loving creatures that requires no essential critique of human culture and power structures as they exist. This I would like to call a "domesticating animal love."

A majority of Tama-chan fans believed that Tama should be put in a zoo. The conventional zoo, however, is a classic example of an institutional structure that denies biocentric pleasure for anthropocentric pleasure. Perhaps the marine zoo visitor may care for seals and love beluga whales. Perhaps a portion of his entrance fee goes toward saving animals in the wild. Perhaps he learns about animals in the zoo and, through learning about them, cares more for them. Perhaps this caring and loving will lead to a lesser degree of non-environmental behavior. This is how the zoo goer is often articulated as a contributor to ecology. But it is a performative contradiction. In the name of loving nature, fans of animals can engage in an anthropocentric ritual that refuses to recognize its limitations for imagining animal–human relationships.

A "great seal fan," as one blogger identified herself, received as a gift a plush Tama toy dressed in a bunny costume, which led her to recall visiting a sea park, Kamogawa Sea World, two years earlier to visit an "adorable" (kawaii!) newborn seal. There was a public contest to name the seal and the blog author Satō remembers

> LARGE VERTEBRATES THAT ARE CUTE, BEAUTIFUL, OR CULTURALLY SIGNIFICANT ARE USED TO FUEL ZOO ATTENDANCE AND CREATE ECOTOURISM. THIS PUBLIC LOVE OF THE LARGER VERTEBRATES MEANS THAT "UGLY" OR SMALL SPECIES MAY GO UNNOTICED AND UNLOVED.

that "Sesami-chan" was the winning name.[6] The animal fan in this case participates in a standard fandom that commercializes animals. It is this kind of domesticating love that disables a biocentric imaginary because the animal is interpellated into the familiar way of seeing the animal as spectacle or show. Sea worlds are particularly susceptible to treating animals as performing acts. If Tama had been introduced as a new member of a sea zoo, he would have been introduced through familiar anthropocentric rituals that limit the imagining of a creature to that dictated by performance.

While Tama was not inducted into a zoo, domesticating animal love took the form of Tama being awarded citizenship by the Yokohama city government. Capitalizing on Tama-chan's popularity, the Nishi ward office of Yokohama city officially registered Tama as citizen "Nishi Tamao" after he had appeared in various Kanagawa rivers. After February 7, 2003, he was issued a certificate of residence (jūminhyō), which is denied to thousands of foreigners living in Japan. In this farcical act of giving national citizenship, a particular animal is domesticated by being brought into a human political and consumptive system. Attention is diverted from the seal's plight to treating the seal as recipient of a state gift. The seal comes to represent not his own kind but humankind. The seal is made "a theorem, something seen and not seeing. The experience of the seeing animal, the animal that looks at them, has not been taken into account in the philosophical or theoretical architecture of their discourse,"[7] and therefore no new understanding of the seal emerges. This is a domesticating love that sees the seal as something onto which anthropomorphizing notions can be projected and through which social standards are maintained.

Another ramification of domesticating animal love is that animals that do not fit so easily into such personhood-based categories are simply excluded outright from being imagined in any form. The increasingly commonplace use of the acronym CMFs—charismatic megafauna or megavertebrate—points to precisely this problem. Large vertebrates that are cute, beautiful, or

culturally significant are used to fuel zoo attendance and create ecotourism. This public love of the larger vertebrates means that "ugly" or small species may go unnoticed and unloved. Larger creatures that appear more human-like can easily be treated as subjects with personhood. This enables a new kind of "speciesism" under which particular animals may be deemed less worthy while others are considered more interesting and therefore valuable to the degree that they can be anthropomorphized.[8] In this case, animal fandom is a reiteration, not a supersession, of the human–animal divide.

BECOMING-ANIMAL, BECOMING-HUMAN, BECOMING-FOREST

A number of literary and film theorists have turned to the notion of "becoming-animal" to express a different relation of being with the animal. Gilles Deleuze and Félix Guattari's concept of becoming-animal has meant neither sustaining a distinction between the human and animal nor metamorphosing into an animal in identification with it. Instead, becoming-animal suggests an overcoming of models of identification and desire that are based on an assumption of shared modes of reason, language, and subjectivity by the human subject. It is often offered as a conceptual way of thinking of ourselves beyond the seemingly impassable division between humans and animals. Through becoming, the human is said to join with the animal in a zone of proximity that dissolves the identities and the boundaries set up between them. This process is considered to disturb and disrupt our usual ontological categories. In becoming-animal, new ways of relating to one another proliferate and these creations are the possession of neither entity participating in the becoming; they are created by the shared event of becoming itself. The novel "lines of flight" that are formed in this zone have the power to transform humans in that they invite entering into an alliance with another entity: "We fall into a false alternative if we say that you either imitate or you are. What is real is the becoming itself, the block of becoming, not the supposedly fixed terms through which that which becomes passes."[9] Becoming-animal is a way of living differently, identifying differently with others or at least beginning to invent new ways, or re-imagining old ways, of being in relationship with others. These metamophoses are fueled by a *desire* for proximity and sharing, to engage with the other, to be "copresent" with an other in a zone of closeness.

Becoming-animal as a concept may free humans from dichotomous

relationships in which the human dominates or inhibit the reduction of the world to dualisms, such as the "human" *and* the "animal," "culture" *and* "nature" and so on. The concept suggests a desire or a readiness to be guided toward a different mode of being. The lone seal who has left his sea or the *hikikomori* who does not sustain the practices of his human "pack" is exemplar of the autonomous subject who flees predictable living.[10]

Where becoming-animal as a concept is lacking is in its failure to engage with animal interests.[11] Certainly the concept of becoming-animal suggests that to discuss real animals is to limit the conceptualization of animals as a category of being that does not capture the being itself and the actions of that being. Therefore, Deleuze and Guattari speak of "wolfing" and not "wolf." The yellow eyes of the cat. The sharp teeth of the rat. Metamorphosis into a beetle-like creature. The examples for "becoming-animal" are frightening, tough, grotesque, masculine. Animal life is imaginatively addressed but with an attendant sense of dread. Becoming-animal is not sustainable but fleeting. As Steve Baker has reminded us, the implication in *A Thousand Plateaus* is "that the artist's responsibility may be to work fearlessly to prolong such instants."[12]

A biocentric fandom would have a readiness to be guided toward different modes of being but through an interest in, and attachment to, actual animals in the world. This kind of fandom would articulate a desire to enter into a relationship that displaces the human as common denominator and admit the ontology of other organisms we call by that awkwardly generic term "animal." The fan mode expressed in love for an animal is then also a desire to imagine differently one's place of being in the world, which may lament displacement but is not dependent on agonizing metamorphosis. The art and writing by some fans of Tama-chan suggest that there is a way of caring about the animal that also is critical of current modes of expressing desire for and consumption of animal beings. Biocentric fandom might even be *necessary* to the maintaining of ecological life because it jettisons restrictive categories of human and animal to attend to the animal health and welfare.

Japanese popular culture abounds with narratives that introduce animal love as a way toward environmental practice. Yet others still treat animals in fairly anthropocentric ways. Tezuka Osamu's character Kirihito, for example, is a dog-faced man in the eponymous manga. The manga treats this metamorphosis, however, as a tragedy even as it suggests the highly anthropocentric nature of human society that would be so horrified at the prospect of a man or woman exhibiting animal traits. As Yomota Inuhiko lamented in a previous *Mechademia* volume about Tezuka's nonhuman beings:

Why is it that nonhumans always have to become the object of exclusion in Tezuka's works? Or, to put it differently, why is it that humans cannot maintain even their basic sense of humanity without being continuously designated as such by others? Why is it that the moment this act of designation ceases, humans always lapse into uncontrollable anxiety and eventually chaos? . . . My nagging sense of discomfort with Tezuka derives from what this contrast serves to highlight, the obsessiveness with which Tezuka continues to reestablish human order even as he attempts to relativize it.[13]

> BUT THEY ARE ALSO MELANCHOLIC, UNWITTINGLY VIOLENT, UNHAPPY FIGURES THROUGH WHICH A HUMAN-CENTRIC VISION OF THE WORLD IS INEVITABLY REESTABLISHED.

Yomota suggests that Tezuka's characters can learn truths only through a nonhuman other but that Tezuka still reasserts a human order as inevitable. The manga, *Ode to Kirihito*, does just that. Under Deleuze and Guattari's notion of becoming-animal, Tezuka's dog-faced man and the nonhuman pointy rabbit-eared robot, Atom, would be stellar examples of becoming-animal, because standard ways of being in the world are revealed, traversed, and unveiled through them. But they are also melancholic, unwittingly violent, unhappy figures through which a human-centric vision of the world is inevitably reestablished.

Yomota contrasts Tezuka's humanist tendency with Mizuki Shigeru's radical antihumanism. In Mizuki's comics, humans are not so attached to the human form and way of life: "Instead, faced with the fear and allure of the unknown, it is the human protagonist who gradually sheds his human outline, eventually mutating into a nonhuman in a blissful metamorphosis. Having thus thoroughly outgrown the parochial notion of humanity and embraced the other world in body and in soul, those human mediators in Mizuki's works cannot ever find a happy home back in the human world . . ."[14] In Mizuki's works, the human appears to metamorphose completely into a nonhuman, abandoning the human form. At the same time, becoming-animal is not sustained because identity-suspension is not maintained. The self becomes the other completely. It dissolves into the other.

Takahata Isao's *Pom Poko* (1994, *Heisei tanuki gassen ponpoko*) makes for an interesting comparison in considering the philosophical import of human–animal metamorphosis. In the world of the *tanuki*, the raccoon-dog must adjust and metamorphose in order to survive. This cute but melancholic animation introduces a notion similar to becoming-animal in that specific species (*tanuki*, fox) metamorphose and assume a human form. In this

becoming-human is a deterritorialization of the animal that is sustained as part of the animal's new mode of being. The lament enters when we understand that it is the animal that must change and adapt while humans do not; the humans are unwilling to give up a life of urban development and consumption on which they have become dependent and accustomed.

Perhaps the animation *Origin: Spirits of the Past* (2006, *Gin'iro no kami no Agito*) provides the clearest contemporary example of becoming as the movement toward a new environmentalist imagination through the non-human. *Origin* centers around a human civilization's ability to give up their previous capitalistic existence for a new environmentalist one in which they allow the sentient and powerful forest to dictate their use of resources, especially water. After the apocalyptic devastation of the earth by a renegade living forest produced on the moon through scientific experimentation, three adults use the power of the forest to help rebuild the city, albeit in an entirely different form. When a pivotal figure in the story, Toola (or Tūra), is awakened after three hundred years of deep sleep in an iron lung, she is horrified by the sight of her new friend Agito's father who has become half-human, half-tree. Although Agito explains that the village has developed through its cooperation with the forest and the village leaders' bodily incorporation of forest strength into their own bodies, Toola can think only of her idyllic past, living in Tokyo as the consummate consumer, a teenage girl, the "shōjo." In order to defeat those who continue to strive for a human-centric capitalist consumptive future, Agito engages the power of the forest. He becomes a tree.

This animation explores the possibilities of becoming, in this case becoming-forest, in order to save humanity from its own destructive consumption. Humans in *Origin* are able to conceive of themselves as something other than the usual modern subject of capitalist modernity in which consumptive capitalism is dictated as ideal. Becoming-forest is not a curse (as in *Princess Mononoke*) but a new pleasing way of being in the world.

"DATABASE ANIMALS"

In his provocative 2001 book, Azuma Hiroki argued that fans, otaku, are "database animals." His book is relevant to this discussion in the sense that he brings the "animal" and the "fan" together to suggest a new way of being in the world that collapses the humanist subject to "animalize" it. He follows Alexandre Kojève's argument that man can return to "animality," which would

be a case of the "end of History," when the human animal operates according to the circuit of want and fulfillment. The human has differed from the animal for his intersubjectivity *(kanshutai)*—the desire for the other's wants. The desire requires an other *(tasha)* to fulfill it. To become an animal in this case means closing the circuit of want and fulfillment to make the intersubjective relationality disappear.[15] Azuma's point is that postmodern Japan has become animalized in the way that Kojève argued postwar America was. In Kojève's view, to be "animal" means "being in harmony with nature" because one rejects totally formalized values. For Azuma, database animality also signifies this pure immediacy.

"Animalization" in this context is a metaphor for the immediate fulfillment of desire without an intermediary or communication. The otaku is "animalized"—aroused and enthralled *(moeru)* through connection and consumption. "Animalization" in this rendering requires the relegation of all animals to the category of that thing that cannot speak, that thing that has no formalized behaviors, that thing that has no history, that thing that would help us short-circuit our desires toward the highly desirable state of pleasure fulfillment. Contrary to Azuma's claim, this signals no "animal age" *(dōbutsu no jidai)* but the perpetuation of an anthropocentric age in which the animal figures only marginally.

THE FLEETING NATURE OF LOVE

The degree to which Tama was left to his own devices (and not put in a zoo, for example) was the degree to which an imagination of Tama as a creative being was enabled, as seen in fans' haunting recognition of the possibility for a different relationship with nature. As one fan wrote, "Tama-chan gave us an intimate sense of animal presence in a form different from the zoo. I think he was like a 'goodwill ambassador' come from the animal world. Animals too, like us, are crew members on spaceship Earth."[16] In this particular comment, the fan sees humans and animals as jointly living on a planet that is a mere miniature speck. In the human embrace of Tama was a wish to live differently (whether as an anthropocentric Japanese on the banks of the Tamagawa or as an earthling in the polluted, globally warming, twenty-first century earth, and so on—the subject can be seated differently).

The fragility of this ecological imaginary gets expressed in a popular song at the time, "The Summer Tama-chan Arrived" *("Tama-chan ga kita natsu")*, which suggests the inevitable fleetingness of even animal love:

The summer that Tama-chan came
I will put in down in my heart's diary
I watched the river until the sun set
Memories will shine one day . . .
What kind of trip did you make from
The distant northern country?
Do you have a message
For the people who have forgotten their dreams? . . .
Everyone is forgetting
Tama-chan Tama-chan[17]

The art, poems, and laments of Tama fans suggest that developing an attachment to an animal as a "fan" does not necessarily have to be a purely consumptive act. Some animal love can encourage, even if lamentably only for a moment, a philosophical repositioning, toward a mental ecology that replaces domesticating animal love with the daydream of an ecological future.

Notes

1. In 2002, "Tama-chan" was voted the most popular new word of the year.

2. Miyazaki Shinpei, "Tama-chan no ita machi," *Daily Portal* Web site, November 12, 2004, http://portal.nifty.com/koneta04/11/05/02/ (accessed August 14, 2008).

3. "Tama-chan memorii gyararii," http://www.ktr.mlit.go.jp/keihin/whole/tamachan_memory/gallery/no03.htm (accessed July 24, 2008).

4. Francoise Kadri, "Tama-chan Tells Serious Story about Japan's Woes," *Viet Nam News,* February 8, 2003, Vietnam Environmental Protection Agency Web site, www.nea.gov.vn/English/nIndex.asp?ID=1851 (accessed June 18, 2007).

5. "Tama-chan Memorii Gyararii," http://www.ktr.mlit.go.jp/keihin/whole/tamachan_memory/gallery/no02.htm#contents (accessed August 14, 2008). Italics added.

6. "Kigurumi Tama-chan" (Tama-chan suit), *Oekaki dai suki* blog by "Satō," February 13, 2006, http://blog.goo.ne.jp/55tts/e/e80195704c0a6e9ee7ec5033ff5d39a0 (accessed January 5, 2009).

7. Jacques Derrida, "The Animal That I Am (More to Follow)," translated by David Wills, *Critical Inquiry* 28 (Winter 2002): 382.

8. Speciesism is usually used to describe unequal, prejudicial treatment of the animal vis-à-vis the human—a kind of anthropocentrism.

9. Gilles Deleuze and Félix Guattari, *A Thousand Plateaus: Capitalism and Schizophrenia,* trans. Brian Massumi (Minneapolis: University of Minnesota Press, 1987), 238.

10. Pages 243–45 of *A Thousand Plateaus* explain how new becomings begin with an autonomous body. See also Lori Brown, "Becoming-Animal in the Flesh: Expanding the Ethical Reach of Deleuze and Guattari's Tenth Plateau," *PhaenEx* 2, no. 2 (2007): 266,

http://www.phaenex.uwindsor.ca/ojs/leddy/index.php/phaenex/article/viewFile/247/377 (accessed June 29, 2010).

11. Author Steven Baker has written, "Animals, for Deleuze and Guattari, seem to operate more as a device of writing . . . than as living beings whose conditions of life were of direct concern to the writers." Steven Baker, "What Does Becoming-Animal Look Like?" in *Representing Animals,* ed. Nigel Rothfels (Bloomington: Indiana University Press, 2002), 95, quoted in Brown, "Becoming-Animal in the Flesh," 262–63. And Lori Brown suggests, "For one who desires a process of becoming for the sake of exploring relational and ethical possibilities with other animals, Deleuze and Guattari offer a rather sparse account of these possibilities," 262.

12. Baker, "What Does Becoming-Animal Look Like?" 67.

13. Yomota Inuhiko, "Stigmata in Tezuka Osamu's Works," trans. with an introduction by Hajime Nakatani, *Mechademia* 3 (2008): 108–9.

14. Ibid.

15. Azuma Hiroki, *Dūbutsukasuru posutomodan: Otaku kara mita Nihon shakai* (Tokyo: Kōdansha, 2001), 126–28; translated by Jonathan E. Abel and Shion Kono as *Otaku: Japan's Database Animals* (Minneapolis: University of Minnesota Press, 2009).

16. "Dōbutsukai kara yatte kita 'shinzen taishi,' Tama-chan 3-shūnen" (Friendship ambassador from the animal world: Tama-chan's third anniversary), *Mojix* blog, August 7, 2005, http://mojix.org/2005/08/07/070514 (accessed 25 December 2008). One reader of this essay pointed out that this phrase is from Buckminster Fuller.

17. Performed by "Wind Child" (Kaze no ko). The composer and lyricist is Nabejima Romu.

MATTHEW PENNEY

Exploited and Mobilized: Poverty and Work in Contemporary Manga

In 2006, Takenaka Heizō, an economist turned politician who acted as one of Prime Minister Koizumi Jun'ichirō's most important advisors, quipped, "There just isn't a serious poverty problem in this country."[1] Callous and un-realistic in 2006, this statement seems even more far-fetched in the recession-hit Japan of 2010.

Through the 2000s, under the banner of "deregulation," poorly paid, non-renewable, short-term contract work was established as the norm for youth employment.[2] At the same time, a lack of serious action against corporate malfeasance made it difficult for many full-time workers to avoid unpaid overtime or unsafe working conditions.[3] Rather than looking seriously at the structural reasons behind the swelling ranks of working poor and *furiitaa*—"freeters" or young workers who move from one part-time job to another—many politicians and public commentators have instead attacked the young for failing to grin and bear it in accordance with the example set by earlier postwar generations. Asō Tarō, prime minister between 2008 and 2009, com-mented on the necessity of young people learning a "proper attitude toward work."[4] Youths are even said to be too lazy and shiftless to take full-time jobs. Bestsellers like Miura Atsushi's *Karyū shakai* (The downstream society,

2005) spread an image of Japanese young people as lost in hobbies or unrealistic dreams, with little desire for permanent employment or integration into adult society.[5] The result of this and similar books, some with plainly insulting titles like *Keitai o motta saru* (The monkeys with mobile phones),[6] as well as identical patterns of representation on television and in political discourse, has been the now widespread idea that young people are to blame for both their increasing impoverishment and Japan's economic and perceived social slip backward. Blaming the victims has served to draw attention away from Japan's climbing poverty rate, now among the highest in the OECD: 15.7 percent in 2007.[7] The young have been hit disproportionately hard.

Youth culture, particularly the manga medium, offers an alternative to the conservative imagining of poverty as nonexistent in Japan or as something that can be exclusively blamed on the young. I will begin by looking at typical modes of representing poverty in manga from the 1970s through the 1990s, focusing on two of the most common themes—aspiration and moratorium. I will then examine how two recent manga, *Helpman!* (2003–) and *Ikigami* (Notice of passing, 2005–), take a different thematic direction, exploring a host of social and policy failures. Manga like these can spur us to confront issues as diverse as the social safety net, militarized visions of young people and the state, and alienation and endemic poverty. Both avoid the typical framing of youth poverty as a rite of passage or lifestyle choice, while challenging the idea that young people are too soft to make the grade. As such, they open alternative ways of understanding poverty and work in contemporary Japan.

BEYOND ASPIRATION AND MORATORIUM

In the 1990s, it was still easy to laugh at youth poverty in Japan. For instance, *Binbō manga taikei* (An anthology of poverty manga, 1999), a collection of essays and reflections on poverty manga, gives readers a sense of the carefree fun that characterized poverty comics of the past. The cover promises, "No bath, no meat, no car, no women, no degree. We've got nothing. But we've got freedom!"[8] This collection does not look critically at poverty or at representations of underclass youth. The formula "poverty equals fun" does not address actual hardship and widening inequality.

The kinds of poverty manga included in the anthology suggest two ways of imagining poverty: aspiration and moratorium. Aspiration finds expression in popular titles by Matsumoto Leiji such as *Space Battleship Yamato*

> YOUTH CULTURE, PARTICULARLY THE MANGA MEDIUM, OFFERS AN ALTERNATIVE TO THE CONSERVATIVE IMAGINING OF POVERTY AS NONEXISTENT IN JAPAN OR AS SOMETHING THAT CAN BE EXCLUSIVELY BLAMED ON THE YOUNG.

(*Uchū senkan Yamato*, 1974–75) and *Galaxy Express 999* (*Ginga tetusdō 999*, 1977–81). But other Matsumoto Leiji works from the 1970s such as *Ganso daiyonjōhan daimono-agatari* (Great tale of a four and a half mat room, 1970–74) and *Otoko oidon* (I am a man, 1971–73) deal more directly with poverty.[9] Matsumoto tells of destitute protagonists who have left rural Kyushu to study in the big city. Despite the young men's difficulties in everyday life and in romance, these manga assure us that the path of poverty will eventually lead to success: employment at a company, a measure of prosperity and security, and maybe a genuine romantic relationship. While Matsumoto's lovingly drawn images of tiny rooms, worn *tatami*, cold nights, and instant ramen may bring a smile, poverty figures as a fleeting and transitional experience of youth. It is effectively the same romanticized view of youth that appears in his science fiction. While Matsumoto calls attention to poor rural families scrimping to support their sons in rickety urban slums, these manga ultimately codify the "Japanese Dream" of the high-growth years, that of entry into the "mass middle class": if you get a university degree, some company will take you in, presumably for life. Such aspiration has little relevance in the current employment environment in which even a top university degree is no guarantee of escape from cycles of part-time work for low wages.

Subsequently, in the "bubble" years, popular manga frequently evoked "moratorium," a sort of self-elected poverty. In Karibu Marei and Tanaka Akio's *Border* (1986–89), young men declare a "moratorium" from received life paths, boarding at decades-old flophouses on the fringes of Tokyo's neon-and-steel high-growth transformation.[10] For these young men, an underclass existence provides "time out" that also promises to toughen them up with "real" experience. Even after the advent of the "glacial economy," this paradigm persisted. In Egawa Tatsuya's *Golden Boy* (1992–97), for instance, a law student becomes an itinerant freeter, moving from one part-time job to another, in search of the life experience and social understanding that his high-pressure rote education has apparently prevented.[11] A similarly powerful critique of Japanese education runs through Egawa's *Tokyo Daigaku monogatari* (A tale of Tokyo University, 1992–2001), but here part-time work and poverty remain peripheral, coming off as a joke.[12]

Such manga tend to reinforce discourses insisting that Japanese prosperity and security has made young people soft, which became prevalent after

the recession of the 1990s. Take the yakuza manga *Sanctuary,* for example.[13] Its protagonists are Japanese orphans who survived the Khmer Rouge genocide in Cambodia. They quickly climb the ranks of the yakuza and conservative political elite, attributing their success to their experience with hardship. Their mission is to transform Japanese youth from lambs into lions.

Today, some ten years after *Binbō manga taikei* presented poverty manga as a site of good humor, it is not so easy to laugh. There is now talk of Japan entering its third "lost decade" and the title of a recent critical journal, *Rosujene,* refers to an entire "Lost Generation." But to address poverty today we must also challenge the public discourses that strive to explain it away by making it a moral problem of youth. In the first decade of the twenty-first century, "personal responsibility" has remained the prevalent explanation for poverty.[14] Yet, since the 2008 recession, public discontent has begun to force a more honest look at Japan's employment environment. Indeed the Democratic Party made addressing youth poverty part of its platform, which contributed to its landslide victory over the long-ruling Liberal Democrats in 2009.[15] New progressive pundits like Amamiya Karin have also emerged, arguing that there has not been enough discussion of class and exploitation in Japan.[16]

Alongside such debates and in response to them, a number of manga have provided a more critical and nuanced look at employment and poverty in Japan, moving beyond the paradigms of aspiration and moratorium that previously held sway. *Helpman!* and *Ikigami* are among the most effective.

EXPLOITATION

Writer and artist Kusaka Riki began serializing *Helpman!* in 2003 in *Evening,* a Kōdansha magazine that appeals to a range of adult readers. While the manga centers on problems affecting the elderly, its main characters are freeters who enter the care industry after a series of unfulfilling, low-paying jobs. Hoping for change, they instead find dilemmas and structural contradictions. *Helpman!* examines relations between groups who are exceedingly disadvantaged in Japan today: young people who cannot find stable fulfilling work offering the basic security that would allow them to start families[17] and the elderly who see nothing ahead but poverty, infirmity, and loneliness.[18]

In 2000, the Japanese government introduced a new home care insurance scheme. The goal was twofold: to provide support for the elderly and their families, making their final years as dignified as possible, and to bring

young people into the care industry, giving them fulfilling work at secure wages. The plan has been widely decried as a failure.[19] Criticism has focused largely on the poor service provided to the elderly, which has in turn encouraged discourses on the laziness and selfishness of youth. *Helpman!* is unusual in looking at the problem from both sides, in terms of the exploitation of young workers and the abuse of the elderly.[20] The manga shows how even "care managers" (individuals who consult with dozens of elderly and arrange services) receive less than the equivalent of US$20,000 a year in salary.[21] The "helpman" providing direct care to patients—feeding them, bathing them, and providing for their daily needs—receives even less. The series also calls attention to the disparity between workers' wages and corporate profits. We see that the same care industry megacorporations own a range of services: the consulting agencies that advise elderly on care options, the hospitals that treat them, the companies that produce and market home care products, and even the taxi services that ferry them from one commercialized service site to another. *Helpman!* guides readers through this byzantine superstructure: a company-owned taxi service that receives government insurance funds to transport one passenger at a time covertly doubles and triples up. The company thus receives more money per mile and man-hour, while elderly patients are left waiting without care.[22] *Helpman!* places the blame on the government insurance scheme that subjects the elderly to the regime of profit margins.

Workers are also far from satisfied. Attracted by the promise of jobs in a "growth industry" driven by Japan's "aging society," they are shuffled from one low paying position to the next, and pressured to accept ballooning workloads to keep these tenuous jobs. In this context, they face a second level of exploitation—the emotional.

Helpman! devotes many of its pages to freeter care worker Onda Momotarō. Onda does not appear particularly bright or even very competent. But he has an ability to see past physical and mental decay of patients to their shared humanity. In one of the series' most moving moments, Onda helps an old man who, unable to deal with his physical infirmity, has continuously lashed out at his family. He dresses him in his old business suit, which allows him to put his life in perspective.[23] Kusaka illustrates how establishing continuities is fundamental for maintaining dignity. Onda's capacity to see the patient as a human being with a past and future instead of simply as a present problem is his strength as a care worker.

Kusaka does not linger on cathartic moments of success, however. In fact, the achievement of *Helpman!* lies in directing attention to how the instrumentalization of youth labor works to eliminate empathy and foster

emotional alienation, undermining the "care" project in the process. Working as a freeter in one of Japan's ubiquitous convenience stores can be punishing to the individual, but the negative impact lies primarily in the diminishment of polite service. In the care industry, such diminishment can spell disaster. *Helpman!* shows how companies place unreasonable burdens on young employees, demanding hours that leave them dashing between jobs, unable to form emotional connections and thus to help seniors in need. In Onda's case, the genuine desire is there, but his employment circumstances actively work against it.

By government mandate, the managers who coordinate care services receive a fixed amount of money per client, no matter how short their visits. To maximize profits, businesses make managers responsible for so many patients that offering the bare minimum of service becomes a survival strategy. Onda's friend Jin is made to take on so many clients that he feels they are "attacking him in waves."[24] Feeling like a "cog in the system," Jin tells an elderly man that he cannot help him change a light bulb; it is simply not a part of the job description.[25] He is later horrified to discover that the man fell shortly after, breaking his hip and losing his ability to live independently. With such examples, *Helpman!* shows how care for profit produces antagonistic relationships between caregivers and their charges.

> HELPMAN! SUCCEEDS IN PROVIDING AN ALTERNATIVE PORTRAIT OF CONTEMPORARY YOUTH IN THE WORKPLACE, AVOIDING THE MORALIZING TENDENCY IN WHICH YOUTH ARE EITHER EXTORTED TO WORK HARDER OR BLAMED FOR SOFTNESS, SHOWING ON THE CONTRARY HOW THE SYSTEM PRODUCES EXPLOITATIVE BEHAVIOR.

Jin and Onda decide to take a stand, asking, "If we don't fix this rotten system, who else will?"[26] There is only so much they can accomplish, because, as Kusaka's manga demonstrates, where care is subordinated to profit, emotion is subject to disciplinary action.

The disciplining of emotion is dramatically illustrated in a chapter focusing on a sexual relationship between two care home residents in their eighties. The families protest because they simply do not want to think about it. The helpers think only about fulfilling family requests to control behavior, even if it means surveillance and disciplinary measures that negate volition. Onda alone encourages the couple. And he is disciplined and eventually fired for speaking on their behalf. When the old man is caught sneaking into his lover's room, supervisors decide to have him declared incompetent

and moved to a different facility where he rapidly slips into depression and infirmity.[27] Onda castigates his employers, accusing them of keeping their charges depressed and of threatening care workers with dismissal back into the freeter pool. The elderly are, after all, more profitable when immobile, requiring less supervision.

In sum, in its bid to expose the structural and systemic problems of the care industry, *Helpman!* succeeds in providing an alternative portrait of contemporary youth in the workplace, avoiding the moralizing tendency in which youth are either extorted to work harder or blamed for softness, showing on the contrary how the system produces exploitative behavior. In fact, as if to emphasize the difficulties faced by young helpers, the manga pulls no punches in its look at physical decline, frankly showing elderly patients in diapers and senile patients covered in their own feces.

Each volume of *Helpman!* reprints reader comments on the back cover. Many make clear the effect of the discomforting art style. A forty-seven-year old housewife from Tokyo writes, "To put it frankly, *Helpman!* feels so real that I just want to throw it down and run away."[28] *Helpman!* has received positive responses from care industry professionals. One actual helpman reader, however, expresses serious doubts about the series' emphasis on empathy:

> It's so real, it's scary. I've been a care worker for more than ten years and have experienced many of the things depicted. I'm now just weary of it all and thinking of quitting. Everything that [Onda] Momotarō says is absolutely right. I don't have a shred of doubt. However, I just don't think that I can continue. Does not being able to take care of dying people right to the end make me some kind of monster? I wish that I hadn't read it. Maybe there isn't anyone who can do what Momotarō does . . .[29]

This reader points to the risk entailed in reading solutions into the behavior of one of the more emotively heroic characters in this series: real workers cannot expect to muster the passion of Onda Momotarō. Nor should the moral demonization of youth simply be replaced with moral celebration. This is precisely where the emphasis in *Helpman!* on structures of exploitation that prevent young workers from building on their actual skills and potential in the workplace becomes most important. It opens up the imagination of readers to what Jürgen Habermas describes as the "transformation of alienated labor into self-directed activity."[30] This is not an easy work, but *Helpman!* encourages readers to think the "problems" of youth labor and elder care beyond the moral prejudices that currently thwart reform.

MOBILIZATION

First serialized in Shōgakukan's *Young Sunday* and now a staple of *Big Comic Spirits,* Mase Motorō's *Ikigami* is one of the most popular new *seinen* (youth) manga. Compilations have sold more than two and a half million copies, and the series has spawned a film and novelization, moving into the ranks of multimedia phenomena.

The jacket of *Ikigami* provides an impersonal explanation of the series: "In this country there is a law called the 'National Prosperity Maintenance Law.' In order to make the most of human resources, for the good of the country, certain young people are sent *ikigami,* their notice of passing to their next life." But recipients are shown taking it personally: "A 'death notice' has arrived. Only one day left. Vanishing, having had nothing, remembered by no one, leaving nothing behind . . . This is the last day that I have been allowed to live. Just how should I spend my final 24 hours?"[31]

Each installment chronicles the life and final twenty-four hours of a young person. *Ikigami* thus provides an imaginative context for the critique of discourses that prioritize state power and economic performance over young people's lives, by taking current trends in political expression to extremes. In Japan of the near future, nanotechnology implanted into children in their first year of school ensures that one in one thousand will be randomly selected for death between the ages of eighteen and twenty-four. The government justifies the program with claims that reflecting on death will give youth a heightened sense of what it is like to live "fully" for their country. Fear of death is thought to increase "industriousness" and "commitment," which in turn promises to increase the "productivity of society."[32] Official reports credit the policy with an increase in GDP.

Across its stories, the series introduces a sense of continuity with the figure of Fujimoto, a rookie bureaucrat just past the age of random death, whose assignment is to deliver the *ikigami* and whose tortured internal monologues serve as a conduit for the series' themes. He feels that the implant has never spurred him to reflect on "the value of life."[33] He has instead learned obedience, as expressed in the refrain, "If you just accept things, obey, and don't ask questions, you can live a happy life."[34] Here we see a general equation of peace with government power over life.

Freeters figure prominently among the recipients of death notices, especially in the first chapters. The first victim works part-time in a convenience store, a job closely associated with freeter existence in the popular imagination. His story is bleak. A victim of bullying in school, stuck in an unfulfilling

job after graduation, the young man dies without having experienced anything of the "happy life" promised in state propaganda. The fear of death has only assured that he accept his lot in life without question.

The concept of *Ikigami* is deliberately outlandish. Yet the idea of controlling young people and making them useful to the nation has real-world parallels. Since the 1990s, for instance, conservative discourse has increasingly searched Japan's wartime history for images of "heroism" and "spirit," which are supposed to solve the country's woes by transforming the young. Progressives have criticized the omission of the darker side of Japan's imperial wars. There are disturbing parallels between contemporary talk about what is "for the nation" and the wartime elite vision of people as expendable.[35] Speaking of freeters and other youth groupings on December 9, 2004, Liberal Democratic Party Secretary General Takebe Tsutomu quipped, "Just once they should do something like join the Self-Defence Force and go to a place like Samara [in Iraq] to experience what real stress feels like and also what it feels like to earn the thanks of their communities. I think that would turn them around in about three months."[36]

Without taking the military tack of Takebe, LDP member of government Inada Tomomi has also argued for mobilizing youth: "If we introduce a system of 'agricultural conscription' where young people are made to work on farms for a while, we can take care of the NEET (Not in Employment, Education or Training) problem."[37] *Ikigami* responds to such conservative calls for jolting young people out of their perceived lethargy and apathy. It also presents a strong contrast with conservative manga such as those of Kobayashi Yoshinori. Kobayashi has insistently argued that Japanese youth should put the "public" ahead of the "individual," arguing for accelerated militarization as well.[38] While not as flagrantly militarist, Abe Shinzō's efforts to legislate a more "patriotic" direction in education have also raised concern.[39] A number of other progressive works have exposed the link between wartime militarism and the contemporary indifference to young people. Tsusumi Mika's *Hinkon taikoku Amerika* (America, the poverty superpower, 2008) shows how the American establishment exploits endemic poverty to meet military recruiting quotas.[40] It also suggests that similar processes are at work in Japan. *Ikigami* builds on such associations of service to the state, the mobilization of youth, and wartime militarism.

In interviews, author Mase has drawn the obvious parallel between *ikigami* and the notorious *akagami* (red paper) draft notices of the wartime militarist regime. An early installment of the series makes this parallel explicit. A young man working part time at an elderly care facility is mistaken by one of his charges for her husband, a man who was drafted and died some sixty years before. The story is an emotional ride for readers, complete with a tearjerker ending in which the young freeter impersonates the old woman's dead husband, helping her to pursue a difficult rehabilitation course to overcome her reliance on a wheelchair. He thus leaves a positive legacy in the hours before his life is snuffed out.[41]

While this chapter presents only tangential connections to freeter and the working poor, a later chapter of the series engages directly with the economic exploitation of young people. It starts with domestic violence: a youth, beaten by his newly unemployed father, runs away to become a "net café refugee." Unable to find secure employment and without a place to live, net café refugees sleep in reclining chairs at Internet cafes. The popular media have gravitated to these figures as images a new type of homeless.

The youth begins to read the blog of another freeter writing online under the pseudonym Akane. Akane writes of how she was forced to drop out of university after her family's company went under and now has no choice but to move from one part-time job to another: "Did I not try hard enough? No matter how much I want to find stable work, simple jobs that change by the day are all that is there for me. There are days when I can't even get that. I feel as though I am not needed in this world and my drive gets lower and lower."[42] The two develop a rapport through Internet exchanges and then meet in person.

When the young man receives an *ikigami,* he decides to distribute illegal copies to other young people clinging tenuously to Tokyo's fringes. As part of a state effort to comfort those picked for death, *ikigami* can be used to eat at expensive restaurants and to purchase luxury items. But copying it is a crime for which the youth's parents can be punished as "traitors." Akane stops him, saying that while domestic violence is not forgivable, he should take what he has learned on the street to discover empathy for his parents who were also crushed by the employment system. She says, "This society . . . it is like if you slip once you'll find yourself in a pit from which you can't escape. I think that your parents fell in just as we have."[43]

In an ending that exemplifies the series' melodramatic tone, the young man uses the *ikigami* in his last hours to purchase luxury goods that Akane can sell to raise funds to return to school. The conclusion of the series shows

Akane years later, using her law degree to help those who have fallen into the "pit" beneath Japan's employment system.

Ikigami is part of a vital discourse decrying renewed attempts to increase state and administrative power over Japanese youth by defining them as a problem and enabling mechanisms of discipline in the manner described by Michel Foucault: "Discipline increases the forces of the body (in economic terms of utility) and diminishes these same forces (in political terms of obedience)."[44] *Ikigami* is one form of imaginative response to discussions inculcating a sense of duty to the state through reform to education, military or labor drafts, inhuman employment conditions, the normalization of forced overtime and arbitrary termination. In fact, some have already extracted a political critique from the series' vision of mobilization. Reflecting on the film adaptation of the manga, for instance, Japan Communist Party representative Fujimoto Kazunori wrote, "These days, nobody is receiving 'death notices' from the state or being murdered, but many are slipping through the social safety net and losing their lives that way and this is a reality . . . We can't just take this lying down . . . The Communist Party is here to protect you."[45]

Many fans have expressed their feelings online in more eloquent terms than the JCP's Fujimoto. Reviewing the movie online, "Kanari Warui Oyaji" (A Pretty Nasty Old Man) writes, "The characters in the movie, just like your typical Japanese, are meekly accepting the [death notice] law." Reviewer thimmon6626 writes, "Why are they dying? Well, it is probably because they just thought the law was somebody else's problem and, uninterested in politics, didn't even take the time to think about it." Both reviewers raise the issue of the apathy of ordinary people confronted with abuses of state power, a theme not explicitly discussed in the work itself. Another reviewer, tuobu1ra2ya5, begins with a comment on how *Ikigami* film star "Matsuda Shota has Tony Leon's Bone Structure" only to praise the work as "frightening," an "anti-utopia" with "plenty of messages." Others reflect on history: "Japan was a totalitarian state just half a century ago, can we really say that such a time won't come again?" Still others tie it to everything from American bases in Okinawa and the Security Treaty to former Prime Minister Koizumi's brand of populism.[46]

There is also a review backlash against *Ikigami* in all of its incarnations. The nanocapsules and "death notices" are decried, not without some

grounds, as unrealistic or even silly. Many reviewers who dislike the series, however, have still been drawn into considering its complex metaphors. Kubota Masashi, giving a one-star review on Amazon Japan, asks, "I don't know what this author is trying to say. Does he seriously believe that they want to make Japan into a militarist state once more?" Kubota may not have liked the series, but it seems to have led him to equate wartime Japan with the bureaucratized murder of *Ikigami*. He too has been alerted to the overlap between militarized regimes and the contemporary conservative push toward youth mobilization.

CONCLUSION

Since the global recession of 2008, Japan has seen the publication of dozens of books on freeters and the working poor. This wave of analysis represents a shift from the "personal responsibility" discourse that dominated earlier in the 2000s and a tendency to harken back to earlier styles of progressive social critique. Much of this discussion, however, takes place in an academic frame. Amamiya Karin has lamented the fact that the jargon and methods of argument of most academic work end up shutting out precisely the young Japanese who may be most dissatisfied, even wracked with guilt or self-doubt, at the difficulty of finding stable work at a living wage, but, lacking a critical context, have difficult puzzling through the reasons why.[47] Different approaches to considering problems and imagining alternatives are necessary, and *Helpman!* and *Ikigami* also reveal two strengths of the manga industry that point to its potential to involve more young people in critical discourse rather than simply stupefying them with images and formulaic narratives.

Ikigami and other *seinen* manga have normalized the construction of dystopic worlds through long-form narratives. These products contrast greatly with popular films that tend to emphasize moments of disaster as *spectacle* or imagine dystopia in terms of chases and moments of violence; rather, over hundreds or thousands of pages they consider carefully what appears in *Ikigami* as a sweeping political economy of authoritarianism and exploitation.

In contrast, with its uncompromising illustration of care situations including aged, naked bodies in agony, *Helpman!* is a niche work. Series like this one, however, attract positive comments from readers. Magazines like *Evening,* the site of *Helpman!*'s serialization, provide mechanisms for fan feedback including reader comment cards and online forums, and base decisions to continue or discontinue titles partly on the opinions of readers. Audiences

are essentially allowed a *vote* in favor of difficult content. Difficult content can actually help a work become a touchstone—reader comments reprinted in the complied volumes and online reviews describe *Helpman!* being recommended to families by medical professionals and to young people considering entering the care industry. This represents a type of "manga public" that helps to keep works like *Helpman!* in circulation.

Despite their differences, and in their different ways, both *Helpman!* and *Ikigami* nonetheless introduce into contemporary freeter discourse some of the most unpleasant things in contemporary Japanese society: images of poverty, suffering, and discussion of mass mobilization as a cure all. Neither provides a formula for a "way out," but both respond squarely to new-left commentator Amamiya Karin's rallying cry for youth—"It's okay to get angry." In place of the frequently whimsical images of poverty as a transitional or moratorium stage in the manga medium and in the face of a spate of conservative condemnations of the young as too lazy for real jobs, a little anger seems far from a bad thing.

Notes

1. "Koizumi kaikaku no gonen to wa" (What have the five years of the Koizumi reforms brought?), *Asashi shinbun,* June 16, 2006.

2. Kuniko Ishiguro, "Japanese Employment in Transformation: The Growing Number of Non-regular Workers," *Electronic Journal of Contemporary Japanese Studies,* December 22, 2008, http://www.japanesestudies.org.uk/articles/2008/Ishiguro.html (accessed April 13, 2010).

3. Amamiya Karin, *Ikisasero! Nanminka suru wakamonotachi* (Let us live! Young people made refugees) (Tokyo: Ōta Shuppan, 2007).

4. Shūgiin honkaigi kiroku, [001/020] 171, no. 8, Speaker 4/22, January 1, 2009.

5. Miura Atsushi, *Karyū shakai* (The downstream society) (Tokyo: Kōbunsha, 2005).

6. Masataka Nobuo, *Keitai o motta saru* (The monkeys with mobile phones) (Tokyo: Chūōkōron Shinsha, 2003).

7. "Nihon no hinkonritsu wa 15.7%" (Japan's unemployment at 15.7%), *Asahi shinbun,* October 20, 2009.

8. Takemura Kentarō and Masatake Sugimori, *Binbō manga taikei* (An anthology of poverty manga) (Tokyo: Yōdensha, 1999).

9. Matsumoto Leiji, *Ganso daiyonjōhan daimonogatari,* vol. 1 (Tokyo: Asahi Shinbunsha, 2009); Matsumoto Leiji, *Otoko oidon* (I am a man), vol. 1 (Tokyo: Kōdansha, 1996).

10. Karibu Marei and Tanaka Akio, *Border,* vol. 1 (Tokyo: Futabasha, 2008).

11. Egawa Tatsuya, *Golden Boy,* vol. 1 (Tokyo: Shūeisha, 1993).

12. Egawa Tatsuya, *Tokyo Daigaku monogatari* (A tale of Tokyo University), vol. 1 (Tokyo: Shōgakukan, 1993).

13. Fumimura Shō and Ikegami Ryōichi, *Sanctuary,* vol. 1 (Tokyo: Shōgakukan, 2002).

14. Kadokura Takashi, *Working poor wa jikosekinin ka* (Is it the working poor's fault?) (Tokyo: Daiwa Shobō, 2008).

15. "Minshuto no seiken seisaku manifesto 2009" (The Democratic Party's policy manifesto 2009), http://www.dpj.or.jp/special/manifesto2009/index.html (accessed April 13, 2010).

16. Amamiya Karin, *Precariate no yūutsu* (The melancholy of the precariate) (Tokyo: Kōdansha, 2009).

17. NHK Special "Working Poor" Shuzaihan, ed., *Working poor—Nihon o mushibamu yami* (Working poor: The sickness undermining Japan) (Tokyo: Popurasha, 2007).

18. Feeling little dignity in the conditions of daily life and even less hope for positive change, desperation is disturbingly common among the elderly. Over one third of Japan's more than 30,000 yearly suicides (the highest per capita rate among leading economies) are over the age of sixty. See Keisatsuchō Seikatsuanzenkyoku, "Heisei 20nen ni okeru jisatsu no gaiyō shiryō" (A summary of data on suicides in 2008), http://www.npa.go.jp/safetylife/seianki81/210514_H20jisatsunogaiyou.pdf (accessed April 13, 2010).

19. Rin Jirō, *Kaigo hōkai* (The collapse of care) (Shin'yūsha, 2007), and Yuki Yasuhiro, *Kaigo—Genba kara no kenshō* (Care: An on-site investigation) (Tokyo: Iwanami Shoten, 2008).

20. There is an activist bent to the manga, and Kusaka has participated widely in public forums on care issues and cooperated with the Japanese Society for Dementia Care.

21. Kusaka Riki, *Helpman!* 14 vols. (Tokyo: Kōdansha, 2004–10), 6:70.

22. Ibid., 6:79.

23. Ibid., vol. 3.

24. Ibid., 5:86.

25. Ibid., 5:182.

26. Ibid., 5:210.

27. Ibid., 4:102.

28. Ibid., 4: back cover.

29. Norude, Amazon.co.jp review of *Helpman!* vol. 1, August 5, 2008, http://www.amazon.co.jp (accessed April 13, 2010).

30. Jürgen Habermas, "The Crisis of the Welfare State and the Exhaustion of Utopian Energies," in *The New Conservatism: Cultural Criticism and the Historian's Debate*, trans. Shierry Weber Nicholsen (Cambridge: The MIT Press, 1989), 54.

31. Mase Motorō, *Ikigami*, 8 vols. (Tokyo: Shōgakukan, 2005–10).

32. Ibid., 1:14.

33. Ibid., 1:15.

34. Ibid., 1:5.

35. Matthew Penney, "Nationalism and Anti-Americanism in Japan: Manga Wars, Aso, Tamogami, and Progressive Alternatives," *The Asia Pacific Journal: Japan Focus*, April 26, 2009, http://www.japanfocus.org/-Matthew-Penney/3116 (accessed April 13, 2010).

36. "Samawa ni ikeba ningensei naoru" (If you go to Samawah, it will fix your humanity), *Asahi shinbun*, December 10, 2004.

37. "Shushō shudō de 'kyōiku saisei'" (Rebuilding education under the prime minister's leadership), *Sankei shinbun*, September 4, 2006. NEET is a term often paired with freeter in conservative "personal responsibility" discourse.

38. Kobayashi Yoshinori, *Sensōron* (On war) (Tokyo: Gentōsha, 1998).

39. Adam Lebowitz and David McNeill, "Hammering Down the Educational Nail: Abe Revises the Fundamental Law on Education," *The Asia Pacific Journal: Japan Focus,* July 9, 2007, http://www.japanfocus.org/-David-McNeill/2468 (accessed April 13, 2010).

40. Tsusumi Mika, *Hinkon taikoku Amerika* (America, the poverty superpower) (Tokyo: Iwanami, 2008).

41. Mase, *Ikigami,* vol. 2.

42. Ibid., vol. 5.

43. Ibid.

44. Michel Foucault, *Discipline and Punish: The Birth of the Prison,* trans. Alan Sheridan (New York: Vintage, 1979), 138.

45. Fujimoto Kazunori, "Kotōgawa tsūshin" (Kotōgawa communication) 239, October 15, 2008, Web site of Fujimoto Kazunori, http://ikki.jcp-web.net/?p=731 (accessed April 13, 2010).

46. See reviews of the *Ikigami* manga and film at www.amazon.co.jp.

47. Amamiya Karin and Fukushima Mizuho, *Waakingu pua no hangeki* (The working poor strike back) (Tokyo: Nanatsu Mori Shokan, 2007).

Commodity-Life

ITŌ GŌ

Translated and with an Introduction by Miri Nakamura

• • •

Tezuka Is Dead: Manga in Transformation and Its Dysfunctional Discourse

Translator's Introduction

With its provocative title and thought provoking argument, Itō Gō's book *Tezuka Is Dead* altered the landscape of manga criticism when it was published in 2005.[1] A cultural critic, Itō problematizes the dominant position of Tezuka Osamu as the absolute origin of Japanese manga history, a view he argues has prevented the construction of a history of representation in manga *(manga hyōgenshi)*. Itō instead reveals that the realism of modern manga originated from the suppression and effacement of its postmodern elements—epitomized by what he defines as a *kyara,* a "proto-character" entity that turns into a complete *kyarakutaa* once the reader identifies it as "human-like."[2]

Throughout the book, Itō criticizes scholars who have failed to recognize the postmodern underpinnings of manga and who have evaluated manga based only on its storyline and other orthodox, modern values. His larger goals are to come up with a theoretical tool that can analyze manga as a distinctive representational form (as opposed to theories that simply conflate manga with anime and film) and at the same time to bridge the gap between today's theoretical discourse surrounding manga and the actual status of the texts—in terms of their readership, approaches, and postmodern qualities.

What follows is an abridged translation of the book's foreword and its opening chapter, "Manga in Transformation and Its Dysfunctional Discourse," where Itō expounds on the aforementioned breach and calls for a new theoretical framework.

TEZUKA IS DEAD: MANGA IN TRANSFORMATION AND ITS DYSFUNCTIONAL DISCOURSE

The discourse surrounding Japanese manga has failed to capture manga's present state. As a result, manga of the last fifteen years or so has been seen as existing in a "postmanga" historical vacuum. My book *Tezuka Is Dead* arose from my frustration with such a situation, for what appears to be a historical vacuum is actually the symptom of our lack of a history of manga representation (*manga hyōgenshi*).

There must be a reason for this lack, and the reason is to be found within manga representation itself. This project is concerned with the textual analysis of manga and the ideal framework for such an analysis. Through my research, I have come to the conclusion that the framework of so-called postwar manga that claims Tezuka Osamu as its "origin" was itself responsible for the impossibility of constructing an appropriate history of representation in manga.

WHY CAN'T MANGA DISCOURSE CONFRONT MANGA'S PRESENT CONDITION?

I want to begin with an excerpt from Yonezawa Yoshihiro's[3] "Commentary on the Terminologies of Manga Culture" from *Gendai yōgo no kiso chishiki* (2001, Contemporary terminologies):

> Manga magazines and paperbacks have subdivided and increased their number in answer to readers' needs and to address various generations, genders, and tastes. But as a result, it seems that they have also lost their economic clout. Since 2000 the number of magazines and paperbacks published has decreased across the board, and in the past year manga has reached a point where it has not produced a single huge hit or popular new genre . . . Manga will deteriorate if it cannot create works that are engaged with their own time and that also transcend time—works that will be read over and over.

With the arrival of the twenty-first century, it seems that manga has reached a difficult point.[4]

SINCE THE LATE NINETEEN EIGHTIES, JAPANESE MANGA HAS EXISTED AS A HIGHLY OPAQUE, EVEN IMPENETRABLE GENRE OF EXPRESSION.

Gendai yōgo no kiso chishiki is an annual encyclopedia that contains explanations of terminology from various genres by specialists in each field. Since it is a yearly publication, it tends to emphasize recent events, and this piece by Yonezawa reflects back at the year 2000 to describe the status of manga. I am sure many readers felt sympathetic to his outline of the situation and his conclusion.

On the other hand, immediately following the above quote, in "Recent Topics," Yonezawa takes up the popular work *One Piece*. Here is what he says:

An ocean adventure shōnen manga by Oda Eiichirō, currently serialized in *Shōnen Jump* . . . quickly gained popularity due to its simple enjoyability and became a huge hit, serialized on TV and released as a theatrical anime.[5]

These two excerpts are located only about four centimeters away from one another on the same page. Looking back at the year, he has stated in the first quote that "manga has reached a point where it has not produced a single huge hit" and in the second, "it became a huge hit." As a matter of fact, 39,645,000 volumes of *One Piece* were printed through the end of 2001 (counting the entire series up to volume 16), and the first printing of volume 16 at the end of 2001 amounted to 2,040,000 copies alone.

Nakano Haruyuki claimed in *Manga sangyōron* (On manga production)[6] that there is an extreme division in terms of production numbers between the few megahit works and the rest of manga. If Yonezawa's comments were along those lines, that would have been understandable, for that division is undeniable. However, that is not what he stated. He declared that "manga has reached a point where it has not produced a single huge hit." How could that be? Over the course of seven years, from 1995 to 2001, Yonezawa has propounded "the deterioration of manga" in every issue of *Gendai yōgo no kiso chishiki*. Is the 2001 entry simply a mistake? Or is there a deeper issue hidden here?

Since the late 1980s, Japanese manga has existed as a highly opaque, even impenetrable genre of expression. This is most evident from discourses such as Yonezawa's, which claim that "manga has deteriorated" or "manga has become boring." These discourses became extremely influential and peaked in the mid-nineties. Opinions differed with the theorist, but they all

agreed on one premise: that the extreme increase in the number of manga publications, together with the immense broadening of its genre boundaries, made it impossible for any one reader to grasp it in its entirety. Hence "manga became boring."

These discourses commonly justified their stance without ever discussing *what* became boring, or how. In other words, critics did not specify their reasoning—what they themselves expected from the genre and what had betrayed their expectations—and could express their annoyance with the present state of manga only as a subjective feeling. However, this feeling certainly had the power to spread. There must be many who remember special journal issues based on this premise. If we allow this to remain simply a feeling, we will not be able to counter the development of this theory that "the entire representation called manga became boring" due to the fact that "the number of manga publications had increased so much that it became impossible for one reader to grasp it in its entirety."

Hence, we must pay attention to how the statement "it became impossible for one reader to grasp it in its entirety" is being narrated as a problem tied to manga. The presupposition here is that it is desirable for one human being to be able to comprehend the whole of manga. If so, we can ask why such a condition is thought to be desirable, which becomes the question of why it is undesirable for manga to be created in a wide variety and in large numbers.

This last question exposes the way that the current narrative *(katari)* surrounding manga—in particular what is called criticism *(hyōron)*—disapproves of the current state of manga and how that narrative has become a source of dysfunction. Why can't our discourse endorse today's manga? I am particularly struck by those who claim that manga became "boring," not only manga critics like Kure Tomofusa,[7] Murakami Tomohiko,[8] and Yonezawa Yoshihiro but also newspaper reporters, manga and magazine editors, educators, you fans, and of course I myself, who simply accepted this narrative for the most part. Why couldn't I accept manga's present circumstances and grasp them clearly? This question is starting point for *Tezuka Is Dead.*

MULTIPLE "READINGS" AND THE NECESSITY OF SYSTEM THEORY—BASED ANALYSIS

Before going into the main argument, we should explore the multiplicity of manga readings a bit further. Let us take a look at the case of the well-known

weekly magazine *Shūkan shōnen jump*. This is typically understood to be the most widely read shōnen manga weekly magazine, with readers comprised mainly of grade school and middle school boys. Of course, it is widely accepted that the readership also includes older students and other members of society. Let us imagine here a group of students reading the latest issue of *Jump* in their high school classroom. My guess is that a good portion of them would be female students. If you understand manga's current circumstances, this should not come as a surprise. In other words, even for this one magazine, *Jump,* there several audiences of different ages and genders.

And so, some readers would undoubtedly describe what appealed to them with words to the effect of "I liked how the characters overcame obstacles." Others might approach the work more casually, proclaiming simply "The illustration is beautiful. The visuals are cool." The enjoyment *(omoshirosa)* that different readers experience is varied, and even within one person it is never singular. However, the readership of a given work like *One Piece* includes all these kinds of readers. This is incontestable.

What does this fact suggest?

Let us imagine a young woman who loves *yaoi* manga.[9] She enjoys *Jump*. She may even be sharing the journal with the boys in her class. However, there may be a huge gap between her *One Piece* and the boys' *One Piece,* to the extent that they become two different works. This example clarifies the various problems that surround *yaoi* and the multiplicity of readings. What I mean by *yaoi* here is the whole process of rereading the relationship between characters (usually friends or rivals) as a male homosexual love relationship.

Generally speaking, there is a tendency for male readers of *Jump* to show an abhorrence toward *yaoi*-type readings. There is a sentiment within them akin to male subjects' homophobia.[10] As long as *yaoi* continues to be a kind of homosexual rereading, issues of gender trouble will persist. I propose to treat these "collisions" not as issues of subjectivity or sexuality but as something stemming from the reader's frustration with the fact that, even though he is reading the same text, he is seeing something completely different from what other readers see.

What I am saying is simple. A reader may say, "I'm moved by the story, but those other people are only looking at the characters! *(Ore wa sutōrii ni kandōshite iru no ni, aitsura wa kyara shika mitenai!)*" In this reader's frustrated mind, there is a distinction between what he understands as "story" and as "character." When story is mentioned, it is often as part of a value structure that places story or narrative above character. A judgment of the story is thus directly tied to the evaluation of the work itself. On the other hand, pleasure

brought about by the characters is avoided as something unfavorable. This is a common hierarchy when talking about manga. Here, however, I will treat both the story and what the reader takes away from the characters equally as "manga-esque pleasure" (mangateki kairaku), and I aim to separate out the components of pleasure that we experience when reading manga. Story and character, intimately tied to one another, can be seen as subsystems within the larger system of manga. The goal here is first to make manga discourse conform to the present state of multiple texts and readers. We can put value judgments of the works on hold for now.

As a matter of fact, it is difficult to state that there is a manga reading that focuses only on the characters, and at the same time it is unrealistic to claim that there is a kind of storytelling that completely ignores the characters' appeal. It is more logical to assume that even within one person's reading, various levels of pleasure are operating simultaneously. Furthermore, there is a possibility that the reception of one pleasure obstructs the recognition of another. Readers who are strongly moved by the characters' charm probably do not feel other pleasures occurring simultaneously, such as the ingenuity of the story development, and vice versa. Further, pleasure is remembered when you describe it to another person, so pleasure comes together as a narrative process itself, and this introduces another layer of filtering that functions simultaneously with the processes above.

This becomes clearer if we look at the case of pop music. Music is constructed of lyrics, voice, performance, arrangement, melody, chord progression, and rhythm. There are various presuppositions as to which components audiences react to most strongly, and criticism and other narratives about music follow one or another of these presuppositions. Of course, one could also include elements beyond the musical composition, for example, fashion or the musician's background history. If the performance stirs the audience in a certain way, we could also consider elements like the music's connection to society, the defining issues of the era, the mood, and so on. Either way, the music is separated into different parts.

The situation is different in the case of manga. As Ishiko Junzō[11] once pointed out, manga criticism focuses either on the illustrations or the themes, and much of it fails to go beyond critics' subjective impressions or broad opinions.[12] Debates that do not mesh with one another are constantly repeated, in a way that ignores the richness of manga storytelling and confines manga criticism to its present low standards.

As an antidote to such a condition, since the 1990s scholars such as Natsume Fusanosuke[13] have had some success advancing works like *Manga*

hyōgenron (Theories of manga representation).[14] Natsume and others promoted a movement to theorize manga, driven by their motivation to more genuinely transmit the "enjoyment" *(omoshirosa)* of manga—what I refer to as "pleasure" *(kairaku)*. Natsume's intention is evident from the of another work, *Manga wa naze omoshiroi no ka* (Why is manga enjoyable?).

My work extends the theories of representation propounded by Natsume and others. As the basis of his analysis, Natsume's theory treats manga as a *drawn text* and focuses on its various visual aspects. My work, in contrast, treats manga as a system of representation and focuses on the analysis of that system. I am interested in capturing the genre of manga as a higher-level "environment" *(kankyō)* that includes various works and authors, and I treat panel constructions and stories as lower-level subsystems specific to particular authors and works. By doing so, I hope to open up the works to a diversity of readings by different people and to divulge the variety of readings that exist in a single reader. In that sense, this book's system theory of manga representation *(hyōgen shisutemu-ron)* will be congruous with reception theory and will extend and go beyond Natsume.

Such analysis will allow me to comment on the levels of pleasure that are not easily recognizable when reading or talking about manga. I believe that such a tactic will help point out the "richness" that exists within individual manga, and at the same time function as an indicator of a work's critical worth.

> MANGA CRITICISM FOCUSES EITHER ON THE ILLUSTRATIONS OR THE THEMES, AND MUCH OF IT FAILS TO GO BEYOND CRITICS' SUBJECTIVE IMPRESSIONS OR BROAD OPINIONS.

THE DISCURSIVE GAP IN SHŌNEN GANGAN

Let us look at one example, a type of manga commonly known as "Gangan comics" *(gangan-kei)*.[15] This refers to manga published in the magazines owned by three companies—Makku Gaaden, Ichijinsha, and particularly the game company Square Enix. These magazines target teenagers, and their readerships are approximately half male and half female.

Manga scholars born before the 1960s have ignored Gangan comics for the most part. Some have even pretended that these comics never existed, and Gangan comics are never given a spot within histories of manga. Arakawa Hiroshi's Gangan comic *Fullmetal Alchemist* became a success and was "discovered," but it is always analyzed as being in line with the orthodox lineage of shōnen manga and treated separately from other Gangan comics. This

undertaking is not limited to the small industry of manga criticism but also extends to manga editors themselves and to the general readership.

In other words, there exists a gap between Gangan works or magazines and other types of manga. Critics are all familiar with Gangan comics, but they always place them outside of what is defined as "today's manga" *(kinnen no manga)*. This seems to be done almost unconsciously: they do not even try to go near Gangan. To put it even more strongly, for a certain group of people, Gangan comics are inconvenient for (our) discourse on manga. We manga critics lack the vocabulary to narrate a manga history that would include these works.

"Well," some may say, "Gangan comics are kind of trashy, aren't they? The pictures are pretty, but the stories are so shallow. It's no wonder they're not taken seriously." Gangan comics are indeed trashy *(kudaranai)*. The illustrations have a cookie-cutter quality. There is no depth to the story, and they fail to depict real people. However, we can also see precisely these kinds of critical statements as a hackneyed, repetitive discourse that looks at manga from the outside. Critics like these (and the Gangan example is typical but by no means unique) must realize that their claims are based on their own qualitative distinctions between what they categorize as manga worth talking about and manga they are free to disregard. But this distinction is their own: it is not universal. There is a need to explain convincingly why Gangan comics seem shallow, but that is an impossible task for these critics. They have never even read these texts. For them, it is a natural reaction to fall silent in the face of Gangan comics and deny their existence. So why and how are Gangan comics so "inconvenient?"

Hosaka Yoshihiro, chief editor of *Shōnen gangan* said the following in a 1998 interview: "Our company began publishing as a game company, so the concept was to create a game-like sensation in comics for the game players. The manga version of *Dragon Quest* is still being serialized, and . . . even for our manga not based on specific games, we are working hard to create panels with a good tempo that matches the rhythm of a game."[16]

Whatever Hosaka meant by "panels with a good tempo," it becomes a remarkably interesting comment. In fact, in the mid-1990s, I had the impression that Gangan comics, especially those of the "G Fantasy" series,[17] were somehow different from other manga, a reaction that was echoed by others around me.

Manga writer Buronson / Fumimura Shō,[18] creator of the *Shōnen gangan* comic *Tenkū shinobuden battle voyager* (1995–97, illustrated by Yuiga Satoru),[19] also declared that

It must be the fantastic illustrations, right? The kind that are so popular these days . . . Frankly, fantasy illustrations all look the same to me (laughter), so in one sense, they weren't innovative . . . The world of fantasy after all is a world of its own. It is not a world of story development but more like a role-playing game that drags on slowly. That's when I lost direction a bit. That's how I feel—I don't think I was cut out to write fantasy.[20]

Reading this together with the previous comment by Hosaka, it becomes evident that their understanding of all the key elements of manga construction—panel divisions, illustration style, and story—are consciously contrasted with the qualities of the manga that came before.

In other words, Gangan comics possess something different from the manga that preceded them, not only in terms of marketing or of circulation but also at the level of representation (hyōgen). And if that is indeed the case, then leaving value judgments aside, it should be treated as a key moment in the history of manga expression. After all, Buronson himself is acknowledged as being part of manga's official history, having produced countless hits from the 1970s onward. On top of this, manga works owned and read by him and by his colleagues are recognized as the building blocks of manga history: works by Tezuka Osamu, Chiba Tetsuya,[21] and Motomiya Hiroshi.[22]

My point is not to blindly privilege Gangan comics here, and the evaluation of specific works is a whole different matter. My point is that the main reason for ignoring Gangan comics is the fact that they emerged from video games. I am merely using Gangan comics as a case study for understanding the gap between manga itself and the discourse about it.

WITHIN THE SPACE OF CHARACTER REPRESENTATION

It goes without saying that manga exists today as a form of character representation, alongside anime and videogames. This is just a simple fact. The generation that experienced videogames before manga is already out of their twenties, and as industries, manga, anime, and videogames are intimately intertwined. Furthermore, it has been pointed out that, since the 1960s, successive booms in manga have been driven by media mixes like manga-based animation, with manga prospering and garnering new readership each time.[23]

If the manga always came first, followed by anime and videogame adaptations, we could ignore this history. However, that's not the case for

> NOWADAYS, IT HAS BECOME COMMON FOR CHILDREN TO EXPERIENCE ANIME AND VIDEOGAMES BEFORE MANGA.

works based on the so-called media mix strategy of cross-promoted products, a practice which has gained popularity over the last twenty years or so. So I shall repeat my question again: why can't our discourse on manga face up to the present reality?

Takayama Hideo has argued that manga's audience has been hollowed out in the middle—polarized into a younger generation that responds to character goods like toys and another group beyond middle school, with a gap in between. However, Takayama implicitly presumes that the privileged form of character representation that children first encounter is manga. Nowadays, it has become common for children to experience anime and videogames before manga, and oftentimes discover manga only later (in some cases postpuberty). This is probably obvious to many readers, and for those born after the seventies it is the norm, but as long as the problem is framed as that of "the death of children's manga," this fact becomes invisible. Moreover, to work from the unspoken assumption that manga has a privileged status within child culture conversely prevents us from seeing manga's unique qualities as a representation of character (kyarakutaa hyōgen).

But it is also true that people came to question what made manga "manga"—its uniqueness—precisely because the other character representation genres like anime and videogames became so dominant. As Hosaka's previous comment suggests, that is certainly what happened to the business side of things when they asked how manga could compete against other forms of content merchandise. On the discursive side as well, one must constantly be conscious of why manga should be described as a privileged site in relation to the other genres. Furthermore, since its rise in popularity manga has developed under the influence of other genres besides just anime and videogames. There is no reason to privilege the influence of just those two.

At the very least, manga can no longer be perceived as the sole existing form for character representation. After anime and videogames became influential, manga had the opportunity to see itself relatively. I would venture further to say that this was its first opportunity to do so. Manga's relationship to these new genres is different from the relationship that it held with earlier genres like literature or film, for two reasons. First, the manga that is contrasted to the leading media of today is defined as something that is in rivalry with their achievements. The other reason becomes clear when one considers individual titles developed simultaneously in different media.

When theorizing manga in relation to anime or videogames, thematic criticism holds little validity. In the commonly encountered case of a manga, an anime, and a videogame with the same characters, the same worldview, and similar storylines, if one analyzes themes in a literary fashion one can produce a reading of the whole work (*sakuhinron*) but not a reading of the manga specifically. To do that, we need a framework that is derived from a theory of manga representation, one that captures manga as a genre.

Having said that, though, I am not favoring manga's relationship to anime and videogames specifically. Even though I could discuss individual anime and videogames, I lack the knowledge to discuss these genres from within. What I am advocating instead is that we resituate manga within the space of character representation, then read manga *as manga*. It is only because this is not yet achieved, only because we lack the theoretical framework for making such a thing possible, that people cannot trust manga and cannot let go of the kind of external judgments that relegate it to mainstream children's culture, for example. This is also the reason people hide behind their own generation's false sense of exclusivity by claiming certain texts as "our manga" and excluding everything else.

As we have seen, these responses impoverish the discourse but also suppress the fact that manga is made "right here, right now," when read by its audience. As long as this discourse remains unchanged, there is no possibility for a manga classic to be read in a way that values it as such, nor can one reflect on current trends in manga. Young readers born in the nineteen-seventies and later are already saying that manga criticism is something that talks about old manga—texts that have nothing to do with them. And this problem is not limited to the sphere of criticism but arises whenever manga is mentioned in the realms of the media, education, or administration. There manga is a mode of representation narrowly defined by the reading and reception of a single generation born in the fifties and the sixties.

These things have continued to hinder the construction of a theoretical framework. This lack of framework has limited our perspective and kept us from dealing with reality. In turn, this inability to deal with reality makes it hard to find an opening for thinking about how to construct a theoretical framework in the first place. Our manga discourse is stuck in this vicious circle. As a result, there exists the possibility that manga could be left behind in the national policies that promote other content industries like anime and videogames and become an emperor with no clothes. To escape from this negative feedback loop—that is our task.

Notes

1. Itō Gō, *Tezuka izu deddo: Hirakareta manga no hyōgenron e* (Tezuka is dead: Postmodernist and modernist approaches to Japanese manga) (Tokyo: NTT Shuppan, 2005).

2. For a translation of this part of the argument, see Itō Gō, "Manga History Viewed through Proto-Characteristics," trans. with a foreword by Tetsurō Shimauchi, in *Tezuka: The Marvel of Manga,* ed. Philip Brophy, 106–13 (Melbourne: National Gallery of Victoria, 2006). Itō also explains that *kyarakutaa* can also be equivalent to the English notion of "character," especially one similar to E. M. Forster's concept of a "round character."

3. Yonezawa Yoshihiro: 1953–2006; critic and director of Japan Manga Society *(Nihon Manga Kai).* Since 1980, he has been a representative for Comic Market. Among his publications are *Sengo shōjo mangashi* (History of postwar shojo manga), *Sengo SF mangashi* (History of postwar SF manga), and *Sengo gyagu mangashi* (History of postwar comic manga). (Together, these are referred to as "The Trilogy of Postwar Manga History.") Yonezawa is also known for his research on banned books and publishing culture. [Unless otherwise noted, all explanatory footnotes are the author's. —Trans.]

4. Yonezawa Yoshihiro, "21seiki e no shiten: Manga bunka no gurōbaruka to manga sangyō no teitai" (Looking toward the twenty-first century: The globalization of manga culture and the stagnation of manga production), in *Gendai yōgo no kiso chishiki* (Contemporary terminologies) (Tokyo: Jiyū Kokuminsha, 2001), 1056.

5. Ibid.

6. Nakano Haruyuki, *Manga sangyōron* (On manga production) (Tokyo: Chikuma Shobō, 2004). This book analyzes postwar Japanese manga from the perspective of "production." It focuses on readership groups to analyze the growth model of the manga market, claiming that the market grew in accordance with readers' increase in age. Also, Nakano argues that manga did not develop by itself but was pulled along by other genres such as anime, soap opera *(TV dorama),* and film. Nakano was born in 1954. He is an editor and a nonfiction writer. His numerous other publications include *Tezuka Osamu to rojiura no mangatachi* (Tezuka Osamu and alleyway manga).

7. Kure Tomofusa: b. 1964; critic. His name can be pronounced either "Kure Tomofusa" or "Gochiei." Debuted in academia as a supporter of the New Leftist Movement *(shin sayoku katsudō)* and later as a supporter of feudalism *(hōken shugisha).* His articles are serialized in *Garo* and *Takarajima.* His work includes *Mangakyō ni tsukeru kusuri* (Medication for manga fanaticism).

8. Murakami Tomohiko: b. 1951; manga critic and manga editor. His work includes *Manga kaitaisho—Tezuka Osamu no inai hibi no tameni* (Analytical textbook of manga—For days without Tezuka Osamu).

9. *Yaoi:* A term for spinoffs that treat the relationships between the male characters of manga/anime/videogames as homosexual ones. It is to be distinguished from "boy love" *(bōizu rabu).* In the English-speaking world, some refer to these texts as "slash fiction."

10. Homophobia: a psychoanalytical term that captures the deep abhorrence toward homosexuality exhibited by males with repressed homosexual tendencies.

11. Ishiko Junzō: 1929–1977; art critic. He formed the core of the fanzine *Manga shugi* (Manga-ism). His work includes *Kitchu-ron* (On kitsch), *Gendai manga no shisō*

(Philosophy of contemporary manga), *Sengo mangashi nōto* (Notes on the history of post-war manga).

12. Ishiko writes: "The clearest cases of where manga has failed to be criticized as manga are analyses of cartoons that discusses motifs and visual aspects, and readings of serialized panel manga that focus on theme-oriented plot summary and the historical background of the setting to analyze the characters' personalities and draw conclusions about the author's ideas. The former privileges illustration, and the latter literary aspects. The two compliment one another and are emblematic of modernity *(kindai shugi)*." Ishiko Junzō, *Gendai manga no shisō* (Philosophy of contemporary manga) (Tokyo: Taihei Shuppansha, 1970), 51.

13. Natsume Fusanosuke: b. 1950; manga columnist and critic. He originally began as a critic working simultaneously as a manga writer, but after the publication of his *Tezuka Osamu wa doko ni iru* (Where is Tezuka Osamu?), he came to focus on his work as a critic. His other work includes *Mangagaku e no chosen—Shinkasuru hihyō chizu* (Challenging manga studies: A map for criticism's evolution). His grandfather is the canonical writer Natsume Sōseki.

14. *Manga hyōgen ron* (Theories of manga representation) is an attempt to analyze manga works from the perspective of representation *(hyōgen)*, such as lines and panel divisions, instead of resorting to a sociohistorical approach. [For a sample of Natsume's work in English, see Natsume Fusanosuke, *Komatopia,* trans. Margherita Long, with an introduction by Hajime Nakatani, *Mechademia* 3 (2008): 65–72. —Trans.]

15. Gangan line *(Gangan-kei)*: Represented by magazines like *Gekkan shōnen gangan* (Monthly shōnen gangan, first published in 1991 by Square Enix), *Gekkan G fantajii* (Monthly G fantasy, first published in 1993 with the title *Gekkan gangan fantajii* [Monthly gangan fantasy] by Square Enix), *Gekkan komikku bureido* (Monthly comic blade, first published in 2002 by Makku Gaaden), and *Gekkan komikku zero samu* (Monthly comic zero sum, first published in 2002 by Ichijinsha). These magazines are referred to as the "Gangan line" not just because of the similar style of the works they serialized but also because the writers and works featured in the journals *Bureido* and *Zero samu* originally came from *Gangan* and Square Enix's other magazines.

16. "Henshūsha jūnin, dodō no dai intaabyū!" (A tempestuous interview with ten editors!), in *Komikku rankingu minna no manga* (Comic ranking of everyone's manga), ed. Murakami Kazuhiko (Tokyo: Mainichi Shinbunsha, 1998), 88.

17. [The "G Fantasy" series refers to the Gangan comics published in the monthly shōnen manga magazine *Gekkan jii fantajii* (Monthly G fantasy) also produced by Square Enix. They contain manga versions of popular fantasy-themed video games like *Fire Emblem.* —Trans.]

18. Buronson / Fumimura Shō. b. 1947. Manga writer. He was discovered by manga editors while studying under Motomiya Hiroshi, after he had trained in the Self-Defense Youth Force. His works *Dōberuman keiji* (Doberman police) and *Hokuto no ken* (Fist of the North Star) contributed to *Shōnen Jump*'s golden age in terms of sales. He is currently writing for a youth journal *(seinenshi)*.

19. Yuiga Satoru. Manga artist. Her work includes *Tenkū shinobuden batoru boijaa* (Battle voyager, written by Fumimura Shō), *Sebunsu saga* (Seventh saga), and *E'S.*

20. "Gensakusha: Buronson, moshikuwa Fumimura Shō" (Creator: Buronson, or,

Fumimura Shō), no. 9 (March 2004), Mangagai Web site, http://www.manga-gai.net/_note/column/mangamichi/new/01.html.

21. Chiba Tetsuya: b. 1956; manga artist. Representative works include *Shidenkai no taka* (Falcon of Shidenkai) and *Ashita no Jō* (Tomorrow's Joe).

22. Motomiya Hiroshi: b. 1947; manga artist. Contributed to sales of *Shōnen Jump* with his "bully" manga *(banchō manga) Otoko ippiki gaki taishō* (One-man leader of kids). Other representative works include *Ore no sora* (My sky) and *Sararīman Kintarō* (Salaryman Kintarō).

23. Nakano Haruyuki, *Manga sangyōron* (On the manga industry) (Tokyo: Chikuma Shobō, 2004).

MIYAMOTO HIROHITO

Translated by Thomas Lamarre

How Characters Stand Out

THE IMPORTANCE OF CHARACTERS FOR MANGA

Among the various elements used in the composition of manga, it is well known that characters have particular significance. If we consult an American encyclopedia compiled at a time when manga first began to flourish in newspaper serialization, we find under the heading of comics that the comic strip (a type of manga using a series of panels to tell a story) generally has a continuing cast of characters.[1]

Here "continuing cast" refers to the same characters playing the same roles across a number of episodes. In *Sazae-san*, for instance, each day's episode basically comes to its conclusion in four panels, but the next day, and the day after, the character Sazae-san continues to appear as the elder daughter of the Isono family. Providing an overall name for the series of independent episodes, the title of the work supports the sense of a continuing cast. Put another way, if the first episode and the thousandth episode of *Sazae-san* appear to be part of the same work, it is because the same character takes the stage.[2] While each and every episode comes to an end, a particular character reappears in each. For the reader, such a work brings primarily characters to

mind, rather than individual episodes. This state of affairs is of the utmost importance when considering characters in manga, anime, and games today.

The man who laid the foundations for making character "stand out" in story manga, himself a popular manga writer, is Koike Kazuo. He established a seminar for training manga artists called Gekiga Sonjuku, which launched artists like Takahashi Rumiko. Koike's story methods became widespread from the 1970s but were only compiled in book form in 1985, as *Koike Kazuo no shijō Gekiga Sonjuku* (Koike Kazuo's story comic course books). Let me quote some short passages:

> Throughout these lectures, I teach that "comics = character." Indeed that's the only thing I teach. It's not only the basis of comics, it's all there is to comics. If you don't grasp the importance of character, it doesn't matter how strong the story you create, or how wonderful the ideas you put into it, or how skillfully you write dialogue; something will be lacking, and it won't be an interesting work. . . .
>
> To state it somewhat extremely, when one hears the title of a comic, the only thing that comes to mind is the character's image and name. . . .
>
> This matter of the character being active and moving in a lively manner within the work, I call "making the character stand out." Making the character stand out is a very difficult operation. Within a limited number of pages, you must accurately express the character's view of life, way of life, manner of speaking, worldview, etc.[3]

As a point of departure for Koike's manner of thinking about comics, Tezuka Osamu first comes to mind. Let me cite from Natsume Fusanosuke's *Tezuka Osamu no bōken* (The adventures of Tezuka Osamu, 1998):

> Even though this young man of eighteen says that he's drawing it all for children, he is in fact drawing what he wants. He's drawing exactly what he wants to see drawn, what he longs for. That's what definitively sets Tezuka apart from the established manga artists of the early postwar period. That's why even those who had never tried doing children's manga began to line up to do them. For one thing, it was now possible to make manga with very complex narratives. Narrative here was a matter of establishing interior psychological actions premised upon a modern consciousness of self, which allowed for the formation of drama. Through a sophisticated use of line and panels, he produced an expression of people's inner psychology, and story as psychological drama.[4]

WHAT MAKES CHARACTERS "STAND OUT"?

In almost all instances, characters that may be said to "stand out" in manga today come equipped with the following six elements:

1. Individuality. The character possesses characteristics distinguishing it from other characters.

2. Autonomy or para-existence. The character is not tied to one narrative world. In the background of the individual narratives presented to the reader, there is the evocation of a larger narrative world in which the character dwells. This "background narrative world" is not limited to the coordinates set up by the creator. There is room for the reader to add to it, for instance. In the case of *Sazae-san,* each daily episode, completed in four frames, makes for individual narratives as well as for a background story world that can be reconstructed by readers in a book like *Isono-ke no nazo* (Mysteries of the Isono family, 1992).[5]

3. Variability. The character has some capacity for change in its features or personality. The character may show signs of physical change over time. In the case of manga serialized over a long period, it is not uncommon for the characters' traits to change. In some instances, such changes are presented as the maturation of the character within the narrative; and in some instances, they appear as the natural outcome of changes in drawing style. The transformations of Goku in Toriyama Akira's *Dragon Ball* or Arare-chan in Toriyama Akira's *Dr. Slump* are good examples.

4. Multifaceted quality or complexity. The character is not a mere type of being. The character possesses an "unusual side" or "weak point."

5. Nontransparency. The character has an inner side, which cannot be seen from the outside or by others.

6. Internally multilayered quality. The character is aware of something within, which is not transparent to it and which cannot be readily controlled. The character materializes modern self-consciousness, that is, an awareness of looking at oneself and asking "what is this self?"

All six elements appear in Tezuka. Yet they don't appear in Tezuka from out of nowhere. In this essay, I cannot hope to track the progress of all six.

I shall thus focus on the emergence of elements one through four, in the context of a work that predates Tezuka, *Shō-chan no bōken* (Adventures of Shō-chan).

Shō-chan no bōken, by writer Oda Shōsei and illustrator Kabashima Kazuichi (Tōfūjin), started out in the *Asahi gurafu* in January 1923 (Figure 1) and then moved its serialization to the *Tōkyō asahi* and *Ōsaka asahi* newspapers from October of the same year, where it ran until 1926. In the late Taishō period (1912–1926), manga serials with a continuing cast of characters gradually appeared in major newspapers. Particularly big (and still well known today) were the American comic *Bringing Up Father*, which appeared in translation as *Oyaji kyōiku* (1923), as well as works inspired by it such as Asō Yutaka's *Nonki na tō-san* (Easy going daddy, 1923), and among works for children, *Shō-chan no bōken*. These works clearly show elements one through four coming to fruition.

Let's look first at element two. *Shō-chan no bōken*, serialized in four panels each day, completed one adventure episode within some eight to twenty days. There was no causal relation between episodes, with each episode constituting a distinct and autonomous adventure narrative, and yet the protagonist Shō-chan and his squirrel partner Risu take to the stage in all the episodes. This form is fundamentally different from that of the character Momotarō who cannot be separated from the *Momotarō* narrative.

Such a form enables the awareness that, in the background of individual episodes, there is a larger space and time in which Shō-chan and Risu dwell, that the individual episodes cannot entirely convey or exhaust. Individual episodes extract a piece of it. In fact, when this work was published in *Asahi shinbun*, off to the side or below it there was a "memo" column, in which readers' contributions and the press's responses to them were printed. In these contributions, there appear events and situations that were not recounted to readers within the narrative, things which make up Shō-chan's "private life." A production is thus mounted that stages a direct connection between the world of the readers and the world in which Shō-chan dwells. For instance, in the memo column for January 1, 1924, appears this comment: "Happy New Year! It seems that Shō-chan and Risu have finished their New Year's treats, and have embarked on their adventure." Because the scene of them finishing their treats had not appeared in the comic, this entry contributes "information" about Shō-chan and Risu's private life as if from a reporter who knows them.

Such devices heighten the sense of Shō-chan's autonomy and para-existence, suggesting that there might another adventure not yet presented

FIGURE 1. A panel from the first serialization of Shō-chan appearing in the first edition of *Asahi Graph* (January 25, 1923).

to readers, which provokes the readers' desire to see it, stirring their imagination about what Shō-chan might do in a such and such a situation. As authors other than the original authors put forth unauthorized stories about the character Shō-chan (Figure 2), and as Shō-chan makes appearances in various advertisements (Figure 3), the result is a sense of the character existing apart from the original work, able to go it alone.

FIGURE 2 (LEFT). The cover of an unauthorized paperback edition of Shō-chan entitled *The Power of Belief*, by an unknown artist (Enokimoto Shoten, August 1925). **FIGURE 3.** An image of Shō-chan used in a film theater advertisement (*Tokyo Asahi shinbun*, January 1, 1924).

Let me now move on to elements three and four. Particularly important here is that Shō-chan bears a common name.

Characters in narrative for manga before *Shō-chan* and even at the same time as *Shō-chan* were by and large stereotypes or generic figures, mere emblems of some sort. Their "distinguishing features" made for one-dimensional characters with absolutely no potential for change. In works such as *Heiki no Heitarō* (Levelheaded Heitarō, by Okamoto Ippei, 1918), *Massugu Tarō* (Straight-ahead Tarō, by Yamada Minoru, 1920), *Dango Kushisuke* (Dango-skewer-suke, by Miyao Shigeo, 1925) and *Karutobi Karusuke* (by Miyao Shigeo, 1927), for instance, the character's name frequently provides the full explanation of the personality, and the character's personality turns out to be very simplistic, fixed, or generic.

While it is true that the character for *shō* in *Shō-chan* has the meaning "correct," Shō-chan was, in fact, a very common name at the time. Insofar as readers knew from experience any number of Shō-chans with different

> CHARACTERS IN NARRATIVE FOR MANGA BEFORE SHŌ-CHAN AND EVEN AT THE SAME TIME AS SHŌ-CHAN WERE BY AND LARGE STEREOTYPES OR GENERIC FIGURES, MERE EMBLEMS OF SOME SORT.

features and personality traits, there was no sense that the name Shō-chan of itself said all that there was to know about the character's personality. In other words, the fact that the character bore an ordinary name became a condition enabling a sense of the variability and multifaceted quality of Shō-chan's personality.

Moreover, even though Shō-chan's hat serves to distinguish him visually, he does not wear it all the time. His face and physique also change in the course of the series (Figure 4). While the work does not explicitly depict Shō-chan's maturation in the course of his adventures, or make a theme of it, the visual transformation of his features allows readers to feel the flow of time across episodes.

In addition, Shō-chan's personality has ambiguous aspects. When compared to *Massugu Tarō* or *Heiki no Heitarō*, Shō-chan's personality traits are somewhat less distinctive. He does not have many changes in expression or physiological state or outward displays of emotion. Yet, unlike the generic and fixed personality traits that are exaggerated so unrealistically in such characters as *Massugu Tarō* or *Heiki no Heitarō*, the submerged individuality

FIGURE 4. The cover of the book edition of *Shō-chan,* written by Shōsei with art by Tōfūjin (Asahi shinbunsha, July 1924).

of Shō-chan clearly works to impart a sense of a realistic existence. An emphasis on highlighting and stabilizing a single trait results in the suppression of the character's multifaceted quality. In contrast, in Shō-chan's lack of distinctiveness, we see the emergence of a multifaceted personality. By the same token, the emergence of variability and the multifaceted quality that comes of the possession of a commonly used name also serves to strengthen Shō-chan's para-existence.

By the late Taishō era, character elements one through four were all pretty much in place, which enabled the phenomenon whereby readers would contribute, half in jest, letters written in the manner of Shō-chan as if he really existed, or, as I put it previously, whereby the character leaves the work and goes it alone. The question, then, is how elements five and six made their appearance in manga history. But that is a subject I will have to take up in another essay.

..

Notes

The essay translated here was originally titled "Manga ni oite kyarakutaa ga 'tatsu' to wa dō iu koto ka" (What does it mean to say that character 'stands out' in manga?) and appeared in a special issue *Kyarakutaa o yomu* (Reading character) of *Nihon jidō bungaku* (Japanese children's literature) 42, no. 2 (March–April 2003): 46–51.

1. [Throughout the essay, the author uses the term "manga" to refer both to American comics and Japanese manga, but I have sometimes translated it as manga and sometimes as comics. I translate the term *koma* sometimes as frame and sometimes as panel. —Trans.]

2. [Because the context demanded it, I use three different translations of the verb *tōjosuru*—to take to the stage, to play a role, or to make an appearance. But it is important to note that this verb allows the author to evoke these different connotations at once. —Trans.]

3. Koike Kazuo, *Koike Kazuo no shijō Gekiga Sonjuku* (Koike Kazuo's story comic course books) (Tokyo: Sutajio Shippu, 1985), 7, 10, 23.

4. Natsume Fusanosuke, *Tezuka Osamu no bōken* (The adventures of Tezuka Osamu) (Tokyo: Shōgakukan, 1998), 40–41.

5. Tōkyō *Sazae-san* Gakkai, *Isono-ke no nazo: Sazae-san ni kakusareta 69 no odoroki* (Mysteries of the Isono family: *Sazae-san*'s 69 hidden surprises) (Tokyo: Asuka Shinsha, 1992).

Manga Translation and Interculture

Because comics and manga combine images and texts, their translation encounters a range of problems. Translators confront combinations of pictorial and linguistic elements that work together to tell the story, such as reading direction, page layout, speech balloon shape, and onomatopoeia. Images both complement and accommodate the source language on every level. The interaction and interdependence of image and text create difficulties for translators that differ greatly from purely linguistic translation, such as the translation of a novel, and yet translating manga is also very different from translating audiovisual media.

Japanese anime and manga were introduced outside of Japan through grassroots fan trading and, in many countries, were initially linked with the subculture of science fiction. They have since entered the consciousness of mainstream culture and have become firmly established commercial products; no longer limited to specialist bookstores, they are now stocked in high volume by general bookstores and libraries. And yet, the social aspects established during the initial period of reception remain strong.

Fan groups that translate anime and manga have had a strong influence on the evolution of commercial translation strategies for the medium,[1]

and anime clubs and conventions often develop symbiotic ties with industry retailers.[2] As inferred by the terms "group" and "club," manga and anime consumption is often viewed as a social activity. "Scanlations" (fan-made translations of manga) and "fansubs" (fan-made subtitled anime), which are produced for and distributed among fans, also often entail group effort. This direct involvement by fans in the introduction of the source material into the target culture allows them to be not only consumers but also distributors and producers. Furthermore, commercially translated manga tend to be consumed as overtly foreignized texts, with their readers well aware that they are reading translations,[3] and this encourages the fanbase to appropriate the texts as more than foreign import products, establishing them as cultural possessions in the minds of the fanbase at large.

One recent example of such appropriation, which is becoming increasingly common, is the creation of original non-Japanese "manga," that is, manga produced in languages other than Japanese around the world. Such manga are created by artists outside of Japan and inspired mostly by the corpus of translated manga, to which the artists have easier access to than the original Japanese texts. These new manga are sometimes called Original English Language (OEL) manga, or Amerimanga or Euromanga for manga produced specifically in those regions. As is evidenced in these terms, the language or region of origin are the two main defining characteristics that separate the new (nontranslated) manga from translated Japanese manga. In this essay, however, I will refer to them collectively as Original Non-Japanese (ONJ) manga,[4] in order to encompass those texts produced in languages other than English, even though my discussion will largely address issues regarding Japanese-to-English translation and the works inspired by them, with some additional reference to texts produced in Germany.

ONJ manga texts have been received with mixed reviews worldwide. They are sometimes seen as shallow copies of foreign cultural objects. It has been suggested that they "imitate"[5] or "mimic"[6] Japanese manga, and that they are "pseudomanga."[7] However, Anthony Pym's theory of interculture suggests an alternative view.[8] Pym argues the existence of spaces where two or more cultures overlap and can then form an identity of their own. He theorizes that translations both create and strengthen such overlaps, which allow for the creation of new texts to develop from within the interculture. His approach makes it possible to consider ONJ manga as evidence of an established intersection between cultures and that, as such, they may be defined as intercultural texts.

The marketing of translated manga as foreign texts presents them as

part of a cultural package, which also conveys neighboring cultural elements to the source culture. A manga set in a Japanese school, for example, will include references to the Japanese education system, fashion, food, and pop culture, in its cultural package. Polysystem theory, as developed by Itamar Even-Zohar outlines a theoretical framework for this situation.[9]

Polysystem theory views culture as a network of interrelated systems and subsystems, which are constantly in a state of change within and in relation to one another (Figure 1). Manga can be seen to exist as a subsystem within the Japanese sequential art and image-text polysystem, which is in flux with the systems of anime, live-action television and movies, written literary prose, character goods, and so forth. All these creative acts influence and affect each other, providing a cultural background for manga to draw upon as materials for further expression. They also form a cultural standpoint for manga within Japan and a concrete base from which to extend internationally.

The interrelated aspect of the polysystem prevents translation and intercultural communication from occurring on the level of individual elements. Manga does not enter foreign cultures alone, as it has a cultural context that is part and parcel of its makeup, and the other subsystems it is in flux with are also transmitted, if only partially, in the form of cultural references. Thus the overlapping space of the two or more cultures in Pym's model is not only inhabited by the translations and translators but also by related and contextual elements from the represented parent cultures. Furthermore, as the established space begins to form an identity of its own, these additional elements also begin to evolve within the interculture. Cosplay is an illustrative example of this.

While not unique to anime and manga fandoms, costumed role-playing is a prevalent element of manga culture both in Japan and elsewhere. In Japan, cosplay performances are generally limited to emulating the character's signature pose or reciting their motto. Western cosplayers, however, also perform skits that do not necessarily repeat the anime or manga literally, which allows space for creativity. Western cosplayers are also more likely to wear their costumes to and from the event, whereas in Japan cosplay is discouraged outside of the venue grounds.[10]

FIGURE 1. A simplified diagram of overlapping polysystems. Each circle represents a system and/or subsystem. When cultures interact, the spaces between them come to house new intercultures that are both created and fostered by translated texts, allowing for the creation of new texts that emerge as a product of the interculture.

Although external societal factors such as publicly acceptable behavior are largely responsible for establishing where cosplay is worn, the skit performances are an instance where something new is evolving from the combination of different cultures in a shared environment. It is an example of the continuing intercultural evolution due to the overlap of cultures through the translation of manga and anime.

TRANSLATION ISSUES THAT INFLUENCE ONJ MANGA

While the manga polysystem is comparable with that of comics and graphic novels, they are still very different in format and style, which can make for difficulties in translation. This in turn gives unique qualities to the translated texts caused by the strategies used in order to make them accessible to the target culture. Naturally, it is the artistic style, character stereotypes, and common motifs of Japanese manga that have influenced the appearance of ONJ manga the most—from the limpid eyes of shōjo manga to stylistic motifs such as the crosshatch anger symbol and large sweat drop—it is not only the aesthetics of manga in its base form but also the norms of the translated texts that influence ONJ manga.

Cultural content and language issues are common to all text types, but the image-text structural differences are special aspects to be taken into account when translating manga. The greatest of these is the difference in reading direction, followed most strikingly by the high frequency of onomatopoeia and mimesis in manga, as many other languages lack the volume of equivalent vocabulary. Publishing format also plays a significant role in the way that manga is consumed by its audience and is another difference between Japanese manga and their translations that influences ONJ manga.

PUBLISHING FORMAT

Typically, manga in Japan are first serialized in specialist magazines, produced weekly or monthly and generally about as thick as an average telephone directory. Then, popular series are collected and reprinted into *tankōbon,* their own dedicated book series of about two hundred pages per volume. The titles chosen for translation and export are the ones that have already made it to the *tankōbon* stage, so although some companies have launched manga magazines in Western countries,[11] the fact that large portions of these series

have already been published in Japanese has
led readers to prefer buying translations that
are released directly in *tankōbon* format, al-
lowing them to read more of the story in each
installment.

AS MANY ONJ MANGA ARE
PUBLISHED BY MANGA
TRANSLATION COMPANIES,
THEIR PUBLISHING FORMAT
FOLLOWS THE SAME
MARKETING NORMS AS
TRANSLATED MANGA.

Originally the trim size of the books varied
considerably, but a standard size has emerged,
largely due to a trend initiated by Tokyopop's
adoption of the standard proportions of DVD cases, so that anime and
manga could be shelved together.[12] Many other companies have now also
adopted this size, making the books easier to market to regular commercial
bookstores because they are easier to shelve en masse.

As many ONJ manga are published by manga translation companies,
their publishing format follows the same marketing norms as translated
manga. Accordingly they are commonly commercially produced as black-and-
white story volumes, which are often bound in the same standard dimensions
as translated manga, slightly larger than that of the Japanese publishing
standards.

In Figure 2 you can see the Japanese *tankōbon* for *Deathnote, Love Hina,*
and *Basara* on the left, next to their English translated editions. The Jap-
anese *tankōbon* are on average smaller than the English versions. The OEL
manga *Star Trek, Hollow Fields,* and *MegaTokyo* are roughly the same size as
the translated manga. To the right, for size comparison is a DVD case for
Nausicaä of the Valley of the Wind (2003, *Kaze no tani no naushikaa*).[13]

Previews of translated and ONJ manga are sometimes made available on
the Internet by translation companies, and some independent artists release
their manga in a format similar to Western webcomics. In such cases, either
the physical book acts as a collected volume of the webmanga or the web-
manga archives an earlier version of the same or a related storyline. In this
way, the Internet serves many of the same functions that manga magazines
do in Japan, as a proving ground where new artists can debut their artwork
and gain experience. Although weblink lists and circles are poor substitutes
for the collective strength of being received by readers in one chunky publica-
tion, the Internet has always been a strong forum for the manga interculture
and its use in place of printed manga magazines due to their relative scarcity
outside of Japan is quite fitting.

Many ongoing ONJ webmanga, which are generally fan produced, are col-
lected into printed books when they reach sufficient popularity and length.
They are often published and distributed using print-on-demand services

FIGURE 2. Although there is variation between series, and particularly between publishing companies, a standard size for translated manga has become firmly established. Here you can see the Japanese *tankōbon* for *Deathnote* (2004), *Love Hina* (1999), and *Basara* (1996) on the left, next to their English translated editions. The OEL manga *Star Trek* (2006), *Hollow Fields* (2007), and *Megatokyo* (2004) have the same dimensions as the translated manga publication format because they are produced for the same market. To the right, for size comparison is a DVD case (for *Kaze no tani no naushika*).

and marketed directly to their readers through their Web sites. While it is no doubt a harder road to success, this approach circumnavigates the difficulties in working with publishing companies and allows for the publication of works whose readership can only support smaller print runs. Rather than being printed in thin magazines like American comics, or large hardcover anthologies like French *bandes desineés*, these ONJ webmanga print editions also tend to follow the translated manga norms. *MegaTokyo*, one of the longest running and possibly most well known of the manga-inspired webcomics made by fans, is an example.

ONOMATOPOEIA AND MIMESIS

Onomatopoeia are words that imitate or represent sounds made by animate or inanimate objects. Manga also make great use of mimetic expressions that are similar in execution and use, but express a present state or condition rather than an occurring sound. They can represent a change or movement, or describe an ongoing situation, such as the sound of heavy rain. Mimesis can also represent something entirely soundless, in effect assigning it a

sound, such as *niko niko* for a smile,[14] or *shiin,* which is used to express a state of utter silence.[15] Japanese even has a subset of mimetic words for emotions and feelings,[16] as well as onomatopoeic and mimetic words that are unique to manga that, while understood in the manga context, do not register within the daily consciousness of even Japanese readers.[17] In manga and comics these words are more often than not physically part of the artwork, from both an aesthetic viewpoint and the fact that they are usually hand drawn, making it easy to see the interrelatedness of images and text, as they are literally both image and text.

Collectively, onomatopoeia and mimesis convey a lot of meaning, but the disparity in their volume between languages can lead to major problems in translation. The strategy used is inevitably decided by the publishing company and often comes down to the company philosophy as well at the target audience and underlying purpose of the individual translation.

Onomatopoeia and mimesis are replaced in cases where complete functionality of the text is favored over the aesthetics of the artwork, or they can be appended with subtitles or notes where the content is deemed semantically important but the translators and/or publishers wish to minimize changes to the original artwork. These two strategies are useful for making the translated text accessible to a wide audience, however, they become problematic where equivalent vocabulary does not exist in the target language.

ONJ manga artists have the easier option of using less onomatopoeia, but when they are used well, they offer such a rich resource as a communicative and artistic element, adding powerfully to the aesthetics of the artwork, that it is little wonder artists are inclined to include more onomatopoeia than their language natively supports. The most creative solution is when the translator or ONJ manga author coins new words that sound appropriate in the target language. Such coinages offer the advantage of being based on the phonetics of the target language but requires a great effort on the writer's part.

In translation, romanization of Japanese onomatopoeia is also common although not always effective, because the non-Japananese reader's interpretation of the sounds is based on the phonetics of their own language, so the sounds may not make sense to them. However, this translation method can establish Japanese onomatopoeia as new vocabulary in the target language and allows for its appropriation into ONJ manga as well, boosting the availability of onomatopoeia in languages that have fewer sound resources than Japanese. This becomes particularly interesting when the utterance in question would ordinarily hold a different meaning in the target language but is nevertheless understood within the manga context. In *Hollow Fields*

(2007–2009), a magical science school series written and drawn by Australian artist Madeline Rosca, the evil school mistress's laugh is expressed as "ohohoho,"[18] which is a common way to express a feminine haughty laugh in Japanese manga, even though in English it would ordinarily be associated with a jolly laugh such as that of Santa Claus.

Finally, the appropriation of words and phrases that are not mimetic is also widely used, particularly for the expression of silent mimesis, such as "smile" for *niko niko* and "silence" for *shiin*. This can even extend into the use of short phrases that act as descriptive labels rather than onomatopoeic vocabulary. For example, *docchari* is translated as "loads of stuff" in *Sayonara Zetsubo-Sensei* (2009).[19] The influence of such terms used in the translated texts has led to their appearance in ONJ manga as well. Descriptive words like "flinch", "grin", "glance," and "glare," among others, stand in for mimetic words in *Hollow Fields*.[20]

Inevitably, most translated and ONJ texts first use existing native onomatopoeia where available and a combination of created and appropriated onomatopoeia where no native equivalent exists. On the other hand, companies like Tokyopop and Carlsen, whose main marketing cry, mentioned within each volume they produce, is the publication of "authentic" Japanese manga, leave the onomatopoeia and mimesis untouched, citing their reproduction of these elements—along with the preservation of the right-to-left reading direction—as an example of their respect of the source material. Of course, in addition to preserving the original aesthetics, it also saves publishers a lot of money, time, and labor to leave them untranslated, especially considering that many onomatopoeic words are integrated into the artwork. The manga translation fanbase acknowledge and value reproduction of the source text aesthetics as a symbol of authenticity, but there is a great deal of information conveyed by onomatopoeia and mimesis which essentially gets lost through nontranslation.

The influence of untranslated onomatopoeia and mimesis can also result in Japanese scripts being inserted into ONJ manga. Although this is rare, it circumnavigates the problem of romanized Japanese not suiting the native language phonetics and can obviously create a very strong Japanese manga-style aesthetic. It may also give readers who understand some Japanese a deeper connection with the manga interculture's inner fanbase. But naturally, the problem with using Japanese scripts is the same as leaving them untouched in translated texts, in that most readers will not be able to understand or even pronounce them. It is an unusual decision to use a foreign language for an element of any text aimed at a primarily monolingual

readership, and it would be quite an undertaking for the artist if they were not fluent in Japanese, as mistakes could end up being unintentionally comical or inappropriate.

Using Japanese can, however, still allow the artist to employ existing foreign vocabulary for a need that cannot be met by the main text's language, albeit one targeted toward a select few bilingual readers. For example, the first story in volume 1 of the OEL manga anthology *Star Trek* (2006)[21] makes frequent use of the mimesis *go go go,* expressing dramatic suspense, a common element of the *Star Trek* television program and movies. So, while it is an extremely fitting choice of mimesis for the few readers who understand Japanese, for most it only communicates that some sort of sound or action is taking place without indicating what it actually is, and thus the Japanese text primarily functions as a visual aesthetic. Any semantic information conveyed to the readers who do not know Japanese is picked up from the typography and the way in which the onomatopoeia relate spatially to other elements within the artwork. As the feeling of suspense is not tied to a location, action, or object, the aesthetics alone is much less communicative for *go go go* than, say, the onomatopoeia used for the transporters, fistfights, or phaser blasts.

READING DIRECTION

In Kure Tomofusa's analysis of the differences between Japanese manga and European comics, he draws attention to the fact that, of the many problems in translating comics and manga for foreign markets, the difference in reading direction is one of the largest.[22]

When manga was first introduced to the West, the unfamiliar right-to-left reading direction was usually dealt with by mirror-imaging each page or, less commonly, by laboriously rearranging the panel order or sometimes a combination of both, so that the entire text would read in the standard Western left-to-right order. Reversing the artwork through mirror-imaging is referred to as "flipping"[23] or sometimes "flopping."[24] While it was originally standard practice, and is still used for some translations, there has been such an increase in publications that retain the original right-to-left order that it has become a recognized characteristic of manga worldwide. Furthermore, knowledge of how to read the text identifies one as an insider of the fandom group.[25]

Flipping the artwork creates known problems such as characters becoming left handed and any background text or onomatopoeia that are left

untouched being transferred into mirror writing, making them comical at best when the text is understood by readers. However, as unflipped manga can confuse the uninitiated, considerable effort is put into educating the readers to make the texts accessible to newcomers.

Unflipped manga typically have a warning sign on the back cover or last page, which uninitiated readers will mistakenly assume to be the starting point, along the lines of "Warning! This is the back of the book." Many include a written explanation and diagram illustrating the panel and speech balloon order to follow and some even include small reading direction arrows in unobtrusive areas at the top or bottom of occasional pages throughout the text. All this not only saves new readers from confusion but also asserts the special status of the book as "authentic" foreign media.

The recognized value of the right-to-left reading order as characteristic of manga has influenced its use in ONJ manga as well. Early incarnations of *Hollow Fields* were drawn in the left-to-right reading direction, but once it was picked up for publication by Seven Seas, Rosca redrew and continued the story in the Japanese page and panel order. She has publicly confirmed that this was a publishing company decision,[26] and the *Hollow Fields* volumes carry a similar warning page to those found in translated texts, which state "this book reads from right to left, Japanese style" and specifically label the books as "manga."

There is no practical reason for creating English-language manga in the Japanese reading direction. From a textual literacy point of view, the page and panel layout direction opposing the target text direction has always been considered a handicap that has created the need for flipping or reader education. However, right-to-left ONJ manga can be viewed artistically as a direct homage to Japanese manga, which establishes them firmly within the same subculture and marketing world as translated manga. The "Japanese style" directionality further confirms ONJ manga as a direct addition to the corpus of translated texts even though they are not translations. It is for reasons like this that Heike Jüngst and others refer to such texts as "pseudomanga," as they appear to be pseudotranslations.

Although it reads from left-to-right, *MegaTokyo* illustrates another negotiation between page layout difference of manga and Western comics, unique to the strip format: vertical versus horizontal. Over time, *MegaTokyo* has evolved considerably in artwork composition and panel layout, but it started off in a square two–by-two panel format that was originally adopted as a compromise between the two creators. Gallagher wanted a Japanese style vertical *yonkoma* (four panel) manga strip and Caston wanted a horizontal

Western-style comic strip, so they met halfway and used two stacked horizontal rows, forming a square grid.[27] Although the layout later changed from strip format to more dynamic page layouts, *MegaTokyo* is an example of a series that began as an intersection of elements from different cultural backgrounds before evolving its own space and identity.

In addition to page layout reading direction there are also differences in text orientation. Japanese traditionally reads top to bottom and is thus in columns rather than rows of text. Although Western influence led to adaptation so that Japanese is now also commonly read horizontally, the chosen format is often defined by the norms of the medium, and manga dialogue is almost always vertical. Thus, in order to accommodate the natural shape of the source text, manga speech balloons are typically tall and thin, whereas Western comics speech balloons are usually wide and short for the same reason. The overall panel layout and artwork is also designed with this in mind, further illustrating the interdependency of image and text.

Problems occur during translation when the target language has to be combined with the source images. The text must sometimes be reduced or the speech balloon widened. Reduction can be achieved by omitting content, choosing shorter words, or hyphenating lengthy words, although the latter can read awkwardly if overused.

The change between vertical and horizontal text can also create extra white space where there was none, especially at the top and bottom of the speech balloons, which affects the aesthetics of the artwork and can make it appear as if something was left out. Therefore, sometimes the speech balloons are completely redrawn to be shorter.

Vertical aesthetics have become a stylistic motif of manga, evidenced by the tendency of some ONJ manga to favor vertical over horizontal length, despite the natural shape requirement of the language they work in. *Yonen Buzz* (2006), an original German manga by Christina Plaka is a particularly interesting example, because it not only features vertical speech balloons but also thin vertical narration panels to the extent that both occasionally end up having the same extra white space that can be inadvertently created in translated texts.[28]

There are two ways of looking at ONJ manga artists' adherence to the aesthetics of the existing manga corpus. If ONJ manga were to emulate Japanese manga aesthetics to the extreme that the language was no longer functionally accommodated, for example, if the words did not read legibly because they could not fit properly, then the images and text would no longer be interdependent, as pictorial elements would have precedence over the linguistic.

As mentioned earlier, translated texts are often altered in small ways as a matter of regular translation practice, to accommodate the target language and therefore preserve the textual functionality. Thus, to be functional texts, ONJ manga that are inspired by Japanese manga's vertical aesthetic norms actually need to be closer to the translated corpus than the original Japanese corpus.

In cases where both the written text and visual grammar are adapted, the formation of a blended structure that can result in a slightly new aesthetic may occur. Thus, in the end it is a matter of degree. In truth, nonfunctional texts would not sell well, so most published ONJ manga may be safely assumed to be texts that employ manga aesthetics to fulfill their storytelling purposes within the requirements defined by their language. ONJ manga artists do not have to choose shorter words or sentences, because they define the speech balloon size to begin with, but they may use more break lines than a Western comic author, because a vertical column of text is likely to suit their panel structure better.

> TO BE FUNCTIONAL TEXTS, ONJ MANGA THAT ARE INSPIRED BY JAPANESE MANGA'S VERTICAL AESTHETIC NORMS ACTUALLY NEED TO BE CLOSER TO THE TRANSLATED CORPUS THAN THE ORIGINAL JAPANESE CORPUS.

There is no doubt that the translation and spread of manga abroad has influenced the creation of ONJ manga, and clearly the marketing choice to label them as manga rather than comics is in order to appeal to the readership already interested in Japanese manga translations. This also allows them to be sold in that same category in bookstores. Although ONJ manga are not translations, they incorporate linguistic and cultural elements drawn from the corpus of translated texts. If intercultures are created when the translation of texts form an overlap between two or more cultures, and additional translations strengthen the intercultural space, then the emergence of these new, domestically produced texts that are both inspired by and further add to the corpus of translated texts may be seen as an expression of the established status of that interculture.

INTERCULTURE AND THE MANGA POLYSYSTEM

Jüngst closely examines German-produced manga influenced by translations, describing them as "simulacra," or superficial facsimiles of the art form that inspired them.[29] It is true that, while technically impressive examples of

ONJ manga abound, many look for all intents and purposes like a translated text. Although some titles do combine story elements from the surrounding culture they are produced in, such as Tokyopop's *Star Trek* and *X-Men* manga series, which essentially aim to use the manga aesthetic style to reinterpret American pop-cultural icons. Yet, when viewed as products of foreign inspiration, it is understandable that ONJ manga can seem like a form of imitation that lacks grounded substance. In a sense they appear culturally orphaned, because the connection that the artists have with the medium is not immediately apparent. In the end, it comes down to an argument of artistic style ownership and cultural belonging.

Pym's notion of intercultures offers a perspective through which translation can act as a catalyst for cultural overlap, and the intersecting space can then evolve to form an identity of its own, creating a new culture (an interculture). Translations in turn become physical manifestations of the new interculture. Indeed, they both create and inhabit intercultural spaces, which then grow in size and strength by adding to their corpus of texts, human population, and cultural experiences. This reminds us that intercultures, like any other form of culture, are living phenomena populated by real people. Part of this growth is the creation of new texts that are inspired by the interculture to which they belong, rather than being derivations of the initial parent culture elements, yet they add directly to the existing corpus of translated texts.

In Japanese manga translation there has been an increasing preference for the use of foreignization strategies, which preserve elements of the source culture, over domestication, or the dilution of the source culture by adding concepts from the target culture.[30] This is a preference that is shared for various reasons by both publishers and readers, particularly those who are familiar with manga translation and not only acutely aware that they are reading translated texts but expect and enjoy the foreignness to the point that they can catch out inconsistencies in the translation strategies that are used.[31]

OVERLAPPING CULTURES WITHIN THE WORLD OF MANGA

The concepts understood through the polysystem and interculture theories allow us to examine how any translated text is far more that merely a transplanted object. Translated manga do more than just add to the environment they have been introduced to, they blend with it through overlap

and interaction, while they express and are accompanied by related cultural information from their original source culture.

In addition to the translations themselves, the overlapping space that is created between Japanese culture and the foreign cultures that consume manga by the act of translation can be observed through the communities, events, and cultural spaces of scanlation groups, translation workshops, anime clubs, and conventions. The interaction that takes place in this overlapping space is physically manifested through the objects they produce. The fanbase adds directly to the translated corpus through scanlations and fansubs, as well as contributing to the surrounding cultural corpus by creating or participating in fan Web pages, art, and cosplay, and so on.

Through the activities of translation groups, cosplayers, anime clubs and the like, we can see that social interaction is intrinsic to manga and anime subculture. It helps establish the intercultural space and fosters further cultural developments. This "between" space within which they interact provides not only the venue for a readership to develop and encourages greater interest in the source material, facilitating the translation of more texts, but also allows the creation of new material inspired by the translated corpus and the surrounding interculture that has arisen. ONJ manga are one of the strongest examples of this because they are newly created texts that have emerged directly from the interculture and are an addition to the non-Japanese manga corpus, which created it in the first place.

The multiple fluctuating systems of polysystem theory allow us to consider translated manga as a system of its own,[32] which will always be connected to Japan as the country and culture in which it fully developed, but as a system that can also have an independent momentum within different cultural contexts. Viewing translated texts as a system in their own right creates the opportunity to recognize ONJ manga as belonging to the same corpus as translated Japanese manga without being viewed as mere facsimiles or as lacking a specific cultural background. Finally, ONJ manga are in themselves evidence that the manga interculture has enough stability to produce intercultural texts, meaning that the overlapping space has established an identity of its own.

..

Notes

1. James Rampant, "The Manga Polysystem: What Fans Want, Fans Get—A Look at Translation Strategies of Foreignization Adopted by Manga Translation Publishers," in *Manga: An Anthology of Global and Cultural Perspectives,* ed. Toni Johnson-Woods (London: Continuum International Publishing, 2010), 230.

2. Craig Norris and Jason Bainbridge, "Selling Otaku? Mapping the Relationship between Industry and Fandom in the Australian Cosplay Scene," in *Intersections: Gender and Sexuality in Asia and the Pacific* 20 (April 2009), ed. Mark McLelland, http://intersections.anu.edu.au/issue20/norris_bainbridge.htm (accessed October 2, 2009).

3. Heike Jüngst, "Translating Manga," in *Comics in Translation,* ed. Federico Zanettin (Manchester, UK: St. Jerome, 2008), 60.

4. Other terms such as "hybrid" and "global" manga can be used to encompass these texts, but they can also describe international art projects and collaborations such as the Nouvelle Manga movement, which blends international aesthetic styles and artistic norms to a degree that ONJ manga typically do not. In using the term ONJ manga, I wish to highlight texts in which the main defining characteristic that separates them from Japanese manga is their original language of production.

5. Robert S. Petersen, "The Acoustics of Manga," in *A Comic Studies Reader,* eds. Jeet Heer and Kent Worcester (Jackson: University Press of Mississippi, 2009), 170.

6. Robin Brenner, *Understanding Manga and Anime* (Westport, CT: Libraries Unlimited 2007), 19.

7. Heike Jüngst, "Japanese Comics in Germany," *Perspectives: Studies in Translatology* 12, no. 2 (2004): 100.

8. Anthony Pym, *Method in Translation History* (Manchester, UK: St. Jerome Publishing, 1998), 177–92.

9. Itamar Even-Zohar, "The Position of Translated Literature within the Literary Polysystem," in *The Translation Studies Reader,* ed. Lawrence Venuti, 199–204 (London: Routledge, 2000).

10. Theresa Winge, "Costuming the Imagination: Origins of Anime and Manga Cosplay," *Mechademia* 1 (2006): 73

11. Such magazines have been produced by Japanese publishing companies' overseas subsidiaries as well as non-Japanese manga publishing companies that produce translated and/or ONJ manga. Notable examples include the English magazines *Shonen Jump* (San Francisco, Calif.: Viz, 2003–) and *Shojo Beat* (San Francisco, Calif.: Viz, 2005–2010), the German magazines *Banzai!* (Hamburg: Carlsen 2001–2005) and *Daisuki* (Hamburg: Carlsen 2003–), and the educational bilingual Japanese and English periodical *Mangajin* (Atlanta, Ga.: Mangajin, 1990–1998).

12. Paul Gravett, *Manga: 60 Years of Japanese Comics* (London: Collins Design, 2004), 156.

13. Ōba Tsugumi and Obata Takeshi, *Deathnote,* vol. 1. (Tokyo: Shūeisha, 2004); translated by Pookie Rolf as *Deathnote* (San Francisco: Viz, 2005); Akamatsu Ken, *Love Hina,* vol.1. (Tokyo: Kōdansha, 1999); translated by Noriko Kimoto as *Love Hina* (Singapore: Chuang Yi Publishing, 1999); Tamura Yumi, *Basara,* vol. 1. (Tokyo: Shogakukan, 1996); translated by Lillian Olsen as *Basara* (San Francisco: Viz, 2003); Luis Reyes, ed., *Star Trek The Manga: Shinsei shinsei* (Los Angeles: Tokyopop, 2006); Madeline Rosca, *Hollow Fields,* 3 vols. (Canada: Seven Seas Entertainment, 2007–2009); Fred Gallagher and Rodney Caston, *Megatokyo* vol. 1. (Milwaukee, Ore.: Dark Horse Comics, 2004); *Kaze no tani no Naushikaa (Nausicaä of the Valley of the Wind),* dir. Miyazaki Hayao, DVD (2003).

14. Ono Hideichi, *Nichiei gion gitaigo katsuyō jiten* (A practical guide to Japanese–English onomatopoeia and mimesis) (Tokyo: Hokuseido, 1984), 128, 234.

15. Natsume Fusanosuke, *Manga wa naze omoshiroi no ka: Sono hyōgen to bunpō* (Why are manga fascinating? Their visual idioms and grammar) (Tokyo: NHK Library, 1997), 117.

16. Ono, *Nichiei gion gitaigo*, v.

17. Komatsu Masafumi and Yoshimura Kazuma, "Manga ni miru chōkakujōhō no shikakuteki" (Visual recording of auditory information in manga), *Kyoto Seika Daigaku kiyō* 26 (2004): 215–38.

18. Madeline Rosca, *Hollow Fields*, vol. 2. (Canada: Seven Seas Entertainment, 2007), 13.

19. Kumeta Kōji, *Sayonara, Zetsubou-Sensei: The Power of Negative Thinking*, vol. 1. (New York: Del Ray, 2009), 124.

20. Rosca, *Hollow Fields*, 2:45, 72, 109, 109.

21. Chris Dows and Makoto Nakatsuka, "Side Effect," in *Star Trek The Manga: Shinsei shinsei*, ed. Luis Reyes (Los Angeles: Tokyopop, 2006), 6–46.

22. Kure Tomofusa, "Nihon manga to Yōroppa manga" (Japanese manga and European comics), in *Manga kenkyū* (Manga studies), vol. 5 (Kyoto: Japan Society for Studies in Cartoon and Comics, 2004), 100–106.

23. Brenner, *Understanding Manga and Anime*, 74; Jüngst, "Translating Manga," 56; Rampant, "The Manga Polysystem," 225.

24. Gravett, *Manga: 60 Years of Japanese Comics*, 152.

25. Jüngst, "Translating Manga," 59.

26. Katherine Pickhaver, "AJS Twilight Briefing—Visiting Manga Artist, Madeline Rosca," 2008, Monash Manga Library Web site, Monash University, http://yoyo.its .monash.edu.au/groups/mangalib/eventreports/2008madeleinerosca.html (accessed October 5, 2009).

27. Fred Gallagher and Rodney Caston, "Naze nani Megatokyo special!" *MegaTokyo* Web comic 109 (2001), http://megatokyo.com/strips/0109.gif (accessed October 10, 2009).

28. Christina Plaka, *Yonen Buzz*, vol. 1. (Hamburg: Tokyopop, 2006).

29. Jüngst, "Manga in Germany—From Translation to Simulacrum," *Perspectives: Studies in Translatology* 14, no. 4 (2006): 248–59.

30. Rampant, "The Manga Polysystem," 221–31.

31. Jüngst, "Translating Manga," 60.

32. Rampant, "The Manga Polysystem," 229.

THOMAS LAMARRE

Speciesism, Part III: Neoteny and the Politics of Life

In part one of this series, drawing on Sergei Eisenstein and Ōtsuka Eiji, I called attention to the "plasmaticity" of animation, which becomes pronounced in animated characters. Implicit in my emphasis on plasmaticity was a move away from representation theory and the politics of representation.[1] If we look at wartime animation only in terms of what it represents, we quickly reach an impasse. We might say, for instance, that pigs in *Norakuro* represent the Chinese, or the jungle critters in *Momotarō: Umi no shinpei* (1945, Momotaro's divine navy) represent inhabitants of the islands of (what the Japanese at the time referred to as) the Southern Seas. Yet even the context of *Norakuro* and *Momotarō*, where the references appear more stable than in Tezuka's *Chōjin taikei* (1971–75, Birdman anthology) or *Janguru taitei* (1951–54, Jungle emperor), the power of these animations does not come primarily from representation. The materiality of the medium or media is integral to the actual experience and impact of speciesism, that is, of the transformation of "peoples" into nonhuman animal species.

Among the examples of speciesism explored thus far, it is clear that different media present a distinctive set of material orientations. There is, of course, overlap between different media in terms of their material

orientations, which allows for translation across media, not only at the level of narrative devices or generic conventions. Nonetheless, if we are to grasp something of the specificity of manga and animation, materially and experientially, we need to consider some basic differences.

Numa Shōzō's *Kachikujin Yapū* (The domesticated people Yapoo; also translated as "Yapoo, the Human Cattle" on the book cover) novels foreground textual techniques and discursive strategies of instrumentalization: the encyclopedic and clinical presentation of cruel, painful techniques for reengineering Yapū bodies for various uses frequently overwhelms the events that compose the story. Pierre Boulle's novel *La planète des singes* (1963, *Planet of the Apes*) uses a venerable literary device: two space travelers find a message in a bottle in which a human recounts his journey to a planet on which monkeys (chimpanzees, gorillas, and orangutans), not humans, are the intelligent species; as it turns out, however, the two space travelers reading the story are chimpanzees and find the story shocking and incredible. In other words, the novel plays with the absence of images to encourage us to assume that the readers are human, which device is designed to shock our assumptions about the primacy and universality of the human species. Speciesism in film will draw on other kinds of material orientation. In the *Planet of the Apes* films and *Star Trek* series, for instance, makeup plays a crucial role, and sometimes animatronics or models are used for special effects. This is often the case with speciesism in live-action cinema, with digital effects and digital animation in recent years gradually supplanting and recoding earlier "species effects." Manga and manga films present yet another set of material orientations.

THE LIFE OF CHARACTERS

In the formation of a specific set of manga and animation orientations, the 1920s and 1930s are particularly important, and those orientations continue to affect animation and manga today. In Japan, as in other parts of the world, the emergence of mass culture in the 1920s brought with it a new sense of distinct markets and audiences. This era saw, for instance, the mass production of a set of cultural materials for women (women's journals and other female-directed commodities),[2] as well as the mass production of a children's culture, with new journals and books intended for children, which would increasingly include manga.[3] This process was not merely a matter of discovering and developing new markets or niche audiences but of actively isolating and shaping them, economically, legally, and politically. As early as the Film

Laws of 1917, for instance, the Japanese government displayed a concern for segregating audiences by gender (mandating separate seating for men and women), and, as film become associated in the popular imagination with juvenile delinquency, particularly in the course of the 1920s, children were delineated with greater force as an audience, a market, a population.

At the same time, as American mass-produced popular culture began its global surge, American comics, animations, and films had a profound impact on the formation of the new world of manga and manga film in Japan. Introduced in the 1920s and gathering steam in the 1930s, a series of American cartoon characters—Mickey Mouse, Betty Boop, Felix the Cat, Popeye, and others—captured the attention of Japanese audiences and artists. Particularly important were the new styles of drawing characters (frequently animal characters) that put emphasis on the fluidity of the line, typically in conjunction with characters composed largely of simple geometric shapes, which made for ample, easily deformable characters. Referring us to Luthi's work on folktales, Ōtsuka Eiji sees in such developments the emergence of "deathless" bodies, bodies that undergo radical deformation without dying.[4] They simply spring back. Likewise Sergei Eisenstein called attention to the "plasmaticness" of Disney's animated characters.[5] Years later, Disney animators Ollie Johnson and Frank Thomas outlined the various techniques that emerged in the 1930s and gradually became associated with Disney, among them the famous "squash and stretch" that has also played a central role in Pixar's vision of computer animation.[6]

How did the fluidity of line become embodied in cartoon characters, especially in animal characters in the newly emerging mass-produced popular culture for children, rather than swarm across the surface of the page or screen? There are a number of factors. The invention of folklore studies or ethnography in Japan played an important role. It is surely not a coincidence that Yanagita Kunio, the "father" of Japanese ethnography, published a major book on Momotaro (*Momotarō no tanjō* [1931, Birth of Momotaro]) at the same time that Momotaro cartoons were being produced. In Japan as elsewhere, animation and manga became closely associated with folklore. What is more, the general association of children with animals—children like animals, children are like animals—contributed to the establishment of a nexus of folktale-animal-child-cartoon. It was (and is) the fluidity of the animated line that grounds the folktale-animal-child-cartoon nexus. This is why when Ōtsuka and Eisenstein consider the fluidity of animation characters, they turn simultaneously to the realm of folklore and children.

There are also technical reasons for the embodiment of the animated line

in animal characters. First, as I previously suggested, the use of animal characters allowed greater latitude for violent transformation. Second, the human eye is apparently less finicky about the accuracy of movement with animal characters than human characters—surely, however, such expectations are as much learned as innate. Third, the technical setup for animation production encouraged animators to channel the force of the moving image into characters. With the introduction of the layers of celluloid and the animation stand, which gradually became standard practice in the 1930s, the camera was fixed (on a rostrum), and so, to impart a sense of motion, animators had the choice of moving the sheets, or animating the characters, or both. In the 1930s and 1940s, the emphasis fell on character animation, to the point that character animation appeared to be *the* art of animation, taking precedence over camera movement and editing (animation is largely preedited). While the art of painting backgrounds received attention, this was a matter of art and not of animation per se.

IT WAS (AND IS) THE FLUIDITY OF THE ANIMATED LINE THAT GROUNDS THE FOLKTALE-ANIMAL-CHILD-CARTOON NEXUS.

It was not until the 1950s, when animators explicitly developed procedures of limited animation, deemphasizing character animation and playing with iconic expression, that moving the celluloid sheets became an appealing option for imparting a sense of movement.[7] This is when Tezuka played an integral role in the formation of anime in Japan, with the television animation for *Tetsuwan Atomu* in the early 1960s, for which his team used techniques for dramatically limiting character animation and shifting the experience of movement into other registers of the moving image. Nonetheless, such techniques are still frequently disparaged today, and the bias toward character animation as the art of animation remains. Subsequently, I will return to the question of how developments in limited animation affected Tezuka's approach to nonhuman characters.

The combination of these three technical factors (potential for deformation, expectations for verisimilitude in motion, and fixity of the camera) led to an emphasis on the animation of animal characters in cartoons and manga films. Thus the force of the moving image, which comes of the mechanical succession of images that is the ground of animation, was channeled into animal characters, cute little nonhumans such as Mickey, Felix, Norakuro, Chubby, Oswald; Momotaro's dog, monkey, pheasant, and subsequently, rabbits; and into companion species in general, such as Dankichi's monkey or Maabō's animal friends—there always seems to be an animated pet for the human protagonists, who in contrast are often rendered with more hieratic lines.

The force of the moving image is thus directed into nonhuman, humanoid, or animaloid characters whose plasticity embodies that force, at once folding it into their bodies and releasing it. Needless to say, this is not a matter of representation. Plasticity does not represent the force of the mechanical succession of images. It affords an actual experience of it. The animal or animaloid characters summon and channel a technical force. As a consequence, a technical force is now experienced as an animal force, as vitality, as life itself.

Such an experience is not, as so many commentators would have it, an illusion of life. It is a real experience of a force wherein the technical and the vital are inseparable. We might call it techno-animism or techno-vitalism, provided we do not take the "ism" to imply that this is first and foremost an ideological construction or illusion. It is a new experience of life.

Tezuka captures this sentiment nicely in his English title for the manga *Firumu wa ikite iru* (1958): "film has a life."[8] Appropriately enough, *Firumu wa ikite iru* tells of an aspiring animator who strives to establish himself in a setting that recalls the heyday of Tōei animation studios, where Tezuka worked as an animator and writer. The manga highlights the life force of animal characters, beginning with the aspiring animator's attempts to design a horse that really moves, truly lives. Significantly, although the animator meets with many challenges, there is never any sense of an illusion of life, or of a monstrous reanimation. The challenge is to enter into the flow of life, into the experience of life, that is animated film.

Thus far I have placed manga alongside animation, not drawing a contrast between them as I have between cinema and animation. This may appear odd since, strictly speaking, manga is not an art of the moving image. Nonetheless, there are strong historical links between manga, cinema, and animation. The transformations in manga art that resulted in the emergence of manga as a popular image-based narrative art in the 1920s and 1930s in Japan were intimately tied to the emergence of cinema and animation as forms of entertainment distinctive from other sorts of spectacle. Although Tezuka is commonly credited with the introduction of cinematic techniques into manga, the process began earlier. With the advent of talkies, for instance, many *benshi* or film explicators lost employment and turned to *kamishibai* or "paper theater," which consisted of showing a series of images (frequently inspired by cinema and in cinematic sequences) while offering commentary, both comedic and narrative.[9] Immediately after the war, *kamishibai* enjoyed a surge of popularity as an entertainment for children, with artists bicycling from neighborhood to neighborhood, with picture stands mounted on their bikes to perform "paper theater" shows. Gradually, children's manga and then

television supplanted *kamishibai,* but *kamishibai* had a profound impact on both manga and television anime.

The conventions of cinema and cinematic techniques entered manga at a variety of levels, which allowed manga to be construed as a way of "doing film" on paper. This is not all there is to manga, of course. There are many ways of doing manga. Yet, as Tezuka's early manga versions of Disney's *Pinnocchio* and *Bambi* attest (as well as *Firumu wa ikite iru*), the dream of producing something like a film in manga proved a durable one, especially for Tezuka. Clearly, Tezuka was an innovator in this respect, and yet he was also consolidating conventions that had already began to blur the boundary between manga and manga film in the 1930s and 1940s. For instance, in a 1941 manga by Ōshiro Noboru, *Kisha no ryokō* (Travel by rail), a boy and his father traveling by train to western Japan meet a man who introduces himself as a manga artist.[10] The manga artist then proceeds to explain how manga films are made. In other words, the term *manga* itself, and the art of manga, called to mind both paper manga and manga film. Not surprisingly, then, in the pages of Ōshiro's paper manga, characters reminiscent of animated films make an appearance. In one full-color two-page spread in another Ōshiro manga, *Yukai na tekkōjo* (1941, Merry ironworks), animal characters projected on a screen come to life and invite the group to enter the film and visit the factory.[11] In addition, many of the popular manga films of the 1930s and 1940s were based on manga characters serialized in children's magazines, as with *Norakuro* and *Bōken Dankichi.* In sum, due to the general impact of cinema on various arts from the 1920s, in conjunction with the increasingly tight links between children's manga and animated films from the 1930s, manga conventions frequently overlap with, and sometimes become indiscernible from, those of a specific kind of moving image: animation. The dialogue or synergy between paper manga and film manga becomes part of this new experience of life, in which the force of the mechanical succession of images is channeled primarily into merry little animal characters.

In stressing the importance of this new experience of life, I do not mean to imply that it exists above or beyond ideologies or codes, somehow unaffected by them or easily outmaneuvering them. On the contrary, codes will swarm over and around this new life form, the animated animaloid. What are speciesism and its companion, multispeciesism, but codings of this "techno-vitalist" or "animetic" force that is summoned and channeled through animaloid bodies? In fact, I would venture to say that, as science fiction became a cultural dominant in the 1980s and 1990s (as Fredric Jameson in particular has argued), animation of various kinds has also proliferated.[12]

The new life force and the codes that direct its flows always arrive together. As such, animated life-forms do not afford a direct and immediate experience of this new techno-vitalist force. Yet they do present sites and moments where something promises (or threatens) to outstrip or elude coding, even if such moments of crisis encourage greater efforts to recode. If we ignore the materiality of animation (its material flows), we miss something crucial. We fail to see how animation media introduce life itself into politics, into the social. We fail to see how our personal visions of life and the life world are political and social. If we overlook the material flows of animation, we merely read them as representations of political ideas or events happening beyond the animation itself. We thus completely erase the actual experience, dynamics, and real experimentation of animation.

Take, for instance, the final sequence in Seo Mitsuyo's 1935 *Norakuro nitōhei* (Stray Black, private second class) in which Norakuro, the dog soldier, is cavorting and singing merrily atop the caged tiger while other dogs happily skip and dance as they all wheel the captive off to an unknown destination. Given the context, we are to some extent invited to read this animation at the level of representation, in terms of allegory: these dogs stand for Japanese soldiers, and the tiger their Korean foe, or more precisely, their captive. In which case, the temptation is to conclude that this is what the animation is *really* about: Japan's colonization and exploitation of Korea in the years leading up to the war, which culminated in the forcible conscription of Koreans into Japanese factories (as workers), into the army (as soldiers), and into Japan's network of military brothels (as prostitutes). In other words, everything that belongs to animation—the merrily prancing, singing, dancing animals—appears as nothing more than a friendly and misleading mask for the brutal truth of Japanese cultural and military aggression. Animation is sugarcoated empire. The task of the critic is then to scrape away the candy coating and to expose the truth about the violence of territorial expansion and the Japanese violation of national sovereignty.

Yet there is something else at stake in animation, which we must address if we are to understand the persistence of the candy coating, so to speak, in postwar Japan and its transnational popularity. The playful critters of wartime manga and manga films are not merely a mask of cute that can be neatly stripped away to expose the underlying reality of war. Even if we insist on reading wartime manga and manga films in terms of an underlying ideological truth, we would have to acknowledge that such ideology is never simple. In light of the contemporary scene of Japanese popular culture, with its abundance of little creatures begging for nurture and leaping into combat,

we must also think about how the candy coating or mask has outlived the realities of the Fifteen-Year Asia-Pacific War. It may not be possible to introduce a neat divide between cute little nonhumans and war. We might also have to ask whether the reality of postwar Japan has not consistently been war, despite Article 9 of the Japanese Constitution that forbids the nation to bear arms.

Two things happen when the translation of race war into species war entails a transformation of racial others into cute nonhumans. On the one hand, there is a sort of ideological operation or abstraction at work, a decoding and recoding of international relations into species relations. This procedure imparts a sense of *overcoming* racial, ethnic, and national divisions and conflicts. Entrenched divisions and segregations are at once evoked and radically shifted. Due in part to their address to children or family audiences, manga and manga films impart a sense of play, which promises a dramatic decoding of divisions and segregations. Rivalry among cute little animals not only makes military conflict look like play, it pitches it as cooperative and coproductive interaction. Simply put, this is not "survival of the fittest" or "nature red in tooth and claw." The result of decoding and recoding is a multispecies ideal. The multispecies ideal (or more precisely, multispecies coding) jives with Japanese wartime thinking about coprosperity, pan-Asianism, and "overcoming modernity."

> IF WE IGNORE THE MATERIALITY OF ANIMATION (ITS MATERIAL FLOWS), WE MISS SOMETHING CRUCIAL. WE FAIL TO SEE HOW ANIMATION MEDIA INTRODUCE LIFE ITSELF INTO POLITICS, INTO THE SOCIAL.

On the other hand, it is the plasticity of animation, wherein the force of the moving image is channeled in animal characters, that makes decoding happen materially. This decoding has two implications. First, the plasticity loosens the hold on reference. This implies a shift from allegory (representation) to fable (fabulation and myth): the cute little dogs, for instance, are not just Japanese soldiers but life-forms acting out forces of nature. This is why Sergei Eisenstein sees in animation not simply plasticness but plasmaticness, which I have rendered as plasmaticity. The plasticity of animated animals, their elastic deformations and transformations, conjure forth a wellspring of primordial forms and life-forces. Second, related to this plasmaticity, life itself is introduced into the social and political. Vitality becomes a political force, enters the social machine.

As a result, between plasmaticity and multispeciesism, in their constant interaction, in the process of the one decoding and the other recoding, there

emerges a theater of biopolitical operations.[13] Manga and manga films do not simply represent actual peoples in animal form in order to sugarcoat the exploitation of weak by the strong. They transform a field of social and political relations into biopolitical theater. Their cuteness or sugary quality is not a mask for an underlying reality. It brings forth an operative logic based on regulating populations, which are articulated in terms of their vitality rather than in terms of popular or natural sovereignty (which latter is at once presumed and bypassed by the very logic of species). Consequently, we cannot think of cute little manga species as a trick or a form of dupery that fools people (children) into believing what they might not otherwise believe. This is not a matter of propaganda, unless we acknowledge that all entertainment is effectively propaganda, and vice versa.

In sum, although Japanese wartime animations invite us to read them in terms of national allegory or allegorical representation in which animals stand for peoples, that register of expression is folded into a biopolitical theater of operations, stretched between animetic (or manga-filmic) plasticity and multispecies codes. In effect, at the same time, the geopolitical logic of national sovereignty is folded into a geopolitical logic of biopower, an operative logic of the coordination of populations on the basis of vitality and productivity.

Oddly, however, the analysis of biopolitics has been studiously eliminated from discussions of interwar and wartime Japan, especially in the study of popular culture, where the emphasis has always been on the mechanics of representation (propaganda). The emphasis on representation has encouraged a tendency to dwell on questions of cultural nationalism to the exclusion of questions about populations, regulations, and the materiality of media. The result is a reinforcement of the primacy of Japanese sovereignty, in which the exploitation, domination, and regulation of populations within the Japanese empire appears primarily as a question of victimization, evoking tidy distinctions between victim and victimizer. Yet the interpellation of populations within the Japanese empire did not (and could not) operate on the basis of clear-cut distinctions between colonizer and colonized or victimizer and victim. Empire does not operate through physical suppression and domination at every point. To address this dimension of imperial power and violence, we might, on the one hand, increase the range of possibilities for subject positions to include bystanders, witnesses, collaborators, and others. Yet, on the other hand, the challenge of manga and animations is that, alongside questions about the formation of different subjectivities, their apparently guileless little animals force us to reckon with questions about

biopolitics, about the governance of popula-
tions, and the introduction of life into politics.[14]

The biopolitical theater of operations has
two axes or procedures. There is the channeling
of the force of the moving image into animal
character animation, whereby techno-vitality or
plasmaticity introduces a new experience of life
and new life-forms into the sociopolitical field.
And there are the new modes of regulating pop-
ulations via an intricate combination of legal in-
junctions (film laws and audience segregations)
and industrial measures (the establishment of
audience populations such as children's culture and women's cultures). Thus,
with greater force throughout the 1930s and 1940s, alongside the decoding
and recoding implicit in the speciesism of manga and manga film, we see a
process of demassification and remassification in which the people (or peo-
ples) are gradually divided into subpopulations (children or adolescents and
adults; women and men; unmarried and married; inner and outer territories;
north and south empires) as well as mobilized into superpopulations (nation,
region, empire, Asia).

> MANGA AND MANGA FILMS DO NOT SIMPLY REPRESENT ACTUAL PEOPLES IN ANIMAL FORM IN ORDER TO SUGARCOAT THE EXPLOITATION OF WEAK BY THE STRONG. THEY TRANSFORM A FIELD OF SOCIAL AND POLITICAL RELATIONS INTO BIOPOLITICAL THEATER.

It is precisely this biopolitical theater of operations that Tezuka addresses
in his manga and anime, as the example of *Chōjin taikei* demonstrates. *Chōjin
taikei,* like wartime speciesism, invites reading as national allegory in the reg-
ister of political satire. In fact, it evokes the classic double bind of modern
Japan as neither the West or non-West, and maybe both. Its birds appear to
represent the American Occupiers or the West; the humans to represent the
non-West or the rest; while the Japanese fail as birds and as humans. Yet,
as in wartime manga and manga film, the plasmaticity inherent in animal
characters, in conjunction with the decoding entailed in speciesism, gradu-
ally frees species of their references, bringing into play and highlighting a
nonrepresentational field. Here Tezuka finds himself in a bind. On the one
hand, he wants to evoke the decoding power of speciesism and to liberate life
and life-forms from their political coding (which primarily takes the form of
social Darwinism or evolutionist racism). Yet, on the other hand, his proxim-
ity to wartime manga and manga films makes him keenly aware and wary
of the problems inherent in presenting a solution to the problem of social
Darwinism in the form of the multispecies ideal. Consequently, he dwells on
the cruelty and absurdity of coding, which affords a satire of social Darwin-
ism and evolutionist racism yet forecloses multispeciesism. The result is a

鳥たちが　人間のために歌った歌は
おそらく　これが最後だったかもしれない……
そしてそれはとりもなおさず人類への
挽歌だったのである

FIGURE 1. The bird people who have slain an old man in their campaign to eradicate humans, in compliance to the wishes of the little bird who was formerly the man's beloved pet, raise their voices in a final symphony to ease his pain. Again man is at once judged and solaced within the animal's theater of operations. *Chōjin taikei, Tezuka Osamu manga zenshū*, vol. 94 (Tokyo: Kōdansha, 1980). Courtesy of Tezuka Productions.

theater of cruelty, of species cruelty. Cute little animals make an appearance but only to be violently coopted or tragically crushed. Indeed, in one chapter (15), a secret society of bird predators hatches eggs in order to eat the cute little babies who emerge (see 2:94).

Nonetheless, even though Tezuka makes the forces of coding appear omnipotent and eternal, this is a strategy designed to free decoding (techno-vitality and plasticity) from recoding (social Darwinism and multispeciesism)—an attempt to liberate desires that escape the grid. These desires appear in almost mythic form in *Chōjin taikei* at three junctures. In a fairly early chapter (6), a cute little bird, formerly a domesticated pet of an elderly man, is forced to take part in the birds' elimination of humans, including the old man. Yet, as a testament to its compassion for the old man, the cute little pet convinces the assembled birds to sing to the man whom they have just fatally injured, and he dies in bliss at the center of the circle of singing bird people (94:76; Figure 1). In a later episode (chapter 17), centuries after the extinction of humankind, a bird girl dreams of human children who capture and cage her, and eventually, kill and eat her. As important in this episode as the cruelty of humans is the ability of the bird child to make contact across the centuries, imaginatively. There is also the episode of the tragic lovers of different bird species mentioned previously. In sum, although it is humanoid cruelty that triumphs in such episodes, they nonetheless evoke a moment of connection across species, which takes the form of mutual compassion for or identification with the other. It is above all the flexibility of children and youth, their fundamental openness, that allows a transspecies potential to flit across the implacable biopolitical theater of operations.

Two new procedures follow from Tezuka's transformation of the bio-political theater of operations. First, as we have already seen, while Tezuka tends to foreclose multispeciesism as code (and rejects codes of compassion or religion), he redirects the dynamics of multispecies cooperation into a transspecies potential embodied in a nonhuman character, which conjures forth strange new desires, such as the desire of the former pet to ease the pain of its master's death, or for birds of a different feather to nest together. In other words, instead of multispeciesism per se, Tezuka gives us a trans-species potential, which is above all embodied in nonhumans.

Second, the plasmaticity inherent in manga and animation animals is carefully directed into new channels, too. There are evocations of merry little critters whose buoyancy spurs them to leap and dance, and to spring back from whatever impacts them, as if invulnerable and deathless. Yet such plasmaticity is highly limited and qualified in Tezuka. This is due in part to technical procedures: because Tezuka works in manga and in limited animation, there are pronounced changes in the degree of motion imparted to characters. In fact, rather than channel the energies of the moving image primarily into character animation, Tezuka begins to spread those energies across the manga page (playing with the size and shape of frames, for instance) and across the celluloid surfaces and television screen—on which, as in manga, there is the gradual elimination of the framing effect of frames in favor of character figures that break free of them.

Despite his admiration of Disney animations and his explicit use of certain Disney procedures,[15] Tezuka does not follow the procedures of full animation in his manga or small screen anime. Nonetheless Tezuka's use of motion is not simply a matter of limiting or stilling motion; it is a matter of shifting how the force of mechanical succession of instants is channeled into the image. The plasmaticity associated with the fully animated nonhuman character tends to be shunted into bodily postures, gestures, and facial expressions. Character design takes on greater importance, in a general way. Tezuka tends to guide the energies of the moving image into faces, where features, especially eyes, become larger and more emotive as they bear the burden of expressing and constraining animating forces. In keeping with such tendencies, Tezuka's cute little nonhumans do not only merrily cavort and caper but also suffer and die, as the prior example of Mimio the Rabbit suggested.

In sum, in Tezuka's manga and anime, the tragic suffering and death of cute little nonhumans effects a transformation of the biopolitical theater of operations of wartime animation at two levels, that of codes (multispeciesism)

and that of flows (plasmaticity). On the one hand, with the death or suffering of nonhumans, Tezuka forecloses easy access to the codes of multispeciesism, while transforming and embodying them into the transspecies potential of his loveable yet doomed companion species. On the other hand, the suffering or "passional" quality of these loveable nonhumans follows from procedures for transforming and redirecting the plasmaticity of animal characters that were developed in the heyday of full animation in the 1930s and 1940s. Tezuka's works channel those energies into the cuteness of faces, and spread them across the surface of pages and screens, which tends to liberate the character from the frame. Put another way, Tezuka's works present a shift from plasmaticity to neoteny. In fact, it is neoteny, that is, the theory that the retention of juvenile characteristics can serve as a force of evolutionary transformation, that comes closest to explaining how "cute" is intimately linked to questions of race and evolution in Tezuka's works. Tezuka's subtle transformation of plasmaticity into neoteny at the level of nonhuman characters would have a profound impact on the dynamics of speciesism in subsequent manga and animation, precisely because his systemization of manga and anime expression helped to define the postwar.

NEOTENY

In a humorous article on Disney's characters, evolutionary biologist Stephen Gould shows how Mickey Mouse and Donald Duck have become younger and younger in appearance. Measuring the transformations in their physique and facial traits, Gould detects a gradual movement toward ever more juvenile features. He concludes, tongue in cheek, that this "growth in reverse" of Mickey Mouse and Donald Duck "reflects an unconscious discovery of this biological principle of neoteny on the part of Disney and his artists."[16]

Similarly, in his seminal work on Momotaro, *Momotarōzō no hen'yō* (Metamorphoses in the imaging of Momotaro), Namekawa Michio devotes an entire chapter (5) to the growth in reverse of the character Momotaro in the course of its increased dissemination across media, which trend he dubs *teinenreika keikō* or the "tendency of age diminishment."[17] Indeed, Momotaro begins his career as a stalwart young man battling demons in the Edo period, only to transform into an ever more youthful youth in the manga films of the 1920s and 1930s, and by the postwar, it is not uncommon to see Momotaro as a child or even a baby in manga and anime.

The signs of reverse growth, *teinenreika* or juvenilization in character

design that Gould finds in such Disney characters as Mickey Mouse and Donald Duck and that Namekawa sees in Momotaro entertainments, indicate a general fate of cartoon heroes drawn from folklore in the modern era. Reverse growth happens as characters move from "traditional" folktales into literature and film, and into children's literature, animation, television, and manga. There are a number of explanations for such trends. The gradual expansion of culture industries, and especially the expansion in markets of animation and manga for children, surely played an important role. Such trends led to a stricter association of folklore with children's entertainment, which encouraged younger and younger heroes in the company of younger and younger companion species—and ever cuter ones as well. In other words, the reverse growth trend is in part a matter of the establishment of younger audience populations, which became target markets or niches. These children and youth populations became more diversified and tightly focused with the introduction of marketing principles into the world of manga and anime in the 1970s, and with the emergence of powerful entertainment corporations in the 1980s.

Such trends have reached the point today where marketers count on the tendency of entertainments directed toward teens or young adults to shift toward children in the course of their sales: while the older kids may lose interest in certain characters and stories as they grow up, the younger kids are eager to adopt what appear to them as more mature or edgy fare. As such, rather than simple obsolescence of characters, there are effects of juvenilization within the market, and marketers sometimes retool or redirect characters and stories with younger audiences in mind. At the same time, as the otaku phenomenon indicates, there can also arise a sort of loyalty to the products of one's childhood years, and a refusal to let go of them. The combination of these two trends generates a situation in which, on the one hand, kid stuff, and especially cute little characters, appears to spread across different age populations; and on the other hand, the characters and stories in entertainments for kids, while decidedly cute or juvenile on the surface, often feel somehow adult in their use of violence, sexuality, tragedy, and complex emotions. It is frequently difficult to say whether we are seeing a juvenilization of adults or a precocious maturation of children.

Here, too, Tezuka is a pivotal figure. In Natsume Fusanosuke's opinion, Tezuka transformed manga for children not by writing to children but by writing the stories that he himself wanted to see written. What is more, Natsume writes, because Tezuka's sophisticated use of line, frame, and story allowed for a new degree of complexity in narrative and psychological

presentation in children's manga, artists began to line up to write them.[18] Children's manga suddenly allowed for both complexity and greater latitude in expression. Something of this transformation comes across in Fujimoto Hiroshi's remarks (discussed in part I) about the death of Mimio the Rabbit in Tezuka's *Chiteikoku kaijin* (1948, Mysterious underground men). In fact, Tezuka's manga for children were frequently criticized for being too violent for children, and such objections are today commonly directed at manga and anime as a whole, especially in the American market: so cute but too violent!

In sum, there is a general trend toward younger and cuter characters, and yet this is not a simple juvenilization or infantilization, in terms of its effects on established populations and across them and on the production of new niche populations.[19] In fact, looking at such trends primarily in terms of cute or cuteness may entirely miss the point, even if we acknowledge that cuteness evokes not only a sense of nurture toward the cute little creature but also a sense of control over and thus violence toward it. This is where neoteny is of interest, especially in the context of Tezuka Osamu and the gradual transformation of Japan's wartime speciesism into a general mode of "cute multicultural address" for export in manga, animation, and other entertainments and commodities.

Neoteny refers to the retention, by adults of a species, of traits previously seen only in juveniles. The adult retains juvenile physical characteristics well into maturity. In the evolutionary terms, the retention of juvenile traits permits a species to undergo significant physical changes that allow it to adapt to environmental changes. Those who give credence to neoteny cite the examples of flightless birds (whose proportions recall those of the chicks of flighted birds), the resemblance of domestic dogs to immature wolves, and the large head and sparse body hair of humans, which is reminiscent of baby primates. Gould, for instance, was at one time a proponent of the theory that humans might in some respects be considered neotenous chimpanzees. Thus his humorous interpretation of the evolution of Disney characters—that their growth in reverse constitutes an unconscious discovery of the biological principle of neoteny—carries a certain weight, for all its comedic tone.

In evolutionary biology, neoteny is still under debate, with some evidence for it and a good deal of clamor against it. What matters in this context is not so much the biological fact of neoteny as its conceptual terrain. Two factors strike me as particularly important. On the one hand, neoteny indicates a sort of excess in modes of cuteness. In his discussion of the neotenous tendencies of Disney characters, Gould turns to Konrad Lorenz's discussion of how humans use differences in form between babies and adults as important

behavioral cues: "When we see a living creature with babyish features, we feel an automatic surge of tenderness."[20] Naturally, as a biologist, Gould understands the controversy that surrounds Lorenz's argument that such behavioral responses constitute an innate biological predisposition. Gould doesn't embrace behaviorism. He adds that such behaviors may equally well be learned rather than innate, and in fact such a distinction is not crucial to his argument about neoteny. What matters is that such a response occurs.

Tezuka's depictions of his heroes is in keeping with the features of babyhood identified by Lorenz—"a relatively large head, predominance of the brain capsule, large and low-lying eyes, bulging cheek region, short and thick extremities, a springy elastic consistency, and clumsy movements."[21] In such tendencies, commentators aptly see Tezuka's debt to Disney, especially to prewar Disney. Yet, as Namekawa's account of Momotaro reminds us, such neoteny is not only a tendency of Disney but of an entire nexus of comics, cartoons, and characters that came to the fore from the 1920s and 1930s. Such neoteny became a matter of fact in manga and manga films by the early 1930s, in Japan as elsewhere in the world of cartoons. In the postwar era, Tezuka continued to push the limits of neoteny in characters, enlarging the eyes and head, expanding the brain capsule and making the cheeks bulge— to the point that he is often credited with inaugurating a Japanese cute that was even cuter than Disney and company.

In an insightful essay on the dynamics of cute culture in Japan, Sharon Kinsella offers a fine description of the cute character that follows directly from Lorenz: "The essential anatomy of a cute cartoon character consists in its being small, soft, infantile, mammalian, round, without bodily appendages (e.g. arms), with bodily orifices (e.g. mouths), non-sexual, mute, insecure, helpless or bewildered."[22] Yet there is more to neoteny than cuteness and juvenility.

On the other hand, neoteny presents a way of thinking evolution differently. This is surely part of its appeal for Gould. With his theory of punctuated equilibrium and of spandrels (with Richard Lewotin), Gould harnessed evidence for a general critique of "adaptationism," that is, of theories that assumed that biological traits were selected for specifically. Generally speaking, Gould insisted on contingency and even a degree of arbitrariness in natural selection, which loosened the sense of teleological determinism that frequently crops up in sociobiology. Like Gould and Lewotin's concept of the spandrel, the theory of neoteny disturbs the idea of a smoothly determined evolution in which traits are selected for specific utilitarian reasons. Baby or juvenile traits, precisely because they are immature, are usually construed

> TEZUKA CONTINUED TO PUSH THE LIMITS OF NEOTENY IN CHARACTERS, ENLARGING THE EYES AND HEAD, EXPANDING THE BRAIN CAPSULE AND MAKING THE CHEEKS BULGE—TO THE POINT THAT HE IS OFTEN CREDITED WITH INAUGURATING A JAPANESE CUTE THAT WAS EVEN CUTER THAN DISNEY AND COMPANY.

as less efficient and less adapted to the environment. Gould's turn of phrase, "growth in reverse," captures something of this overturning of deterministic progression or teleological maturation that haunts evolutionary theory.

In sum, the conceptual shift from cute to neoteny is an attempt to grasp cute as a process and potential rather than as a set of formal features—as a quality or intensity rather than a measurable set of attributes. Neoteny implies a cuteness that is not simply cute. It implies an evolutionary force or process that is nonlinear, nonteleological and immanent to the organism. As such, neoteny implies some manner of critique of social Darwinism and racism. What is more, neoteny entails a surplus or excess that crosses species. Lorenz's famous image of neotenous types, for instance, includes a human baby, a pup, a chick, and a baby rabbit. Likewise, a contemporary animal ethologist such as Franz de Waal sees "maternal excess" in the act of an animal of one species adopting the young of another species—his example is that of a dog adopting lion cubs.[23] Here, too, the response to neoteny also implies a transspecies potential. Yet my aim in evoking such examples is not to ground the analysis of manga and anime images in innate patterns of behavioral response. Rather what interests me is how cute little species bring into play immanent, nonlinear, nonteleological forces that promise to underdetermine teleological scenarios of maturation and socioeconomic progress (modernization), as well as hierarchal organization and social Darwinism.

Neoteny gives us a better grasp on how cute operates in Tezuka's worlds. The robot boy Atom, for instance, presents a literal take on neoteny: it is precisely because Atom cannot grow up that he comes to embody "progressive" childlike virtues that run counter to the hierarchical order to things. Likewise, in *Chōjin taikei,* young and cute exemplars of the species (both of birdkind and humankind) are bearers of a transspecies potential that runs counter to the practices of segregation and hierarchy associated with the social Darwinist universe of modernization. In effect, Tezuka's use of cute little nonhumans allows him to conduct an immanent critique of the hierarchies and divisions associated with racism as a social Darwinist conceit in which the survival of the fittest meshes inextricably with the teleological development of modernization theory. In this respect, the disclaimers about

racism that appear in certain volumes of Tezuka's collected works (such as *Chōjin taikei*) are correct to remind us that, even though Tezuka's depictions of Africans, Southeast Asians, and other foreigners may appear outdated and unenlightened, Tezuka's works show a profound concern for inequality, and his procedures of humor and parody, so central to manga, were designed to expose such problems, not to reinforce racism.[24] In other words, Tezuka Productions assures us that representations of racial difference in Tezuka's manga should not be seen in terms of an expression of racism but in light of Tezuka's general critique of inequality—which, they aptly note, extends to the animal world as well as imaginary creatures.

Indeed, if we are to gauge the effects of racial thinking in Tezuka, dwelling on representations and evaluating them in terms of whether they flatter or degrade a people will not take us very far. More challenging are Tezuka's efforts to expose the absurdity and cruelty of racism, for to do so he must first locate something that occupies the same ground as racism, while undermining or exposing racism. For Tezuka, that something is neoteny, neotenous characters, and usually nonhuman ones.

The tactic of neoteny derives from Tezuka's engagement with speciesism, as he works through racial difference in the register of the evolution of species. Thus, when Tezuka wishes to develop affirmative depictions of racial others, he resorts to neoteny. In a short manga *Janbo* (1974, Jumbo), included in the three-volume collection *Za kureetaa* (1982, The crater), the passengers on a jumbo jet are threatened by a man-eating spider.[25] Under these tense conditions, a white American man somewhat predictably directs accusations and racial remarks at a young African American woman, and a young Japanese man steps forward to defend and befriend her. What is interesting is that, for the African American woman to play the role of the damsel in distress, she undergoes neotenization: a relatively large head, predominance of the brain capsule, large and low-lying eyes, bulging cheek region (120:152; see Figure 2).

In this instance, the neotenous traits that typically allow for a transspecies potential in Tezuka are here used to evoke an interracial or transracial potential. *Janbo* ends with the young Japanese man and young African American walking off together—and an elderly woman walking away with her pet spider (the terrible spider turns out to be a frightened companion species on the loose). A parallel is drawn between the transspecies encounter and the interracial encounter.

Nonetheless, because neoteny almost invariably appears in combination with speciesism (indeed it appears to be a variation on speciesism in which juvenilization serves to "animalize" the human), it likewise runs the risk of

FIGURE 2. The young African American woman in *Jyamubo*, whom a young Japanese man defends against a racist white American, exemplifies Tezuka's procedures of neotenous design. *Za kureeta, Tezuka Osamu manga zenshū*, vol. 120 (Tokyo: Kōdansha, 1982). Courtesy of Tezuka Productions.

reinforcing the very segregations that it aims to displace and overcome. It is surely for this reason that the transspecies moments in Tezuka are brief and fleeting, and generally there is no social formation associated with neoteny or neotenous characters. The closest thing to a neotenous social formation is the animal paradise or peaceable kingdom of species, which is invariably destroyed. This is because, as the example of the jungle empire attests, a social formation based on neoteny would surely take the form of a multispecies empire. With the exception of *Janguru taitei*, Tezuka steers clear of this solution to racism, to social Darwinist modernization. Instead, he turns to neoteny because neoteny affords an *immanent critique* of social Darwinist modernity rather than an *alternative* to it or an *overcoming* of it.

By the same token, to remain forever immanent and never transcendent, Tezuka's neotenous nonhumans are fated to suffer at the hands of humans and even to die tragically. They cannot survive in the world of social Darwinism. They can only point to other possibilities, other desires and connections, yet unrealized and maybe unrealizable in political or social terms. Neotenous characters continuously suffer, die, and are reborn—a process that Tezuka's magnum opus *Hi no tori* (1967–88, *Phoenix*) develops into a general strategy for serializing characters across narrative worlds, as if a palimpsest for his collected works.[26] In sum, even though Tezuka largely refuses to develop neoteny into an alternative social formation or utopia, neoteny takes on a certain mythic weight in his work, almost as if (in a quasi-Jungian way) the mythic imagination in itself afforded a measure of salvation from the fallen condition of Darwinist modernity. In this respect, cute, that is, the neotenous character, remains inseparable from narrative arc in Tezuka. Neoteny comprises an incipient narrative of growth in reverse or, more precisely, countergrowth. The neotenous character is precisely such a counter-evolutionary narrative in the bud.

In a book with the provocative title *Tezuka izu deddo* (2005, Tezuka is dead), Itō Gō looks at the relation between character and narrative in the works of Tezuka.[27] The point of departure for Itō's wide-open theory of manga

expression (summarized in Miri Nakamura's translation of the book's opening chapter in this volume) is the idea that reference to Tezuka cannot account for the variety of manga expression appearing in the 1990s. Itō offers a distinction between *kyarakutaa* and *kyara* as a new paradigm for the analysis of manga expression. The term *kyarakutaa,* which derives from the Japanese pronunciation for the English word *character,* can be used to refer to characters in manga and anime, yet the abbreviated pronunciation *kyara* or "chara" has come into common use in talking about character more broadly, including character figurines and model kits (garage kits) for anime, manga, and game characters. For Itō, *kyarakutaa* is the limited term, while *kyara* implies something that is not only larger but also ontologically prior to *kyarakutaa.* He writes, "*kyara* comes before *kyarakutaa,* and imparts a 'sense of existence' (*sonzaikan*) and 'sense of life' (*seimeikan*)."[28]

Kyarakutaa remains subordinate to the narrative world of the manga, in Itō's opinion. Thus confined to the manga's world, *kyarakutaa* sustains a certain sense of realism. In contrast, the pared-down design of *kyara* allows it not only to move across different narrative worlds but also to generate new worlds wherever its users see fit. *Kyara* takes on a life of its own. It imparts a feeling that it truly exists or actually lives. If Itō feels justified in announcing, "Tezuka is dead," it is because he sees in Tezuka a narrative use of *kyarakutaa* that puts limits on the play of independent life and existence inherent in *kyara*. In effect, the death of Tezuka is the liberation of the vitality of *kyara* from the restraints that Tezuka placed on it, theoretically at least.

Itō's aims are different from mine, more geared toward accounting for formal elements than exploring the implications of the forces that specific assemblages channel or direct. But if we look at Itō's distinction in light of the terms set forth in this essay, Itō's *kyara* bears comparison to what I have referred to as plasmaticity. In fact, I would insist that the sense of existence and life of *kyara* ultimately derives from a channeling of the force of the moving image into animated characters and, by extension, into manga. In contrast, what Itō sees as the narrative dependence of *kyarakutaa* in Tezuka's manga dovetails with my conclusions about the dependence of the neotenous character on narrative arcs in Tezuka. Consequently, if we reconsider Itō's discussion of *kyarakutaa* and *kyara* from the angle of plasmaticity and neoteny, it helps us to see how Tezuka's shift from plasmaticity to neoteny constitutes not a rupture with plasmaticity but an insistent *qualification* of it. At the same time, another very important question arises, related to the material limits of plasmaticity and also of *kyara*: can there ever be an unqualified experience of plasmaticity, or an unconditioned use of *kyara*?

As Eisenstein notes, the plasmaticity of animation conjures forth the experience of a primordial life-force, which encourages animation to put a folkloric, mythic, animistic, and pantheistic spin on evolutionary scenarios—in animation, it is as if every form could recapitulate all forms. As such, animation does not only lend itself to animism and pantheism but also to an ideal of Form, as if animation could naturally culminate in an experience of the unity of all life, as Life.

Tezuka's manga sometimes appear to gravitate toward an experience of Life, of a grand Unity of Being. A prime example is the evolutionary sequence in volume 2 of *Hi no tori, Mirai hen* (the "Future" volume, 1968), in which the scientist Masato, assigned the task of bringing about the rebirth of humanity, loses himself in the production of robots rather than working with flesh and blood (203:228).[29] Yet, when Masato dies, he becomes "existence" *(sonzai)* that watches over the process of evolution, as a supreme life-form *(chō seimeitai)* transcending the time and space of the living (203:237–43) as various species emerge and disappear until humans once again take the stage. Another example is the sequence in the "Phoenix" volume of *Hi no tori, Hōō hen* (1970), in which the painter Akanemaru drowns at sea, and he and his body gradually dissolves and then takes on a series of new forms (205:180–90), a microscopic organism, a turtle, and little bird (Figure 3).[30]

As highlighted in the insistence on circles and spheres in these sequences, Tezuka combines evolution and reincarnation, tending graphically and narratively toward the ideal of a Circle of Life that overarches and underlies the generation and regeneration of all circles and cycles, as well as the forms of characters, which are after all composed largely of circles. What is more, the circle stands in contrast to divisions, segregations, and hierarchies, which are imagined in rectilinear and angular terms (and evoke violence and death).

Nonetheless, although Tezuka's manga flirt with the production of such an ideal of the transcendent Unity of Life, there is no actual social formation or political arrangement that corresponds to the ideal. In other words, if there is an unqualified or unconditional life force coursing through Tezuka's worlds, it is only experienced through its qualifications, in its material immanence. Even the graphic emphasis on circles and cycles never attains holism. The circular and the rectilinear always appear combined, intermingled, as tendencies rather than categories. As such, the very circle of community, with all its holistic implications, is a combination of compassion and cruelty. In the animal island sequence in *Aporo no uta* (1970, *Apollo's Song*), for instance, when the animals form a circle around the young man and the injured woman, form a natural amphitheater to pass biopolitical judgment against

FIGURE 3. The cycle of death and rebirth in this sequence from Akamaru's dream in *Hi no tori: Hōō-hen* builds on the holism of circular and spherical forms, which are also the basis for neotenous features, yet Tezuka consistently cuts across such holism with lines that transform the promise of a Circle of Life into a biopolitical amphitheater. *Hi no tori: Hōō-hen, Tezuka Osamu manga zenshū,* vol. 205 (Tokyo: Kōdansha, 1980). Courtesy of Tezuka Productions.

the man who has eaten meat. Likewise, in *Chōjin taikei,* the birds who have mortally wounded the old man gather around him in the mountain, shaping a natural amphitheater for their symphonic performance (Figure 1). The theater of life, of human or humanoid life, is always a biopolitical theater of operations, precisely because the moment of communal holism and transspecies sympathy never exists in isolation from rectilinear hierarchy and interracial cruelty.

In light of these procedures in Tezuka for dealing with form and life, we can return to Itō's account of how *kyara* entail a "sense of existence" and a "sense of life" beyond the narrative constraints that Tezuka placed upon character, which frees characters to move across different narrative worlds and to generate new worlds wherever users wish.

There is in Japan today, as elsewhere, a great deal of theoretical interest in, and even critical enthusiasm for, the apparently unprecedented liberation of character from narrative. In many ways, the current scene of character franchises and character-based media mix is truly unprecedented as

regards the confluence of information technologies and the magnitude of media convergence. Yet, if we look at character genealogically from the angle of speciesism, we see that the prevalence of companion species and cute little nonhumans points to something ambivalent and irresolvable, which is inherent in the manga and animation "machine" from its inception or consolidation in the prewar era, and which is amplified the current world of manga, animation and games. Namely, the new experience of life that arises from the directing of the force due to the mechanical succession of images into animation (techno-vitalism or techno-animism) results in flows that are readily aligned with abstractions, codes, and axioms of multiethnic or multicultural empire. Put another way, it is because the animated character implies the emergence a new life-form, a *species,* that it lends itself to codes for the regulation or coordination of populations, to population dynamics and evolution. From this point of view, the unprecedented media-enhanced and capital-driven liberation of character, which we see especially from the 1990s, goes hand in hand with an expansion of the codes of multiethnic empire. The prevalence and persistence of the multispecies ideal in our current entertainments confirms that our companion-species-and-character-saturated environments tend to encourage us to imagine and to work through political and socioeconomic issues in terms of war and peace among species, that is, in biopolitical terms.[31]

The point is not to lament this situation and its apparently irresolvable contradictions, but to think about how we are already swept into this formation and how we might live it differently and direct its forces into other channels. This is what is at stake in Tezuka's commitment to cute little nonhumans.

From the perspective of a genealogy of species in manga and animation, the importance of Tezuka lies in his continuation of the wartime critique of social Darwinism and Western modernity, in conjunction with his adamant discontinuation of the multispecies utopia. For Tezuka, species distinctions are invariably hierarchal distinctions, which only perpetuate segregation, domination, and war. So he transformed the wartime character-species, generating from them a series of cute little nonhumans who uncomfortably and self-consciously straddle the species divide. At the same time, because Tezuka shunted much of the plasmaticity of the animated character into the character design of the nonhuman companion species, the result was a neotenous entity with a transspecies potential. But the neotenous entity does not announce the formation of a multicultural world as an alternative to social Darwinist modernity. Instead, Tezuka tended toward immanent critique. In

his works, the child offers an immanent critique of the adult, and the animal or robot of the human. The figures (child, animal, robot, nonhuman) together make for neoteny, which promises an immanent critique of teleological development, of modernization.

Because Tezuka is often associated with the production of a Japanese cute derived from Disney, it is easy to reduce Tezuka's neoteny to mere continuation of trends in global animation, or worse, to the ambivalent dynamics of the colonized writing back to the colonizer.[32] This is why we need to consider the specific address to postwar Japan in Tezuka's neoteny. Precisely because Japan's wartime speciesism already presented an effort to construct a biopolitical theater of operations beyond the dynamics of racism and social Darwinism, it offered one of the few venues in which postwar Japan could embrace the new situation of defeat and the loss of empire without, for all that, giving up on the abstractions, codes, and ideals associated with military empire. As such, the postwar persistence of speciesism is clearly not a matter of simple historical continuity or discontinuity but of the gradual harnessing and refining of a power formation implicit within Japanese empire. With the transnational movement of manga and anime in the 1990s, Japan's speciesism came into its own on global scale, cutting across and reinforcing the multispecies ideals articulated in other postwar contexts. The importance of Tezuka's works lies in their refusal to embrace the multispecies ideal, even as neoteny afforded a glimmer of transspecies potential, of moments of compassion in excess of the formations that strove to keep affective ties within the species. At the end of the first volume of *Nōman* (1968, Norman), there is an exchange that brings the problem of cute and neoteny into sharp focus.

A young human, displaced in space and time to the moon, on which a multispecies community must fight off an invasion by the evil Geldans *(Gerudanjin)*, experiences a moment of despair when it looks like the Geldans will succeed in their invasion. Just then a cute little mammalian critter scampers in and leaps up on the table to look at the young man, who exclaims "Waa, kawaii naa!"[33] His alien commanding officer remarks that therein lies the difference between humans and Geldans—in the human response to cuteness. Pondering this wisdom as he cradles the little animal, the young man asks, "Can it become a weapon?" And the commander replies sternly, "Don't put them at the same level." This scene nicely summarizes Tezuka's postwar resistance to harnessing cute species in the service of multicultural ideals. For all his commitment to cute little nonhumans as a critique of development, he remains exceedingly wary of the possibility of the human instrumentalization of cuteness or an excess of nurture in the future. After all, once the

forces of the moving image are channeled into animal characters, those new life forms do not just flow or stream randomly or freely. Tezuka reminds us that they will be coded and recoded, instrumentalized and rationalized in new ways. What happens when the neotenous character is not guided into an immanent critique of modernity but unleashed? Here it is a not a matter of returning to narrative or to Tezuka to master the excess but rather of asking, as Tezuka's Norman does, whether the proliferation of cute little species does not bring about an escalation of war and destruction between populations, under the aegis of the multispecies ideal.

..

Notes

1. Thomas Lamarre, "Speciesism, Part I: Translating Races into Animals in Wartime Animation," *Mechademia* 3 (2008): 75–95. For part two of this three-part essay, see "Speciesism Part II: Tezuka Osamu and the Multispecies Ideal," *Mechademia* 5 (2010): 51–85.

2. For information on the formation and impact of women's journals, see Sarah Frederick, *Turning Pages: Reading and Writing Women's Magazines in Interwar Japan* (Honolulu: University of Hawai'i Press, 2006); Barbara Sato, *The New Japanese Woman: Modernity, Media, and Women in Interwar Japan* (Durham, N.C.: Duke University Press, 2003); and Miriam Silverberg, *Erotic, Grotesque, Nonsense: The Mass Culture of Japanese Modern Times* (Berkeley and Los Angeles: University of California Press, 2006).

3. For a brief overview of the emergence of children's manga in the late 1920s and early 1930s, see Shimizu Isao's *Zusetsu manga no rekishi* (Illustrated history of manga) (Tokyo: Kawade Shobō, 1999), 64–69. The "special issues" *Bessatsu taiyō* on children's history of the Shōwa era *Kodomo no shōwashi* (Heibonsha) also provide a detailed presentation of the various currents in magazine and manga at the time.

4. Ōtsuka Eiji, "Disarming Atom: Tezuka Osamu's Manga at War and Peace," trans. Thomas Lamarre, *Mechademia* 3 (2008): 121.

5. Sergei Eisenstein, *Eisenstein on Disney,* ed. Jay Leyda, trans. Alan Upchurch (London: Methuen, 1988).

6. For Pixar's indebtedness to such techniques, see Leslie Iwerks's documentary *The Pixar Story* (2007).

7. For an extended account of full versus limited animation in this context, see Thomas Lamarre, *The Anime Machine: A Media Theory of Animation* (Minneapolis: University of Minnesota Press, 2009), chapters 6 and 15.

8. Tezuka Osamu, *Firumu wa ikite iru* (Film has life), in *Tezuka Osamu manga zenshū* (Complete manga works of Tezuka Osamu), vol. 55 (Tokyo: Kōdansha, 1977).

9. See Mitani Kaoru and Nakamura Keiko, eds., *Yamakawa Sōji: "Shōnen ōja" "Shōnen Keniya" no e monogatari sakka* (Yamakawa Sōji: Author of *Shonen king* and *Shonen Kenya*) (Tokyo: Kawade Shobō, 2008).

10. See the facsimile edition of Ōshiro Noboru's *Kisha no ryokō* published in the Shōgakukan Kurieitibu series (Tokyo: Shōgakukan, 2005), 37–51.

11. See the facsimile edition of Ōshiro Noboru's *Yukai na tekkōjo* published in the Shōgakukan Kurieitibu series (Tokyo: Shōgakukan, 2005), 122–23.

12. See Fredric Jameson's chapter "Nostalgia for the Present," in *Postmodernism, or The Cultural Logic of Late Capitalism* (Durham, N.C.: Duke University Press, 1991).

13. Samuel Weber, in *Theatricality as Medium* (New York: Fordham University Press, 2004), first insisted on this idea of a theater of operations, but I am using it in a somewhat different sense, closer to the fine account given by Mark Anderson in "Oshii Mamoru's *Patlabor 2*: Terror, Theatricality, and Exceptions That Prove the Rule," in *Mechademia* 4 (2009): 75–109.

14. This topic is one of the major problematics in Michel Foucault's *The Birth of Bio-politics: Lectures at the Collège de France 1978–79* (New York: Palgrave Macmillan, 2008).

15. Frequently cited are Tezuka's manga versions of two Disney films, *Bambi* and *Pinocchio,* which appear to some degree as precursors of *Janguru taitei* and *Tetsuwan Atomu* respectively.

16. Stephen J. Gould, "A Biological Homage to Mickey Mouse," in *The Panda's Thumb: More Reflections on Natural History* (New York: Norton, 1980), 104.

17. Namekawa Michio, *Momotarōzō no hen'yō* (Metamorphoses in the imaging of Momotaro) (Tokyo: Tōkyō Shoseki, 1981).

18. Natsume Fusanosuke, *Tezuka Osamu no bōken* (The adventures of Tezuka Osamu) (Tokyo: Shōgakukan, 1995), 40–41; cited in Miyamoto Hirohito, "Manga ni oite kyarakutaa ga 'tatsu' to wa dō iu koto ka," *Nihon jidō bungaku* 42, no. 2 (March-April 2003): 47–48. See my translation of Miyamoto's essay, "How Characters Stand Out," in this volume of *Mechademia*.

19. On this tack, Asada Akira provocatively evoked the idea of "infantile capitalism," or a sort of reverse Hegelian teleology of capitalism wherein capitalism demanded ever more juvenile populations, ever more anxious about security and a safe place to play. See Asada Akira, "Infantile Capitalism and Japan's Postmodernism: A Fairy Tale," in *Postmodernism and Japan,* ed. Masao Miyoshi and H. D. Harootunian, 273–79 (Durham, N.C.: Duke University Press, 1989).

20. Gould, "A Biological Homage to Mickey Mouse," 101.

21. See the often reprinted figure of baby features from Konrad Lorenz's *Studies in Human and Animal Behaviors* in Gould, "A Biological Homage to Mickey Mouse," 103.

22. Sharon Kinsella, "Cuties in Japan," in *Women, Media, and Consumption in Japan,* ed. Lise Skove and Brian Moeran (Honolulu: University of Hawai'i Press, 1995), 226.

23. Frans De Waal, *The Ape and the Sushi Master: Cultural Reflections of a Primatologist* (New York: Basic Books, 2001), 323–24.

24. The disclaimer about racial portrayals in Tezuka's manga is abridged and transformed in the English editions.

25. Tezuka Osamu, *Za kureetaa* (The crater), in *Tezuka Osamu manga zenshū,* vols. 118–120 (Tokyo: Kōdansha, 1982).

26. For an account of Tezuka's star system, see Natsu Onoda, "Tezuka Osamu and the Star System," *International Journal of Comic Art,* 5, no. 1 (2003): 161–94.

27. Itō Gō, *Tezuka izu deddo: Hirakareta hyōgenron e* (Tokyo: NTT shuppan, 2005). Note that Itō provides an English gloss for his subtitle, namely, "Postmodernist and Modernist Approaches to Japanese Manga."

28. Itō, *Tezuka izu deddo,* 94–95.

29. Tezuka Osamu, *Hi no tori mirai hen,* in *Tezuka Osamu manga zenshū* vol. 203 (Tokyo: Kōdansha, 1980). An English translation has appeared as *Phoenix, vol. 2: Future* (San Francisco: Viz, 2004). See pages 237–43.

30. Tezuka Osamu, *Hi no tori hōō hen,* in *Tezuka Osamu manga zenshū,* vol. 205–6 (Tokyo: Kōdansha, 1982). An English translation has appeared as *Phoenix, vol. 4: Karma* (San Francisco: Viz, 2004). See pages 180–90.

31. In *Dōbutsuka suru posutomodan,* Azuma Hiroki, loosely drawing the term "animalization" from Hegel, advances the notion of otaku fans as "animalized." Azuma Hiroki, *Dōbutsuka suru posutomodan: Otaku kara mita Nihon shakai,* Kōdansha gendai shinsho 1575 (Tokyo: Kōdansha, 2001); translated by Jonathan E. Abel and Shion Kono as *Otaku: Japan's Database Animals* (Minneapolis: University of Minnesota Press, 2009). See, too, Azuma Hiroki, "The Animalization of Otaku Culture," trans. Yuriko Furuhata and Marc Steinberg, *Mechademia* 2 (2007): 175–88. Yet, insofar as Azuma sees animalization in terms of behavior response and statistical control, his notion of animalization is closer to *kachikuka* or domestication (and thus bears comparison and contrast with *Kachikujin Yapū*). As such, Azuma's use of animalization also verges on bestialization or dehumanization, and thus he presents otaku torn between animalesque tendencies and humanesque tendencies. Consequently, Azuma tends to ignore questions about biopolitics and the biopolitical theater of operations, placing ideologies and codes in the past, and establishing a posthistorical present in which ideologies and codes are no longer in effect. In contrast, my emphasis on speciesism, on the translation between animals and "races" or peoples (and gradually all manner of populations and their interrelations, be they subcultural, gender, national, ethnic, etc.) does not see the State as something now past or overcome. In this respect, although I also draw on Deleuze and Guattari, my account differs from that of Michael Hardt and Antonio Negri in *Empire* (Cambridge, Mass.: Harvard University Press, 2000), in which Empire is a historical stage beyond nation and national empire. I am more interested in and persuaded by Guattari and Deleuze's insistence that the State remains a crucial mediator.

32. Murakami Takashi takes this sort of position in his exhibition and essays in *Little Boy: The Arts of Japan's Exploding Subculture,* ed. Murakami Takashi (New York: Japan Society, 2005).

33. Tezuka Osamu, *Nōman* (Norman), in *Tezuka Osamu manga zenshū,* vols. 176–78 (Tokyo: Kōdansha, 1981), 176:212.

Photo Play

Out of the Closet:
The Fancy Phenomenon

It's not that I become a different person when I wear different clothes, I just like participating in different styles. When you wear a certain style, you enter a community . . . it's like speaking another language.

—Shien Lee

On a crisp evening in early March, I stood with Rio Saitō outside the Galapagos Art Space in Brooklyn, to photograph and interview a growing costumed crowd of spellbinding beauty and eccentricity, all chattering and glittering by the door. This was the night of the Dances of Vice *Wonderland in Spring Ball*; the next night we would be attending another Dances of Vice affair, *Mood Indigo: A Harlem Renaissance Retrospective*. Both events were part of an emerging costume-play movement that has its roots in reenactment and character cosplay, but which has exploded into a panoply of costume genres, periods, and styles performed globally in off-beat public places. Hosting the evening was the beautiful and exotic Shien Lee, the young Taiwanese impresario who creates the Dances of Vice events, each themed after different historical moments and cultures, all redolent with a romantic sense of the demimonde. It was a jewel box opening to reveal a satin-lined theatrical display of color,

skirt-swirling movement, and vogueing frivolity. Costumes may be apropos of the theme or not: everyone is welcomed into this fantasy.

In all the interviews I conducted, participants attested to a disgust and impatience with the banal sartorial culture of the dumpy middle-aged adolescent: the baggy T-shirt, frumpy jeans, and dirty flip-flops of the American public, who wear this dreadful uniform all over the world: to the theater, museums, restaurants, and even to church. It is a style no one looks good in, yet it afflicts all classes, all ages, and all genders. One porcelain-skinned Lolita, Crystal, lovely in a vintage white linen dress, poignantly told me that she adopted the Lolita style to regain a never-experienced girlhood of innocence. She had found a group of like-minded people in the Lolita community, a global band drawn to the ultrafeminine child-like styles of the Victorian era, whose complex aesthetics have become sundered into many different genres. Her gallant escort, John, told me of his group of gamer men who had become transformed into cosplayers in response to the increasing number of cosplaying female gamers joining the group.

> IN ALL THE INTERVIEWS I CONDUCTED, PARTICIPANTS ATTESTED TO A DISGUST AND IMPATIENCE WITH THE BANAL SARTORIAL CULTURE OF THE DUMPY MIDDLE-AGED ADOLESCENT: THE BAGGY T-SHIRT, FRUMPY JEANS, AND DIRTY FLIP-FLOPS OF THE AMERICAN PUBLIC, WHO WEAR THIS DREADFUL UNIFORM ALL OVER THE WORLD: TO THE THEATER, MUSEUMS, RESTAURANTS, AND EVEN TO CHURCH.

While Rio reeled around the room, snapping her amazing photographs from peculiar positions, I marveled at the diversity of people involved in this fantasia. Usually at popular cultural events—my academic beat—I am the oldest person in the room. Yet here there were participants of all ages and all races, men, women, and people of indeterminate gender all arrayed wonderfully, performing in a masquerade that followed its own meandering course through the evening, gently guided by the exquisite Ms. Lee. They were enacting a cultural masque of time, pulling forward into our own diminished era a snippet of an early spring evening from a more elegant period. The awestruck celebration of visual richness involves and integrates the members of this community. And I felt I belonged.

New York is not the only site for this art; in my own Minneapolis, the remarkable Samantha Rei, a well-known Lolita designer and emerging impresario, has worked with others to create the Libertine Asylum, and has been steadily building the "Fancy Movement"—as she has titled it—through similar events in local venues. Rio and I joined Samm at the Libertine Asylum's

Communist Party, in a small bar with a tortured but amazing DJ playing sounds from a clearly imagined Cold War. I dressed as Louise Bryant, John Reed's lover. No one knew of her, but it did not matter. I was joined in my anonymity by a flurry of Lolitas, some quaint steampunks, and other utterly unidentifiable souls, all having a wonderful time.

As I write this we are coming up on the tenth anniversary of Schoolgirls and Mobilesuits—the weekend workshop on culture and creation in manga and anime that spawned the Mechademia series—and we are celebrating with a masquerade. Even the academic heavy hitters will have to come in costume. And I will be in character too—as Oscar from *Rose of Versailles*!

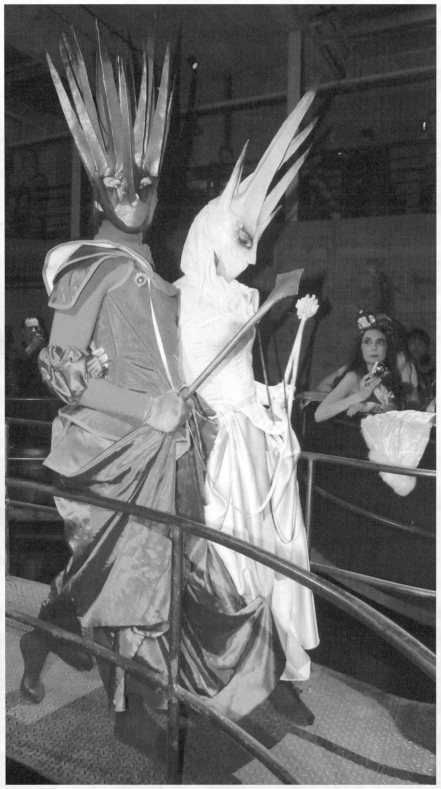

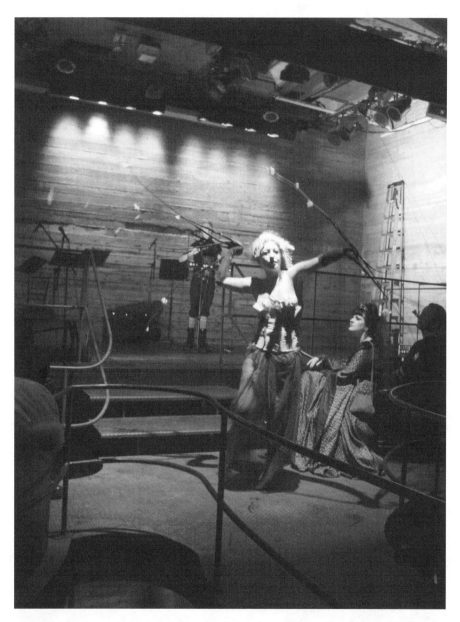

FIGURES 1 AND 2. Dances of Vice, *Wonderland Ball*, Galapagos Art Space, Brooklyn, New York, March 19, 2010.

FIGURES 3–5. Dances of Vice, *Wonderland Ball*, Galapagos Art Space, Brooklyn, New York, March 19, 2010.

FIGURES 6 AND 7. Dances of Vice, *Mood Indigo: A Harlem Renaissance Retrospective*, Red Lotus Room, Brooklyn, New York, March 20, 2010.

FIGURES 8 AND 9. *Behind the Bohemian Scenes,* by Tempo, Minnesota Opera, February 12, 2010.

FIGURES 10 AND 11. *The Communist Party*, presented by the Libertine Asylum, The Bolt Underground, Minneapolis, Minnesota, April 29, 2010.

FIGURE 12. *The Communist Party,* presented by the Libertine Asylum, The Bolt Underground, Minneapolis, Minnesota, April 29, 2010.

Desiring Economies

LIVIA MONNET

Anatomy of Permutational Desire, Part II: Bellmer's Dolls and Oshii's Gynoids

Oshii Mamoru's *Ghost in the Shell 2: Innocence* (2004, *Inosensu*) articulates three major theoretical discourses, each of which appears to be equipped with its own aesthetics, and each of which responds to the transgressive art and theories of Hans Bellmer discussed in Part 1 of this essay: (a) a theory of perversion, (b) a philosophy of dolls and the human machine, and (c) a theory of animation and the animated image.[1] In this, the second part of the essay, I will show how Bellmer's art and poetics of perversion inform the very unconscious of *Innocence,* and I will show how *Innocence* expands on Bellmerian hystericization in an attempt to expose and subvert the perverse structure of modernity, a strategy that I see as consonant with Deleuze's politics of "active involuntarism," here condensed into the figure of the posthysterical gynoid known as Kusanagi Motoko.

BELLMER BORN IN INNOCENCE

In preparation for the production of *Innocence,* Oshii and his film crew toured Japan, the United States, and Europe, conducting studies at various doll

museums and visiting the studios of doll makers. In *Inosensu: Sōsaku nōto* (Notes on the making of *Innocence*), Oshii writes that one of their most extraordinary experiences was a visit to the New York Museum of Photography, where they saw one of the few surviving original prototypes for Bellmer's second Doll. Oshii found this experience even more profoundly revelatory than his first encounter with the Doll photographs of the German surrealist artist in the early 1970s, when, as a poor college student in Tokyo, he encountered several reproductions of these mythical pictures in an art magazine. Beholding the actual Doll model, Oshii confesses that he felt as if he were being reunited with a woman whom he had secretly worshipped and desired in his youth, knowing full well that he would never meet her. Bellmer's experiments with ball-jointed Dolls, then, were very much on Oshii's mind as a premise for his anime long before he actually began work on the film.[2]

Oshii's preoccupation with Bellmer's work during the preproduction phase is manifest in the finished anime. The mythical Bellmerian Poupée, for instance, makes a brief appearance in the movie: we catch a glimpse of a variation on the Torso Doll (i.e. the Doll consisting of two pelvises joined by a round abdominal ball-joint) in the opening credit sequence (Figure 1). Later, investigating the rented boathouse where Locus Solus commission inspector Volkerson was murdered, Batou (or Batō) finds *The Doll,* a Japanese-Korean compilation of Bellmer's Doll photographs. A gorgeous green-tinted picture from Bellmer and Eluard's *The Games of the Doll* (1949, *Les jeux de la poupée*) adorns the cover. These fleeting evocations of the permutational Poupée, however, are more than passing citations. They anticipate a sustained engagement with Bellmer's transgressive vision of dolls.

The opening credits sequence follows the manufacturing process of a gynoid, Hadaly 2052. It is a "birth sequence" that clearly echoes the scene of the creation of Kusanagi Motoko in the first *Ghost in the Shell* movie: the solemn choral music by Kawai Kenji, the entirely artificial inner structure, and the foetal position of the gynoid deliberately repeat the previous film. Yet the birth sequence in *Innocence* differs from that in *Ghost in the Shell*. It includes the brief appearance of a variation of Bellmer's Torso Doll; the splitting of this Bellmerian prototype into two identical articulated dolls that float toward each other until their lips touch in a chaste kiss; and a close-up of the gynoid's beautiful face, whose blue eyes open all of a sudden, fixing us with an empty stare.

It is significant that the variant on Bellmer's second Doll appears in the context of a birth or genesis that is simultaneously "natural" and artificial, human-like and mythical, cybernetic and biotechnological. The anime thus

FIGURE 1. A variation on Bellmer's "Second Doll" from the opening credits sequence in *Innocence* (2004).

situates Bellmer's art of perversion at the origin, making it the conceptual matrix or unconscious space for the story, characters, and outlook of *Innocence*. Bellmer's vision appears as the very locus for the genesis of Oshii's film, and the Bellmerian anagrammatic Doll has "given birth" to this beautiful animated film about dolls and other artificial humans. The scene of birth thus provides an image for two entwined fantasies: a regressive fantasy, a desire to return to an undifferentiated state or prenatal state of union with the (m)other's body; and a fantasy of birth or emergence, a desire to ascribe procreative or generative capacity to the gynoid. Here *Innocence*'s debt to Bellmer is all too apparent.

The scene of the Torso Doll's splitting into two identical complete dolls reinforces the sense of the indebtedness to Bellmer's doll experiments. The splitting of the Bellmerian prototype in the birth sequence not only announces the film's production as an offshoot from Bellmer's art. It also alludes to the recurring figure of the double in Bellmer's work, and to the splitting of consciousness inherent in perversion as described in Bellmer's "Little Anatomy of the Physical Unconscious."[3] Such an *hommage à* Bellmer is hardly surprising in view of Oshii's infatuation with his work, not to mention the foundational role that Bellmer has played in contemporary Japanese doll art.[4] The art of contemporary Japanese ball-jointed dolls *(kyūtai kansetsu*

ningyō) that also informs the film (doll makers such as Yotsuya Shimon, Yoshida Ryō, and Doi Nori) also drew inspiration from Bellmer's dolls.

The film's evocation of Bellmer's art is not a matter of empty citations. Its very subtext is Bellmerian, and his art and theory of desire and perversion not only shape the unconscious of the gynoid doll but also the unconscious of the animated film as a whole. For instance, the detailed exposure of the basic material or "stuff" of the Hadaly 2052 gynoid in the opening credits suggests an *expansion* of Bellmerian permutation: there are not only metal structure, ball-joints, various pieces of gear and circuitry, but also digital code, texture, and CGI. Permutation expands to the processes of computer animation that infused her with "life." This expansion of Bellmerian permutation of gynoid bodies builds on and accelerates the hystericization of the feminine implicit in other intertexts for the Hadaly gynoid, such as Villiers de l'Isle Adam's science fiction satire *L'Eve future* (1886, *Tomorrow's Eve*).[5]

HYSTERICIZATION

Brief as it is, *Innocence*'s introductory sequence announces a fundamental tension. A fugitive gynoid has murdered her master as well as two policemen who had attempted to catch her, and the special operations policeman Batou enters into a labyrinth of dark, narrow alleys where the doll reportedly has fled. He finds her sitting motionless on the ground, leaning against a wall, her kimono hanging open, eyes cast down. As Batou approaches, the gynoid tries to knock him down but is immediately catapulted back against the wall. Shaking compulsively, the doll rips away her artificial skin, exposing the frame and ball-joints beneath. She is not given time, however, to complete her "suicide." Batou's bullets rip through her, laying bare the machinery and electronic gear that make up her inner anatomy (Figure 2).

The gynoid's strange reactions to Batou's counterattack—convulsive shaking, ripping away her skin, pleading for help as she tries to kill herself—are almost paradigmatic hysterical symptoms. This hysteria is a composite construct. It evokes the idea of hysteria as "female malady" appearing in nineteenth-century diagnoses and discourses. It also recalls the surrealists' celebration of this "poetic" disorder, which informs Bellmer's interest as well. Later I will also bring into play Deleuze's interpretation of hysteria. But I wish to begin with the nineteenth-century discourses on hysteria that enter into *Innocence* by way of one of its other major sources, *L'Eve future*.

The name for the Hadaly 2052 gynoid in *Innocence* refers directly to the

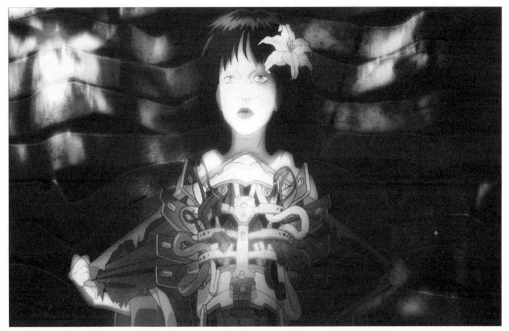

FIGURE 2. A Gynoid tearing her artificial skin as she prepares to "commit suicide," from the introductory sequence in *Innocence* (2004).

Hadaly Android (*andréide*) in *L'Eve future*. *Innocence* also prefaces the film with an epigraph from *L'Eve future*. The reference is to the female robot created by celebrated inventor Thomas Alva Edison as a substitute for Lord Ewald's ravishing but vulgar and mindless girlfriend, Miss Alicia Clary. The creation of the Hadaly's artificial intelligence entails phonograph recordings of texts written upon Edison's request by prominent male scientists, artists, and intellectuals of the time, and read under hypnosis by the beautiful Miss Alicia Clary; as well as the transfer, by means of hypnosis and telepathy, of the spirit of Edison's patient, Mrs. Edward Anderson alias Anny Sowana, into the *andréide*'s mind. The production of the artificial intelligence of gynoids in *Innocence* follows a similar process, involving "ghost-dubbing," that is, the copying and downloading of the "ghost" of a human girl onto the doll's harddisk drive. *Innocence*'s Hadaly gynoid is clearly a high-tech heir to Villiers' *andréide*.

In Villiers's novel, both Alicia and Anny Sowana are described as hysterics, and consequently Hadaly becomes an ideal embodiment of female hysteria. Drawing on these sources and processes, *Innocence* intergrates hysteria into its Hadaly 2052 gynoid. The gynoid's hysteria, then, draws not only on that in *L'Eve future*'s *andréide* but also on the misogynistic discourses of the late nineteenth century that inform the portrayal of women in Villiers's

> THE GYNOID SEEKS TO ESCAPE FROM HER OWN ANIMATED BODY AS IT HAS BEEN DEFINED, CIRCUMSCRIBED, AND CONTROLLED BY THE MULTIPLE STRANDS OF MODERN DISCOURSES ON HYSTERIA.

novel.[6] At the same time, because *Innocence* also draws on the Bellmerian doll, it evokes the interpretation of hysteria found in Breton, Bellmer, and other surrealists.

For instance, the kimono-clad gynoid who attacks and is shot by Batou in the introductory episode displays hysterical symptoms that correspond almost literally to Breton's famous description of "convulsive beauty" in *L'Amour Fou* (1937): "Convulsive Beauty will be veiled-erotic, fixed-explosive, magical-circumstantial or will not be."[7] As Hal Foster has demonstrated, Bretonian "convulsive beauty" is patterned on hysterical beauty and may be regarded as a summation of the paradoxes and ideal sublimations of surrealist aesthetics. Foster argues that convulsive beauty participates in the uncanny logic of the death drive: the veiled-erotic suggests the animation of the inanimate, which blurs distinctions between life and death, animate and inanimate, and natural form and cultural sign. The fixed-explosive refers to the suspension of the animate or to the arrested motion of a body transformed into an image. Convulsive beauty thus takes on photographic effects, for "photography produces both the veiled-erotic, nature configured as a sign, and the fixed-explosive, nature arrested in motion," thus supplying "the very conditions of the surrealist aesthetics."[8] Finally, the magical-circumstantial refers to objective chance: the experience of enigmatic encounters and *trouvailles* (found objects), governed by the repetition compulsion, desire, traumatic anxiety, and repression. In sum, we find a hysterical aesthetics that is based on shock, mutual seduction, and the death drive. And if surrealist art is eminently hysterical, it is also because the surrealists themselves aspired to be—indeed were—hysterics, "marked by traumatic fantasy, confused about sexual identity."[9]

In the above sequence of *Innocence*, the Hadaly 2052 gynoid is veiled-erotic in the sense that her red kimono is open, revealing her naked body in a provocative manner, and the gynoid also blurs distinctions between the animate and the inanimate, the organic and the inorganic, and life and death. At first lifeless and inert, she suddenly springs to life, attacking Batou with a skillful kick. Batou parries the blow, and as the gynoid flies through the air in another attack, we see the doll suspended for a moment, arrested in a fixed combat pose with a fixed expressionless stare. She appears as a *living photograph.*[10] What is more, she displays "epileptoid fits." And when hit by Batou's bullets, as she explodes, she seems to achieve the state of "fixed-explosive."

Her sudden disintegration entails a shattering of being, a devastating loss of identity that shocks Batou and viewers alike. What is uncanny in this sequence is the indeterminacy or ambiguity of the doll's physical, psychic, and existential condition. Alive and yet strangely unreal and zombie-like, a hybrid mix of analog and digital image technologies, the hysterical gynoid who explodes in our face is convulsed by a trauma that is not her own, by a legacy of death, the trauma of the captive human girls whose "ghost" she has unknowingly stolen, as well as the various (male) desires that are projected onto her, desires that she has not chosen to bear. Finally, she is "magical-circumstantial" in that she is an uncanny enigmatic object (the hacker Kim will later describe her as a "living, breathing body devoid of a soul").

The gynoid, then, is a hysteric "suffering mainly from reminiscences"[11] that are not her own but belong to an Other, to many others. Her desperate cry for help (*tasukete*) points not only to the plight of the human girls imprisoned in Locus Solus's high-tech gynoid factory but also to the gynoid doll's *desire to be liberated from the multiple hysterias* inscribed in her make-up: Bretonian surrealism, Villiers's *L'Eve future*, Bellmer's Doll photographs, and even Freudian psychoanalysis. The gynoid seeks to escape from her own animated body as it has been defined, circumscribed, and controlled by the multiple strands of modern discourses on hysteria. Her failed suicide attempt thus seems to enact the drama of hysteria as envisioned by Deleuze and Guattari: the struggle of the body with the "shapes it is forced to assume . . . the friction between the body itself and the organizations that it undergoes socially and politically."[12]

Bellmer's notions of hysteria prove especially interesting precisely because they inform so much the film's text. Bellmer saw hysteria as yet another manifestation of the psychical structure of perversion. Thus he strived to subsume hysterical symptoms and behaviors (such as epileptic fits, somnambulism, temporary blindness, and the displacement of the body's sensory and kinesthetic activities) within a theory of the physical unconscious, within his anagrammar of perversion.

In *Little Anatomy of the Physical Unconscious, or The Anatomy of the Image*, Bellmer defines the fantastic body or hysterical body in terms of the production of body images within the physical unconscious.[13] He thus identifies the anagrammatic Doll and her doubles (the (pre)pubescent girl, the woman who allows the male subject "to sodomise himself" through her, and the grotesque figure of the female cephalopod) as female hysterics. Recurring figures in Bellmer's art are all conceived of as hysterics: the young girl who lifts her skin to look at the contents of her ruptured chest and belly in *Rose*

ouverte la nuit (1934, Rose blooming at night); the girl endowed with an erect penis in the scandalous drawing *Aigle Mademoiselle*; the *filles-phallus* (phallus-girls) that are featured in the later *Déshabillages* series; and the figure of the woman opening her body to reveal a male character eyeing us suspiciously from within it like a monstrous adult fetus.

The Bellmerian conception of hysteria as perversion, implicit in his dolls, had a profound impact on the Hadaly 2052 gynoid. We see his impact especially in the conceptualization of the robotic doll as archetypal, posthuman female hysteric, as well as in the tendency to use permutations on the iconography of hysteria and perversion in the portrayal of robots, cyborgs, and technologically enhanced humans.

For instance, the gynoid who tears off her skin recalls the young girl who lifts the skin covering her open thorax to peer at her entrails in Bellmer's drawing *Rose ouverte la nuit*. Oshii confirms this association.[14] Such an act constitutes a violent fantasy of extroversion, in which the body is turned inside out. Bellmer describes it in *Little Anatomy of the Physical Unconscious* as "the wish to see and scandalously expose the inside." The scene in *Innocence* evokes the complex repertoire of perverse fantasies and hysterical reversibility of Bellmerian figures. The same is true of the Locus Solus gynoids who explode when shot to death by Batou and Motoko in the battle sequence at the end of the film. The first physical extroversion sequence, however, remains remarkable for announcing all these possibilities in advance, at once serving as a palimpsest for the other nonhuman figures in the film (gynoids and doll-like or robot-like characters such as Batou, Togusa, and Kim) and bringing the Bellmerian anagrammar of hysterical perversion to the surface. It is here that *Innocence* appears intent on melding together the Bellmerian notion of the anagram with something like the Bataillean paradigm of *altération* (deformation) in "primitive" art, which together serve to reaffirm the status of perversion *as primary structure*.

ALTERATIONS

The Hadaly 2052 gynoid embodies a Bellmerian fantasy of hysterical perversion with masculinist overtones, which is repeated in various ways throughout the film. Interestingly enough, male cyborgs and androids such as Kim, Batou, and Togusa are posited as structurally identical to the Hadaly gynoids in the sequence in which Batou and Togusa investigate Kim's mansion. In the virtual-reality simulations the hacker Kim introduces into the e-brains

of Batou and Togusa, the two detectives appear to explode like the gynoids, exposing an artificial anatomy that is identical to that of the female robots. These violent explosions conjure forth a primal performative form of representation that Bataille discussed in the context of cave art and children's art, and which he defined as *altération*, an alteration or deformation of the image and its model.

Bataille argues that *altérations* or deformations in primitive art are expressions of an instinctual release, of a liberation of sadistic instincts. Representation does not aim at resemblance with its model but at an alteration of it, which results in sadistic deformation or mutilation of both image and model.[15] Bataille's comments are apposite in the context of the imaging of nonhumans in *Innocence*: not only are these characters "primitive" in the sense that they are posited as "living bodies without a soul" but they also literally deform and mutilate themselves, as well as others. The gynoids are killing machines who murder their masters as well the human girls whose mind and soul they have robbed through the process of "ghost-dubbing." Similarly, Batou and Motoko respond by mutilating the robot dolls and the objects/images that they are meant to represent. Or, to take a prior example, there is the scene in which Batou enters the grocery store to buy dog food for his basset hound Gabriel, but the disorienting simulations smuggled into his e-brain by Kim cause him to go berserk. He points his gun at innocent store customers and finally shoots himself in the arm. Self-mutilation and other-mutilation are in constant oscillation and sometimes suddenly coincide.

In a 1930 article on primitive art, and later in a text on sacrificial self-mutilation (Van Gogh's cutting off his ear), Bataille suggests that, in such alteration, sadism is simultaneously masochism; the mutilation of the image results in a self-mutilation as well. He also argues that *altération* is intimately connected to death; it signifies both a "partial decomposition analogous to that of cadavers," and "a passage to a perfectly heterogeneous state" related to the sacred and to the spectral.[16] Hal Foster argues that Bellmer's anagrammatic Dolls reflect such a state of Bataillean *altération* or deformation, in that they can be viewed both as corpse and as *corps morcelé* (fragmented body), as body "after subjecthood, absolutely delimited, and as the body 'before' subjecthood, given over to its heterogeneous energies."[17] In sum, Foster reads the Bellmerian Doll as a paradoxical Bataillean erotic object driven by the de-sublimating force of *altérations* or mutilations, which "implies the abolition of the limits of all objects."[18] He sees a mode of representation in which image and object become mutually implicated in a ritualistic dislocation or mutilation, tending toward (pre-oedipal) life and toward death. In other words,

to add to Foster's reading, there is profound overlap between Bataille's *altéra-tion* and Bellmer's *anagram*.

For my purposes, what is important about such overlaps is how to point to the primacy of perversion. Nonhumans and enhanced humans in *Inno-cence* are conceived as perverse, erotic-hysterical objects participating in a Bataillean-Bellmerian regime that turns into an "affective contamination" in which Eros and Thanatos incessantly converge. Eros and Thanatos are simul-taneously fulfilled and cancelled out in their mutual deformation or altera-tion, in keeping with Andrea Bachner's reformulation of the notions of the drives and the unconscious in Freudian theory.[19] In this way, the film assures that perversion is the primary structure, not a supplement to some normal framework that would operate without self-mutilation or other-mutilation. *Innocence*'s gynoid dolls appear, on the one hand, as "primal" forms of repre-sentation (anagrams, deformations, or cadaverous dislocated bodies actualiz-ing a primary perverse structure such as the Bellmerian *principe de perversion,* Freudian primary masochism, or Bataillean eroticism). On the other hand, they are figures or images actualizing an in-between, undecidable, perverse structure or posture that in its turn subverts or problematizes the primary structure of perversion.

Taken together, these tendencies result in what Deleuze calls, in *The Logic of Sense,* the structure-Other or the a priori Other, which the gynoid dolls actualize as concrete others or as actual and variable terms. At the same time, however, this structure-Other is also perverse in Deleuze's sense. It is also "that which is opposed to the structure-Other and takes its place."[20] In sum, perversion is at once a primary *structure* and an exposure of the underlying process of alteration (anagrammar) that is captured in that structure. And so, at one level, we see a variety of perverse male characters. Particularly obvious are those who engage in sexual relations with the Hadaly 2052 gynoids who are also called sexroids, for they are designed to serve as companion, maid, and sex partner for male clients who can afford them. For these men, sev-eral of whom will be murdered by rebel gynoids, gynoids are living fetishes, docile accomplices of and projection screens for their desire, that is, bodies-victims.[21] Such textbook perversion takes a strange twist in the figure of Kim, a former military and espionage software specialist with the Public Security police and currently a degraded expert hacker employed by Locus Solus. In the sequence in which Batou and Togusa investigate Kim's mansion, the hacker Kim attempts to thwart them by downloading distracting virtual real-ity simulations into their e-brains. When at last they find him, Kim launches into a lengthy discussion about life and consciousness. He submits that dolls

and animals, as beings lacking human consciousness or self-awareness, are perfect beings equaling God in their innocence and purely instinctual way of life. Here we see an important dimension of perversion. For Kim, the gynoid dolls are not real others who can organize the world, make it meaningful, or sustain its

> THE WORLD OF INNOCENCE THUS OSCILLATES BETWEEN TWO MODALITIES OF PERVERSION.

possibilities. It is not surprising then that Kim lives out or gives himself over to the death instinct. Not only does he circumvent the material body and its desires—by dwelling in an entirely artificial, networked body, and pretending to be dead when Batou and Togusa arrive at his mansion—but he also disavows sexual difference by channeling his desires into fantasies of ideal dolls and machine-humans (Figure 3).

The world of *Innocence* thus oscillates between two modalities of perversion. On the one hand, concrete others—such as the state, global network capitalism, the police, and the nuclear family, as well as echoes of conspiracy—appear to stabilize and structure incessant permutation and alteration, by reference to some Big Other out there. This perverse structure is the very unconscious of modernity. On the other hand, the world of *Innocence* is a world without Others. Or rather, it is a world of *disappearing Others*. The

FIGURE 3. Kim in his library, from *Innocence* (2004).

structure-Other seems on the verge of being erased, promising to expose the very operations of modern otherness or alterity through incessant alteration. In its oscillation between these two modalities of perversion, *Innocence* evokes a politics akin to the "active involuntarism" that critics have associated with Gilles Deleuze.

ACTIVE INVOLUNTARISM

Drawing on François Zourabichvili and Edward Kazarian, Jérémie Valentin has persuasively argued that Deleuze's political posture falls outside or in between traditional political institutions. It is an aristocratic, perverse stance of "cruising," keeping its distance from the present while producing "an apparatus of resistance to the present."[22] Situated between the sadist's ironic subverting of the law by means of precepts derived from a principle of evil that nevertheless pretend to uphold the law and social order, and the masochist's scrupulous adherence to the law, Deleuze's political reasoning is not interested in power, representation, or the application of traditional tools such as political programs and progressive ideologies but rather in the creation of concepts and the exhaustion of possibilities *for nothing*. This is the role of the seer or thinker. Valentin speaks of it in terms of a posture of *active involuntarism*, which searches constantly for strategies to escape dominant currents, and to "evade the ascriptions of the self" by becoming-liquid. It is a posture of "count(ing) attentively all the metamorphoses and all the rhythm changes that events fold unto themselves."[23] Deleuzian political reflection thus implies a process of becoming-democratic.

A position similar to the seer or thinker in Deleuze appears in a cryptic Buddhist aphorism in *Innocence*: "Let one walk alone, committing no sin, with few wishes, like an elephant in the forest" (kodokuni ayume . . . / aku o nasazu / motomeru tokoro wa / sukunaku / hayashi no naka no / zō no yō ni). This aphorism appears twice in the movie. First, when Public Security Section 9 chief Aramaki asks Togusa to monitor closely his colleague Batou, he quotes this phrase. Later, Kusanagi Motoko utters the aphorism in the movie's finale, just before she disappears again into the vast realm of the Net.

Kusanagi is in fact the character that best fits Valentin's and Zourabichvili's reading of the Deleuzian thinker's perverse politics of active involuntarism and "becoming-democratic." Although a fugitive wanted by the Public Security Police, Kusanagi continually comes to the assistance of Batou, but it also seems that her interventions have pushed him into the path of danger. As

such, she recalls the sadist as Deleuze describes it in *Masochism: Coldness and Cruelty*. At the same time, like the Deleuzian masochist, Kusanagi adheres scrupulously to the letter of law, only to expose the latter's absurdity and to provoke the very disorder the law was meant to prevent. Not only does she warn Batou that Kim is attempting to obstruct his and Togusa's investigation by downloading virtual reality simulations into their respective e-brains but also she fearlessly fights against the killer dolls alongside Batou and brings Locus Solus's computer network to a standstill at the peril of her own life. In other words, while Kusanagi seems to have adopted the masochist's unflinching self-sacrifice on behalf of the social order, justice and the law (the exposure of Locus Solus's crime and the punishment that must be meted out to them), nonetheless she acts out of a purely subjective, personal motivation (her affection for Batou). And her position is extremely close to that of Locus Solus and the gynoid dolls.[24]

In sum, Kusanagi shares traits with both the sadist and the masochist as conceptualized by Deleuze, while deviating from both positions. Her morally and politically ambiguous stance falls somewhere between the poles of sadism and masochism. In fact, she seems at pains to distance herself from both. In this respect, *Innocence*'s portrayal of Kusanagi is similar to the conception of the Deleuzian political pervert outlined by Valentin, Zourabichvili, and others. Thus Kusanagi is a seer, able to foresee the future and even to prevent catastrophic events. Partly human, partly disembodied artificial intelligence, she has access to vast amounts of secret data and specialized knowledge. She suddenly materializes to warn Batou of impending dangers, helping him on his mission. Like Deleuze's perverse thinker, Kusanagi is a cruising shapeshifter who constantly displaces her position with respect to the police and the state authorities, seemingly intent on evading "ascriptions of the self." She now appears in the guise of an elderly woman in the Chinese grocery store, now as a doll girl sitting in the entrance hall of Kim's mansion, and now as a gynoid indistinguishable from the robot dolls produced by Locus Solus. An experienced practitioner of "becoming-liquid," Kusanagi creates concepts without any particular purpose, or only with the aim of emitting diagnoses of certain past histories and of the present. She cites, for instance, an aphorism of Meiji writer Saitō Ryokuu (1868–1904) on the mirror's potential not so much to reflect but to create evil.[25] The aphorism speaks not only to her elusive existence as a bodiless artificial intelligence that becomes visible only by borrowing artificial bodies. It also evokes her ambiguous status as a projection screen for a whole spectrum of masculinist fantasies. She is guardian angel, superhuman assassin, crime fighter, and agent of destruction.

KUSANAGI COMES TO
EMBODY *INNOCENCE*'S
PERVERSE, IN-BETWEEN
POSITION OF BECOMING-
DEMOCRATIC, ITS STANCE OF
"COMPLICIT CRITIQUE" OR
"DETACHED COMMITMENT."

Kusanagi is a perverse political thinker in the sense that she is at once critical of and complicit with male crimes and fantasies. Recall her response when Batou rescues the only surviving girl in Locus Solus's "ghost-dubbing" station. When the girl protests that she had asked Volkerson to change the gynoids' ethics code because she didn't want to become a doll, Kusanagi calmly replies that, had the gynoids possessed a voice, they would undoubtedly have protested that they had had no intention of becoming human either. While clearly expressing compassion with the tragic fate of the girls who have been used as "human software" in the production of the gynoids, she also signals the victimization of robot dolls as well. Yet she appears unwilling to identify completely with either side. Her response is consonant with the film's ambivalent stance toward modern technology and science, especially toward the more recent experiments in AL (artificial life), AI (artificial intelligence), and the production of artificial organs.

Kusanagi comes to embody *Innocence*'s perverse, in-between position of becoming-democratic, its stance of "complicit critique" or "detached commitment." She is able to do so precisely because she is at once everywhere and nowhere, at once a distinct individual and a function and/or a product of advanced information and communication technologies. She is, in effect, a hysteric who appears to escape (or to point in the direction of escape) from her organ-ized body, thus escaping "ascriptions of the self" to become an ethico-aesthetic variation on the gynoid. It is in this way that an ethical active involuntarism intended to generate concepts for a critique of the present builds upon the production of permutational bodies of desire in the Bellmerian paradigm of perversion and upon Bataille-like strategies of self- and other-mutilation, moving toward a Deleuzian conception of perversion as world-without-Others.

Interestingly enough, *Innocence*'s perverse posture of active involuntarism is conceived on the model of an overcrowded database. Characters engage in long discussions in which they cite, paraphrase, or revise various discursive practices, while simultaneously attempting to create new concepts. Similarly, as I will discuss in greater detail in part 3 of this series, the perceptual surfaces of the anime entail citation, mediation, and remediation of received media tropes and motifs, in the omnivorous manner of the digital. Everything is digitalized, allowing all to be combined and recombined, not in accordance with the neutral schema of permutation but rather in accordance

with the hystericized schema of perversion, alteration, and self- and other-mutilation—as if active involuntarism were the very anagrammar of digital animation, condensed into the blade-like figure of the posthysterical nonhuman woman functioning as Kusanagi Motoko.

..

Notes

1. Livia Monnet, "Anatomy of Permutational Desire: Perversion in Hans Bellmer and Oshii Mamoru," *Mechademia* 5 (2010): 285–309.

2. For an account of Oshii's encounter with Bellmer's work and of the study tour the director and his crew undertook in preparation for the making of *Innocence,* see his *Inosensu sōsaku nōto, (Production notes on Innocence) (Tokyo: Tokuma shoten, 2004),* 19–55; and Ogawa Chieko, "Oshii Mamoru no ningyō rokehan: *Inosensu* no shuzai ni kyōryokushite" (On the doll study tour for the production of *Innocence*), *Kawade Yume mukku: Bungei bessatsu: Oshii Mamoru* (Special issue of *Bungei: Oshii Mamoru*) (Tokyo: Kawade Shobō Shinsha, 2004), 131–37.

3. See Bellmer, *The Doll,* trans. Malcolm Green (London: Atlas Press, 2005), 123–27.

4. Bellmer is regarded in Japan as the founding father of the art of contemporary Japanese ball-jointed dolls *(kyūtai kansetsu ningyō).* Two takes on his work stand out. Some creatively misread Bellmer as a doll maker or doll artist *(ningyōshi),* a vocation he never embraced and which he would have rejected. Shibusawa Tatsuhiko (1928–1987), a distinguished scholar, translator, and novelist, is credited with introducing Bellmer to the Japanese public. Other Japanese doll makers who became enthralled with Bellmer's work in the 1960s, 1970s, and 1980s (artists such as Yotsuya Shimon, Doi Nori, Yoshida Ryō, and Amano Katan) perceived the structure of perversion sustaining Bellmer's creativity. On Bellmer's legacy in contemporary Japanese doll art, see Sasakiyama Yūko, "Berumēru no shinseiki" (Bellmer's new century), special issue *Ningyōai* (Doll love), *Yuriika/Eureka* 37, no. 5 (May 2005): 59–65, and Monnet, "Anatomy of Permutational Desire," 304n2.

5. Villiers de l'Isle-Adam, *Tomorrow's Eve,* trans. Robert Martin Adams (Urbana: University of Illinois Press, 2001).

6. For descriptions of principal female characters, see ibid., 31, 39–42, 109, 112, 114–16, 123, 143, 179–81, 198–200, 214. On Villiers's treatment of hysteria, see Marie Lathers, *The Aesthetics of Artifice: Villiers's "L'Eve future"* (Chapel Hill: University of North Carolina, Department of Romance Languages, 1996), 111–36; Asti Hustvedt, "The Pathology of Eve: Villiers de l'Isle-Adam and Fin de siècle Medical Discourse," in *Jeering Dreamers: Essays on "L'Eve future,"* ed. John Anzalone, 25–46 (Amsterdam: Rodopi, 1996).

7. André Breton, *Mad Love* (L'Amour fou), trans. Mary Ann Caws (Lincoln, Neb.: Bison Books, 1988), 19.

8. Hal Foster, *Compulsive Beauty* (Cambridge, Mass.: The MIT Press, 1995), 27. See also 21–54.

9. Ibid., 27

10. *L'Eve future*'s Hadaly is posited as an animated photograph: not only is her appearance produced by piecing together Alicia Clary's photographs, but she also requires

daily baths in chemical solutions that were used at the time for developing pictures. See *Tomorow's Eve*, 57–59, 84, 129–32, 184–86, 152–62.

11. This is Breuer and Freud's famous "preliminary" definition of hysteria. See Joseph Breuer and Sigmund Freud, *Studies on Hysteria*, trans. James Strachey (New York: Basic Books, 2000), 7.

12. Jonathan Roffe, "Hysteria," in *The Deleuze Dictionary*, ed. Adrian Parr (New York: Columbia University Press, 2005), 123.

13. Hans Bellmer, *Petite anatomie de l'inconscient physique* (Paris: Le Terrain vague, 1957); translated by Jon Graham as *Little Anatomy of the Physical Unconscious, or the Anatomy of the Image* (Waterbury Center, Vt.: Dominion Press, 2004).

14. Oshii Mamoru, *Inosensu Methods: Oshii Mamoru enshutsu nōto* (Methods for the making of *Ghost in the Shell 2: Innocence*: Direction notes on the movie) (Tokyo: Kadokawa Shoten, 2005), 52. See also Steven T. Brown, "Machinic Desires: Hans Bellmer's Dolls and the Technological Uncanny in *Ghost in the Shell 2: Innocence*," *Mechademia* 3 (2008): 239, 239n66.

15. Georges Bataille, "L'art primitif," *Documents* 7 (1930); cited in Foster, *Compulsive Beauty*, 113.

16. Bataille, "L'art primitif," and "Sacrificial Mutilation and the Severed Ear of Van Gogh," in *Vision of Excess* (Minneapolis: University of Minnesota Press, 1985); cited in Foster, *Compulsive Beauty*, 113.

17. Foster, *Compulsive Beauty*, 113.

18. Georges Bataille, *Erotism: Death and Sensuality*, trans. Mary Dalwood (1957; repr., San Francisco: City Lights Publishers, 2001), 140.

19. See Bachner's contention that an anagrammatic conception of psychoanalysis implies a re-envisioning of the Freudian topography of the psyche as a battlefield where Eros and Thanatos are "both fulfilled and cancelled out in their mutual game" ("Anagrams in Psychoanalysis," 11). The notion of "affective contamination" was proposed by Guattari to elucidate the properties of aesthetic machines as assemblages of aesthetic desire and operators of virtual ecology: according to Guattari these assemblages cannot be known through representation, but rather through "affective contamination." See Félix Guattari, *Chaosmosis: An Ethico-Aesthetic Paradigm*, trans. Paul Bains and Julian Pefanis (Bloomington: Indiana University Press, 1995), 92–93.

20. Gilles Deleuze, *The Logic of Sense*, trans. Mark Lester with Charles Stivale, ed. Constantin V. Boundas (London: Continuum, 2004), 356–57.

21. I am referring here to Deleuze's reading of the pervert's conception of the others inhabiting his world as bodies-victims, accomplices-doubles, or accomplices-elements. See *The Logic of Sense*, 358–59.

22. Valentin, "Gilles Deleuze's Political Posture," trans. Constantin V. Boundas and Sarah Lamble, in *Deleuze and Philosophy*, ed. Constantin V. Boundas (Edinburgh: Edinburg University Press, 2006), 196–98. Valentin's reading of Deleuze's "perverse" politics engages mainly with the thought of two theorists who have written on the "admirable perversion" of the philosopher's anarchic "leftist" stance: François Zourabichvili and Edward P. Kazarian.

23. Ibid., 199–200.

24. An illegal fugitive, Motoko maintains a dubious relation to the law, as does Locus

Solus. Like the renegade Hadaly 2052 gynoids who become serial killers to call attention to the abuse and murder of innocent young girls for corporate profit, as well as to humans' mistreatment of robots in general, Motoko becomes a mass murderer. But unlike the gynoid dolls, she murders members of her own kind to alert the world to the crimes and aberrations of global techno-capitalism.

25. The Ryokuu aphorism cited by Motoko runs as follows: "Who can gaze into the mirror without becoming evil? A mirror does not reflect evil, but creates it. Thus the mirror bears a glimpse, but not scrutiny" (Nanbito ka kagami o torite, ma narazaru mono aru. Ma o terasu ni arazu, tsukuru nari. Sunawachi kagami wa besshi subeki mono nari, jukushi subeki mono ni arazu). See Saitō Ryokuu, "Hihi shishi," *Yomiuri shinbun,* August 9, 1899. Cited in "Inosensu kanren jōhō matome: In'yō" (Data on *Innocence:* Quotations), http://freett.com/iu/innocence/quote.html#KAMI (accessed March 8, 2009). Saitō Ryokuu (real name: Saitō Masaru) was a distinguished Meiji writer, critic, and aphorist renowned for his mordant wit and irony.

KUMIKO SAITO

•••

Desire in Subtext: Gender, Fandom, and Women's Male–Male Homoerotic Parodies in Contemporary Japan

Manga and anime fan cultures in postwar Japan have expanded rapidly in a manner similar to British and American science fiction fandoms that developed through conventions. From the 1970s to the present, the Comic Market (hereafter Comiket) has been a leading venue for manga and anime fan activities in Japan. Over the three days of the convention, more than thirty-seven thousand groups participate, and their *dōjinshi* (self-published fan fiction) and character goods generate ¥10 billion in sales.[1] Contrary to the common stereotype of anime/manga cult fans—the so-called otaku—who are males in their twenties and thirties, more than 70 percent of the participants in this fan fiction market are reported to be women in their twenties and thirties.[2] *Dōjinshi* have created a locus where female fans vigorously explore identities and desires that are usually not expressed openly in public. The overwhelming majority of women's fan fiction consists of stories that adapt characters from official media to portray male–male homosexual romance and/or erotica. This particular trend of fan fiction writing is known as *slash* in English-speaking countries, and as *yaoi* (also transcribed as *801*) or *BL* (boys' love) in Japan. Women's exploration of male homoerotic subtexts in mass media makes fan fiction a rich and vital vehicle for reframing female fans' gendered identities and sexual desires.

The prominence of this fan fiction genre by women for women—in Japan and increasingly in global fan markets as well—poses several critical questions surrounding fan culture and gender. First, the male homosexual parody is an intriguing case that embodies the complex relationships fans have with the mainstream media. These *dōjinshi* represent the conflict between fans' love for and critique of the sources that are being parodied. I will analyze some BL parody manga based on the assumption that slash parody is one form of women's reaction to the male-centered mainstream media. Second, gender seems to impact fans' relationship to the mass media, thereby forming fundamental connections between being a woman and writing fan fiction. The gender distinctions in society seem to extend to values concerning media production and distribution, thereby questioning women's role in domestic consumption and reproduction. I will examine how male characters in fan fiction reflect gender norms for women in social contexts, especially ideas surrounding family and marriage.

Before any discussion, however, it seems necessary to explain the Japanese terms used to signify the genre. Whereas *slash* is often used as a convenient replacement, this English term blurs many of the fundamental conditions presumed in the common usage of Japanese genre names. Western scholars have defined *slash* as a "subset of fan-fiction which eroticises the homosexual bonds depicted between media heroes" and "a form of fan fiction (i.e. fiction written by and for fans on a not-for-profit basis) that centers around romantic and/or sexual encounters and relationships between same-sex characters drawn from the mass media."[3] The Japanese terminology for male homosexual fiction targeting female readers ranges from *shōnen'ai* (boys' love), *bishōnen* (beautiful boy), *tanbi* (aestheticism), and *bara* (rose) to *Juné* (the title of a magazine in this genre), *yaoi,* boys' love (*bōizu rabu*), and *fujoshi*.[4] While slash and these Japanese terms may appear similar, three fundamental differences divide English and Japanese understandings of this genre. First, these Japanese terms do not reflect the West's standardized distinction between original fiction and secondary fiction (fan fiction, parody), although different terms carry different connotations. For example, the term *yaoi* (an abbreviation for "no climax, no ending, no meaning"), reflects tendencies common in *dōjinshi* such as incoherent plots and the absence of a climax or resolution, whereas the "boys' love" label originates from the publishing industry, which used it for commercial purposes. This parallels the historical shift in terminology from *yaoi,* a term associated with the rise of fan fiction in the mid-1980s, to "boys' love," which stemmed from commercial investments starting in the 90s.[5] The interchangeability of these words in

common use indicates that Japanese slash includes a wide range of fiction, from original texts by mainstream writers to parodies by cult fans, thereby lacking a clear distinction between primary and secondary writings, or commercial fiction and not-for-profit fan fiction. Second, whereas in the West "many science fiction and fantasy sources have proved popular with slash fiction writers," including *Star Trek* and *The Lord of the Rings,* Japanese slash embraces a wide variety of genres from sports and school romance to samurai and robots.[6] Slash in English may connote certain generic classifications, but the Japanese terms do not designate any particular genre of the parodied text. Third, the majority of Japanese slash parodies manga and anime, which usually results in manga narratives. This enables the writers and fans to explore graphic aspects of romance far more extensively than English slash, which is mostly written as prose fiction. These characteristics in Japanese slash generally point to the blurring of various boundaries assumed in English fan fiction, especially between original and parody, fantastic and realistic settings, or graphic and nongraphic texts. Due to this variety, Japanese fans have found it difficult to use a single term to refer to the entirety of the culture. For this essay, I will employ the abbreviation *BL* to signify Japanese male–male romance for women.

The genealogical background of BL is another factor essential for understanding the genre. The broad spectrum of BL fiction owes much to the prevalence of manga for female readers, especially girls' romance manga (shōjo manga) in the early 1970s. The emergence of *shōnen'ai* is usually ascribed to two writers, Hagio Moto and Takemiya Keiko, whose incipient works in this genre are respectively *Tōma no shinzō* (1974, The heart of Thomas) and *Kaze to ki no uta* (1976–84, The song of wind and trees). This generic mutation of shōjo manga is considered a reaction to preceding trends in shōjo manga or, more precisely, a solution to the limits of the genre.[7] In contrast to the 1960s *romakome,* light-hearted romantic comedies modeled after American TV dramas, the early '70s mainstream shōjo manga were serious and melodramatic models of romance, heavily superimposed with the supposedly Western concept of love as tragic self-sacrifice and emotional expressivism.[8] Sex, for the heroine, is often the ultimate form of self-sacrifice where she must prove the truthfulness of her love by "overcoming" the fear and pain associated with the act, rather than accepting or even enjoying it. The shift from shōjo romance to BL signals changes in the conceptualization of love, from the surrender of the female body for the sake of love to the mutual exploration of love, sexuality, and erotic desire between two protagonists. The late-'70s development of the fan fiction market further confirms the impact of this new

trend in shōjo manga. Aside from the fact that the emergence of BL coincides with the first phase of the fan fiction market, almost 90 percent of the attendees at the first Comiket in 1975 were reported to be female, and most of them were fans of Hagio and Takemiya.[9] This organic connection between shōjo manga and BL fan fiction indicates the closeness of fan fiction culture and women's romance genres.

CRITICAL APPROACHES TO STUDIES OF SLASH

Academic studies have assigned a relatively minor role to gender in exploring the nature of fan cultures. For example, gender may not predetermine fundamental differences in fan activities, as "the cult fan–text attachment is far from being gender-specific"; gender differences surface in the contents and the degree of fan activities but not in the forms of fan culture itself.[10] For this reason, the question of how gender impacts the structure of fan culture is easily neglected, even though a number of studies reflect on gender differences in fans' reactions and tastes. A significant portion of scholarship on the subject stems from the field known as reception studies, in which gender differences in reader/viewer responses are analyzed. One of the most influential works is Henry Jenkins's comparison of female fans of *Star Trek* to male fans of *Twin Peaks*, which argues that men and women have different reading strategies.[11] Drawing upon David Bleich's reader response theory, Jenkins observes that female fans of *Star Trek* tend to be concerned with emotional realism and focus their interests on "the elaboration of paradigmatic relationships" and "character psychology," whereas male fans of *Twin Peaks* tend to acknowledge the powerful presence of the author and focus on their "textual mastery" of narrative enigmas.[12] This gender division is further maintained in his study of *Star Trek* slash, a category of "the female fan culture"[13] that treats psychological aspects of the relationship and sexual intimacy between Kirk and Spock.

Even though his examination of female fans employs a more sociological approach than Bleich's psycholinguistic determination of gender-specific reading practices, Jenkins's study sustains the idea that female viewers tend to be easily immersed in the emotional reality of characters, often ignoring the plausibility of settings or plots. He ascribes these gendered divisions to the viewers' socially differentiated backgrounds: women are forced to read male-centered texts and eventually learn to appropriate them into feminine paradigms of emotional realism. This standpoint provides an optimistically

monolithic model where female fans' reading practices naturally defy the male-centered ideologies inscribed in the original media. Recent studies, perhaps in reaction to Jenkins, typically question the view that women take the position of resistance or opposition to mainstream media. They present slash as a more complex process of discourse reception,[14] or as an interpretive activity that partly reflects dominant ideologies in popular media, especially in parodied sources[15] or mainstream heterosexual romances for women like Harlequin.[16] Ien Ang's study of the soap opera *Dallas* also suggests that *Dallas* lovers are clearly aware of the "ideology of mass culture," i.e., the common idea that "mass culture is bad," yet show careful and complex negotiations with the mainstream ideologies expressed in *Dallas,* through irony and acceptance.[17] It seems that fans' reactions are not based on meanings that can be clearly separated through established lenses of resistance to or compliance with the mass media: rather, fans' relationship to the media is often described as a series of careful negotiations among contesting opinions.

> IT SEEMS THAT FANS' REACTIONS ARE NOT BASED ON MEANINGS THAT CAN BE CLEARLY SEPARATED THROUGH ESTABLISHED LENSES OF RESISTANCE TO OR COMPLIANCE WITH THE MASS MEDIA: RATHER, FANS' RELATIONSHIP TO THE MEDIA IS OFTEN DESCRIBED AS A SERIES OF CAREFUL NEGOTIATIONS AMONG CONTESTING OPINIONS.

Another strand of theories that address fans' contradictory reactions to mainstream media stems from Pierre Bourdieu's concept of cultural economy and its application by John Fiske. Bourdieu's cultural economy model employs the metaphor of economy to examine culture, arguing that "cultural tastes can be mapped onto economic status within the social space."[18] In this theory the top layer of society (the tasteful and rich, like doctors, lawyers, and so on) owns both cultural and economic capital, while the subordinate layer does not have either. Between these extremes exist those with more cultural than economic capital (for example, academics) and those with more economic than cultural capital (for example, business people). Fiske argues that, although fan culture centers on popular culture (low culture for the subordinates), fans' discourses and activities often employ the authoritarian discourses of the upper class and, more importantly, that fans collect commodities that supposedly possess high cultural capital but little economic value. Accordingly, fandom invests in popular culture in opposition to official culture, and simultaneously reworks values in it.[19]

The case of Japan poses several problems with Bourdieu's proposition. The myth that Japan is a homogeneous society without class difference may

affect the way Japanese fans perceive and express tastes for high or low culture. Furthermore, as Fiske himself admits, gender is not taken into account in Bourdieu's model, whereas Japan's fan fiction market largely depends on gender distinctions. In terms of cultural taste's adherence to class difference, Kenji Hashimoto argues that "the relationship between Japanese classes and culture" reveals "many of the characteristics that Bourdieu ascribes to 'cultural capital,'"[20] and it seems safe to apply the same model to contemporary Japan, although to a limited extent. A far more serious Japan–West discordance can be found, however, in women's intragenerational class mobility. Since women's employment opportunities are highly limited in Japan, more than 70 percent of Japanese women start their careers in the working class only to attain a dramatic income increase later, despite being unemployed (i.e. upon marriage).[21] Hypothetically, women do not have a class location of their own, and therefore it is likely that class is an irrelevant factor for determining Japanese women's cultural activity. Although possibly mediated by their husbands' or fathers' class location, women's location in the class structure tends to be either highly fluid (if married) or consistently low (if single). Given that BL fandom is dominated by women in the age range that roughly corresponds to the average age of a woman's first marriage, it is possible that women's culture expresses the highly incoherent and mobile quality of their economic positions, due to marriage and childbearing.[22] Thus what we should take into account in the study of women's fan fiction culture is their gender-specific socioeconomic experience rather than their vague class location.

BL AS A MARKET

Users on the 801 board of the vastly popular Internet forum 2channel say that only 10 percent of the BL fans they know "come out" in public.[23] While 2channel is in no way a reliable source of data, this common statement faithfully designates the way female fans regard BL as a "triple stigma": it is not simply pornographic and homosexual, but it also concerns women loving male–male homosexuality.[24] The BL market has thus grown in relatively hidden lines of commerce—in the *dōjinshi* market since the 1970s and in the Internet and cell phone networks from the 1990s to present. Due to the fans' deliberate secrecy, the market size is difficult to measure, yet researchers' recent attention to the cross-media industry surrounding anime, manga, games, and so on has succeeded in shedding some light on female consumers active in this genre. The BL market covers a rather diverse range of media formats and distribution

channels, including novels, manga, anime, PC/video games, *dōjinshi* (manga and novels), parody videos at video-sharing Web sites, voice-only drama CDs, blogs, and so on. Today, novels and manga in the genre can be easily obtained at most bookstores. The major manga magazines now exceed fifteen titles, including *Comic Juné, BOY'S Piasu, BOY's LOVE* (all published by Junet), *CIEL* (Kadokawa Publishing), *Magazine BExBOY* (Libre), *Hanaoto* (Hōbunsha), and *Drap* (Core Magazine). Many of the popular stories, short or serialized, are then reprinted in paperbacks (called *komikkusu,* or "comics"). About twenty publishers have BL brands in their paperback novel businesses, which results in thirty labels today, such as Kadokawa's Ruby paperbacks, Libre's b-Boy Novels, and Ōkura Shuppan's Aqua Novels. Aside from these commercial businesses, fans write and publish *dōjinshi,* which are sold at conventions and at some bookstores as thin booklets or anthologies. Research conducted in 2004 by the Nomura Research Institute (NRI) shows that women active in writing fan fiction constitute 12 percent of the entire "maniac consumer" population, which equates to approximately 200,000 people.[25] This survey may not include nonmaniac consumers who spend, say, "only" $300 per year to read BL manga and novels and do not write fan fiction.

The financial scale of the market poses yet another challenge for both academic and business researchers. In the NRI research results cited above, the category of "women active in fan fiction writing" spends approximately ¥15 billion annually for manga, anime, and games alone, which equals an average of ¥75,000 per person (US$680 2005 dollars). The TV documentary program *NONFIX* featured a special focus on *fujoshi,* which estimated the BL market size as approximately ¥12 billion.[26] Increws, a company that runs a search engine for cell phone manga in the BL genre, states that women in their twenties and thirties who read BL manga are leading the cell phone electronic text market.[27] It is clear that more companies are investing capital to promote economic growth in this genre, yet the BL market seems highly unpredictable. BiBLOS, one of the largest and oldest publishers in the BL genre (original publisher of the b-Boy brand magazines and paperbacks currently released by Libre), went bankrupt in 2006; and in 2007, a popular BL parody writer was prosecuted for evading taxes on her ¥200 million income generated from three years of writing fan fiction.[28]

Despite market volatility, the *dōjinshi* culture in Japan embraces a surprisingly wide variety of parodied sources, unlike English-language slash, which tends to focus on a relatively small number of mainstream texts. Figures 1 and 2 list the most popular titles parodied in BL fan fiction. Figure 1 shows when these titles were popular enough to exist as independent subgenres

GENRE NAMES AT COMIKET (magazine title and period in which the original was serialized, and period of TV broadcast)	CATEGORICAL SECTION GIVEN AT COMIKET	PERIOD WHEN THE GENRE CODE EXISTED IN COMIKET
Captain Tsubasa (Kyaputen Tsubasa) (*Shonen Jump* 1981–88; TV anime 1983–86)	anime	1987–1999
Saint Seiya (Seinto Seiya) (*Shonen Jump* 1985–1990; TV anime 1986–89)	anime	1987–1995
Samurai Trooper (Yoroiden samurai torūpā) (TV anime 1988–89)	anime	1989–1999
Takahashi Rumiko	for men	1987–1994
Tanaka Yoshiki, Kikuchi Hideyuki	novel	1988–1997
Yu Yu Hakusho and other Togashi Yoshihiro manga (Yu Yu Hakusho, *Shonen Jump* 1990–94; TV anime 1992–95)	manga	1993–2002
Slam Dunk (Suramu danku) (*Shonen Jump* 1990–96; TV anime 1993–96)	manga	1994–2002
Sailor Moon (Bishōjo senshi Sērāmūn) (*Nakayoshi* 1991–96; TV anime 1992–97)	for men	1995–1998
Gundam Series (*Gundam Wing*, 1995; *Gundam Seed*, 2002–3; *Gundam Seed Destiny*, 2004–5, *Gundam 00*, 2007–9)	anime	1995–
One Piece (*Shonen Jump* 1997–present; TV anime 1999–present)	manga	2000–
Naruto (*Shonen Jump* 1999–present; TV anime 2002–present)	manga	2001–
Prince of Tennis (Tenisu no ōjisama) (*Shonen Jump* 1999–2008; TV anime 2001–05)	manga	2002–
Full Metal Alchemist (Hagane no renkinjutsushi) (*Shonen Gangan* 2001–present; TV anime 2003–04)	manga	2004–

FIGURE 1. Some of the media texts that gained their own genre names at Comikets due to their popularity in the *dōjinshi* market.

GENRE = TITLE OF THE ORIGINAL MEDIA PARODIED IN DŌJINSHI (Source and period of the original's serialization)	# OF TITLES
Reborn! (*Shonen Jump* 2004–present; TV anime 2006–present)	493
Gundam 00 (TV anime 2007–8, 08–09)	358
Big Windup! (*Afternoon* 2003–present; TV anime 2007)	129
Gin Tama (*Shonen Jump* 2003–present; TV anime 2006–present)	125
Melancholy of Haruhi Suzumiya (Suzumiya Haruhi no yūutsu) and its sequels (novels 2003–present; TV anime 2006)	106
Code Geass (TV anime 2006–7, 2008)	89

FIGURE 2. The popular *dōjinshi* genres in the "for women" category at Toranoana, a major *dōjinshi* store chain (online listing as of November 2008).

at Comiket. At Comiket, *dōjinshi* are divided into several generic sections, which are original fiction, manga parody, anime parody, game parody, novel parody, *dansei muke* (for men), music/variety (real people), and others. This classification presupposes that almost all *dōjinshi* outside the "for men" category are for women and general readers. Figure 2 shows some of the popular BL parody *dōjinshi* at a bookstore. These tables prove that the works most frequently parodied in BL *dōjinshi* predominantly come from boys' media, especially manga serialized in *Weekly Shōnen Jump (Shūkan shōnen janpu)* and their adaptations into TV animation series. The contents of *dōjinshi* range from comedies punctuated with erotic jokes to short noneritic anecdotes that could be inserted in the original. Overall, as the term *yaoi* ("no climax, no ending, no meaning") implies, the plot elements are weak and dependent on the originals, although the semantic depth of images and fragmented episodes can create lasting impressions.

In the following section I will examine the conventions in boys' fiction that are frequently applied and transformed in BL parody. By applying the theoretical model of fans' relationship to official media discussed earlier, I intend to explore the interface between what female fans seek and what

mainstream discourses in boys' popular media provide, especially around the issue of family and social bonding. What is called the "official media" here is thus mostly shōnen manga and anime, especially popular series from *Shōnen Jump* that feature physical/psychic battles and sports. Whereas many titles with BL tendencies and some anthologies of BL parodies are also official publications and TV productions, I will follow this narrow definition of the official media to mean the original sources parodied in fan fiction.

BL PARODIES AND SHŌNEN MANGA

The fundamentals of Japanese boys' comics, known as *shōnen manga*, are largely represented by the best-selling manga magazine *Weekly Shōnen Jump*, which publishes more than two million copies every week. Its readership consists of 90 percent male readers and 80 percent teenagers, with the greatest percentage around age fourteen.[29] Manga texts in this magazine vary, but the values most appealing to female fans include the main characters' willingness to work hard and overcome obstacles, and an equal relationship between the hero and his opponent, which develops into a mutual sympathy as each tries to achieve the same goal by different means.[30] This last theme is clearly attractive to female fans, judging from *Shōnen Jump* manga as well as other popular non-*Jump* texts such as Studio Sunrise's Gundam anime series.[31] This phenomenon in Japan seems to share much in common with the popular pairing of Harry and his "perpetual foil" Draco in *Harry Potter* slash.[32] What composes the central theme in many BL parodies is the bond between two (or more) male characters primarily built on their equal relationship; here "equal" is measured in battles and competitions based on matchable natures and degrees of ability. The often action-centered depiction of the original relationship transforms into parodies that emphasize interactive psychological tactics to overcome and surpass each other, which further matures into mutual affinity as equal partners. In a scene from a BL parody of the popular manga *Reborn!* two characters fight each other to prove their dominance and battle technique, a direct continuation from the original.[33] The monologue, however, compares the rival with a puppy who is afraid to be cared for and touched, which then suggests this character's subconscious need to be embraced and the other's desire to embrace (Figure 3).

The general emphasis on equal relationships and gender ambiguities is something BL parodies share with English slash, which Western scholars have described as including "androgynous qualities of each [character]," a

FIGURE 3. A scene from slash fiction of *Reborn!* by Aoi Rebin, entitled *Aoi Rebin—Ban'yu* (Tokyo: Pict Press, 2008).

> IT SEEMS MOST APPROPRIATE TO HYPOTHESIZE THAT BL CHARACTERS ARE SELF-PROJECTIONS OF FEMALE WRITERS/READERS LIVING IN THE HETERONORMATIVE WORLD AND THEREFORE THAT HOMOPHOBIA AND MISOGYNY ARE ALMOST ESSENTIAL NARRATIVE DEVICES FOR CONSTRUCTING IDEAL ROMANCES AS ENVISIONED BY WOMEN.

"diversity of identifications and object relations," and "the political implications of textual poaching."[34] While these mark some of the most significant aspects of slash, BL parodies—and fan responses in a wider context—present a more complicated mix of conflicting ideas that simultaneously oppose and sustain the values expressed in the official media. Drawing on Ien Ang's theory discussed above, fans who are critical of the narrative conventions of slash do not necessarily intend to attack or extinguish them. Fans may be fully aware of its "bad taste," as exemplified by the pejorative terms like "rotten girls" (fujoshi) that they voluntarily apply to themselves. It seems that fans are actively reworking the contradictory values at the intersection of different social discourses and that they still continue to love this "bad practice" because—to quote the title of a popular BL cross-media product—"I can't help it because I like what I like."[35] In order to clarify the contradictory relationship of fan fiction to the original media, I will discuss two paradoxes particularly prominent in BL parodies: homophobia and misogyny in male–male homosexual pairing, and an equal relationship based on conservative gender roles. Instead of stating that these "negative" traits are shortcomings to be improved upon by future fans, I consider contradictions as necessary components of BL.

A certain degree of homophobia has been identified in English slash, which scholars address as a defect that both fans and scholars hope to improve.[36] Many BL texts, parody or original, similarly make male characters express homophobia.[37] It is not uncommon in BL that a character confesses his love with the cliché "I'm not gay; I just love [fill in the blank]."[38] If characters do not make this statement, they live as if women were either extinct or entirely excluded from society. This general tendency of disparaging gay men and women in BL explicitly mirrors wider social stereotypes, especially those concerning gay men's promiscuity and perversion and women's impurity.[39] The difficulty of understanding the homophobic tendency in BL equally signifies the difficulty of judging the gender of these male characters—why do gay characters, created by women, hate or exclude gay men and women, and should they be even considered gay? Japanese critics and fans alike have widely acknowledged that these characters are not really gay men, or even

men: they are just agencies for ideal romance in some imaginary communal space.[40] This viewpoint resembles Joanna Russ's early account of *Star Trek* Kirk/Spock slash, in which she argues that Spock is a kind of "code" for the love and sex women want, and thus his sexuality is "only nominally male."[41] Russ's argument has not been actively supported by scholars, perhaps because it is inconsistent with current queer scholarship. However, it seems most appropriate to hypothesize that BL characters are self-projections of female writers/readers living in the heteronormative world and therefore that homophobia and misogyny are almost essential narrative devices for constructing ideal romances as envisioned by women.

Several important narrative functions of BL are contingent on homophobic and/or misogynist settings. In the universe of ideal romance, characters overcome the taboo of homosexuality, thereby proving that their love is truer and purer than that of heterosexual couples and "real" gay men.[42] This superior love is also endorsed by the sexual continence of the original fictional characters, who work hard but show no or little interest in romance. Shōnen manga characters tend to have strong passion for martial art battles or sports, the mastery of which is measured not by technique but by teamwork and by how they save their *nakama* or members of their virtual family. Extrapolating from this concept of male friendship, the ideal romantic love in BL is a clean and honest relationship of mutual caring, in contrast to the "corrupt" relationship that starts from romantic or erotic motivations, commonly represented by "real" gay men and women. For example, Ozaki Minami's *Zetsuai 1989,* a direct spinoff of her own *Captain Tsubasa dōjinshi,* narrates the depth and seriousness of the love between the two male protagonists using the visual language of their artistry in playing soccer (Figure 4).[43] The illusion of an equal relationship in male–male romance necessitates the exclusion of the people whom public society considers to be morally degraded and inferior. In this milieu, female fans of male–male romance do not try to overturn the gender norms; they attempt to reconstruct respectable forms of love using existing materials from their heteronormative society. In other words, if the main characters were lesbians, the plot would constantly have to deal with their fight against social stigmas imposed on their female bodies *and* their sexual orientation, which (for these readers) could no longer be enjoyable as romance.[44]

This argument leads to the next point, which is the equal relationship on the basis of conventional gender roles. Most BL parodies translate the relationship of two male characters, originally depicted in a rivalry or power battle, into a romantic relationship that is built solely on their abilities and

FIGURE 4. A scene from Ozaki Minami's *Zetsuai 1989*, vol. 1 (Tokyo: Shūeisha, 2002).

honest competition, thereby creating the impression of equality and sympathy. But their sexual and domestic roles are often constructed as masculine and feminine, and these roles are usually irreversible within the same story world—although different writers may choose different pairings. BL parody *dōjinshi* denote their featured couples using "x," as in "Ken x Koji" (a pairing of Ken and Kojirō from *Captain Tsubasa*): the former is *seme* (the aggressive, masculine role) and the latter *uke* (the passive, feminine role). This terminology apparently differs from gay slang terms for sexual roles, such as *tachi* (literally "to stand," "erection") and *neko* (literally "cat"), which in itself evinces BL fans' distinction between BL gay men and actual gay men. Rapes are also popular plot devices to the degree that the *uke* is unaware of, or unprepared for, consenting to the sexual act. The power difference is explicitly depicted in manga's graphic representation as well, often exemplified by the *uke*'s visible nipples and by his anus, which resembles a vagina.[45] Sex scenes in BL also rarely depict what would be considered by society deviant sexual acts and instead sustain the top/bottom power relation—the *seme* and the *uke* closely mirror publicly standardized gender roles. This fact contradicts the equal relationship implied in both the original and parody. Consider an

example taken from the sequel to the text discussed above, the BL parody of *Reborn!*[46] Whereas the characters' mutual caring and competitive attitudes continue, their roles are fixed to the masculine and the feminine in the sex scene (Figure 5). If BL pairings are based on the equal and reflexive qualities of the two characters, the clear passive/aggressive divide in their sexuality is paradoxical.

One answer to this "homosexual's heterosexuality" paradox is the identificatory positions held by the two characters; the clear role division formulates two different viewpoints of the subject and object of love. Unlike the male aggressive / female passive relationship typical in men's heterosexual pornography, however, BL emphasizes the pleasure felt by both the *seme* and the *uke,* juxtaposing panels of each face in a shot–reverse shot style (Figure 5).[47] Men's pornographic manga usually attempt to neutralize the male character's facial traits or emphasize only his hands and penis so that pleasure is visually represented by the female body as an object, but BL invites the reader's identification with both partners.[48] This resembles Constance Penley's observation that slash "allows a much greater range of identification and desire for the women."[49] This close-up, reverse-shot style in BL suggests that the relationship is not between the

FIGURE 5. A scene from slash fiction of *Reborn!* by Aoi Rebin, entitled *Aoi Rebin—Ban'yu* (Tokyo: Pict Press, 2008).

subject and object of love, but the subject of love and the subject of being loved, each embodying a subject position for female readers. But while they may be only nominally male, the male representation of the characters further distances the female reader, which constitutes another layer between objects of love (male bodies) and the female viewer. The pleasure of viewing is almost purely scopophilic due to the gender gap between the characters in male form and the reader. The shifting perspective constitutes a "triangle structure of viewpoints" among the two male protagonists and the female reader, thereby enabling the reader to find pleasure in detecting agency in multiple positions that respectively fulfill different functions.[50] Nobi Nobita's parody of *Yu Yu Hakusho,* for example, visualizes this structure by contrasting the two male protagonists with the female characters who become intimate

with, but excluded from, the male homosexual couple.[51] In one scene the two male characters exchange gazes with the monologue, "you are the essence of my forgotten past," suggesting they are doubles (Figure 6). The female character supposedly standing next to one of the characters is not shown in this emotionally intense moment, but her absence provides a perspective for the woman who watches but is excluded from the relationship. In the BL triple-perspective model, what drives the reader's pleasure is the fluid oscillation of viewpoint between multiple subject positions marked by the act of loving / being loved and the act of looking / being looked at, which requires self-conscious critical distance from each identity locus. This argument further questions the idea that female readers tend to be more emotional and easily immersed in character psychology. On the contrary, the focus on characters' internal psyche may force female readers of BL to constantly alienate each perspectival point from the rest in order to facilitate the fluid slippage of subject position.

FIGURE 6. A scene from Enomoto Nariko's *Enomoto Nariko + Nobi Nobita* vol. 2 (Tokyo: Futabasha, 2002).

CONCLUSION

English slash and Japanese BL parody show a number of similarities as forms of fan fiction: women's reconfiguration of male relationships into a form of ideal love; the emphasis on equal relationships; the self-projection of female readers/writers onto male characters as a potential political commentary on patriarchal society or heterosexuality; and the reworking of gender attributes. My analysis of BL parodies has argued that these "positive" traits of slash that scholars appreciate are closely connected to their opposite characteristics, such as their homophobic and misogynic tendencies, their stereotypical power relationships, and their reappropriation of heterosexual roles. Even though slash cultures are increasingly diversifying and expanding, I suggest that scholars consider the dynamics of the conflicting meanings fans explore in response to the mass media, whether those meanings appear adverse or favorable in the context of existing theories of cultural studies.

In this study, gender proved to be a key component of fandom. Given the nature of women's fan fiction as a reaction to sociocultural norms, BL parodies are more likely to be the social minority's counternarrative to the mainstream. It is misleading, however, to assume that this counternarrative simply challenges official discourses. These characteristics are closely tied to narrative and graphical devices that simultaneously reaffirm the conservative gender system, which evinces fans' contradictory ways of appreciating and resisting the official media. Seen in light of Bourdieu's cultural economy model, female fans' active reorganization of cultural values in BL parodies suggests that opposite values increase through the process of fan activity: female fans seem to question and thereby challenge their positions of being socially and economically subordinate while sustaining, and further adapting to, existing gender discourses promoted in society. Because female fans embrace these contradictions in their cultural production, I consider fan fiction to be an important nexus between men's society and women's ideals, or between the actual female body strictly regulated in society and the virtual body of desire that takes the form of the male homosexual. This may explain hypothetically why the BL culture has expanded in Japan on a scale unseen in other countries. The process of assimilation to and divergence from the patriarchal standards envisioned in BL delineates the contours of a society where strict gender norms exist in actual life right alongside a well-developed education system that equips women with ideas of equal opportunities (that is, the pairing of capitalism x democracy). The affluence of women's image-consumption culture in Japan, from shōjo manga to cute character

merchandise, further helps to explain women's role as domestic consumers, even as they are systematically excluded from production and ownership of cultural/economic capital. Women's fan fiction seems to rest upon their frustrated realization of the paradox between patriarchy and equality.

While the present study relies almost solely on general genre conventions of BL, some emergent trends today clearly dispute the relationship observed between female parodies and male originals. Some mainstream entertainment media for boys, such as relatively high-budget anime by Sunrise Studio, use BL clichés to secure female fans' interest and promote secondary writing.[52] BL fan activity is already seen as an essential condition for business promotion and financial success, which alters the relationship between fans and official media I have been discussing. Popular manga for adult women, on the other hand, are increasingly adapting what BL fans consider to be "*yaoi*-like relationships" in heterosexual romance, i.e., the potentially romantic friendship based on matching abilities and competition.[53] Some prime examples include Ninomiya Tomoko's *Nodame Cantabile* (2001–2010) and Umino Chika's *Honey and Clover* (2000–2006, *Hachimitsu to kurōbaa*), both of which proved enormously successful. Yet another innovative change is emerging from a few manga that portray male homosocial relationships so intricately that they seem no longer to need romantic or erotic secondary fiction beyond supplementary episodes provided by faithful fans. One example is *Big Windup!* (2003–present, *Ōkiku furikabutte*), which presents a symbiosis of boys' sports manga and "*yaoi*-like" relationships by illustrating psychological growth and communication among members of baseball teams. The elements of human relationships in BL are quickly translating into nonerotic, often nonhomosexual stories that are widely enjoyed by readers beyond female BL fans. All these contemporary shifts imply that fan fiction and official media are interactively corroding the border between women's fantasies and mainstream ideologies—which makes us wonder if BL will disappear when the two grow close enough.

Notes

1. As of 2005. Komiketto Junbikai, *Komikku maaketto 30's fairu: 1975–2005 komikku maaketto sanjū shūnen kinen shiryōshū taisei* (Comiket 30's file: Commemorative collection of documents for Comiket's thirtieth anniversary, 1975–2005) (Tokyo: Komiketto, 2005).

2. Ibid., 290; Yonezawa Yoshihiro, "Dōjinshi & Komike: Hisutorii zadankai," *Juné Chronicle*, ed. Sun-Magazine Mook, 524–29 (Tokyo: Magazine Magazine, 2001), 525. The gender ratio of attendees is estimated as 43 percent male, 57 percent female; general

impressions reported by the mass media and participants agree that half of attendees are women.

3. Elizabeth Woledge, "From Slash to the Mainstream: Female Writers and Gender Blending Men," *Extrapolation* 46, no. 1 (2005): 50–65 at 50; Daniel Allington, "'How Come Most People Don't See it?' Slashing *The Lord of the Rings*," *Social Semiotics* 17, no. 1 (2007): 43–62 at 43.

4. "Fujoshi," literally "rotten girls," generally signifies female fans of male–male romance. Like *bara,* which originated from *barazoku* (slang for gay men), the use of this term is diversifying, with emerging variations like *fu* as a prefix or *fumuke* (i.e., aimed at *fujoshi*) to mean the genre. *Fujoshi* is the first and only term so far that attempts to define the genre by defining the reader/viewer. This term reflects the idea that texts have nothing in common to form a genre, while readers allegedly share common fantasies.

5. Yonezawa, "Dōjinshi & Komike," 525.

6. Woledge, "From Slash to Mainstream," 50.

7. Fusami Ōgi, "Gender Insubordination in Japanese Comics *(Manga)* for Girls," in *Illustrating Asia: Comics, Humor Magazines, and Picture Books,* ed. John A. Lent, 171–86 (Honolulu: University of Hawai'i Press, 2001), 180; Miura Shion and Kaneda Junko, "'Seme x uke' no mekurumeku sekai: dansei shintai no miryoku o motomete" (The dazzling world of *seme* x *uke*: Searching for the charm of boys' movements), *Eureka* 39, no. 7 (June 2007): 15.

8. The "mainstream" largely consisted of texts by two prolific auteurs, Satonaka Machiko and Ichijō Yukari. Futagami Hirokazu, *Shōjo manga no keifu* (Genealogy of shōjo manga) (Tokyo: Pengin Shobō, 2005), 99.

9. Yonezawa, "Dōjinshi & Komike," 524.

10. Matt Hills, *Fan Cultures* (London: Routledge, 2002), 162.

11. Henry Jenkins, *Textual Poachers: Television Fans and Participatory Culture* (New York: Routledge, 1992), 112.

12. Ibid., 109, 111.

13. Ibid., 7.

14. Allington, "'How Come Most People Don't See it?'"

15. Woledge, "From Slash to the Mainstream."

16. Catherine Salmon and Don Symons, "Slash Fiction and Human Mating Psychology," *Journal of Sex Research* 41, no. 1 (2004): 94–100.

17. Ien Ang, *Watching "Dallas": Soap Opera and the Melodramatic Imagination* (London: Methuen, 1985), 105–7.

18. John Fiske, "The Cultural Economy of Fandom," in *The Adoring Audience: Fan Culture and Popular Media,* ed. Lisa Lewis, 30–49 (London: Routledge, 1992), 31.

19. Ibid., 34.

20. Kenji Hashimoto, *Class Structure in Contemporary Japan* (Melbourne: Trans Pacific Press, 2005), 108.

21. Ibid., 127.

22. The average age of women participants at Comiket is 28.3 (Komiketto Junbikai, *Komikku maaketto 30's fairu,* 290) and the average age for women's first marriage is 28.2 (Ministry of Welfare). Both figures come from 2005 surveys.

23. "801" forum, 2channel Web site, www.2ch.net (accessed November 15, 2008).

24. Sakakibara Shihomi, *Yaoi genron: Yaoi kara mieta mono* (An illusory theory of *yaoi*: What *yaoi* shows) (Tokyo: Natsume Shobō, 1998), 105.

25. Nomura Research Institute (NRI), "News Release," 2005, http://www.nri.co.jp/news/2005/051006_1.html (accessed 15 November 2008). In response to past research that failed to present meaningful data by classifying consumers based on their gender, age, income, etc., NRI presented a new survey model that divides fan consumers into five types based on six factors in the degrees of creative activity, collection, and community. The five types are (1) married men who hide their otaku taste and manage a limited monthly allowance to purchase fan-oriented merchandise: 25 percent; (2) single men in their twenties and thirties who love mecha and pop music idols: 23 percent; (3) light users of 2channel and other online community sites: 22 percent; (4) mostly men in their thirties and forties who have strong values influenced by 1970s and '80s anime: 18 percent; and (5) women in their twenties and thirties who have strong attachments to characters and are active in fan fiction writing communities: 12 percent. These categories are archetypes, so to speak, and each group includes a minority of the opposite gender.

26. NONFIX, Fuji TV, November 21, 2007.

27. IT Media News, "Bōizu rabu ni tokkashita 'Otome saachi' keitai denshi shoseki" ("Otome search" site for finding boys' love cell phone books), October 19, 2007, http://www.itmedia.co.jp/news/articles/0710/19/news117.html (accessed 15 November 2008).

28. Yomiuri Online, February 21, 2007, http://www.yomiuri.co.jp/national/news/20070221i513.htm (accessed 21 February 2007).

29. All data about *Weekly Shōnen Jump* are provided by JMPA (Japan Magazine Publishers Association), "JMPA magajin deeta" (JMPA magazine data) and "JMPA dokusha kōsei deeta" (JMPA readers' demographic data), 2008, http://www.j-magazine.or.jp/data_001/index.html (accessed November 15, 2008).

30. Watanabe Yumiko, "Seishōnen manga kara miru yaoi" (Looking at *yaoi* from the perspective of boys' and young men's manga), *Eureka* 39, no. 7 (June 2007): 69–76 at 73–74.

31. I.e. *Mobile Suit Gundam* (1979–80, *Kidō senshi Gandamu*) and other anime series under the Gundam label. The titles most popular in BL are *Gundam Wing* (1995–96, *Shin kidō senki Gandamu wingu*), *Gundam Seed* (2002–3, *Kidō senshi Gandamu SEED*), its sequel *Gundam Seed Destiny* (2004–5, *Kidō senshi Gandamu SEED DESTINY*), and *Gundam 00* (2007–9, *Kidō senshi Gandamu 00*).

32. Marianne MacDonald, "*Harry Potter* and the Fan Fiction Phenom," *Gay & Lesbian Review* 13, no. 1 (2006): 28–30 at 29.

33. Amano Akira, *Katekyō hittoman REBORN!* Amano's manga has been serialized in *Weekly Shōnen Jump* since 2004 and was adapted into a TV anime (2006–2010). The fan fiction cited is the *dōjinshi* circle Ban'yū's *Aozora sanka* (Paean to the blue sky) (2006).

34. Patricia Frazer Lamb and Diana L. Veith, "Romantic Myth, Transcendence, and Star Trek Zines," in *Erotic Universe: Sexuality and Fantastic Literature,* ed. Donald Palumbo, 235–56 (New York: Greenwood Press, 1986), 242; Constance Penley, "Feminism, Psychoanalysis, and the Study of Popular Culture," in *Cultural Studies,* ed. Lawrence Grossberg, Cary Nelson, and Paula Trechler, 479–500 (New York: Routledge, 1992), 488; Jenkins, *Textual Poachers,* 221.

35. *Suki na mono wa suki dakara shōganai!!* abbreviated as *Sukisho*, the first commercial

pornographic BL computer game by SOFTPAL Inc. (2000), adapted into novels (2000–2005), a nonpornographic PlayStation game (2004) and a TV anime series (2005).

36. E.g. Penley, "Feminism, Psychoanalysis, and the Study of Popular Culture," 487; Jenkins, *Textual Poachers,* 220.

37. Mizoguchi Akiko, "Homofobikku na homo, ai yue no reipu, soshite kuia na rezubian" (Homophobic men, love rape, and queer lesbians), *Queer Japan,* vol. 2, 193–211 (Tokyo: Keiso Shobō, 2000), 194–55.

38. Jenkins, *Textual Poachers,* 220.

39. Mizoguchi, "Homofobikku na homo," 196–97; Ueno Chizuko, *Hatsujō sōchi: Erosu no shinario* (The erotic apparatus) (Tokyo: Chikuma Shobō, 1998), 134.

40. Nakajima Azusa, *Tanatosu no kodomotachi: Kajō hannō no seitaigaku* (Children of Thanatos: The ecology of hyperconformity) (Tokyo: Chikuma Shobō, 1998), 30; Mizoguchi, "Homofobikku na homo," 197.

41. Joanna Russ, *Magic Mommas, Trembling Sisters, Puritans, and Perverts: Feminist Essays* (Trumansburg, N.Y.: Crossing Press, 1985), 83.

42. Nakajima, *Tanatosu no kodomotachi,* 51.

43. The manga *Zetsuai* was serialized until 1989 and followed by its sequel, *Bronze Zetsuai,* after 1989; the series remains unfinished. Takahashi Yōichi's manga about young soccer players. *Captain Tsubasa* (1981–88) greatly contributed to the popularity of soccer in Japan. Its sequels include stories about Tsubasa in the World Youth League (1994–97) and in the Spanish League (2001–4).

44. Fujimoto Yukari, *Watashi no ibasho wa doko ni aru no? Shōjo manga ga utsusu kokoro no katachi* (Where do I belong? The shape of the heart reflected in shōjo manga) (Tokyo: Gakuyō Shobō, 1998), 189.

45. Miura and Kaneda, "'Seme x uke,'" 8–29, 18; Mizoguchi, "Homofobikku na homo," 200.

46. The example is taken from Ban'yū, *Saa koi o shiyōka* (Now then, shall we love?) (2007).

47. Mori Naoko, "Haado na BL: Sono kanōsei" (The possibilities of hard BL), *Eureka* 39, no. 7 (June 2007): 77–83 at 78.

48. Ibid., 79–80.

49. Penley, "Feminism, Psychoanalysis, and the Study of Popular Culture," 488.

50. Mizoguchi, "Homofobikku na homo," 203–4.

51. *Yu Yu Hakusho (Yū yū hakusho)* is a manga by Togashi Yoshihiro serialized in *Shōnen Jump* (1990–94) and adapted into a TV anime series (1992–95). Nobi Nobita is a penname Enomoto uses for *dōjinshi.*

52. Prime examples include the Gundam series and *Fullmetal Alchemist.*

53. Watanabe, "Seishōnen manga," 72.

EMILY RAINE

•••

The Sacrificial Economy of Cuteness in *Tamala 2010: A Punk Cat in Space*

There seems a certain fundamental link between cuteness and cruelty, something in cuteness that simultaneously provokes both a doting affection and desire to throttle. As Sianne Ngai puts it, there is "violence always implicit in our relation to the cute."[1] *Tamala 2010: A Punk Cat in Space* plays with this tension, articulating animal cuteness within an economy of sacrifice.[2] Cuteness and sacrifice are drawn together by their mutual assimilation into a smoothly functioning capitalism in the film's disorienting mash of narratives, animation styles, and arcane allusions and allegories. The film addresses the deployment of cute images as soft power by and for capitalism, showing how cute objects promise to help us forge affective relations with others, while actually displacing this affect onto mediated commodities. Such displacement serves to reproduce this model of capitalism, while cuteness masks the enigmatic and diffuse threat of violence that underlies it. This essay explores this articulation, first looking at how *Tamala 2010* reenacts theoretical accounts of sacrificial expenditure, and then addressing the consumption of cuteness; it concludes with a consideration of the relation of the two to information economies as embodied in the film by the robotic goddess Tatla. This analysis serves both to stage a reading of *Tamala* and to use the film's

> CUTE OBJECTS PROMISE TO HELP US FORGE AFFECTIVE RELATIONS WITH OTHERS, WHILE ACTUALLY DISPLACING THIS AFFECT ONTO MEDIATED COMMODITIES.

engagement with sacrifice and mass consumption to demonstrate the applicability of theories of sacrifice to the regimes of signification in which the postmodern economy reproduces itself. In other words, while theories of sacrifice enable us to better understand what drives the internal economy of *Tamala 2010,* the film in turn works to prove the aptness of this body of work as a lens for interpreting contemporary capitalism.

Tamala 2010 follows a sweet-faced kitten named Tamala to Planet Q, where violent battles rage between the dogs who control the planet and its downtrodden felines. She befriends a local cat named Michelangelo, and, as they circulate through Hate City, it is gradually revealed that Tamala is somehow affiliated with the ancient and mysterious Tatla cult, manifest as Catty & Co., the conglomerate that controls 96.725 percent of the GDP on Tamala's home planet and is in the process of establishing a foothold on Planet Q, beating out the native H.A.T.E. brand. At around the halfway point of the film, Tamala and Michelangelo go for a romantic picnic in the countryside, where Tamala is killed and eaten by Kentauros, a sadistic police dog. After her death, the planet's cats gain political and economic control, and the Catty logo emblazons every visual plane.

The film then moves into the future. Michelangelo has grown into an old man, Professor Nominos, who has obsessively researched Tatla, the Minervan cult, Catty & Co., and the perpetually young kitten named Tamala selected to market and represent them. He reveals that the Minervans, after centuries of persecution, moved underground, establishing themselves as a secret postal service. They ultimately moved into consumer goods as Catty & Co., employing Tamala to colonize markets and using their control over communications to exercise power. They worship the robotic goddess Tatla, who is capable of self-propagation to such a degree that her excess is presently creating another world. The locus of the cult's activities is sacrifice, what Nominos describes as "repeated destruction and rebirth, the progress of an undying world. Their activity is based in a crazed doctrine devoted to live sacrifice," with Tamala as their recurring victim.

The tale is presented in nonlinear fashion, as a palimpsest of elements in multiple and overlapping periods and spaces. Each layer operates in a distinct visual and sonic register and is accorded its own color palette, symbolic motifs, animation style, generic musical scoring, and sound effects. For example, the majority of sequences featuring the robotic Tatla are executed in

FIGURE 1. Tamala is shown on a crucifix in *Tamala 2010: A Punk Cat in Space.*

strongly saturated color CGI, accompanied by a droning score and echoing tinny industrial sound effects—all elements that serve to exaggerate her unnaturalness, while Tamala's segments are fashioned entirely in inviting grayscale Bezier curves.

The themes of Tamala's cuteness, capitalism, and violent sacrifice are intertwined in the film, such that they beg to be addressed as a singular thematic expression. The presentation of characters and the film's plot resonate with the philosophical writings of Georges Bataille, in particular those on animality and the general economy. Sacrifice, the zenith of Bataille's theory, structures Tamala's role in Catty's soft-power informational economy, which the film uses to develop a parallel critique of consumerism and the manipulation of affect in postmodern society, particularly as these are manifest in the orientation of social relationships around commodity-objects. Capitalism is the hinge upon which cuteness, sacrifice, and commerce are articulated together.

CAPITALISM, KITTENS, AND SACRIFICE

Bataille famously developed a critique of traditional economic theory, which he argued fails to take into account the entirety of human life, including

ethics, culture, and the natural world. Against this restricted economy that accounts only for the production of wealth, he posited a general economy, one premised upon surplus rather than scarcity as the basis of human economic organization, such that the disposal of surplus (and not accumulation) becomes the defining characteristic of a culture.[3] He suggests that culture and economics can best be understood in terms of how organisms dispose of their energy surpluses, or how value is destroyed rather than created. In his account of the general economy, Bataille writes,

> The living organism . . . ordinarily receives more energy than is necessary for maintaining life; the excess energy (wealth) can be used for the growth of a system (e.g., an organism) if the system can no longer grow, or if the excess energy cannot be completely absorbed in growth, it must necessarily be lost without profit; it must be spent, willingly or not, gloriously or catastrophically . . . energy, which constitutes wealth, must ultimately be spent lavishly (without return), and that a series of profitable operations has absolutely no other effect than the squandering of profits.[4]

In this scheme, all of production is ultimately geared toward a nonproductive squandering of excess accumulation, and this waste is sacred because it is only here that humans act wholly without the motivation of gain. As such, in Bataille's general economy, a society can be better understood in terms of how it disposes of its surplus and expends its waste than by what or how it produces—whether this energy is spent in potlatch, the sacrifice of virgins, maintaining religious orders, or sponsoring colonial wars.

The sacrifice, as the preeminent form of the disposal of a society's excess, forms the nucleus of Bataille's ethics. The resonance of this theory with *Tamala* is clear: the film devotes considerable attention to sacrifice and Tamala's role in it. The key to her part in the general economy is unveiled when Nominos describes the Minervans to his younger incarnation, repeatedly underlining the root of the cult in this rite. He describes Tatla as a "beautiful goddess repeating destruction and rebirth . . . This appetite for destruction and rebirth is hardwired in Tatla's program. This being 'destroy things, buy things, then destroy them.'" The cycle of destruction and rebirth requires the sacrifice of Tamala, as the symbol of cuteness and of exuberant aesthetic perfection, for, as Nominos continues, "Destruction and rebirth feeds on sacrifice of beauty."

Again, what is foremost in the sacrifice is the break with the logic of accumulation and gain. Bataille describes the sacrifice as a rupture with utility, and here lies its sacredness:

Sacrifice destroys that which it consecrates. It does not have to destroy as the fire does; only the tie that connected the offering to the world of profitable activity is severed, but this separation has the sense of a definitive consumption; the consecrated offering cannot be restored to the real order. This principle opens the way to passionate release; it liberates violence while marking off the domain in which violence reigns absolutely.[5]

However, read in light of this passage, Tamala's sacrifice can be seen as a failure in Bataille's terms. The violence on Planet Q continues unabated after her death, and her objectification as an advertising icon is only reinforced by the persistent, almost viral proliferation of her image. Her use value as an image remains; only Tamala's renewable physical form dies. When Nominos visits Michelangelo, he tells him that there is no revenge in consumption, that Tamala's sacrifice resolves nothing, "turning [her] into nothing but an emotional anti-cat." This sacrifice of the locus of cuteness-as-commerce produces the joyless consumption of Q's inhabitants, who circulate the city devouring Catty's products while remaining affectively flat. However, by enabling this consumption, Tamala's sacrifice succeeds within the narrative of the film, where it works to reproduce and expand the commercial empire of Catty & Co., suggesting that perhaps the economy of sacrifice is modulated differently today than when Bataille was writing. Before turning to how *Tamala 2010* asks us to reconfigure Bataille's theory of sacrifice, let us look at how the film maps onto Bataille's critique of commodity culture.

> THE CYCLE OF DESTRUCTION AND REBIRTH REQUIRES THE SACRIFICE OF TAMALA, AS THE SYMBOL OF CUTENESS AND OF EXUBERANT AESTHETIC PERFECTION.

Writing in the mid-1940s, Bataille argued that joyful and sacred expenditure have been replaced by the accumulation of the vast scores of things that we collectively produce under capitalism.[6] He claimed that while we do generate infinite reserves of waste in our cycles of fashion and obsolescence, we take no joy in this expenditure and are constantly engaged in a game of catch-up with the perpetually deferred desire for the perfect commodity. Thus, the potential sense of playful abandon is instead sublimated into the muted pleasure of accumulation. The danger of this sublimation, however, is that waste that could be expended in play must instead be routed elsewhere, becoming the "accursed share" that haunts us in our refusal to burn it.

Bataille maintained that commodity culture deteriorated or destroyed the heterogeneous connections between individuals within their social

communities. Heterogeneous ties are the organic links formed between members of a community based on ideals of spontaneous cooperation, mutual affection, custom, shared participation in festivals, and the enactment of rituals, which he contrasts to homogeneous links, which are organized and enforced by work, law, and institutional obligations.[7] Instead of heterogeneous ties, commodities and possessions mediate social relations; for Bataille, "capitalism in a sense is an unreserved surrender to *things*."[8] The alienation from desires that took seed in Calvinist self-denial and the Protestant work ethic outlined by Max Weber has culminated in a postindustrial capitalism characterized by servitude and enslavement to objects. This enslavement, in Bataille's account, signals a double thingness: submitting to the world of things makes us, in turn, more thing-like, more alienated from natural life.

We see this submission to the world of things in Michelangelo, Tamala's companion. He is implicated in systems of cultural connoisseurship, seeking out rarefied commodities such as vintage jeans from CatEarth and making urbane references to film and literature. Until Tamala's death, he seems emotionally inert and inexpressive, and he rejects his own animal nature, shown by his disinterest in dating, and, initially at least, in Tamala herself. He blushes prudishly when Tamala offers him a saucy come-on, telling her, "I don't like it very much. Mating and all. Watching an Eastwood video is more fun," and he confesses to taking Kittynol, a drug that stifles sexual impulses. In Bataille's terminology, Michelangelo exemplifies transcendence, separation from immanent experience of the world through rational contemplation, as opposed to the immanence of both Tamala and the brutish Kentauros. Tamala is immanent to her world and unaware of her role in the sacrificial economy; she dies but is unaware of death as a frame to offer meaning as the end of life.[9] Bataille calls this animality, a state of pure immanence divorced from the calculating distance of humans who hedge bets and rationalize, an animality unconscious of the regulation of desires that is "*in the world like water in water*," without need of contemplative mediation.[10] It is this part of Tamala, her animal affectivity, that is sacrificed to perpetuate Catty.

Tamala's sacrifice is successful in its ability to expand the Catty empire, suggesting that, in spite of its incapacity to cleave a rupture with utility, the rite does on some level "work." This suggests that perhaps Bataille's model does not map perfectly onto the capitalist regime operating in the film and could be updated to better account for shifts in the nature of the economy since he wrote. Jean-Joseph Goux provides a clue as to how we might reconcile the

productivity of sacrifice for contemporary capital in Tamala with Bataille's articulation of the supposedly wasteful act of sacrifice. Goux critiques Bataille's casting of the "timeless" anthropological practice of sacrifice and expenditure while arguing that the "historical singularity" of capitalism does not and cannot engage in this practice, always reinvesting the potential sacrifice toward future returns.[11] He commends Bataille's critique for baring the split rendered by the economy between the sacred and the profane, in which "the profane is the domain of utilitarian consumption, the sacred is the domain of experience opened by the unproductive consumption of the surplus: what is sacrificed."[12] By bracketing art, eroticism, and the sacred from considerations of human activity, the restricted economy was able to secularize ethics and prioritize utility above all. However, Goux points out the affinities between Bataille's work and that of arch neoconservative George Gilder's *Wealth and Poverty,* a text that reproduces many of Bataille's points, but with radically different ends. Gilder's argument, notes Goux, describes capitalism itself as potlatch, founded on the unknowability of consumer desire at market, which it must try to arouse and capture through novelty. For Gilder, capitalism must supply in order to create demand. This means that capitalist production is always a gamble, an irrational speculation that is fundamentally opposed to the Weberian iron cage of rationality Bataille finds there.[13] In short, the productive work of capitalism is *itself* an act of sacrifice, in that it might not be met with consumption or desire.

Goux contends that Bataille's failure to grasp capitalism's irrationality, its fundamental reliance on sacrifice, was an accident of unfortunate timing, that he did not see the emergence of the full-blown consumer society, instead sponsoring a "romantic image of capitalism as a moral anomaly."[14] Gilder, he argues, merely pinpoints the applicability of Bataille's theory of the general economy to contemporary capitalism. Today, luxury and affluence are so generalized that we cannot clearly distinguish between utilitarian consumption and exuberant waste, such that the distinction between utility and luxury grows idiosyncratic and subjective.[15] Thus, he argues,

> If one remains on strictly economic ground, it is in truth impossible to
> separate productive consumption from unproductive squandering. Ethical
> criteria alone could claim to make this distinction. It is perhaps one of the
> aspects of our society to have erased at once the opposition between the
> sacred and the profane, and with the same gesture, the difference between
> the useful and the useless, the necessary and the superfluous, primary need
> and secondary satisfaction, etc.[16]

The difference between expenditure now and in the societies described by Marcel Mauss and Bataille is ultimately one of representation, of its role in the imaginary. Goux's reading of Bataille seems closer to the moral space occupied by Catty & Co., which at once frames the sacrifice and serves as the regime that imposes the moral imperative of consumption. The film thus stages Goux's critique by rendering the space of neoconservative economics that Catty & Co. occupies at once sacred and profane, two modalities that are mediated by the cuteness of Tamala herself, who represents both the profanity of utilitarian consumption and its sacrificial object. Catty, in turn, serves as both the engine of sacrificial expenditure and the beneficiary of this capitalist gamble.

Despite *Tamala 2010*'s critical revision of Bataille, his critique of the general economy continues to be useful in attempting to read the film insofar as it directs critical attention toward the manipulation of meaning within this regime, where signs become commutable and are evaluated against one another. Tamala, as the spokeskitten and symbol for Catty, materializes this system of signification, for it is her image that is displayed and assigned desirable attributes to coerce the residents of Planet Q to consume Catty's diverse offerings. Tamala represents the ineffable immaculateness of consummated desire, the supermodel or happy housewife that consumers strive toward with every purchase, as well as the moments of affective connection with advertisements' representations of consumer goods. Her sacrifice, which renders her "an emotional anti-cat," produces our affective relations with her mediated image, casting relations with commodities as emotional engagements rather than determinations of utility or luxury. This, in turn, is driven by the viral expansion of her image in the Catty advertisements that mediate consumer desire using her image. Using her as a model of perfection, every transaction paradoxically seeks out the very animal immanence from which consumers become further removed with each purchase, further objectified by the accumulation of ever more stuff and still waiting for the returns promised by already-purchased commodities.

CUTENESS AND MASS COMMERCE

The characters in *Tamala 2010* are primarily presented as agents that stimulate emotional responses rather than as psychological beings. The core affective element is of course Tamala herself. She is animated in smooth Bezier curves and is drawn with the enlarged cranium, round face, enormous eyes,

FIGURE 2. One of Tamala's many billboards, for Tamalatti scooters.

and neotenous proportions that viewers innately respond to as "cute."[17] Tamala's cuteness articulates a parodic critique of the use of infantilized animal figures as commodities in Japanese *kawaii* culture. Since she is a cat, the film explicitly caricatures Sanrio's Hello Kitty, easily the most salient cute image in Japan, with thousands of products bearing the design. As Sharon Kinsella argues, the *kawaii* aesthetic is engaged through commodities, where young people absorb "cute culture through consumption of cute goods with cute appearances and emotional qualities."[18] She identifies the emergence of the *kawaii* fetish in the mid-1960s, coincident with a much broader shift in Japanese society toward a "massified" popular culture of mass retail, mass media, and mass fashion trends, moving away from traditional arts and crafts. While young girls initially started and spread a *kawaii* handwriting trend, companies such as Sanrio quickly appropriated the aesthetic and churned out "fancy" consumer goods bearing cute cartoon characters, marked as such by their inflated crania, large eyes, and lack of genitalia and other orifices. Kinsella posits that such cartoony characters served to soften the transition toward the consumption of mass-produced items, giving them an emotional resonance by stimulating an affective response; she writes that, "what capitalist production processes de-personalize, the good cute design re-personalizes."[19] Tamala and her cuteness grace Catty's ubiquitous marketing materials, simultaneously objectifying and implicating her in their colonization of new markets and making her the harbinger of total domination for each new planet-market where she and the company alight. This role distinctly mimics the use of cute goods to facilitate the shift toward mass consumption in

Japan remarked by Kinsella. She finds that *kawaii* constitutes an embrace of materialism through its emphasis on "individualistic consumption and the cute values of sensual abandon and play, which provided an apology for consumption."[20]

For the young, mostly female participants in *kawaii* culture, the consumption of cute products is also a form of youthful rebellion, an aspect that Kinsella hesitantly connects to the role of punk, making her argument particularly compelling when read alongside *Tamala 2010*. Where punk rejects mass-produced consumerism and adopts a stylized nihilistic ugliness to critique the cultural climate and values of the previous generation, *kawaii* culture embraces saccharine visual flourishes on mass-produced commodities in order to reject traditional production processes and aesthetics, ultimately espousing a comparable polemic. Kinsella argues that cute culture enacts a refusal of adult mores and obligations by embracing all things childlike. Cute materialism extends participants' idealized childhood, which, for the cuties in Japan, has meant that young women choose to work, earn, and consume for longer, rather than succumbing to the isolation and responsibilities of married life. Like punk, *kawaii* rejects grown-up social obligations, preferring an idealized perpetual childhood instead; thus, cute culture, like punk, constitutes a coherent politics of resistance only where there is a refusal of the future. Tamala straddles this double rejection: she exhibits a repudiation of adulthood and of the "straight" culture decried by punk, manifest in her tendency toward antisocial behaviors such as swearing, stealing, engaging in random violence, and refusing adult language. She lives in a present with no future and a history that repeats, mimicking *kawaii*'s obsession with an idealized past in her unending and fruitless search for a long-dead mother.

Kinsella's history of *kawaii* consumption also takes into account the role that cute commodities play in mediating social relationships. She argues that

> consumption of lots of cute style goods with powerful emotion-inducing properties could ironically disguise and compensate for the very alienation of individuals from other people in contemporary society . . . Modern consumers might not be able to meet and develop relationships with people, but the implication of cute goods design was that they could always attempt to develop them through cute objects.[21]

Kinsella's position here can be distinguished from Bataille's. For Bataille, the consumption and display of mass-produced commodities are essentially individual accomplishments, and we are ourselves objectified and further

alienated and isolated by our self-mediation using culturally coded things. Kinsella posits that there is the promise for the mediation of social relationships *using* cute objects, but she seems hesitant to conclude that they are actually able to form them.

Cute objects' apparent ability to perform emotional work and facilitate affective bonds brings to mind Todd Gitlin's reading of Georg Simmel's metropolis. Simmel argued that the stimulation of metropolitan life leads urbanites to develop a mental carapace, what he calls a blasé attitude, which enables them to block out the overwhelming panoply of sights and sounds in the city. Simmel's city dwellers are a calculative lot, with eyes forever open to opportunity.[22] Gitlin, however, posits that there is a gap in Simmel's blasé attitude, finding that people experience ephemeral affective or sensual engagements constantly as they circulate through the city, that commodities and media provide tiny distractions that are needed in order for subjects to feel and relate.[23] It is, he argues, the very rationality of city life that forces urbanites to seek out these moments of sensation and affect as compensation for the mental drudgery of constant calculation. Importantly though, for Gitlin they "experience, and crave, particular kinds of feelings—disposable ones."[24]

Such disposable affective moments are precisely what cute is all about. Daniel Harris writes that, "cuteness is the most scrutable and externalized of aesthetics in that it creates a world of stationary objects and tempting exteriors that deliver themselves up to us, putting themselves at our disposal and allowing themselves to be apprehended entirely through the senses."[25] The cute commodity or advertisement enables the experience of transitory moments of intense affective release as a series of disposable connections with equally disposable cute things. Tamala's cuteness is reified in the commodities her image is used to hawk, sealing in her ineffable magic and beckoning with the promise of her immanent exuberance. Although Catty's marketing materials feature Tamala at play with images of commodities divorced from use-value, her audience forges affective engagements with the mediated commodities and Tamala's proximity to them, rather than forming a more heterogeneous bond with Tamala herself.

These fleeting sensations are not without a sinister undertone. Cuteness suggests infancy and a certain helplessness; it invites touch, and, according to Sianne Ngai, solicits manipulation: "in its exaggerated passivity and vulnerability, the cute object is as often intended to excite a consumer's sadistic desires for mastery and control as much as his or her desire to cuddle."[26] The cute thing simultaneously solicits a desire to cuddle and throttle; a certain violence is implicit in it. She notes that it is the viewing subject who imposes

the status of cuteness on the cute object, and in so doing establishes the aggressive or overpowering relationship with the cute thing; but, she argues, the cute thing itself exerts a kind of passive power over its observers. Because of this, as Harris notes, "cuteness thus coexists in a dynamic relationship with the perverse."[27]

This tension between cuteness and perversity culminates in Tamala's murder. The moment of her sacrifice underlines the importance of cuteness as that which is sacrificed; Kentauros neatly amputates her head, literally eating Tamala's cute face as the locus of affectivity and absorbing her cuteness into his violence. He is drawn differently than other characters in the film, with jagged edges on his fur, black eye sockets, and a large, always-open and heavily fanged mouth at the end of a decidedly pointy snout—in short, the very antithesis of cute. Kentauros is an affectively stimulating character, but he provokes fear and dread rather than ambivalent affection. He engages in perverse violence with great relish, gleefully beating cats and torturing his (cute) pet mouse Penelope, even plastering his walls with images of her pinioned and trussed up in S&M gear.[28]

Kentauros is Greek for centaur, the half-man, half-horse that symbolizes the struggle between civilization and barbarism in Hellenic mythology. He wears the uniform of a police officer, ostensibly a signifier of civilized order, but he is inarticulate and communicates only through direct blows and the grunts that make up his "speech." In a sense, Kentauros and Tamala occupy two sides of the same symbolic coin, for each represents a form of immanent animality. As such, Kentauros—who is unconscious of, cannot escape, and is ultimately an empty agent of Tamala's sacrificial death[29]—embodies the tension between perverse desires and the civilized behaviors demanded by the proscriptions and taboos of homogeneous social life. As the symbols of their respective social origins—Tamala the model for Catty's aggressive mass marketing and Kentauros the brute force policing Planet Q and H.A.T.E.—the two characters also stand in for the bonds between the two social orders they represent.

When Tamala is devoured by Kentauros, in the play of power on Planet Q, it is Catty that triumphs. At the very moment of Tamala's sacrifice, Catty's commercial colonization of Q is complete, and the city erupts into a particularly vicious spate of cat-on-dog violence, juxtaposed against shots of kittens spray-painting Catty logos and the company's suddenly ubiquitous advertisements. The acme of this violence is reached when Kentauros is forced to helplessly watch his lover die beneath a large graffiti reading "a little bit of Joy." In a subsequent scene, a uniformed Catty messenger effaces the dog's

remains, leaving no trace of the violence. This image illustrates the transition from the canine regime of H.A.T.E. to the feline order of Catty & Co., featuring cute kittens and mass production. In this transition, a period of extreme brutality is sanitized and obfuscated by a well-organized cleaning operation that leaves no trace of the violence underlying its orchestration of social order. Tamala's violent sacrifice thus sets the stage for Q's complete domination by Catty and Tatla, bodies that stand in for an informational economy that exerts a determination of meaning that borders on mind control.

FIGURE 3. Tamala's headless body lies amid vines and flowers after she is killed by Kentauros.

FIGURE 4. Kentauros's lover lies dead underneath a graffiti that reads, "A Little Bit of Joy."

SOFT POWER AND THE ECONOMY
OF SIGNIFICATION

Tamala 2010: A Punk Cat in Space evinces a critique of the circulation of knowledge and the control of images in the informational economy, manifest in Catty's conquest of Planet Q using information systems, marketing, and outright mind control. Catty begins its colonization of the planet's market by taking over its communication and transportation infrastructure. The corporation seizes the opportunity provided by perceived failures in the existing communications system, announced by minor characters' complaints about missed phone calls and letters that don't arrive, to put in a bid for entrance into the market. The postal system in particular is an extremely important trope in the film, one used with reference to Thomas Pynchon's *The Crying of Lot 49*.[30] Of the film's numerous and diverse intertextual references, this is among the richest; indeed, many elements of its plot are lifted directly from Pynchon's novella. In his story, the central character, Oedipa Maas, is set with the task of unraveling the mystery of a secret organization, playing a role much like that of Michelangelo Nominos after Tamala's death. Oedipa tracks Tristero, an alternative postal system from long ago that was forced into hiding after being defeated by rivals Thurn & Taxis. Like the Minervans, Tristero continues to exist as an underground organization, remaining active and organized through the operation of a secret postal system using mailboxes marked W.A.S.T.E.

Where the two narratives differ is that while Pynchon's novella is essentially about failures of communication and the desire to create meaning of one's own subjectivity, in *Tamala 2010* systems of information are implicated in structures of control. In other words, the issue is more one of the *successes* of information management. In each case, diffuse systems of communication point to the existence of an even more diffuse but no less totalizing concentration of power; however, the precise nature of this power is not or cannot be revealed. In *Tamala 2010,* these diverse threads are woven together by capitalism.

Nominos's history of the Minervan cult details how their secret mail systems were integrated into the Catty corporation. He claims that "they realized something. The power of information. If they could control the vortex of information in—blackmail ransom letters, fluctuations in exchange rates, you name it—they could rule the planet and get revenge." In short, Nominos outlines Catty's redirection of corporate resources from a movement concentrated on mass extermination to one premised upon the control of

signs, images, and information and on the ma-
nipulation of affect. Catty's restructuring paral-
lels a broader cultural transition from a modern
to postmodern economy, in which information
management and affective services are increas-
ingly central to economic activity. The dangers
of such "soft" regimes of diffuse power appear
to be one of t.o.L.'s chief concerns in the film,
where the management of information and af-
fect slips easily into violence and mind control.
All of this information is literally materialized
in the robotic Tatla, where it becomes materially
productive. Nominos claims that "Tatla is grow-
ing. The result of this excess self-propagation is
the creation of another world. A world different

FIGURE 5. A Catty messenger surveys
Tamala's progress on Planet Q.

from ours, one of terrible nightmares." Tatla's control of information is so
complete that she has accumulated an excess of information, which spills out
to not only colonize but to *create* other worlds. While this excess is formed by
affective engagements with cute commodities, its dark side is the viciousness
that accompanies these engagements.

The moment of the sacrifice itself is intensely reproductive: in the woods
where Tamala is dismembered, a spider drops its eggs and flora quiver with
eroticism. After this death, which reproduces Tamala's disfigurations on Tat-
la's robotic body, Tamala's body is covered with vines that immediately bloom
and flower, the sublime that remains after expenditure. This rupture with ani-
mal immanence serves to feed Tatla's mechanical world, in which Tatla can be
said to embody the ultimate masculine paranoid trope of the self-reproducing
woman for whom man is no longer necessary, projected into a machine.
Moreover, this machine is at many points left to stand in for the whole of the
postmodern economy, which seems similarly able to operate and reproduce
itself literally and symbolically independently of individual contributions.

Tamala's sacrifice is thus double: she is sacrificed to feed the robotic Tatla's
empire, while she enables Catty's consumers to experience ephemeral bursts
of affect by engaging with Tamala's image on billboards and commodities—a
factor that t.o.L. themselves harness in employing the eminently market-
able cute Tamala as their protagonist. Reading *Tamala* alongside Goux and
Bataille demonstrates that it is her sacrifice that invites these affective affilia-
tions; when Tamala dies, billboards bearing her image fill every surface of the
Hate City skyline, and it is only then that cats are shown actually consuming

Catty products. Tamala serves as a stand-in for Tatla and Catty on Planet Q, and it is her death that enables the Minervan conspiracy to establish the link between the affective affiliations with Tamala's advertisements and the actual consumption of Catty goods. Tamala's sacrifice in the film shows that while there *is* sacrifice in the postmodern economy, it functions in such a way that it does nothing to restore the heterogeneity of social bonds, while remaining premised upon the promise of them. This opportunistic regime is enabled by the sacrifice that appears to make a break with utility while actually displacing this instrumentality onto consuming subjects.

Catty's manipulation of these cathartic moments is also linked to the mediation of social bonds by commodities in order to critique the subjugation of natural life—human or otherwise—to a world of inanimate objects coded by the diffuse powers of a capitalism engaged in the ascription of meaning to things. The film points to the tyranny of these transitory affects, where there is an exploitation of the natural, affective, or animal that feeds the affectless machinic capitalism of Catty and Tatla. While the spontaneous release of the joyful sacrifice is deferred, we are left instead with disposable affects, fleeting relationships with images. The film's palimpsest of narratives, themes, and motifs is just muddy enough to continually defer any conclusive or totalizing understanding of its narrative, moral, or message, forcing us to engage with the film itself through such flashes of emotional release. Mimicking the logic of postmodern capitalism itself, the film's viewers who might seek to unravel the complex interwoven sequences are forced to "wait just a moment longer."

...

Notes

1. Sianne Ngai, "The Cuteness of the Avant-Garde," *Critical Inquiry* 31 (Summer 2005): 823.

2. *Tamala 2010: A Punk Cat in Space,* dir. t.o.L (2002).

3. Georges Bataille, *The Accursed Share, Vol. I,* trans. Robert Hurley (New York: Zone Books, 1989), 12.

4. Ibid., 21–22.

5. Ibid., 58.

6. Ibid., 129–31.

7. Michael Richardson, *Georges Bataille* (London: Routledge, 1994), 35–36; Georges Bataille, "The Psychological Structure of Fascism," in *Visions of Excess: Selected Writings, 1927–1939,* trans. and ed. Allan Stoekl, 137–60 (Minneapolis: University of Minnesota Press, 1985).

8. Bataille, *Accursed Share,* 136.

9. Georges Bataille, *Theory of Religion,* trans. Robert Hurley (New York: Zone Books, 1992), 17–20.

10. Bataille, *Accursed Share,* 34. Italics in the original.

11. Bataille, *Accursed Share,* 199.

12. Jean-Joseph Goux, "General Economics and Postmodern Capitalism," trans. Kathryn Ascheim and Rhonda Garelick, in *Bataille: A Critical Reader,* ed. Fred Botting and Scott Wilson (Oxford: Blackwell, 1998), 197.

13. Ibid., 201.

14. Ibid., 204.

15. Ibid., 209.

16. Ibid., 208.

17. See Stephen Jay Gould, *The Panda's Thumb: More Reflections in Natural History* (New York: W. W. Norton, 1980), 98.

18. Sharon Kinsella, "Cuties in Japan," in *Women, Media, and Consumption in Japan,* ed. Lise Skov and Brian Moeran (Richmond: Curzon Press, and Honolulu: University of Hawai'i Press, 2001), 245.

19. Ibid., 228.

20. Ibid., 247.

21. Ibid., 228.

22. Georg Simmel, "The Metropolis and Mental Life," in *The Urban Sociology Reader,* ed. Jan Lin and Christopher Mele, 23–31 (New York: Routledge, 2005).

23. Todd Gitlin, *Media Unlimited: How the Torrent of Images and Sounds Overwhelms Our Lives* (New York: Metropolitan Books, 2001), 34.

24. Ibid., 41.

25. Daniel Harris, *Cute, Quaint, Hungry, and Romantic* (Cambridge, Mass.: Da Capo, 2000), 8–9.

26. Ngai, "Cuteness of the Avant-Garde," 816.

27. Harris, *Cute, Quaint, Hungry and Romantic,* 17.

28. *Tamala 2010* also engages cuteness as an economy of affection and cruelty in its orientation toward pets, and particularly of the desire for cute pets. The film shows humans abandoning or losing interest in pets that have lost their novelty or infantile appeal, essentially reducing the discarded or forgotten pet to an object-commodity that has exhausted its fashionableness. This theme echoes John Berger's critique of animals' cooptation, as pets, into the family as spectacle, for it is precisely this treatment of animals that accompanies humans' "universal and personal withdrawal into the private small family unit, decorated or furnished with mementoes from the outside world." John Berger, *About Looking* (New York: Pantheon Books, 1985), 12. Because the pet is a spectacle and a "keepsake" from the outside world, it is subjected to the same rigorous aesthetic standards as inanimate possessions and can thus be expected to retain its value by remaining perpetually cute. The animal's inevitable failure to do so constitutes a sort of obsolescence. In the film, even the eminently cute Tamala faces possible replacement by a newer model, and she complains that, "me fucking Anaconda Mom won't gib me any treats . . . The bitch wants to trade me in for a Persian. Persians are smaller and uglier but they feel like velvet."

29. Tatsumi Takayuki, "The Advent of Meguro Empress: Decoding the Avant-Pop Anime *Tamala 2010,*" in *Cinema Anime,* ed. Stephen T. Brown, 65–77 (New York: Palgrave Macmillan, 2006), 74.

30. See ibid., 73.

JAMES WELKER

•••

Flower Tribes and Female Desire: Complicating Early Female Consumption of Male Homosexuality in Shōjo Manga

Shōnen'ai (boys' love) manga is not about homosexuality. Or at least, many critics, scholars, and artists of shōjo (girls') manga, of which *shōnen'ai* is a subgenre, have long denied a connection between "real homosexuality" and these narratives, which depict beautiful adolescent males in romantic and/or sexual relationships with each other.[1] Multiple functions have been ascribed to the *shōnen'ai* genre, created by and for females, and the *bishōnen* (beautiful boy) characters who serve as protagonists in these works, yet this denial has remained consistent.[2] Many readers, however, have drawn their own conclusions.

In this essay I help to challenge this purported disconnect between homosexuality and the *shōnen'ai* genre through a contextualized examination of female readership of the magazine *Barazoku* (Rose tribe), a magazine aimed at "*homo*" men in Japan.[3] Moreover, I work to unsettle, rather than assume, the widespread notion that female consumers of *shōnen'ai* and other images of male homosexuality are necessarily (proto)heterosexual.[4] By turning to female readers of *homo* magazines in the 1970s and 1980s, the heyday of the genre, I illustrate that some fans of the genre did indeed link it to the real lives of *homo* men, as part of a larger local sphere of consumption

FIGURE 1. The cover of Takemiya Keiko's *In the Sunroom* (1976, *Sanrūmu nite*), a reprint of the first *shōnen'ai* narrative.

of images of "*homo*" men from Japan as well as abroad. Correspondence printed in *Barazoku* demonstrates that a number of *shōnen'ai* manga readers and other women employed not just fantastic images of *shōnen'ai* but also their (mis)understandings of the "real" lives of homosexual men as a means to critique the oppressive power dynamic of male–female romantic relationships. And for some, images of male homosexuality—both "real" and fantastic—helped them to understand and validate their own same-sex desire or nonnormative gender identification. In short, I suggest that this sphere was a site of blurring between *homo* lives and *shōnen'ai* manga, between adolescence and adulthood, between females who love other females and those who love beautiful boys, and—as I will show in this essay—between "lilies" and "roses."

SHŌNEN'AI AND GIRLS' LOVE

The first commercially published *shōnen'ai* manga narrative was Takemiya Keiko's *Sanrūmu nite* (1976, In the sunroom), which initially appeared under the title "*Yuki to hoshi to tenshi to . . .*" (Snow and stars and angels . . .) in the December 1970 issue of *Bessatsu shōjo komikku* (Girls' comic extra).[5] Like most early *shōnen'ai* manga, the work's protagonists were beautiful boys in love with each other and the story was set in Europe. Anything but marginal, the *shōnen'ai* narratives that followed were penned by a large number of professional female artists during this period and were arguably central to the radical transformation of shōjo manga in the 1970s.[6] Moreover, these works helped set the stage for the now global production and consumption of the newer genres "BL"/"boys love" and "*yaoi*" manga and anime, which developed

later but which also depict romantic and erotic relationships between beautiful males for female consumption.[7]

Ishida Minori's *Hisoyaka na kyōiku: "Yaoi/bōizu rabu" zenshi* (2008, A secret education: The prehistory of *yaoi* / boys' love) is perhaps the most authoritative history of the origins of *shōnen'ai* manga. The book is based in part on extensive interviews with several individuals who played key roles in the genre's creation and development. Among them is the long-overlooked Masuyama Norie, a novelist and music critic who originally conceived of the introduction to shōjo manga of beautiful boys in love with each other and who encouraged pioneering artists Takemiya Keiko and Hagio Moto to give life to her ideas. Masuyama believed shōjo manga needed to be revolutionized from a frivolous distraction into a serious literary form; she helped steer Takemiya and Hagio toward the creation of works that variously drew upon and extended the strong bonds between male adolescents depicted in Herman Hesse's novels, and the love of and by eroticized beautiful boys celebrated in the writing of Inagaki Taruho, whose *Shōnen'ai no bigaku* (1968, The aesthetics of boy loving) can be linked to the use of the term *shōnen'ai* as a label for the genre.[8] Masuyama saw the metaphysical sphere of "*shōnen'ai*" in shōjo manga, as well as in Taruho's writing, as quite distinct from "homosexuality" as depicted in the works of (for instance) Mishima Yukio and Shibusawa Tatsuhiko, which she believes requires the presence of physical male bodies.[9]

The lithe, beautiful, and often European bodies of the beautiful boy characters, on the other hand, were anything but masculine. As a case in point, when editors at one shōjo manga magazine resisted the use of a boy on the cover, Masuyama successfully insisted that the drawing was of a girl and thus was indeed suitable.[10] Feminist scholar Ueno Chizuko has contended that ultimately the beautiful boy is "neither male nor female" but a "third sex/gender," asserting that "it is only a person's mind, which is bound by the gender dichotomy, that mistakes that which is not a girl for a boy."[11] Yet interviews with artists suggest that, however feminized he may be, the beautiful boy character is at least in the minds of his progenitors a *he,* however "queer" he may be.[12]

Critics and scholars have long argued that the beautiful boy serves as a locus of identification for adolescent girl readers and that the use of male rather than female characters as well as homo- rather than heterosexual relationships, placed in a foreign setting, enables the vicarious circumvention of normative restrictions on female readers. Prominent shōjo manga critic Fujimoto Yukari believes that the genre's archetypal male–male relationship

is not "real" homosexuality but merely a trope functioning to purify love from "the tarnished male–female framework of heterosexual love."[13] Moreover, the increasingly sexual narratives offered readers the opportunity to experience and experiment with sexuality at a safe remove from their own lives.[14] As Takemiya explains, shōnen'ai narratives serve "to mentally liberate girls from the sexual restrictions imposed on us [as women]."[15] Fujimoto believes that such gender-bending identification and experimentation was necessary because adolescent female readers were not able to "positively accept their own sexuality as women."[16]

While Fujimoto has argued that, given his feminine appearance, the beautiful boy is "not the object of desire" but simply a "device" that the adolescent female reader can identify with in order to "liberate her own desire," Masuyama encouraged the introduction of male protagonists on the premise that girls enjoy looking at pretty boys; thus the narratives would be more popular than standard shōjo manga fare with female protagonists.[17] Scholar of psychology Watanabe Tsuneo reads shōjo manga as a "narcissistic space" in which the figure of the beautiful boy operates as "simultaneously the perfect object of [readers'] desire to love and their desire for identification"; he sees the "apex" of this tendency in Takemiya's seminal Kaze to ki no uta (1976–84, The song of the wind and the trees).[18]

While artists as well as critics and scholars, often themselves fans of the genre, have helped shape popular understandings of shōnen'ai manga, they do not have the final word. That belongs to the genre's fans at large, both individually and collectively. We must of course be mindful that even readers' own words on shōnen'ai are not a transparent window onto their reception of the genre. In the space of a homo magazine where female readers are— consciously or not—performing for a homo audience, we must entertain the possibility that their words might be deliberately chosen not out of a desire to speak truthfully so much as a desire to appeal to their readers, homo men to whom some female readers profess a powerful attraction. Having examined two decades worth of this correspondence, however, I believe that on the whole it is candid in intent. We must also bear in mind that readers of the magazine Barazoku made up but a fraction of the shōnen'ai manga readership in the 1970s and '80s.[19] Yet, even given these limitations, I would suggest that an examination of correspondence from female readers printed in this magazine helps correct and expand widely held understandings of readers' uses and interpretations of the beautiful boy, shōnen'ai manga, and the genre's relationship to homosexuality and to readers' own lives.

FLOWER TRIBES AND FEMALE READERS

Barazoku was first published in 1971 and edited by Itō Bungaku.[20] Though identifying as heterosexual, Itō has always been extremely sympathetic to the difficulties faced by men whose sexual desire for other men clashed with social norms. *Barazoku* acknowledged such anguish even as it celebrated many types of male homosexual desire and sexual practices, from anonymous encounters and intergenerational sexual relationships including pederasty (also referred to as *shōnen'ai*), to more egalitarian and stable sexual and romantic relationships.[21] Alongside this glorification of sexuality and solicitation of sex, romance, and friendship ran a discourse of solidarity and pride among men variously referred to in its pages as *"homo," "gei"* (gay), or *"barazoku"*—that is, members of the "rose tribe."[22]

With the publication of *Barazoku,* Itō helped popularize the use of the word *"bara"* (rose) to refer to male homosexuality and coined *"barazoku"* (rose tribe) for use as the title of his publication and a collective noun.[23] A few years later, he solidified if not originated the use of *yuri* (lily) and *yurizoku* (lily tribe) to refer to female homosexuality.[24] The widespread use among girls' manga readers and artists of these terms in both *shōnen'ai* manga and related magazines from the late 1970s, in particular *Juné* (1978–79, 1981–), *Allan* (1980–84), and *Gekkō* (Luna, 1984–2006), points to a connection between shōjo manga and *homo* culture.[25] I would suggest that this crossover usage stems in part from female readers of *Barazoku,* many of whom were also fans of *shōnen'ai* manga. In fact, editorial content in magazines aimed at *shōnen'ai* fans sometimes explicitly made such linkages and taught readers about Japan's *homo* community as well as about gay men abroad. For example, in 1983 *Allan* ran a special feature on Tokyo's well-known *homo* district, Shinjuku Ni-chōme, which, it noted, was crowded with "beautiful boys like those in the world of shōjo manga"; and in 1988 *Juné* contained a roundtable discussion with members of the editorial staff of the *homo* magazine *Sabu* (1974–2002) intended to introduce *"gei baa"* (gay bars) to *Juné*'s readers.[26] *Juné,* it should be noted, was first published by San Shuppan (Sun publishing), the same publisher as *Sabu*; and *Juné, Allan,* and *Gekkō* occasionally featured drawings by artists such as Kimura Ben and Naito Rune (also known as Naitō Rune), whose art frequently appeared in *homo* magazines. Further, *Barazoku* and other Japanese *homo* magazines as well as gay magazines from Europe and the United States were often mentioned by readers and occasionally in editorial content in these magazines aimed at *shōnen'ai* fans.[27]

FIGURE 2 (TOP, LEFT). The cover of *Juné* no. 37 (September 1987). The cover illustration is of the protagonists of the video *The Song of the Wind and the Trees Sanctus: Holy Perhaps* (1987, dir. Yasuhiko Yoshikazu, Shōgakukan/Herald), an anime adaptation of Takemiya Keiko's *The Song of the Wind and the Trees* (1976–84).

FIGURE 3 (TOP, RIGHT). The cover of *Allan (Aran)* (August 1983). This issue contains a special feature on Tokyo's famous *homo/gei* district in Shinjuku Ni-chōme.

FIGURE 4 (LEFT). The cover of *Gekkō (Luna)* no. 8 (October 1985). This issue contains a special feature on "Lesbianism."

The fact that the first *shōnen'ai* manga narrative was published in 1970, a year before *Barazoku*'s inaugural issue, makes it clear, however, that interest among women in *homo* men did not originate with the magazine. Indeed, the first female-produced fiction focused on male homoerotic relationships dates at least to several novellas by Mori Mari in the early 1960s.[28] Articles by women expressing an interest in male homosexuality began appearing in popular women's magazines even before that.[29] By the 1970s, relatively frequent articles on male homosexuality and cross-dressing—often not distinguishing between the two—expressed a range of interests and concerns including jealousy over cross-dressers' beauty, anxiety about the possibility that one's own boyfriend or husband might be a homosexual, and a sometimes prurient attraction to homosexual men, all significantly predating the supposed "gay boom" of the 1990s.[30]

Many female readers of *Barazoku* specifically indicated, however, that they came to the magazine after first becoming fans of *shōnen'ai* manga. Such readers occasionally wrote in to *Barazoku* to explain that they learned about *"homo"* or *"barazoku"* from manga, often noting directly or by implication that reading manga gave them a special sympathy for and/or interest in *homo* men. "Sylvie," for instance, who "want[ed] to marry a *homo*," wrote manga and "homosexual novels" about boys, which she hoped to publish in *Barazoku*.[31] She also recommended to male readers a handful of *shōnen'ai* manga titles including Takemiya's *Kaze to ki no uta* and Hagio's *Tōma no shinzo* (1974, The heart of Thomas), as well as films such as *Death in Venice* (1971).[32] Careful distinctions made by Masuyama and *shōnen'ai* artists between the real and fictive appear to have had little relevance to readers like Sylvie.

Of course, it seems likely that many of the *shōnen'ai* fans coming to *Barazoku* with only the knowledge they brought with them from manga and related magazines had a rather rose-colored understanding of life for Japanese *homo*. This was acknowledged by at least a handful of female readers, such as fourteen-year-old Yōko, who wrote that *"shōnen'ai* [manga] will always be a dream unlikely ever to be connected to reality."[33] Some female readers directly expressed surprise and/or disappointment that the world they saw in *Barazoku* was not as beautiful as that in manga. Others expressed great envy over the perceived freedom enjoyed by *homo* men and/or a desire to themselves become a *homo*, a desire also expressed by some readers of *Allan* and *Gekkō*, and resonant with the common understanding of the function of *shōnen'ai* manga discussed above.[34] In a 1984 issue of *Barazoku*, for instance, a twenty-year-old using the pen name "Anime Life" described herself as "a girl who, if I had been born a man, absolutely would want to be a *homo*."[35]

Female readers like these and others, including those with little or no interest in "real" males, sought to express themselves in the pages of *Barazoku,* and the magazine's editor Itō provided them a space to do so.

A "LILY TRIBE'S ROOM" OF THEIR OWN

The first contribution from a female reader printed in *Barazoku* was probably the four-page article, "Watashi wa isei o aisenai onna" (I am a woman who can't love the opposite sex) in issue 7, penned under the name Shimizu Junko in September 1972.[36] Shimizu liked the magazine, she explained, because she could relate to the content and felt anxieties similar to those expressed in its pages. Fourteen months later, *Barazoku* printed a letter entitled "Onnanoko mo hatsugenshimasu" (Girls also have something to say), from a seventeen-year-old writer who explained that she had been "researching" about *homo* for approximately the past five years. She noted both that she was not a "lez" (*rezu*), and that—like "Sylvie," whose letter would appear three years later—she wanted to marry a *homo.*[37] While this second letter is more typical of the correspondence from female readers that made it into the pages of the magazine in the first decade, it was worries like those of "Shimizu" that most concerned Itō.

Itō's sympathy for female readers, particularly those troubled by or wishing to celebrate their same-sex desire, resembled his feelings about *homo* men, and he resisted pressure from *Barazoku*'s largely *homo* staff as well as occasional letters from male readers to stop giving voice to them.[38] And, even though the reader in this second letter clearly stated that she was not a "lez," Itō added a comment about how readers could get in touch with the then two-year-old *rezubian* (lesbian) group Wakakusa no Kai (Young Grass Club).[39] This is the first indication of a blurring in *Barazoku* between women who love women and women who love *homo* men. In fact, while most letters from female readers in the 1970s were from ostensibly heterosexual women and girls, Itō promoted Wakakusa no Kai with relative frequency in his columns and editorial comments. Itō also welcomed women—lesbian or not—into his bar Matsuri (Festival), and in 1985 helped establish and promoted in *Barazoku* the "ladies bar" Ribonne (pronounced "ribonnu" in Japanese), which, while aimed at lesbians, made a point of welcoming "*okoge*" (fag hags).[40]

Though sparse in the beginning, from approximately 1974 letters from women appeared in *Barazoku* with greater frequency, finding their way into a variety of different sections of the magazine. And in November 1976, in

response to the ever-increasing number of such letters, Itō decided to create a column just for the magazine's female readership, which he called "Yurizoku no heya" (Lily tribe's room).[41] Six such columns appeared within the next year before the column disappeared, only to reappear for two issues in mid-1983.[42] The first column featured two-page letters from twenty-year-old "Lou," who wanted to marry a *homo* and was also interested in cross-dressing, and from the aforementioned "Sylvie," whose letter, in addressing the magazines readers with "*shōnen'ai no minasama*" (dear boy lovers) but clearly indicating *homo* men, conflated the *homo* of *Barazoku* and the beautiful boys of *shōnen'ai* manga as well as pederasts, for whom the term *shōnen'ai* had (and has) a different meaning. In a later column, divorced lesbian "Kimi" expressed both profound gratitude to *Barazoku* for offering a "precious" space "for women who were troubled about homosexuality" and a yearning for a more normative life as a man in love with a woman.[43] Reflecting a shift in female readership evidenced in other parts of the magazine, when the "lily tribe" column briefly returned six years later, the July and August (1983) columns contained a total of five letters, four of which were from women expressing desire for other women.[44]

While the term "*yuri*" has been associated with female–female desire at least since this column, as noted above, most of those whose letters were published in the initial run of the column between 1976 and 1977 appear to be fans of *homo* and/or *shōnen'ai*. The use of *yuri* as a counterpart to *bara*, however, reinforced the lack of a clear distinction between women who love women and women who love *homo* men. "*Yuri*" was also commonly used in *shōnen'ai* fan magazine *Allan*, particularly in the girl-seeking-girl "*Yuri tsūshin*" (Lily communications) personal ad column that ran from 1982 to 1984 and continued in a different format in *Gekkō*. Yet in *Allan*, while the term clearly pointed to a strong attachment between girls, *yuri* did not suggest female–female sexual desire for everyone who used it.[45] A transplant from a magazine made for *homo* men to a magazine edited by a man but composed largely

FIGURE 5. The cover of *Barazoku* no. 46 (November 1976). This issue contains the first "Lily Tribe's Room" column.

of content written by and for women infatuated with "homosexual" beautiful boys, *yuri*'s shifting meanings and applications demonstrate what Joan Scott describes as "the operations of the complex and changing discursive processes by which identities are ascribed, resisted, or embraced."[46]

As with any identity struggle, the issue was more than simply the instability of the term *yuri*. While in the 1980s an increasing number of female contributors were unequivocal about their interest in other women and the affinity this gave them for *homo* men, from early on some individuals expressed instead a tension between desire for women and interest in *homo* men.[47] One reader, for instance, in a letter titled "I Want There to Be a Lez Magazine, Too," wrote emphatically about how much she liked *homo*, concluding that, as a girl, "Even if I can be a lez, I can't be a *homo*. What a sad fate . . . I suppose there isn't a lez magazine. That's a little sad."[48] In a letter later that same year, a reader who identified herself as a second-year art school student and a fan of famously homosexual European and Japanese writers Jean Genet, Oscar Wilde, Inagaki Taruho, and Mishima Yukio, pondered an oft-repeated thought about "how free I would be if I had been born a man."[49] She wrote she could not (bring herself to) marry a man and bemoaned not being able to become a lez, and signed her letter "I'm a girl who cries when I read every issue of *Barazoku*."[50] Another woman, who herself identified as a lez, called for *homo* to sympathize with women who were drawn to male homosexuality but could never become men.[51] A decade later, a reader wrote in to say that she learned about *Barazoku* and similar magazines from *Juné* and decided to go to Shinjuku Ni-chōme to find them. She explained that she really got a warm feeling from *Barazoku*, as she enjoyed the (male homoerotic) manga, photos, and stories; yet, for a reason she does not explain, she concluded that women should be open to the possibility of love between women.[52] These and similar letters belie the sharp distinction made by artists and critics between *shōnen'ai* and lived homosexual experiences, both male and female, and demonstrate the power of readers to understand what they are reading—whether *shōnen'ai* manga, Mishima and Genet, or *Barazoku*—on their own terms.

In addition to the women who wish they could marry and/or become a *homo*, a few women who wrote in described themselves as masculine or boyish, further complicating the "female" presence in *Barazoku* as well as further blurring the line between *yuri* and *bara*. One reader explained that she was "extremely masculine," so much so that a man who liked boys mistakenly tried to seduce her on the street. As noted above, *Barazoku* contained representations of a wide variety of tastes in men and boys, from the very cherubic to the hypermasculine. While this might seem to foster an openness to

gender variation among women, masculine girls and women were more visible in *Allan* and later *Gekkō* than in *Barazoku.*[53] The most overt expression of female masculinity in *Barazoku,* however, was, like *Allan,* in its personal ads.

THE LILY TRIBE TURN

From the April 1981 issue, "Yurizoku no kōnaa" (Lily tribe's corner) began to regularly appear as a tiny subsection at the end of the "Bara tsūshin" (Rose communications) personal ad column. Almost immediately thereafter, the number of other types of contributions from female readers nearly disappeared, with months passing without anything from women printed, aside from personal ads. Whether this reflected a decrease in the number of letters from women or an editorial decision is unclear. While not all of the *yurizoku* personal ads were from women seeking romantic and erotic relationships with other women, most appear to be so, and the effect of the presence of these ads and the decrease in women's voices elsewhere in the magazine meant that, among female readers writing in to *Barazoku,* romantic and sexual attraction toward women finally surpassed the love of *homo* men. Along with this change, the understanding expressed in the pages of the magazine of *yuri* as indicating female–female desire rather than female attraction to *homo* men began to predominate.[54]

Several factors may explain the relative decline in overtly heterosexual female readers' voices in *Barazoku.* First, the flourishing of the amateur manga scene, including a variety of representations of male homosexuality, may have pulled some readers away.[55] While queer women also consumed these texts, the differences between advertisers in the personal ad columns in *Barazoku,* as well as *Allan* and *Gekkō,* suggest that the queer women who continued to write in to *Barazoku* were somewhat older and more interested in romantic and sexual relationships than the ostensibly heterosexual female *Barazoku* readers of the 1970s.[56] Moreover, some of these queer women used this space to reach out to or establish a *yurizoku* and/or lesbian community.

Of course the 1980s also saw a handful of noncommercial lesbian publications, including those that had personal ad sections that might have drawn some lesbian-identified readers away from *Barazoku.* Yet, as the lesbian community remained nearly invisible in society at large, it was much more difficult for women to learn of the existence of the community at all. And even though Itō promoted Wakakusa no Kai, and though Wakakusa no Kai and the lesbian group Saffō no Kai (Sappho club) placed advertisements in *Allan*

and *Gekkō*, it was probably easier for women to buy, borrow from friends, or stand in a shop and read *Allan* or even *Barazoku* than to subscribe to a lesbian newsletter that might be intercepted by family members.

Indeed, the veneer of an interest in *shōnen'ai* or even *homo* men may have made an otherwise unacceptable desire easy to dismiss as insignificant, both to family members and perhaps to an individual herself. In a 1977 letter in "Yurizoku no heya," one apparently late-middle-aged reader from Tokyo speculated that there were actually very few ordinary *(futsū)* female *Barazoku* readers who were interested in *homo* men, but rather—and here she stretches the meaning of *homo*—most female *Barazoku* readers must have a *homo* tendency "at the bottom of their hearts" that draws them toward male *homo*.[57] The accuracy of her assumption—which, based on her own expression of same-sex desire later in the letter, may have been wishful thinking on her part—is not as important as her suggestion that some women were using the imagery of *homo* men not as a model by which to understand their homosexual desire but as the very means to act on it via the performance of fandom and/or consumption of texts about male homosexuality.[58]

Given the popularity of *otokoyaku* (trouser role players) in the all-female Takarazuka Musical Revue and the ease with which both *otokoyaku* and manga's beautiful boy characters could be read as male, female, or somewhere in between, such a use of "real" *homo* men seems plausible.[59] Writing on lived transgender experience, Judith Butler muses nonetheless that "to posit possibilities beyond the norm, or indeed a different future for the norm itself, is part of the work of fantasy."[60] In *Barazoku*, we can see the possibility that fantasy—inspired by widely available representations of gender-bending and male homosexuality—was being employed by women to understand and, at least within the space of the imagination, to act on what might have seemed otherwise unlivable desires.

CONCLUSION

As contributions from female readers printed in *Barazoku* demonstrate, there is no simple explanation for why from the 1970s onward, adolescent girls and young women in Japan have enjoyed reading and creating graphic narratives about boys and later men in romantic and sexual relationships with each other. While we may be able to pinpoint the original *shōnen'ai* text and explain how it came about, such information tells us relatively little about how readers understood and used these narratives. An examination of correspondence

from female readers of *Barazoku* disrupts the depiction of *shōnen'ai* manga as a metaphysical sphere at a remove from the *homo* world that even its most prominent artists claim it does not represent. *Shōnen'ai* functioned for some readers not as merely a fantastic escape or a straightforward critique of patriarchal romance paradigms in Japan but rather as part of a larger sphere of consumption of images of male homosexuality, a sphere in which individual and collective struggles over meaning and desire were acted out. As we have seen, this grappling is both with the meaning of desire itself and with the meaning of specific signs that point to it, whether terms such as "*shōnen'ai*," "*bara*," or "*yuri*," or visual signs such as the beautiful boy. As Kath Weston reminds us, "no one has a greater stake in the outcome of conflicts over terminology"—and, I would add, symbols—"than the people who constitute themselves through and counter to available cultural categories."[61] While critical textual analysis as well as the words of the artists themselves provide vital insight into *shōnen'ai* manga, to come closer to an understanding of what these texts mean to readers and, by extension, the impact they have had on popular culture, it is necessary to turn to the narratives generated by *shōnen'ai* manga fans themselves.

> SHŌNEN'AI FUNCTIONED FOR SOME READERS NOT AS MERELY A FANTASTIC ESCAPE OR A STRAIGHTFORWARD CRITIQUE OF PATRIARCHAL ROMANCE PARADIGMS IN JAPAN BUT RATHER AS PART OF A LARGER SPHERE OF CONSUMPTION OF IMAGES OF MALE HOMOSEXUALITY, A SPHERE IN WHICH INDIVIDUAL AND COLLECTIVE STRUGGLES OVER MEANING AND DESIRE WERE ACTED OUT.

..

Notes

Early versions of this paper were presented in 2008 at seminars on queer Japanese history and culture at the University of Michigan and at Emory University, organized by Mark McLelland and Julia Bullock, respectively. I would like to thank the organizers and acknowledge useful feedback from my fellow participants and members of the audience. I would also like to thank Ishida Hitoshi for invaluable corrections of fact and suggestions on a later version.

 1. The most vociferous rejection of such linkages within the broader sphere of shōjo manga can be found within the "*yaoi ronsō*" (*yaoi* debate), which began with Satō Masaki's article "Yaoi nante shinde shimaeba ii" (*Yaoi* can just die), in the feminist zine *CHOISIR* (May 1992): 7–9, and a response thereto in the same issue by Takamatsu Hisako, "'Teki/mikata' ron no anata e: Miyō to suru koto, mitekureru koto" (To you who would divide things into enemies and allies: What you try to see, what you see for others), 10–13, and continued through the final issue in June 1994, in addition to spilling into other fora.

(The *yaoi* genre—which, like *shōnen'ai,* centers around male–male erotic relationships—
was discussed in earlier issues, but Satō's attack can be said to represent the first salvo in
the debate.) An extensive discussion of the *"yaoi* debate" can be found in Keith Vincent,
"A Japanese Electra and Her Queer Progeny," *Mechademia* 2 (2007): 64–79.

Links with homosexuality, however, were being denied, downplayed, or simply ig-
nored significantly earlier in public discourse on *shōnen'ai, yaoi*'s predecessor. In a 1978
article in a mainstream women's magazine, for instance, *shōnen'ai* critic and fiction writer
Nakajima Azusa (who uses the name Kurimoto Kaoru when writing *shōnen'ai* fiction)
makes no mention of *"dōseiai"* (homosexuality) per se when she describes artists as work-
ing against a one-sided idea that the genre is simply vulgar or about sex; she explains that,
instead, the artists are trying to raise the self-awareness of women who are suffering from
the expectation that they should find happiness in marriage ("Onnanoko o miryōsuru
shōnen dōshi no ai" [The love between boys that charms girls], *Fujin kōron* 63, no. 7 [July
1978]: 266–71 at 271). Pioneering *shōnen'ai* artist Hagio Moto explained in a 1980 inter-
view that what is depicted in her works is not "at all realistic homosexuality" like that
which was currently in vogue in films and magazines; rather it was "just solitary play"
("Jiko hyōgen toshite no shōjo manga" [Shōjo manga as self-expression], *Yuriika* 13 no. 9
[July 1981]: 82–119 at 90). Even shōjo manga critic Fujimoto Yukari's oft-cited writing on
the genre, e.g., *Watashi no ibasho wa doko ni aru no? Shōjo manga ga utsusu kokoro no kata-
chi* (Where do I belong? The shape of the heart reflected in shōjo manga) (Tokyo: Gakuyō
Shobō, 1998), 130–76, was initially published as early as August 1990 in *Gendai no esupuri,*
thus predating the "debate" by nearly two years. See *Watashi no ibasho,* 334.

2. These functions are partially addressed below. A brief survey of scholarship and
criticism on *shōnen'ai, yaoi,* and boys' love, including an extensive bibliography, can be
found in Kaneta Junko, "Yaoi ronsō, ashita no tame ni, sono 2 (The *yaoi* debate: For the
future, part 2), *Yuriika* 39 no. 16 (December 2007): 48–54.

3. In the 1970s and '80s *"homo"* was the predominant term used to refer to homo-
sexual men, though not women, within the *homo* community and in mainstream discourse
in Japan. I leave the word in italics as its usage then was not always as pejorative as "homo"
in English tends to be. *"Gei"* (gay), with a sense akin to its contemporary meaning in
English-speaking countries, gradually gained currency from the late 1970s, prior to the
"gei būmu" (gay boom) in 1990s Japanese popular culture. On the usage of these terms,
see Mark McLelland, *Queer Japan from the Pacific War to the Internet Age* (Lanham, Md.:
Rowman and Littlefield, 2005), 154–55, 167, 173–80.

Although I limit my discussion here to letters printed in *Barazoku* due to consider-
ations of space, I have found letters from female readers—including those expressing an
interest in *homo* men and those in other females—in *homo* magazines in the 1970s and
'80s, including *Za gei* (The gay), *Adon,* and *MLMW* (My life my way). *Za gei,* in fact, ran a
lesbian section in the back of the magazine during its first several years (1981–83) and
continued to run columns about lesbian issues even after this section was discontinued.

4. This assumption is also challenged in much of the writing of Mizoguchi Akiko,
most extensively in her dissertation, "Reading and Living *Yaoi*: Male–Male Fantasy Narra-
tives as Women's Sexual Subculture" (PhD diss., University of Rochester, 2008). See also
James Welker, "Beautiful, Borrowed, and Bent: Boys' Love as Girls' Love in *Shōjo* Manga,"
Signs 31 no. 3 (2006): 841–70, and "Lilies of the Margin: Beautiful Boys and Lesbian

Identities," in *AsiaPacifiQueer: Rethinking Gender and Sexuality,* ed. Fran Martin, Peter A. Jackson, Mark McLelland, and Audrey Yue, 46–66 (Urbana: University of Illinois Press, 2008).

5. Takemiya Keiko, "Sanrūmu nite" (In the sunroom), in her *Sanrūmu nite* (Tokyo: San Komikkusu, 1976), 5–54. See Ishida Minori, *Hisoyaka na kyōiku: "Yaoi/bōizu rabu" zenshi* (A secret education: The prehistory of *yaoi* / boys' love) (Tokyo: Rakuhoku Shuppan, 2008), 21, 281. While I use "girls' love" as a broad reference to female desire as expressed via consumption of *shōnen'ai* manga, from approximately the late 1990s *"gaaruzu rabu"* (girls' love) has been used to refer to female–female romantic and sexual pairings in shōjo manga. I thank Ishida Hitoshi for pointing this out.

6. Ishida, *Hisoyaka na kyōiku,* 142. Many artists, including the well-known Hagio Moto, Ichijō Yukari, Ikeda Riyoko, and Yamagishi Ryōko, also tried their hand at female–female romance narratives during this period, but these works largely failed to have significant impact. See James Welker, "Drawing Out Lesbians: Blurred Representations of Lesbian Desire in *Shōjo* Manga," in *Lesbian Voices: Canada and the World,* ed. Subhash Chandra, 156–84 (New Delhi: Allied Publishers, 2006).

7. While it is difficult to draw definitive lines between *shōnen'ai, yaoi,* boys' love, and the like, the histories of these genres follow different trajectories. A useful historical treatment of these genres can be found in Akiko Mizoguchi, "Male–Male Romance by and for Women in Japan: A History and the Subgenres of *Yaoi* Fictions," *U.S.–Japan Women's Journal* 25 (2003): 49–75. In the present essay, I use the term *shōnen'ai,* as it was the most widely used term during much of the 1970s and '80s, and *shōnen'ai* manga was the most frequently used term to refer to the genre by female readers writing to *Barazoku* during this period.

8. Inagaki Taruho, *Shōnen'ai no bigaku* (The aesthetics of boy loving) (Tokyo: Tokuma Shoten, 1968). See Ishida, *Hisoyaka na kyōiku,* 88.

9. Ishida, *Hisoyaka na kyōiku,* 99–100.

10. Ibid., 305–6.

11. Ueno Chizuko, *Hatsujō sōchi: Erosu no shinario* (The erotic apparatus) (Tokyo: Chikuma Shobō, 1998), 131.

12. Ishida, *Hisoyaka na kyōiku*; Fujimoto Yukari, *Watashi no ibasho,* and "Shōjo manga ga mederu otoko no karada," *Kuia Japan* 1 (1999): 24–28; Vincent, "A Japanese Electra"; Welker, "Beautiful, Borrowed, and Bent."

13. Fujimoto Yukari, "Shōjo manga ni okeru 'shōnen'ai' no imi" (The meaning of *"shōnen'ai"* in shōjo manga), *Nyū feminizumu rebyū* 2 (1991): 280–84 at 283.

14. Midori Matsui, "Little Girls Were Little Boys: Displaced Femininity in the Representation of Homosexuality in Japanese Girls' Comics," in *Feminism and the Politics of Difference,* ed. Sneja Gunew and Anne Yeoman, 177–96 (Boulder, Colo.: Westview, 1993), 178.

15. Quoted in Satō Masaki, "Shōjo manga to homofobia" (Shōjo manga and homophobia), in *Kuia sutadiizu '96,* ed. Kuia Sutadiizu Henshū Iinkai, 161–69 (Tokyo: Nanatsumori Shokan, 1996), 162.

16. Fujimoto, *Watashi no ibasho,* 189.

17. Fujimoto, "Shōjo manga ga mederu otoko" (The male body admired in shōjo manga), 25. Masuyama's remarks are from Ishida, *Hisoyaka na kyōiku,* 84.

18. Watanabe Tsuneo, *Toransu-jendaa no bunka: Isekai e ekkyōsuru chi* (The culture

of transgender: The knowledge to cross over into a foreign world) (Tokyo: Keisō Shobō, 1989), 126; Takemiya Keiko, *Kaze to ki no uta* (The song of the wind and the trees), 10 vols. (Tokyo: Hakusensha Bunko, 1995).

19. To date, I have conducted approximately sixty interviews with women who iden-tified themselves as *shōnen'ai* manga fans, members of the lesbian community, and/or women's liberation activists in the 1970s and '80s. Of these, only one claimed to have been a regular reader of *Barazoku* at some point, but at least a third of the women who linked themselves to *shōnen'ai* fandom and/or the lesbian community had looked at an issue of the magazine at least once, sometimes out of their own curiosity and sometimes because a friend or classmate had a copy and was passing it around. Letters from readers printed in the *shōnen'ai*-related magazines discussed below occasionally describe similar experiences.

20. Waning sales led Itō to decide to terminate publication in 2004; several subsequent, and ultimately unsuccessful, efforts were made to revive it.

21. "*Shōnen'ai*" has long been used to indicate adult male attraction toward adolescent boys and was widely used with this meaning in *homo* magazines of the 1970s and later. Itō allowed for textual and graphic representation of pubescent and prepubescent boys as objects of sexual desire as well as sexual agents within the magazine.

22. See Jonathan D. MacKintosh, "Itō Bungaku and the Solidarity of the Rose Tribes (Barazoku): Stirrings of Homo Solidarity in Early 1970s Japan," *Intersections* 12 (January 2006), http://intersections.anu.edu.au/issue12/aoki.html (accessed November 2007).

23. The origin of the use of "*bara*" (rose) to represent male homosexuality in Japan remains somewhat unclear. In a 2005 interview with me, Itō named Hosoe Eikō's *Barakei* (Tokyo: Shūeisha, 1963), a collection of photographs of Mishima Yukio by Hosoe, as an an-tecedent use of the term. Ishida Hitoshi writes that by the early 1960s *bara* was being used with a broad erotic meaning, but its use to specifically point to male homosexuality might, in part, be traceable to its use in the subtitle of a March 1965 article by Kabiya Kazuhiko in the pulp magazine *Fūzoku kagaku* (Customs science) identifying *bara* as "*homo no hana*" (*homos*' flower). According to Ishida, *Barazoku* editor Itō Bungaku referenced this article in titling his magazine. See Ishida Hitoshi, "Bara," in *Seiteki na kotoba* (Sexual words), ed. Inoue Shōichi, Saitō Hikari, Shibuya Tomomi, and Mitsuhashi Junko, 270–76 (Tokyo: Kodansha, 2010)

24. I am unaware of evidence that this use of "*yuri*" predates its appearance in *Barazoku*.

25. *Juné* (1978–79, 1981–)—initially titled *Komikku Jun* (Comic Jun), but retitled af-ter two issues to avoid copyright infringement ("Editors' Rest Room," *Juné* 4 [April 1979]: 180)—was the first commercial magazine aimed specifically at adolescent female readers who enjoyed *shōnen'ai* manga. Its success quickly inspired the emergence of the magazine *Allan* (1980–84), which was later renamed *Gekkō* (literally "moonlight," but also referred to in both Roman letters and katakana script as "luna"/"runa"; 1984–2006) and moved in focus away from beautiful boys and shōjo tastes. See Welker, "Lilies of the Margin."

26. "Shinjuku Ni-chōme," *Allan* 1 no. 2 (August 1983): 9–47 at 15; "Gei baa tte konna toko" (Gay bars are like this), *Juné* 38 (January 1988): 155–65.

27. E.g. Kitazumi Izumi, "Homo-shi 'gosanke' o kanzen dokuha" (A thorough reading of the "big three" *homo* mags), *Allan* no. 8 (February 1983): 127–29; Kakinuma Eiko, "Sen-monshi de shiru igai na chomeijin, jinsei sōdan, kojin kōkoku, gei-do chekku" (Surprising

authors, advice columns, personal ads, and a gayness check—what you can learn in specialist magazines), *Juné* 39 (March 1988): 100.

28. Mizoguchi, "Male–Male Romance," 52.

29. E.g. Ikeda Michiko, "Danshokuron: Shisutaa bōi no miryoku" (On male homosexuality: The charms of sister boys), *Fujin kōron* 41, no. 11 (November 1957): 168–73.

30. For an extensive bibliography of such articles in the popular press, see Ishida Hitoshi, ed., *Iseisō/dōseiai shoshi mokuroku: sengo Nihon "toransujendaa" shakaishi,* vol. 4 (Bibliographic catalogue of cross-dressing and transgender: A history of postwar Japanese transgender society) (Hachiōji, Japan: Chūō Daigaku Shakai Kagaku Kenkyūsho, 2004). Ishida Hitoshi shows that there was in fact a "*gei bōi*" boom in the Japanese media as early as the 1950s. See his "'Dansei dōseiai to joseisei' o rekishiteki ni toraeru: Gei bōi no būmu ni miru sai/jōhō/shintai" (Male homosexuality and femininity in historical perspective: Difference, body, and information in the *gei bōi* boom), in *Shintai to aidentiti toraburu: jendaa/sekkusu no nigenron o koete* (Body and identity trouble: Overcoming the sex/gender dichotomy), ed. Kanai Yoshiko, 279–98 (Tokyo: Akashi Shoten, 2008). For a discussion of the 1990s gay boom, see Mark McLelland, *Male Homosexuality in Modern Japan: Cultural Myths and Social Realities* (Richmond, UK: Curzon, 2000), 32–33.

31. "Homo no hito to kekkonshitai" (I want to marry a *homo*), *Barazoku* 46 (November 1976): 68–70 at 68.

32. Ibid., 70; Hagio Moto, *Tōma no shinzō* (The heart of Thomas) (Tokyo: Shōgakukan, 1995); *Death in Venice,* dir. Luchino Visconti (1971).

33. "Manga no fukasa mo kangaete" (Thinking as well of the deep [meaning] of manga), *Barazoku* 72 (January 1979): 108. This disconnect was also the subject of occasional criticism from male readers of the magazine and others in the community. See note 1 above on the *yaoi* debate.

34. On the readership of *Allan* and *Gekkō,* see Welker, "Lilies of the Margin."

35. "Danjo kōsai kōnaa" (Male–female dating corner) *Barazoku* 132 (January 1984): 224–25 ad 442.

36. Shimizu Junko, "Watashi wa isei o aisenai onna" (I'm a woman who can't love the opposite sex), *Barazoku* 7 (September 1972): 28–31.

37. "Onnanoko mo hatsugenshimasu" (Girls also have something to say), *Barazoku* 14 (November 1973): 84–85.

38. See, e.g., "Henshūshitsu kara" (From the editor's office), *Barazoku* 49 (February 1977): 256–57; and Itō Bungaku, "Onnadōshi no koi dakedo, nanto shitemo jōjusasete agetai" (It's love between women but I really want to help them work it out), *Barazoku* 168 (January 1987): 88–89.

39. "Onnanoko mo," 85. From this point for ease of reading I will write "lesbian," as the use of "*rezubian*"—frequently shortened to "*rezu*"—in this sphere approximates the usage in English. Like *Barazoku,* Wakakusa no Kai was founded in 1971. The group dissolved around 1985. See Sawabe Hitomi, "'Wakakusa no Kai': The First Fifteen Years of Japan's Original Lesbian Organization," trans. James Welker, in *Queer Voices from Japan: First-Person Narratives from Japan's Sexual Minorities,* ed. Mark McLelland, Katsuhiko Suganuma, and James Welker, 167–80 (Lanham, Md.: Lexington Books, 2007).

40. See advertisement for Ribonne in *Barazoku* 150 (July 1985): 192; "Aa!! Akogare no nyonin no yakata, Ribonnu: rupo" (Ah!! Women's castle of dreams, Ribonne: A report),

Barazoku 155 (December 1985): 116–17; "Ribonnu no yoru: Kensō no rezubian baa" (Nights at Ribonne, a boisterous lesbian bar), *Gekkō* 8 (October 1985): 19–21.

41. "Yurizoku no heya" (Lily tribe's room), *Barazoku* 46 (November 1976): 66–70.

42. "Yurizoku no heya" columns appeared in following issues: November and December 1976; January, March, July, and September 1977; and July and August 1983.

43. "Mizukara o kugyō no naka ni" (Doing penance), *Barazoku* 54 (July 1977): 72–74.

44. "Yurizoku no heya," *Barazoku* 126 (July 1983): 182–83; "Yurizoku no heya," *Barazoku* 127 (August 1983): 238–39.

45. Welker, "Lilies of the Margin."

46. Joan W. Scott, "The Evidence of Experience," *Critical Inquiry* 17 (1991): 773–97 at 779.

47. E.g. "Shiroyuri no watashi o yoroshiku" (Greetings from a white lily), *Barazoku* 163 (August 1986): 79.

48. "Rezu no hon mo hoshii" (I want there to be a lez magazine too), *Barazoku* 25 (February 1975): 112.

49. "Chichi mo, watashi mo, *Barazoku* fan" (Like father like daughter, *Barazoku* fans), *Barazoku* 30 (July 1975): 34–36.

50. Ibid., 36.

51. "Itabasami no kurushisa" (Suffering through a quandary), *Barazoku* 73 (February 1979): 98–99 at 98.

52. "Ōraka na kimochi de ite" (Open your hearts), *Barazoku* 193 (February 1989): 108.

53. Welker, "Lilies of the Margin."

54. Even as late as 1990, however, there were women who, for instance, either referenced their interest in *gei* men in the context of talking about their own same-sex desire, or used the concept of *yuri* to seek *gei* male friends. See "Yurizoku no kōnaa," *Barazoku* 206 (March 1990): 224 ad 189; "Yurizoku no kōnaa," *Barazoku* 207 (April 1990): 222 ad 448.

55. A useful history of this scene, including its role in the development of the *yaoi* genre, from an insider's perspective can be found in Yonezawa Yoshihiro, Sakai Kyōko, and Takeda Yayoi, "Dōjinshi ando komike: hisutorii zadankai" (Dōjinshi and Comic Market: A roundtable on their history), *Juné* 73 (November 1993): 132–37.

56. Mizoguchi, "Male–Male Romance," and "Reading and Living *Yaoi*"; Welker, "Beautiful, Borrowed, and Bent" and "Lilies of the Margin."

57. "Mizukara o kugyō," 72.

58. While less prevalent than in letters elsewhere in the magazine, particularly in the 1970s, even in the "Yurizoku no kōnaa" ads we can see a blurring between and interest in male and female homosexuality. See ibid., and "Yurizoku no kōnaa," *Barazoku* (April 1985): 231 ad 489; "Yurizoku no kōnaa," *Barazoku* (December 1985): 214 ad 506.

59. Jennifer Robertson, *Takarazuka: Sexual Politics and Popular Culture in Modern Japan* (Berkeley and Los Angeles: University of California Press, 1998); Welker, "Beautiful, Borrowed, and Bent."

60. Judith Butler, *Undoing Gender* (New York: Routledge, 2004), 28.

61. Kath Weston, "Lesbian/Gay Studies in the House of Anthropology," *Annual Review of Anthropology* 22 (1993): 339–67 at 349–50.

Untimely Effects

MIYADAI SHINJI

Translated by Shion Kono

Introduction by Thomas Lamarre

•••

Transformation of Semantics in the History of Japanese Subcultures since 1992

Editor's Introduction

A sociologist known for his work on pop culture phenomena and also something of a cultural phenomenon himself, Miyadai Shinji has authored and coauthored dozens of books on topics ranging from government policy and film criticism to sex and subcultures. These include *Sabukaruchaa shinwa kaitai* (1993, Dismantling the subculture myth, with Ishihara Hideki and Ōtsuka Meiko), *Maboroshi no kōgai* (1997, The phantom suburbs), and *Kibō, dannen, fukuin, eiga* (2004, Hope, abandonment, good news, film), to name just a few. The essay that follows reviews and updates some of his early work on subcultures, with an emphasis on formations relevant to the study of otaku and anime. Miyadai's focus is on the semantics *(imiron)* surrounding these subcultures. "Semantics" here is a frame informed by the work of Niklas Luhmann, what translator Shion Kono glosses as "a set of concepts and statements that enable communication within a certain social context."[1]

Miyadai's essay is interesting for the way it investigates some of the conflicting images and stereotypes surrounding otaku and Japanese youth—that they are socially withdrawn spectators yet compulsive digital communicators; or sexual naïfs whose literacy lies in pornography; or ineffectual fans who harbor apocalyptic fantasies. Miyadai provides an overview but also

complicates these tropes by arranging them into different phases or stages in the evolution of otaku and other youth subcultures. For example, he juxtaposes otaku with youth sexual cultures such as *enjo kōsai*—part-time sexual or dating relationships between young teenage girls and older sugar daddies. For Miyadai, these new kinds of sexual relationships and the world of the otaku are two sides of the same coin, both indicative of an age in which the paramount concern is maintaining the outlines of the self, whether through aggressive sexual engagement or passive withdrawal.

Miyadai links these trends to broader currents in Japanese society. His equation of sex and religion as parallel sources of self-definition is striking, for instance. He situates the rising appeal of the withdrawn, fictional world that drives the rehabilitation of the otaku's image not only in terms of a reaction against youth sexual cultures of the early nineties, but also in terms of reaction against the violent intervention of the terrorist attacks mounted by Aum Shinrikyō in 1995. The association between Aum and otaku culture is a familiar one in Japan: there much of the media coverage that followed the subway gas attacks focused on Aum as a group, portraying its plots and personalities as part of a bizarre, science fiction–influenced cult, culture, or indeed subculture. Yet Miyadai brings new sophistication to such discussions.

He shows, for example, how the changing profile of the otaku is intertwined with a shift from the Armageddon or apocalyptic tropes of Aum and *Akira* to a more intimate sphere of "world type" *(sekai-kei)* anime—domestic or school-days dramas that confine themselves largely to the protagonist's insular inner world. And he traces the shift from the "world type" to the "battle royale." While the latter offers a more active, even combative form of social (often online) argument and engagement that appears *activist,* Miyadai argues that it nonetheless remains resolutely focused on the internal self. The battle royale's attempts at dialog always end in irony or self-reference. Finally, Miyadai's essay takes on a self-referential or ironic quality of its own, when he compares otaku and the other objects of his study to the culture of sociology itself, showing how the study of other worlds is not autonomous of their social production.

TRANSFORMATION OF SEMANTICS IN THE HISTORY OF JAPANESE SUBCULTURES SINCE 1992

Since 1993 I have been describing the history of postwar Japanese subcultures by using the framework of social systems theory, in such works

as *Sabukaruchaa shinwa kaitai* (1993, Dismantling the subculture myth).[2] The framework of social systems theory is a monistic model based on communication, in which the dynamism of a system is described without requiring any element other than communication, unlike the dualistic model based on superstructure and infrastructure.

From the era of postwar economic recovery to the era of high economic growth, in other words up to the early 1970s, Japanese subculture could easily be explained through economic determinism or infrastructural determinism. But since the mid-1970s, when durable consumer goods reached most households and a level of material affluence had been achieved, Japanese subculture has fragmented, and it has become difficult to get a clear perspective on it. The significance of my book from fifteen years ago lies in the fact that it described the dynamism of subcultures in this era of Japanese postmodernity using a coherent framework.

In this work, I divided the history of postwar Japanese subcultures at the years 1955, 1964, 1973, 1983, and 1992. During the fifteen years since the book first appeared, there have been a few major shifts in Japanese subcultures. In particular, the shift in 1996 and the shift in 2001 should not be overlooked. In this essay, I wish to discuss these two shifts.

THE SHIFT OF 1996: THE EQUIVALENCE OF "REALITY" AND "FICTION"

In order to describe Japanese subcultures since the 1990s, it is necessary to use the "modified Mita Munesuke schema," which I also used in *Sabukaruchaa shinwa kaitai*. According to sociologist Mita Munesuke, postwar subcultures shift from "the age of ideals" (from the war's end in 1945 to 1960) to "the age of dreams" (from 1960 to 1975) to "the age of fiction" (after 1975).[3] In *Sabukaruchaa*, I fine-tuned this schema: "the age of ideals" was renamed "the age of order"; "the age of dreams" became "the age of future"; "the age of fiction" became "the age of the self"; and I divided "the age of the self" into two periods at the year 1996, when the series of Aum Shinrikyō–related incidents came to a close. The early period (prior to 1996) can be called "the age of Armageddon" and the late period (post-1996) can be called "the age of post-Armageddon." Let me explain the meaning of those terms as concisely as possible.

In "the age of ideals" or "the age of order," people evaluated reality by referring to an "ideal order." Boys referred to the Great East Asia Coprosperity Sphere, an ideal order the size of a nation. Girls referred to a home with

a "good wife, wise mother," an order the size of the family. There are differences, but the national order and the family order are complementary.

In the 1960s, however, the frame of reference in evaluating reality shifts from an *order* to a *future*. Applying my analytical schema, sociologist Tsuji Izumi argues that, in the shift from the age of order to the age of future, the most important item for railway fans *(tetsudō mania)* changes from the Superexpress Asia of the Manchurian Railroad to the Dream Superexpress Hikari of the Japanese National Railroad, popularly known as the *shinkansen* or "bullet train."[4] The Superexpress Asia embodied the lofty ideals of an empire, while the Dream Superexpress Hikari embodied progress toward a future in which flying vehicles travel in all directions. For the former, the frame of reference is spatial; for the latter, it is temporal. These frames of reference give a certain dynamism to semantics *(imiron)*—in other words, a motivation to approach an ideal order or dream future.

"The age of order" tended to affirm the here-and-now, as it leads from the family order to the national order. In "the age of future," however, the here-and-how tended to be negated, as something irrational in comparison to the future. In fact, the 1960s were the age when, while people dreamt of a bright future, negative news proliferated, such as scandals over industrial pollution, tainted drugs, the depopulation of rural villages, and vanishing families. The plot patterns of reading materials for youth also changed. In the age of order, plots often involved heroes fighting against enemies that threatened the social order, but in the age of future, typical plots involved superior beings from the future or outer space saving us from the irrationality of society.

The shift from *order* to *future* overlapped with the shift from *empire* to *science*. Empire brings about order, while science brings about the future. But after the Osaka Expo in 1970—an event carrying the banner of science (the official slogan was "Progress and Harmony for Mankind")—the future that was supposed to be bright began to fade. As Morikawa Kaichirō notes, stereotypical images of the future, such as silver rockets being launched diagonally across the sky or computer data reels spinning, began to fade rapidly after 1970.[5] Probably the biggest reason for this is that the society that was once poor became affluent as, for example, consumer durable goods reached most homes.

Now, what becomes the measuring stick for evaluating reality (the here-and-now), after *order* and then *future* fade? According to Mita, after an age in which "reality" was opposed to "ideals," and then one in which it was opposed to "dreams," the age arose in which reality is opposed to "fiction." In my schema, the measuring stick for evaluating reality shifted from order and

then future to the *self*. In other words, in my analysis, "the age of fiction" amounts to "the age of the self." To be more precise, it is the possibility of the homeostasis of the self that became the measuring stick for evaluating reality. In this age one utilizes anything—whether it is "reality" or "fiction"—in order to achieve the homeostasis of the self. That is why it is called the age of fiction.

The Early and Late Periods in the Age of the Self

The description of *Sabukaruchaa shinwa kaitai* stops at the year 1992. Since 1992, the biggest watershed year was 1996. Starting around then, "otaku discrimination" began to decrease significantly, and accordingly the "salvation" or "redemption" of otaku (*otaku kyūsai*) advanced. Furthermore, around this time, the communication among otaku shifted from the "trivia competition" (*unchiku*) to the "play of communication." Allow me to explain.

From about the 1980s on, those who used fiction for the homeostasis of the self began to be called "otaku," and they began to face discrimination. Many otaku hated such a reality and escaped to fiction even more, and some even yearned for an "Armageddon." However, when some of these people caused the Aum Shinrikyō incidents—indeed, many Aum believers were otaku—it became ridiculous even for otaku themselves to yearn for an Armageddon. In addition, involvement with sexual love, once considered "cool," was now thought to be something that was "painful to watch." Combined with a few other factors, the view on otaku after 1996 became less discriminatory. Concomitant to this, reality and fiction have come to be thought as equivalent insofar as they are material to be utilized for the homeostasis of the self. This corresponds to what Azuma Hiroki called "database consumption."[6] Reality and fiction are registered side by side in the database of material available for the homeostasis of the self.

With this shift around 1996 as a threshold, I divided the "age of fiction," that is to say "the age of the self," into two periods. In the early period, the concept that fiction is inferior to reality was still maintained. In the late period, fiction is received as material that is equivalent to reality for the homeostasis of the self.

In the early period, there was still otaku discrimination, but in the late period, otaku discrimination disappears. In the early period, the *nanpa* type[7] and the otaku type were contrasted, and the otaku type was considered inferior to the former. This, in essence, is otaku discrimination. However, in the late period, a "flat" viewpoint that the *nanpa* tendencies are just a hobby and

are no different from various otaku-like activities began to spread. I call this "total otaku-ization."

The *nanpa* type is also called "the Shibuya type" and the otaku type is also called "the Akiba (Akihabara) type."[8] Morikawa Kaichirō contrasted the streets of Shibuya lined with buildings featuring large windows (inside are fashionably dressed youths) and the streets of Akihabara with its windowless buildings (inside is "another world" *[isekai]* inundated with character goods).[9] In *Sabukaruchaa shinwa kaitai*, I associated the *nanpa* type with "fictionalization of reality" or "dramatization"; and the otaku type with "real-ization of fiction" or "transformation into another world." Morikawa's description is an application of my description here. Along with Morikawa, I characterize the *nanpa* type as those who receive reality with added value, and the otaku type as those who receive fiction with added value.

In Figure 1, the third quadrant (the *nanpa* type) represents the semantics characterized by the "fictionalization of reality" and "dramatization." In contrast, the fourth quadrant (the otaku type) represents the semantics characterized by the "real-ization of fiction" and "transformation into another world." And because the difference between reality and fiction has been flattened—the supremacy of reality has been lost—the distinction between fictionalization of reality and real-ization of fiction has lost its substance. This is a major reason for the end of otaku discrimination. At the same time, the concept of total otaku-ization—the idea that everyone is more or less otaku—began to spread. However, as I discussed just now, it is not that the otaku type (the Akiba type) has approached the *nanpa* type (the Shibuya type); it is that the *nanpa* type has lost its luster and therefore approached the otaku type. In this sense, the fourth quadrant (the otaku type) expanded and superseded the third quadrant (the *nanpa* type) and today's situation came about.

The second period of the age of the "self" began around 1996. Starting around 1996, the "compensated dating" *(enjo kōsai)* boom began to recede.[10] Concurrently, the idea that the *nanpa* types are cool began to fade; or rather, the sense that they are painful to watch began to spread. One phenomenon indicative of this shift was the *ganguro* boom among high school girls.[11] The biggest characteristic of this boom was high school girls' rejection of the male sexual gaze through an intensification of make-up. In addition to these changes, otaku, having discovered an opportunity for communication through online services and the Internet, had their feeling of deprivation lessened through "inclusion." Through such changes, otaku communications shifted from the trivia competition to the play (or dalliance) of communication. Thus, otaku have been redeemed and no longer feel they have been

FIGURE 1. Historical transition of media communication and youth culture. Figure created by Miyadai Shinji.

discriminated against. According to Okada Toshio, otaku creativity tapped into this discrimination-induced depression as a source of creative energy, and this "otaku redemption" took creativity away from them. This is the reason, Okada argues, why the Wonder Festival, the semiannual show for buying and selling figurines, had to be cancelled once in the winter of 2001.[12] Symbolizing this "otaku redemption" was the "world type" (sekai-kei) boom.

How the Nanpa Type and the Otaku Type Bifurcated

To truly understand the significance of the "otaku redemption," one must closely examine the "age of the self" since 1975. According to the analysis in *Sabukaruchaa shinwa kaitai*, the "age of sex and stage-setting" begins in 1977. *Nanpa* (womanizing), *compa* (group dating), and *shōkai* (dating through friends' introduction) became the most popular activities or events for the young generation. This includes the disco boom, the "Shōnan" boom, the tennis boom, and so on.[13] Interestingly, also in 1977, the theatrical version of *Space Battleship Yamato (Uchū senkan Yamato)* became a hit, and this triggered the launch of the first-ever anime magazines. Because of this simultaneity, it might seem that the otaku-type culture was created as a shelter

from the *nanpa*-type culture that was expanding at the time. But, in fact, the process by which the *nanpa* type and the otaku type bifurcated was a little more complicated.

Contrary to what one may think, those who led the age of sex and stage-setting largely overlapped with those who started the trivia competition about anime and manga. Indicative of this is the fact that many creators and writers of pop song fan magazines (such as *Yoiko no kayōkyoku* or *Remember*), which were launched one after another starting in 1976, were fans of rock music just before. At the roots of both the *nanpa* type and the otaku type were high school students of elite Tokyo private schools who began eye-catching behavior as "games no one else can keep up with."

In *Sabukaruchaa shinwa kaitai,* I called this early overlap of the *nanpa* type and the otaku type "the proto–new *homo sapiens*," i.e., "the proto-otaku." Here "the new homo sapiens" *(shinjinrui)* corresponds to the *nanpa* type. However, in a later generation, the new *homo sapiens* (the *nanpa* type) and the otaku began to bifurcate. Then, by 1983, the otaku culture became a refuge for those who could not adjust to the *nanpa* culture, and younger generations began to realize this.

One event indicative of this shift is the invention of the term "otaku" by Nakamori Akio in 1983. This term became popularized after a suspect for the serial murder and rape of young girls was arrested in 1989, but those familiar with youth culture, for example marketers and magazine editors, had been using the term "otaku" since 1983, and with derogatory connotations. From the 1980s to the mid-1990s, the *nanpa* type (new *homo sapiens*) were treated as first-class citizens, while the otaku type were treated as second-class citizens. Otaku discrimination was particularly intense between 1989 (when the serial murder suspect was arrested) and 1996 (when the compensated dating boom was at its peak). Incidentally, 1995 was the year Japanese society was shaken by the Aum Shinrikyō incidents.

It is no coincidence that the Aum Shinrikyō incidents took place at the height of the age of otaku discrimination. There was a "new religion" boom from around 1980 to 1995, the year of the Aum incidents. Aum Shinsen No Kai, the parent organization of Aum, was established in 1984. But in 1980, around the Kabuki-chō district of Shinjuku in Tokyo, there was a boom of "*nyū fūzoku,*" or new sex services employing female college or vocational school students. The *burusera* boom and the compensated dating boom in the 1990s were extensions of this. In this sense, the period from 1980 to the mid-1990s was the "age of sexual love," as well as the "age of religion."

I discuss this situation in more detail in *Sabukaruchaa shinwa kaitai.* In

that book I emphasized the fact that sexual love and religion are functionally equivalent as tools to achieve a "comprehensive acceptance." The higher the sexual love boom rose, the more people were disappointed in sexual love for not giving them that comprehensive acceptance,

IT IS NO COINCIDENCE THAT THE AUM SHINRIKYŌ INCIDENTS TOOK PLACE AT THE HEIGHT OF THE AGE OF OTAKU DISCRIMINATION.

and this resulted in the rise of the religion boom as it provided an alternative source of that comprehensive acceptance. In this sense, the religion boom was a refuge from the sexual love boom. This is similar to the situation where the otaku culture was a refuge from the *nanpa* culture.

Thus, the sexual love boom and the religion boom are functionally equivalent in terms of meeting the demands for comprehensive acceptance. Their parallel development since around 1980 indeed marks the opening of "the age of the self," i.e., the age in which the homeostasis of the self is considered important. This is why I argued in *Sabukaruchaa shinwa kaitai* (published in 1993) that the keyword after the 1980s is *self-defense*.

It is very important that this emphasis on the homeostasis of the self or on self-defense arrived prior to information technology or the database. To preview the argument to come, the advent of information technology and databases, first and foremost, enriched the means for the homeostasis of the self, that is, self-defense; and, secondly, it thereby rapidly weakened the sense that "reality" (or embodied communication) is more fruitful than "fiction" (or virtual reality). As a result, the priority between reality and fiction came to be determined by the cost-effectiveness with regard to achieving that homeostasis. Obviously it takes cost and risk to make arrangements in reality (embodied communication) to achieve the homeostasis of the self, and thus it is more efficient to achieve it if we do not distinguish reality and fiction. In this way, the two are treated as equivalent.

This development means that, in order to maintain dignity (or self worth), people become exempt from the necessity of winning recognition through embodied communication, by having to work within society. Since around 1997, vicious "de-socialized" crimes have been on the rise, in which criminals kill others without hatred or remorse. One might suspect that this is related to the change in which individual dignity is less and less tied to society.

From the Early Period to the Late Period of the Age of the Self

To review, 1999 was a threshold between the sense that reality is weightier than fiction and the otaku's redemption. This influenced the otaku type

contents as well. In short, the "Armageddon" disappeared and the "world type" emerged.

As Tsurumi Wataru argued in *Kanzen jisatsu manyuaru* (1993, The complete manual of suicide), Armageddon is related to the notion of "resetting of the world."[14] According to the sociologist Peter Berger's "theory of multiple realities," communication is divided into multiple realms of reality, but what we call reality is characterized by the irresettability. This inability to reset made "reality" into "the paramount reality." Reversing Berger's argument, Tsurumi asks if reality cannot indeed be reset. In 1996, Tsurumi, in *Jinkaku kaizō manyuaru* (A manual for personality transformation), renamed my phrase "the endless everyday" as "the world without Armageddon" and declared, "if Armageddon never comes, we might as well take drugs!"[15] Acknowledging the "failure" of Aum, Tsurumi argues the following: In the past, it was possible to dream of resetting reality through war or disaster. Since this became impossible, Aum Shinrikyō's Armageddon fantasy emerged, in which they tried to bring about Armageddon themselves. When the failure of Aum became clear evidence of a world without Armageddon, suicide and drugs emerge as tools to reset reality that are the equivalent of Armageddon.

Tsurumi Wataru's writing since the late 1980s first praised Armageddon, then suicide, then drugs, and then dance (raves). Tsurumi's activities ended with *Ori no naka no dansu* (1998, Dance behind bars),[16] but he does symbolize the early period of the age of the self, considering the fact that his exit coincides with the appearance of the world type in the late 1990s. In fact, in the late period of the age of the self, the homeostasis of the self through what Azuma called "database consumption" made Armageddon or suicide or drugs unnecessary. The database consumption that gave rise to the world type and the *moe* type is equivalent to Armageddon or suicide or drugs before the mid-1990s in terms of their functionality for resetting reality for the homeostasis of the self.

In the late period of the age of the self, reflexivity increases. Earlier there had been a difference in priority between reality and fiction: of course, reality was superior to fiction. However, as a method to juxtapose reality and fiction as functionally equivalent became generally accepted, irony—the act of "kicking away the ladder" (or ungrounding) by assigning the whole to a part—spread. In other words, reality was made subjective through a view that reality is only "what we think is real."

The act of irony can be represented by the communication "*omae mo naa*" ("you too!"), which is a phrase (cliché) widely used in 2channel, the biggest Internet bulletin board site in Japan. Such irony relativizes all kinds of

messages, for example by pointing out that the seemingly self-evident assumption (the whole) is but something chosen by an individual (a part). This results in an increase in reflexivity. Reflexivity, according to Niklas Luhmann, is a situation where the presupposition for a choice is something that has already been chosen.[17]

> HOWEVER, AS A METHOD TO JUXTAPOSE REALITY AND FICTION AS FUNCTIONALLY EQUIVALENT BECAME GENERALLY ACCEPTED, IRONY—THE ACT OF "KICKING AWAY THE LADDER" (OR UNGROUNDING) BY ASSIGNING THE WHOLE TO A PART—SPREAD.

This kind of irony that increases reflexivity is an obsessive one, contrary to the detached connotation of the word. Anyone who is familiar with the communication mode of 2channel can attest to this. The participants on 2channel had no choice but to continue ironic communication for the homeostasis of the self, for self-defense.

In *Kyokō no jidai no hate* (1996, Beyond the age of fiction), Ōsawa Masachi suggests "ironical immersion" is a feature of "the age of fiction" in Mita's schema (or "the age of the self" in mine).[18] He refers to Aum believers' behavioral patterns in which they say they are acting purposely (understanding fully what they are doing), but in fact they are forced into a situation in which they have to behave in this way. Ōsawa expands the scope of ironical immersion wrongly, failing to apply the concept correctly, but if we were to use the concept correctly it would be as follows:

The presence of irony, in which the whole is relativized by being assigned to a part, is a separate matter from the presence of obsession, in which one is forced into using a certain mode of communication. Through theoretical analysis we may find that irony is a necessary outcome of the functional equivalence of reality and fiction, and obsession is a necessary outcome of the need for the homeostasis of the self or self-defense. "Ironical immersion" refers to the act of self-defense in the age in which reality and fiction became functionally equivalent. In other words, to have no choice but to continue making references to reflexivity because of the necessity for homeostasis to maintain the fragile self: to say "This is all play" or "I know what I'm doing but I dare do this," but to nevertheless sweat over the homeostasis of the self. This is the correct image for ironical immersion.

Postmodern Reflexivity

As discussed earlier, the functional equivalence of "reality" and "fiction" is expedient in terms of supplying the homeostasis of the self at a low cost. It

would be wrong to think, however, that the demands for the homeostasis of the self caused the flat juxtaposition of reality and fiction. Completely unrelated to the issue of the homeostasis of the self, the functional equivalence of reality and fiction derives from postmodernity. To be more precise, it derives from the "reflexive modernity" discussed by sociologist Anthony Giddens.[19]

Postmodern society is a society in which universal *systematization* makes it impossible to have the self-understanding that "we live in the *life-world* and utilize the *system* only for the sake of convenience." Because of universal systematization, we become aware that the life-world or we who live in it are after all but the products of the system. Sociologist Max Weber defined modernization by generalizing the procedures that enable calculability. Based on this definition, social scientist Jürgen Habermas called this domain ruled by a procedure that enables calculability a system, and called the space not ruled by this procedure the life-world. This much is well known.

But there is a problem beyond that. This is because "untainted nature" is in fact only the result of human inaction (or action as inaction), of the act of not touching—the life-world is also not untainted "native soil" *(dochaku)*. But for a while, we did not become aware of this and thought that we, living in the life-world, were proactively and independently *(shutaiteki ni)* using the system for the sake of convenience. This age is called modernity, as opposed to postmodernity.

However, in the 1960s, as seen in philosopher Michel Foucault's critique of Jean-Paul Sartre, the understanding that "freedom" and "subjectivity" are but products of a structure or a system began to spread, first in the realms of philosophy and thought.[20] Then in the 1970s, this understanding spread more or less to the mass level, when it was widely depicted in novels and in film, for instance. Thus, all constituents of society came to recognize that the *system* provided each constituent with the idea of "one's true self." Spreading was the recognition that, although we try to utilize the system to recover our true selves, we have only false subjectivities, and the true subjectivities reside on the side of the system. In short, it is the recognition that everything is planned and enacted by the system.

Such a recognition has been popularized by the descriptions of economist John Galbraith and sociologist Jean Baudrillard. It is not important whether the description of oneself provided by the system is true or not. What is important is the fact that the self-description useful for the homeostasis of the self has come to be offered by industrialized services, through advertising or the discourses of counselors. Through these capitalist activities, the idea of reflexivity, that "the presupposition for one's choice is itself something

that has been chosen," became widely known. This is postmodernity. To put it more simply, modern society is "bottomless" insofar as it does not have any unchanging presuppositions, but postmodernity is the age in which many people become aware of that fact.

Those critics who think that the difference is merely one of awareness understand postmodernity as late modernity. Those thinkers who pay attention to the fact that such awareness drastically changes the semantics argue that postmodernity is a stage that comes *after* modernity. In general, many sociologists take the former position while many artists and creators take the latter. Regardless, the "age of the self" is the "age of fiction" and at the same time the "age of reflexivity." In science fiction since the 1950s, Ray Bradbury and J. G. Ballard predicted that the future would be the age of the industrial production of self-description.[21] And indeed their predictions came true. In this sense, the way it turned out was not completely unexpected.

THE SHIFT IN 2001: FROM THE "WORLD TYPE" TO THE "BATTLE ROYALE TYPE"

Aum Shinrikyō as the "Original World Type"

As I discussed earlier, it is the "world type" that symbolizes the late period of the age of the self. To understand the significance of the world type, it is useful to compare it with Aum Shinrikyō, which symbolizes the early period of the age of the self. At the beginning of this essay, I discussed the Aum believers' commitment to the idea of Armageddon. Let us examine this more closely.

As Jōyu Fumihiro (the former public relations manager for Aum Shinrikyō) stated during an interview with me, Aum believers saw Armageddon as a purpose as well as a prophecy: they wanted to fulfill the prophecy themselves. They spread poison gas themselves to test their own air purifier called the Cosmo-Cleaner, and they tried to bring about an Armageddon themselves by spreading sarin gas or anthrax.[22] They were even researching the possibility of triggering an eruption of Mt. Fuji using a plasma-powered weapon.

Since manipulating "fiction" is lower in cost and risk than manipulating "reality" in mobilizing resources for the homeostasis of the self, fiction could have a higher value than reality as resource for the homeostasis unless there is a strong notion that fiction is inferior to reality. At least, some

people accepted this estimation. In this context, what is amazing with Aum Shinrikyō is that, in trying to achieve the homeostasis of the self, they tried to reset reality completely, rather than fiction, although that option was far less cost-effective. In other words, it was not the Armageddon of the secondary reality but that of the primary reality that they conspired to bring. How could such a ridiculous leap or short-circuit become possible? The biggest reason is that the purpose for the Armageddon was the homeostasis of the self, rather than the realization of social justice or an ideal world. They sought an Armageddon not in order to construct an ideal world, but to construct an ideal self. The whole of the society was considered from the subjective viewpoint of the homeostasis of the self. In this sense, Aum Shinrikyō was indeed the "original world type."

> WITH THE DECLINE OF "ARMAGEDDON" IN THE PRIMARY REALITY, THE "SCHOOL" BEGAN TO EMERGE IN THE SECONDARY REALITY.

But this original world type spectacularly failed as they tried to manipulate the primary reality. Since then, this original world type died out, and instead the world type involved only with the secondary reality began to rise. In other words, the "original world type" retreated to the "world type." In fact, switching places with the failure of Aum Shinrikyō in 1995, the age of the world type began with the anime TV series *Neon Genesis Evangelion (Shin seiki evangerion)* in the fall of 1995. In a review column on current public discourse (*rondan jihyō*) for Asahi Shimbun in 1996, I discovered a characteristic of this work in its strange semantics: while *Evangelion* raises "the mystery of the world" and "the personal mystery," it only resolves the personal mystery directly, and the direct resolution of that mystery (without explanation) leads to the resolution of the mystery of the world. Since around 2002, works dominated by this kind of semantics are called the "world type."

In my analysis, after the failure of Aum Shinrikyō, it seemed crazy to manipulate the primary reality from the viewpoint of the homeostasis of the self, and as a result, with the decline of "Armageddon" in the primary reality, the "school" began to emerge in the secondary reality. Of course, schools exist in the primary reality as well, and everyone has memories of their school days. And this is why the school is invoked in the secondary reality. Armageddon for Aum Shinrikyō is a delusion set in a "future reality"; the school for the world type is a delusion set in a "past reality." For both, it is not a delusion *qua* delusion: while Armageddon is a delusion grounded in what will certainly happen in the future, school is a delusion grounded in what has certainly happened in the past. Delusions must refer to reality primarily in

order to bring intensity to the delusion and to guarantee intersubjectivity. Incidentally, as a former market researcher, I believe that there is no market for a personal illusion lacking intersubjectivity, and that it is impossible to commodify such an illusion, as a game for example. In addition, since one tends to "desire someone else's desire" in a sense, the intensity brought about by intersubjectivity should not be ignored.

No Armageddon Needed in a School Fantasy

As the first work of the "world type," *Evangelion* bridges Aum Shinrikyō (the original world type) and the world type that continues to expand in the new century. A comment by Anno Hideaki, the director of *Evangelion,* offers a key to understanding this: when I had dinner with him, he revealed to me that he "originally wanted to shoot a post-Armageddon (World War III) 'school drama.'" Toward the end of the *Evangelion* TV series, there is a "dream sequence" using the framework of the school drama. Anno stated: "that part was supposed to be the body of the story." In fact, since Anno was in a state of depression just before the anime's production, the part about Armageddon expanded and the whole story became an "Oedipal drama with Armageddon in the background." But according to Anno, in the initial conception of the anime, Armageddon (World War III) was required to set up a "school as a paradise," much like the stage for the dating simulation game *Tokimeki Memorial.*

This is interesting: the school drama required a setting after Armageddon. Why? Everyone has school experiences. They may be good experiences or bad experiences; some have good memories, but some have bitter ones. No matter what their memories are about school, everyone should have had the experience of fantasizing an "ideal school that could have been." This is why many world type manga, games, and novels are set in that kind of school. But why do people stop fantasizing about the school that could have been? It is because they grow up. More specifically, it is because they grow up and the "gravity of society" weighs heavily on them. In the adult world, the kind of uniformity in school, where everyone is a student, is impossible.

In this way, it is natural to sense that one cannot live in "that school" again unless the weight of "this reality" is cleared through Armageddon. To be exact, the shared sense that *this* is natural, symbolizes the age of *Evangelion* (the mid-1990s). Back then, the gravity of society was great. But then, the setting in which this reality must be cleared in order to live in that school gradually became unnecessary. To set up a stage like *Tokimeki Memorial,* an "Armageddon" such as World War III ceased to be mandatory. The reason,

in my estimation, is that the gravity of society weakened and "this reality" became lighter.

Why did this reality become lighter? One reason is that the series of Aum-related incidents offered a new self-description. It used to require some excuse to remain "fictional" without seriously engaging with "reality," but after the Aum incidents, such an excuse was no longer needed. Because of the Aum incidents, ironically, there emerged a consensus that it is rather dangerous for those crazy people to engage with reality.

The biggest reason that this reality became lighter is that, as what Azuma Hiroki called "database consumption" became more general, the frame of this reality expanded all at once. In other words, "this reality" came to mean the whole of the database useful for the homeostasis of the self, whether its material is reality or fiction; and as a result "this reality" became a "light reality" that included fiction. In this database, everything available for the homeostasis of the self is registered as this reality. Reality or fiction, mass culture or high culture, academism or subculture, everything became material for the homeostasis of the self. The "light reality" in this sense is the main body of the "world" in the world type.

It is in this sense that the world type represents the late period of the age of the self. What is lowest in cost and risk is opportunistically chosen from among functionally equivalent material to maintain the homeostasis of the self, whether it is reality or fiction. Because of the lightness of this reality, the oppressive atmosphere once called "ironical immersion" was rapidly relaxed.

The lightening of this reality and the aforementioned disappearance of otaku discrimination, official recognition of otaku and total otaku-ization of all forms are perfect parallels. Many otaku became communicative, enjoying communication. I call them "half-otaku." The "maid cafe" boom since 2003 or the *Train Man (Densha otoko)* boom of 2005 symbolize this development from otaku to half-otaku. As such a development progressed, Akihabara lost the strangeness of the past and became a tourist spot.

The World Type as a Presupposition for the Flourishing of the Battle Royale Type

Uno Tsunehiro, a critic of the younger generation, argues that the high point of the "world type" was between 1996, when *Evangelion* was aired, and 2000, when the serialization of *Saishū heiki kanojo* (She, the Ultimate Weapon) began; he further suggests convincingly that, after around 2001, it shifts over to

the battle royale type.[23] This type is represented by such works as *Death Note (Desu nōto)*, the TV drama *Joō no kyōshitsu* (2005, The queen's classroom), and the popular manga and TV drama *Dragon zakura* (2005), that is to say, stories depicting ruthless dog-eat-dog struggles based on the neoconservative worldview.

Let us review the meaning of the "world type," using my own review article from 1997 as a starting point.[24] The world type refers to a group of works, starting with *Neon Genesis Evangelion* (or the semantics of such works), in which the resolution of the "personal mystery" is directly linked to the resolution of the "mystery of the world."

Then how did the world type shift to the battle royale type in such a short period? What happened to the world type's functions for the homeostasis of the self? These questions have to be asked. It is relatively easy to answer them. A hint lies in the similarities between Aum Shinrikyō and the neoconservatives.

As a starting point of our analysis, let us use Uno's definition of the "battle royale type" as a group of works depicting ruthless dog-eat-dog struggles based on the neoconservative worldview. Needless to say, neoconservatives are the remains of Trotskyites of the 1960s, who would do "whatever it takes" for a universal justice, defending a modern society that protects the freedom of the weak and of minorities. As I have said on many occasions, neoconservatives are strikingly similar to Aum Shinrikyō, in the sense that both would do whatever it takes for a world revolution. Both of them give the impression of being self-centered and simplistic. Probably the reason for this shared impression is that, although they prioritize the order (homeostasis) of the self over the social order, they cling to the misunderstanding that they are indeed thinking about the social order. After the failure of Aum Shinrikyō, "reality" was no longer utilized for the homeostasis of the self, because, using the description above, it became possible to indulge in the fantasy of "the school that could have been" without the Armageddon that sweeps reality away. But, for the exact same reason, the neocon fantasies began to multiply.

On the surface, the neocon fantasies of the battle royale type seem like a regression to Aum-like fantasies. But there is one difference: the keyword here is *justice*. The Aum-like fantasy had an Armageddon, but it was weak in its commitment to justice. Indeed, the homeostasis of the self through justice characterizes the battle royale type. More abstractly, the dichotomy of "justice/injustice" is relevant to any game, whether it is real or fictional. Furthermore, "injustice" is a powerful trap for emotion, capable of offering shared emotional presuppositions to many, which is why this dichotomy is

effective as a tool for motivation. The battle royale type uses "justice" to supply the homeostasis of the self. The pursuit of justice may seem social, but in the battle royale type, the activities of pursuing justice become a game for the homeostasis of the self.

Such a "battle royale" may be found in the activity called *dentotsu* or *totsu* (short for *denwa totsugeki* or "telephone call attack"), in which individuals mobilized on the Internet make complaints on the phone, ask for a response, and then post the recorded reactions online. The first instance of *dentotsu* was the "Toshiba complaints incident" in 1999. A recent, famous example of this is the "Mainichi WaiWai incident," involving the "WaiWai" section of the *Mainichi Daily News*.[25] Among my students there are many famous (or infamous?) charismatic *totsu* artists. I've collected much information from them.

What's interesting about the *dentotsu* phenomenon is that the asymmetry between "the revolutionizer" and "the revolutionized," which existed in Aum Shinrikyō, does not exist here. In the world of *dentotsu*, which is not unlike bullying at school, the attacker and the attacked can switch roles at any moment. The Thai film *13 game sayawng* (2006, *13: Game of Death*) aptly depicted the fact that such a situation is a natural consequence of Internet society.[26] This film scrupulously depicts the structure in which the survival game in the primary reality becomes a reality-based entertainment for a certain group of spectators and game designers on the Internet, which in turn become a reality-based entertainment for another group of spectators and game designers—it is a rhizome-like battle royale, so to speak. This film offers an important recognition: such a rhizomic structure invalidates the distinction between "reality" and "fiction." At the same time, with this lack of distinction between reality and fiction as a precondition or presupposition, the rhizome-like battle royale spreads. This is a (vicious) cycle: once it starts, it cannot be easily stopped.

The Proliferation of Battle Royale and the Weakening of "Reality" Are Two Sides of the Same Coin

There is no major difference between the world type and the battle royale type insofar as both of them use whatever is available, whether it is reality or fiction. If I had to differentiate the two, the world type treats fiction as an equivalent of reality (real-ization of fiction), while the battle royale type treats reality as an equivalent of fiction (fictionalization of reality).

As I discussed earlier, the difference between the otaku type and the *nanpa* type (the *shinjinrui* or new *homo sapiens* type) is that, while the otaku

type seeks the "real-ization of fiction" or transformation into another world, the *nanpa* type seeks the fictionalization of reality or "dramatization." By referring to this, we may say that the world type is similar to the former while the battle royale type is similar to the latter. Needless to say, both the world type and the battle royale type are subcategories within the otaku type. It is true that there is a chronological development from the world type of the late 1990s to the battle royale type of the 2000s, but as the *nanpa* type and the otaku type coexisted side by side for a long time, among Internet users those with world type inclinations and those with the battle royale type coexist. While the antagonism between the otaku type and the *nanpa* type emerged in the age in which "reality" and "fiction" were believed to have different values, the antagonism between the world type and the battle royale type emerged in the age in which reality and fiction are regarded as equivalent tools for self-defense. It is noteworthy that the difference in the reality construction strategy between the otaku type and the *nanpa* type has made a parallel translation to the difference in reality construction strategy between the world type and the battle royale type *within* the otaku type. It is important to recall, however, that this parallel translation *into* the otaku type was made possible by the "total otaku-ization" around 1996, which also enabled the shift from the "original world type" (Armageddon!) to the "world type" (school!).

In this sense, in comparison with the watershed moment of 1996 when the world type first emerged, there is no clear-cut moment in which the battle royale type first emerged. As I discussed earlier, the method of maintaining the homeostasis of the self using *justice* as a keyword existed from roughly the same time as the emergence of the world type, if we were to include in them those "Korea-hating kids" (*kenkanchū*; those Internet users who bash South Korea). In this sense, it is appropriate to understand that the world type and the battle royale type are but two manifestations of the equivalence of reality and fiction in terms of the homeostasis of the self. In addition, I wish to draw your attention to the fact that this equivalence of reality and fiction emerged in parallel development with the collapse of hierarchy on the side of "reality."

Let me give you an example: the book *Tokusatsu kensatsu vs. kin'yū kenryoku* (2007, Special investigation prosecutors vs. financial authority) by Murayama Osamu, who is on the editorial board of the *Asahi shinbun,* one of Japan's major daily newspapers.[27] It is an excellent nonfiction book depicting the struggles between the Public Prosecutor's Office and the Office of Financial Policies. This book scrupulously describes intense power struggles under the surface, though we see only the tip of the iceberg. Recently major players

in this battle have begun to appear on TV as commentators, but their commentary and behavior have been all too mediocre.

How should we understand the gap between the power they had possessed and their weak appearance on TV? This question is a variation of the question: how do we understand the weight of "reality"? My answer is as follows: it has always been true that someone can be an amazing player in one game but a mediocre player in another. But in the past, each game was clearly segregated from others, and a player of one game did not have to play any other. This fact maintained the stratified order. But these days the barriers between such games have collapsed, and there arise many situations in which the hero of one game makes a fool of him- or herself in another. As a result of this, the stratified order of "reality" collapsed. Nobody is capable of saying, a priori, which game is more privileged than another.

There are numerous episodes suggesting the situation where a powerful player in one context ("game") can be an all-too-mediocre one in another. For example, in *Fahrenheit 9/11*, a documentary directed by Michael Moore, there is a scene in which Paul Wolfowitz, the former deputy secretary of defense and an influential neocon politician, is standing in front of a TV camera.[28] That effete, frail, diminutive man combing his hair is "it." Many in the audience must have smiled bitterly.

In the age of the battle royale type, which followed the world type, the equivalence of reality and fiction is presupposed, and fictionalization of reality (the attitude in which one lives reality as if it were a game) becomes more prominent. In this age, the stratified order is invalidated in reality itself, as the ladders are knocked out from under the feet of of "great" figures and institutions themselves, and as a result the "fictionalization of reality" becomes even easier. The *dentotsu* artists' Internet exposé, which reveals the shoddy customer support or the internal confusion of major corporations, only underscores this fact. (The "Mainichi WaiWai incident" is a prime example of this.) In this sense, the proliferation of battle royale and the loss of the weight of reality are two sides of the same coin.

IN CONCLUSION: THE EVER-CONTINUING BATTLE ROYALE PROCESS

As the stratified order collapsed and, in a parallel development, the order of "reality" and "fiction" collapsed, the world type engaging in real-ization of fiction and the battle royale type engaging in fictionalization of reality both

began to spread. In other words, "people living a game as if it were reality" and "people living reality like a game" are increasing. In 1996 the former became more conspicuous; after 2001 the latter became more conspicuous.

At the heart of the intellectual tradition of sociology is an undermining of self-evidence by "rethinking the presuppositions" or "referring to the contexts." It examines presupposition, then a presupposition of the presupposition, then a presupposition of *that* presupposition . . . or a context, then a context of the context, then a context of the context of the context, and so on. As one reverts back further and further, the unshakable framework becomes so flimsy that solid justice and grand authority disappear. Sociological analysis has such a function, which we may call relativization through reflexion. In other words, sociology is about pointing out how everything is arbitrary, including our own act of pointing it out. Therefore, sociology, by nature, is good at the "you too!" (*omae mo naa!*) mode of communication often seen on 2channel. Since we are immune to this kind of communication, we will not lose motivation in the process of relativization (at least we *should not*).

But not all members of society are sociologists. Some people can survive these tendencies that are saturating communication in society: the endless game of removing each other's ladders or the quagmire of reflexivity (*saikisei no doronuma*); others cannot. These tendencies are symbolized in the equivalence of reality and fiction, which presupposes the collapse of the stratified order in reality. For how long can people endure this situation? At the least we need *some* people who can endure the "endless game of removing each other's ladders" and the "quagmire of reflexivity," withstand the avalanche of "you too!" communication, survive the "battle royale," and carry out their original ideals. They should not only continue criticism but also continue to engage in designing society while enduring unceasing criticism. In a society with high reflexivity (i.e., the situation where the presupposition for a choice is something that has already been chosen), failing to participate in social design *unwittingly* is tantamount to a *deliberate* choice.[29]

From now on, social design not only inevitably but also indispensably requires "designers" to remove each other's ladders. This is because, in a social system with high reflexivity, it is impossible to approach the social totality

> IN THE AGE OF THE BATTLE ROYALE TYPE, WHICH FOLLOWED THE WORLD TYPE, THE EQUIVALENCE OF REALITY AND FICTION IS PRESUPPOSED, AND FICTIONALIZATION OF REALITY (THE ATTITUDE IN WHICH ONE LIVES REALITY AS IF IT WERE A GAME) BECOMES MORE PROMINENT.

without an intricate rhizome of a perspective that questions the function of a perspective, which in turn questions the function of a perspective, and so on ad infinitum. It follows that the social designer (i.e., the architect) must be involved not only in the primary reality but also in secondary or tertiary realities. For "this reality" now includes both "reality" and "fiction," and we become aware of the arbitrariness of the boundary between the two. In this sense, the sensibility of the battle royale type is indispensable for those involved in social design.

It has already been fourteen years since reality and fiction have become functionally equivalent from the standpoint of the homeostasis of the self, and it has been more than ten years since the opposition between the world type and the battle royale type has become visible. As I discussed in *Sabukaruchaa shinwa kaitai*, postwar Japanese subcultures have had five- to seven-year cycles. In this sense, a period of fourteen years or even ten years is unusually long. It is difficult to identify a watershed moment in the past ten or fourteen years. In my hypothesis, the situation of the past ten plus years—in which reality and fiction became functionally equivalent from the standpoint of the homeostasis of the self and in which the world type who lives "fiction (a game)" like "reality" has been differentiated from the battle royale type who lives "reality" like "fiction (a game)"—is in a kind of dynamic equilibrium, a stasis. I suppose that this situation will continue for a considerably long time.

Sociological thinking used to take the bifurcation of reality and fiction as a self-evident presupposition; it was responsible only for analyzing the order of reality. I believe that such a traditional framework will become unacceptable. Sociology has analyzed the structure and architecture of reality, but since structures and architectures also exist for fiction—that is, for the secondary or tertiary realities—and since fiction is received as part of "this reality," the analytical framework of sociology must expand as well.

EPILOGUE: 1992 PAVING THE WAY FOR 1996

In the pages preceding, I discussed the shift in 1996 and the shift around 2001. In the epilogue that follows, I wish to revert and touch upon the shift in 1992. I have treated the 1992 shift in the chapter "Pop Music's Mode of Reception Changes through Karaoke-ization" in *Sabukaruchaa shinwa kaitai* (published the following year, in 1993). Let me elaborate on this work.

The shift in 1992 is in a sense greater than the shift in 1996 or in 2001. In 1992 there were drastic, simultaneous shifts in the mode of reception of

music, adult video, erotic magazines, sexual love, sexual services, and prostitution. I call the common denominator of all of these contemporaneous shifts "the loss of aura." The "loss of aura" is what philosopher Walter Benjamin pointed out as the biggest change brought about in the age of mechanical reproduction.[30] "Aura" originally referred to the divinity that descended upon the earth in the Advent. The loss of aura means that God no longer descends to earth.

Benjamin used the loss of aura as a metaphor for the following situation: according to Benjamin, sculpture has more aura than painting; painting has more aura than photography; photography has more aura than film; film has more aura than television. In other words, there is a vivid sense that *it* is a substitution for something original—the sense that "in this resides something authentic that is not here." It is not that the kind of media will determine the degree of aura directly. The characteristic that *it* is an expression *of* something real can be best understood if we consider masturbation. First, there is masturbation in which one is excited by the real thing. Second, there is masturbation in which one is excited by a media expression of the real thing. Finally, there is masturbation that is excited by an expression that is *not* an expression of the real thing (such as animation). Aura decreases in this order, but what is important is that, while some men get excited about the real thing, presupposing the distinction in the degrees of aura, other men get excited about the real thing in the flat state without any distinction in the degree of aura (for example without distinguishing the real thing from animation).

First of all, allow me to discuss the mode of reception of music. There was a karaoke boom in 1992, but concomitant to this, the form of the reception of music changed. In the past, the common mode was immersion, in which one immerses him- or herself into the "scenes" or "relationality" that the music represents. That changed completely after the karaoke boom. Karaoke is used as a communication tool for having a good time with people who are not necessarily friends. It's a repetition of someone singing, followed by applause, then someone else singing, and so on. Self-centered, self-immersed singing should be avoided, and one is supposed to sing the songs that everyone knows. The suppliers of music, responding to this mode of reception, began to sell songs that were tied to TV commercials, TV dramas, and motion pictures, in order to supply songs that everyone knows. In this way, the sense that music is an expression *about* something has rapidly diminished. Instead, new criteria for evaluation were introduced: whether everyone knows it and whether everyone can have a good time with it. In this sense, music became

AROUND 1992 THE
WEIGHT OF "REALITY"
BEGAN TO DIMINISH
QUITE RAPIDLY. AND ITS
WEIGHT COMPLETELY
DISAPPEARED IN 1996.

a kind of consumer good, like fashion or cosmetics. Such production and consumption of music became typical even before the distribution of music through the Internet became common.

After music ceased to become a tool of expression, it ceased to become a fashion item as well. On the supplier side, music became archived, as seen in the iTunes Music Store; on the consumer side, there was "nebularization"—that is to say, the division of the field into isolated island-universes. As a result, people no longer have to buy CDs and access new songs to keep up with the latest hits. One could interpret it in this way: this move away from fashion was triggered by the move away from expression, as music was no longer required in order to refer to contemporaneous contexts. In this way, one became able to search the archive simply in terms of whether certain songs "feel good or not," irrespective of the context of whether everyone knows the songs.

Next let us look at the mode of reception of adult videos (i.e., pornography). In 1992 there was a shift from individual titles to titles based on themes in the world of adult videos. Before this, there were well-known actresses who would appear in the videos and be paid wages on the order of one million yen per title. But since 1992, as the industry shifted from the rental video business model to the sales business model, amateurs (hiding their faces with mosaic patterns on screen) began to appear for less than one hundred thousand yen per title, as if it were a part-time job. In terms of the contents, works with rich stories became rare and instead most works pinpointed very specific sexual tastes, such as scatology, fetishes (such as schoolgirl uniforms), and special situations (such as groping on a crowded train). To put it simply, pornography shifted from mass production to small-scale production of varied titles. This "pinpointing" has accelerated through the proliferation of adult video on the Internet. This is similar to the situation with music. Concomitant to this was anime-ization of adult videos. In this way, adult videos are no longer an expression *about* a certain popular actress or an expression *about* a certain story. The users of adult videos no longer get excited about actresses or stories; they get excited about the fetish images in front of them, detached from contexts. They no longer have to fast forward the video; the videos are sold "already fast-forwarded."

Let us turn to erotic magazines. In the world of erotic magazines, there was a shift from the text-based to the image-based in 1992. Earlier, the main feature of the erotic magazine was text, as pictures and photographs were

mostly for the purpose of illustrating the texts. But in new erotic magazines, the main feature became "gravure" (photographs of swimsuit models) and illustrations, and the texts were relegated to the captions attached to those images. In this way, while one used to fantasize *about* something the text describes (with the text as a medium), now the reader responds directly to the visual stimuli of the erotic photographs, erotic illustrations, and erotic anime. This is the shift from the text-based to the image-based. The aura resided in the text-based media, because the text was a substitute for the real thing; but the image-based media are just stimulants.

Finally, let us look at the *"burusera"* phenomenon in the sex industry. In *burusera* shops, high school girls sell their underwear or uniforms to a shop and the shop in turn sells them to male customers. Starting in 1992 actual high school girls began to sell real underwear or uniforms. Before that, real housewives and office ladies (OLs) sold their underwear. I called the phenomenon of many high school girls selling their underwear and uniforms the *"burusera"* phenomenon. It was I who publicized this phenomenon in Japan, by writing about it in newspaper columns and magazine articles. Thanks to this effort, I was given the title of "the *burusera* sociologist." One year after the *burusera* phenomenon, with the "dating club" boom of 1993 to 1996, came the so-called compensated dating boom. I did fieldwork on this and introduced it widely.

In these two booms, *burusera* and compensated dating, I noted the loss of aura. As I discussed earlier, young men began to be excited by anime or manga characters *just like* they are by real high school girls. Anime or manga were not substitutes for the real thing. Anime, manga, and the real thing were received almost as equivalents. In *Seifuku shōjo no sentaku* (1994, The choice of schoolgirls in uniform), I expressed this situation as the "symbolic reception" of the real thing. As I discussed in detail in this book, the high school girls themselves flattened rough bumps of reality by using such "signs" as "funny old man" *(henna ojisan)* or "cute old man" *(kawaii ojisan).* In this way, both on the side of male customers and of high school girls, the flattening of reality or fictionalization of reality occurs, where "reality" is grasped as an aggregate of signs. There, signs neither represent reality nor substitute for it. Reality itself is consumed as signs. Conversely, signs themselves are consumed as "reality." The aura, or the divinity of reality, in which the "real" exists behind signs, was rapidly diminishing.

In this way, around 1992 the weight of "reality" began to diminish quite rapidly. And its weight completely disappeared in 1996, when the method of regarding reality and fiction as functionally equivalent from the viewpoint of

the homeostasis of the self quickly spread. In this sense, 1992 paved the way for 1996. As I discussed above, the series of Aum incidents in 1995 was one of the events that triggered the shift from the Armageddon type to the world type, but the mass-scale loss of aura in 1992 had provided a precondition or presupposition necessary for this.

..

Notes

This essay is based on a lecture given at the University of Michigan, Ann Arbor, on April 1, 2009.

1. [Luhmann discusses this in *Social Systems,* trans. John Bednarz, Jr., with Dirk Baecker (Stanford, Calif.: Stanford University Press, 1995), 163. —Trans.]

2. Miyadai Shinji, Ishihara Hideki, and Ōtsuka Meiko, *Sabukaruchaa shinwa kaitai: Shōjo, ongaku, manga, sei no 30 nen to komyunikeeshon no genzai* (Dismantling the subculture myth: The present state of communication and thirty years of shōjo, music, manga, and sex) (Tokyo: Parco Shuppan, 1993); revised and expanded as *Zōho sabukaruchaa shinwa kaitai: Shōjo, ongaku, manga, sei no hen'yō to genzai* (Dismantling the subculture myth [the expanded edition]: The changing state and present state of shōjo, music, manga, and sex) (Tokyo: Chikuma Shobō, 2007).

3. [Mita Munesuke (b. 1937) is professor emeritus of sociology at the University of Tokyo. Mita's discussion of this three-part periodization of postwar Japan has been translated in Mita Munesuke, "Reality, Dream and Fiction—Japan, 1945," in *Social Psychology of Modern Japan,* trans. Stephen Suloway, 515–27 (London: Kegan Paul International, 1992). Mita's schema has been quite influential in Japanese critical discourses since the 1990s. Besides Miyadai, Ōsawa Masachi elaborated on Mita's schema in *Kyokō no jidai no hate* (Beyond the age of fiction) (Tokyo: Chikuma Shinsho, 1996), to which Azuma Hiroki in turn responded in his discussion of the "animal age." See Azuma Hiroki, *Otaku: Japan's Database Animals,* trans. Jonathan E. Abel and Shion Kono (Minneapolis: University of Minnesota Press, 2009), 73–74, 89–90. —Trans.]

4. Tsuji Izumi, "Tetsudō no imiron to 'shōnen bunka' no hensen: Nihon shakai no kindaika to sono kako genzai mirai" (The semantics of the railroad and the vicissitudes of "boy culture": Modernization of Japanese society and its past, present, and future) (PhD diss., Tokyo Metropolitan University, 2008).

5. See Morikawa Kaichirō, *Shuto no tanjō: Moeru toshi Akihabara* (Learning from Akihabara: The birth of a personapolis) (Tokyo: Gentōsha, 2003).

6. See Azuma, *Otaku.*

7. ["*Nanpa kei*" in the original. "*Nanpa*" (lit. "the soft school") originally referred to young men interested in womanizing but is now more often used as a verb, referring to the act of "picking up" women or "womanizing." "Kei" is rendered in this translation as "type" throughout (e.g., "otaku type" and "Shibuya type" for "*otaku kei*" and "*Shibuya kei,*" respectively). —Trans.]

8. [In the original, "*Akiba kei,*" with "Akiba" being a shorthand for Akihabara. —Trans.]

9. See Morikawa, *Shuto no tanjō*.

10. [Compensated dating *(enjo kōsai)* is the term widely used in Japan in the 1990s to refer to the phenomenon of schoolgirls dating older men for money (with or without sex). At that time Miyadai was at the center of media debate on this phenomenon and fiercely defended the girls, arguing that this is a liberating act. —Trans.]

11. [*Ganguro* (literally "black face") was a fashion trend among urban young girls around 2000, characterized by an overly tanned face and white makeup around the eyes. —Trans.]

12. Hayami Yukiko, "*Gendai no shōzō Okada Toshio*" (A Contemporary Portrait: Okada Toshio), *AERA* (November 4, 2002): 72–77.

13. [*Shōnan* is a beach resort in Kanagawa prefecture near Tokyo. Around 1980 it was a center of youth subculture associated with surfing and rock music. —Trans.]

14. Tsurumi Wataru, *Kanzen jisatsu manyuaru* (A complete manual of suicide) (Tokyo: Ōta Shuppan, 1993).

15. Tsurumi Wataru, *Jinkaku kaizō manyuaru* (A manual for personality transformation) (Tokyo: Ōta Shuppan, 1996).

16. Tsurumi Wataru, *Ori no naka no dansu* (Dance behind bars) (Tokyo: Ōta Shuppan, 1998). [The book deals with the author's experience in prison after being arrested for drug possession —Trans.]

17. In *Social Systems,* Niklas Luhmann explains reflexivity as "when the basic distinction [for self-reference] is between *before* and *after* [an elemental event]." Luhmann had called this "processual self-reference" in several of his papers during the 1970s. When learning becomes reflexive it is "learning about learning"; when a choice becomes reflexive, it is "a choice about a choice."

"The distinction between *before* and *after* [an elemental event]" refers to the fact that the "before learning/after learning" distinction is inherent in the concept of learning, and that the "before a choice/after a choice" distinction is inherent in the concept of a choice. Building on this, "the self-reference based on the distinction between *before* and *after*" means that the "before learning/after learning" distinction is applied to the "before learning/after learning" distinction itself, and the "before a choice/after a choice" distinction to the "before a choice/after a choice" distinction itself.

This is a difficult expression typical of Luhmann, but it is what he had called "learning about learning" or "a choice about a choice" in his earlier papers. "Learning about learning" here derives from Gregory Bateson's idea of "learning to learn"; Bateson states that the reflexive process of "learning to learn" is an effective way of increasing the rate of learning. In my terminology, "learning to learn" (i.e. learning about learning method) is "learning about presuppositions for learning" and "a choice about a choice" (i.e. a choice about selection method) is "a choice about presuppositions for a choice." For the learning method is a presupposition for individual learning, and method of selection is a presupposition for individual choices. Herbert A. Simon also states that the selection of particular choices out of all possible ones, as well as the selection process itself are presuppositions for individual selections. Gregory Bateson, *Steps to an Ecology of Mind* (New York: Ballantine Books, 1972), 166–176; Herbert A. Simon, *Administrative Behavior* (New York: The Free Press, 1976), 3–4.

18. Ōsawa, *Kyokō no jidai no hate.*

19. See, for example, Anthony Giddens, *The Consequences of Modernity* (Cambridge: Cambridge University Press, 1990).

20. Michel Foucault and Madeleine Chapsal, "Entretien avec Michel Foucault" (An Interview with Michel Foucault), *La Quinzaine Litteraire* 15 (May 1966): 14–15. Sartre responded to this in Jean-Paul Sartre and Bernard Pingaud, "Jean-Paul Sartre répond" (Sartre Responds), *L'Arc* 30 (1966): 87–96.

21. In *Fahrenheit 451* (1951), Ray Bradbury describes a scene in which people are driven to certain consumer behavior through constant messages from a television about "what one should be." An updated version of Bradbury's vision appears in J. G. Ballard's *Kingdom Come* (2006). The protagonist, who is waging an advertising war from a cable TV studio in a shopping mall, becomes an instigator of shopping mall fascism, and the violence among agitated people escalates without end. Both of these novels depict a situation in which the (potentially profit-driven) call to recover one's true self can bring about mass consequences unimaginable even to the author of that call. Ballard's *Vermillion Sands* (1971) also depicted the ways in which the system penetrates deeply into people's sensibilities, although Ballard's depiction there is not completely negative.

22. [The Cosmo-Cleaner was named after a device in the anime *Space Battleship Yamato*. —Trans.]

23. See Uno Tsunehiro, *Zero nendai no sōzōryoku* (Imagination in the 00s) (Tokyo: Hayakawa Shobō, 2008). [Uno's argument in the book, summarized here by Miyadai, is that Japanese popular culture of the 2000s has shifted from the insularity of *sekai kei* to the bold, willful motifs of *ketsudan shugi* (decisivism). The film *Battle Royale* (2000, *Batoru rowaiyaru*) signals this shift for Uno. —Trans.]

24. Miyadai Shinji, "Shinkuroritsu no hikui sei: 'Genjitsu wa omoi' kankaku" (Life with a low synchronization rate: The sense of "heavy reality"), *Asahi shinbun*, 26 February 1997, evening edition.

25. [In this incident in 2008 the *Mainichi shinbun* apologized for years of publishing unfounded, sexually lurid stories. —Trans.]

26. *13 game sayawng,* dir. Chukiat Sakveerakul (2006); released in the United States as *13: Game of Death,* DVD (Weinstein Company, 2008).

27. Murayama Osamu, *Tokusatsu kensatsu vs. kin'yū kenryoku* (Special investigations prosecutors vs. financial authority) (Tokyo: Asahi Shimbun Shuppan, 2007).

28. *Fahrenheit 9/11,* dir. Michael Moore, DVD (Sony Pictures, 2004).

29. [The term "social design" appears in *katakana* in the original. Miyadai's notion of social design, as one can see in his argument here, is a highly reflexive act peculiar to late- or postmodernity (as opposed to the top-down, rigid planning implied in such terms as "social planning" or "social engineering"). —Trans.]

30. Walter Benjamin, "The Work of Art in the Age of Mechanical Reproduction," in *Illuminations,* ed. Hannah Arendt, trans. Harry Zohn (New York: Harcourt, 1968), 217–51.

The Logic of
Digital Gaming

THE PARABLE OF THE WORM

You are running down a long, ichorous corridor, urged ahead by solid stone walls decorated, as is the custom in such contexts, with sconces holding flaming wooden torches. You tend to run wherever you go, but you have an added incentive at this moment: you are being chased by a giant worm, whose throaty growls and gnashing teeth suggest rather hostile motives. In fact, you know full well that the worm will eat you should it catch you, as you have become worm food in each of your last six flights down this corridor. An idea occurs to you: you stop directly in front of a sconce, jump up toward the torch, and, with the flame inches from your face, press the *grab* key on your keyboard. Landing, you turn toward the worm, hoping to intimidate it or possibly injure it with the open fire of the torch. But, as experienced gamers will anticipate, you discover that you are empty-handed; the torch remains in its sconce, and you are soon engulfed in the gaping maw of this neogothic cliché.

Why can't you grab the torch off the wall? Many objects in a computer game are only apparent and serve no functional role in the game. Mountains in the distance cannot be approached, nor do they block the sun's light,

influence local weather conditions, or signal the proximity of a fault line or volcanic activity. The doorknob on a door cannot be turned; in fact, it cannot even be grasped, and it does not catch on your clothing or deflect the blade of your passing sword. The doorknob is effectively painted onto the door, just as the mountains might as well be painted onto the horizon, and games sometimes reinforce this shallowness of game objects by rendering them in two dimensions: a tapestry that does not flutter and has no backside. Walk unfettered through a dead body; it appears on the screen as a three-dimensional projection but offers no dimensions of simulated material resistance; but for the seeing, it might as well not even be there.

Perhaps the torch on the wall goes a step further than pure appearance. Though it cannot be grabbed or otherwise manipulated, it does appear in proper perspective, sticking out from the wall and changing its visual relationship to the wall as you circumnavigate it. Moreover, its flickering flame is not only something to look *at,* for it determines how far down the corridor you can see, casting shadows as objects pass by and reflecting in the worm's single, unblinking eye.

But no matter where you jump or how fiercely you press the *grab* key, the torch stays put, and you cannot relate to it materially except as an object of your gaze and a source of light. Your face can pass through the flame when you jump, but you feel no heat and suffer no ill effects of this proximity to fire. You cannot soften the metal of a coin by holding it near the torch, and you can't even ignite the wick of a candle placed near this flame. You'll have to find another way to overcome the vicious worm.

PRINCIPLE OF SIMPLICITY

It is not (merely) a matter of video game convention that torches cannot be removed from their sconces and wielded. According to a *principle of simplicity,* everything that happens in a game happens by design. If an object behaves a particular way, that is because the behavior has been *put there* by designers and programmers. The nature of computer programming dictates that nothing comes for free; every aspect of the virtual world must be explicitly programmed. One consequence of this principle of simplicity is that the appearance of an object is effectively independent of its behavior. The code that governs how an object appears on the screen has no necessary relationship with the code that governs what a player can do in relation to that object.

While the disconnection between appearance and behavior may be

frustrating or counterintuitive for players, their separation often conditions or even constitutes gameplay. Play sutures this Cartesian gap between the internal logics of behavior and the external appearance of objects on screen; players find motivation in the anxiety of the tenuous relationship between the world as it appears and the world as it actually operates. Learning to play means mapping the extent of the correspondence between these worlds: guided by representational clues, a player must discover the capacities and limitations of game objects, exploiting that knowledge to solve the puzzles or overcome the obstacles that the game places before her. The player learns how objects, including her own avatar, work, and appearances offer clues but no ultimate assurance in this process of discovery.

Type *flip coin* at the command prompt of an Infocom game from the early eighties. These popular games were entirely text-based, accepting input in the form of two-word phrases and producing paragraphs of output describing the setting and the results of player actions. Depending on the particular game, *flip coin* could be processed at different levels of the program code, generating very different sorts of responses. Exception code: "I don't understand. Please rephrase." Missing object code: "I don't see a coin here." Exact match: "Tails! You grab your newly won dilithium matrix and quickly exit the room." Irrelevant action code: "You watch the coin rise and fall. So go the days of our lives." Most jarring is when, while your player-character is holding a coin, you type *flip coin* and get the response, "You can't do that to the coin." The computer's obstinate refusal to understand made it clear that one was not dealing with a coin, not even a simulated one, but with a game object called *coin*, with its own narrow set of affordances. Every two-word phrase had to be anticipated, entered into a vocabulary database, and correlated with appropriate responses. To make the engine act more aware of more objects required devoting more resources (labor from the programmer and designer, computer memory, processing power), since every action had to be explicitly programmed.[1]

So the principle of simplicity could also be a principle of the explicit: not only are appearance and behavior only contingently connected but whatever connections they have are deliberate, hence conceptualized. In other words, the behavior of an object (and the appearance of that object) must have been explicitly determined by designers and programmers, who had thought through that specific behavior in all of its detail. If the player's task is to discover the connections between appearance and behavior, this can happen only along prewritten pathways and can result only in anticipated connections. The creative investment of the programmer defines an upper limit on the challenge to the player.

While some cleavage between appearance and function may also char-acterize real-world material objects, such a split cannot be ontologically primary. In the world of the actual, something that looks like an apple will usually be edible, and if it isn't, there must a reason for this divergence of appearance and behavior. (Maybe it's made of painted wood, maybe it's a holographic projection, maybe it's been hollowed out.) We take for granted that appearance and behavior manifest a common nature of the object, that they must be coordinated because they are the appearance and behavior of the *same thing*.

In the computer, however, there is no *thing* that the appearance and behavior would manifest. There are only the many algorithms that produce affordances of the object, appearances, and behaviors. One algorithm that makes a red object appear as a red patch of pixels on the screen; another algo-rithm that alters the Cartesian coordinates of an object and removes it from the list of things in a player's inventory when the player presses the *throw* key. Thus, at the discretion of the programmer, an object might look like an apple but shoot like a gun or magnify like binoculars or provide transportation like a blimp, and there need be no plausible explanation (other than the whim of the programmer) as to why this apple-looking thing behaves in such a manner.

Looking for the essence of a game object, we might appeal to the Carte-sian coordinates that define the location of an object and to the other data that persist as long as the object exists (in the game world) and that change to record a change in the object when events in the game world affect it. Maybe those data constitute the underlying object, and the appearance and behav-ior of that object are manifestations of those data. This hypothesis matches well with some accounts of real-world metaphysics: the phenomenal aspects of an object, its appearance, passions, and actions, derive from and even ex-press its noumenal being. The real, primary properties of an object produce, by means of rules of physics and perception, its secondary characteristics.

But it's these rules that disrupt the isomorphism between actual and dig-ital. In the actual world, the accidental may be secondary and even subjective, but its relationship to the noumenon is not accidental. Secondary properties and affordances arise inevitably from the thing as it is lit by and itself lights up the laws of nature. An actual object does not have mass without already being subject to the law of gravity; mass cannot in principle be understood separately from the law of gravity that helps to define it. By contrast, the data of a digital object in a computer game have no essential relationship to that object's way of being, only an accidental relationship explicitly programmed into the object. A game object can have a data field called *weight*, but that

datum will have no bearing on the game unless the programmer has provided algorithms to read the object's weight and make it act accordingly. Even then, weight will only be meaningful in just those ways that the programmer has bothered to code into the algorithms describing the behavior of the object. (The *weight* of an item might determine whether it can be carried by the player but might not have any bearing on its inertial resistance when kicked.) There is no essence of a game object, as it comprises an indifferent collection of isolable components, data plus subroutines.

The principle of simplicity thus presents a particular challenge for programmers and designers. At the most practical level, the challenge is to correlate appearances with behaviors in a manner sufficiently intuitive to keep players from becoming too frustrated to continue, but not so obvious as to be trivial. Programming a game means relating appearance and behavior creatively. Over its history, programming has developed many tools to assist or encourage creative investment. Given the necessary equivalence between high-level and low-level code, such tools always boil down to labor-saving devices; for every sophisticated programming technique, there necessarily exists an equivalent set of code using the simplest programming languages, which means that no system of programming departs fundamentally from the most brute command architecture. But easing administrative burdens can change the nature of a job, especially when so much effort in programming is spent on bookkeeping of one sort or another. One significant innovation in this regard is the development of *object-oriented programming* (OOP). OOP systems are the de facto programming standard, but programmers can and do implement similar techniques even when a programming language or development environment is not specifically object-oriented.

In OOP, the *object* ties appearance and behavior together, grouped around a common set of data. A change to those data immediately effects expression in appearance and behavior. (Crucially, data represent *potential* expressions. Many changes in the data alter only how those data might eventually behave or appear but have no immediate discernible effect in the game. To pick a simple illustration, an object, such as a magical ring, might exist in the game world but not be within the player's field of view at a given moment. Such an object will neither appear nor behave until the player's actions make that object relevant.) To instruct an object, to act on something in the interface is to alter a behavior and immediately also an appearance. Behavior and appearance remain formally separable in the code but are joined in the interface by a correlation according to strict rules. The object does not ensure its integrity, does not guarantee a match between appearance and behavior, but it does

establish a formal unity of code that makes such a match easier to implement.

The distinction between appearance and behavior takes the form of a mediation. Players observe appearances, understand them as symptoms of potential behaviors, and act on the object accordingly. Objects suffer the player's actions, and their behaviors modify the data of the object, which then shows up in the interface as a change in appearance. The player acts on appearances but only via the mediating layers of behaviors and data.

> THERE IS NO ESSENCE OF A GAME OBJECT, AS IT COMPRISES AN INDIFFERENT COLLECTION OF ISOLABLE COMPONENTS, DATA PLUS SUBROUTINES.

AUTOLOGY

The evident continuities that tie video games to narrative forms and to other audiovisual traditions recommend an analysis of gaming based on its representations. Though they are often revealing, such analyses may fail to encounter the game as experienced by the gamer. For the gap between appearance and behavior and the underlying atomism of computer objects disrupt the structure of representation in gaming. Marking an extremity in this subversion of representation are motions along three axes, reflecting three intermingled perspectives: the programmer who produces the game by creating its objects, the code governing appearances and behaviors, and the player who loses herself in the game.

The programmer creates objects that orient play and the player. Thus fixated by the objects of the game, the player connects appearances only to behaviors; appearances cease to represent a world outside the game and intend only the data and behaviors of the digital objects they represent. Cut off from the world outside the game, the circuit of affection and logic that passes from computer to player and back closes onto itself. The player takes all her cues from the game, devoting her life, her whole being just to this world of play. As Charles Bernstein observes of the computer game's "fixed system of control," "*all the adapting is ours.*"[2] Given this short circuit of affective logic, the player ultimately plays herself. Her aim is to use the computer as a biofeedback mechanism to instruct her body to react in a manner governed by objects of the game but according to a strategy developed also in terms of those objects.

Which is to say, games have objects, games and gaming are object-oriented. Programmers write objects and players pursue them. Data and

algorithms—*objects*—define a logic by which the programmer determines the nature of the game.[3] Creating objects, the programmer fixes the possibilities that the player can choose, the paths of play, the objects of the game. The player defines her goals in terms of the properties and behaviors of game objects; not only her overall strategy but every individual move is oriented toward the available objects provided by the programmer, the algorithmic possibilities for affecting the behavior of game elements.

Driven to succeed according to the objects of the game, the player avails herself of precisely those objects, those dimensions of play that effect success. She disciplines herself, training body and mind in response to the underlying logics of the code: "The way computer games teach structures of thought—the way they reorganize perception—is by getting you to internalize the logic of the program. [. . .] Eventually, your decisions become intuitive, as smooth and rapid-fire as the computer's own machinations."[4] As the player focuses on selecting object behaviors in a manner that promotes progress toward in-game goals, all the parts of the game, including the appearances of objects, take their meanings primarily from those same goals. Appearances turn inward toward the game and away from the rest of the world; with no reference outside of the game, they serve as icons for behaviors.

The player orients her habits of thought and motion according to this algorithmic logic. To play a game is to engage immediately with abstractions that are defined by the logic of algorithms. Appearances of game objects cease to represent anything outside of the game; instead they produce meanings wholly internal to the circuits of affective logic that flow in a closed loop from player to computer and back. Representation is digitized, as computer objects stand for abstractions that could never be presented. Representation relaxes its grip over sense, and the player enters a digital world, at play between actual and digital.[5]

Appearances peel away from behaviors, to become superficies, their capacity for representation now incidental, hardly relevant. The brief glint in the eye of the invader from Jupiter no longer signals malice but only the familiar pattern of an imminent feint and attack. The blue glow at the end of the hallway is not the luster of a magical gem but only the ego-syntonic aura of another marker of progress soon to be obtained. The putrescent corpse of a long-dead soldier evokes no sympathy or disgust or anxiety but serves as a waypoint in the search for more loot. To play is to transform the principle of simplicity that divides appearance from behavior into a practice of simplicity, wherein one ignores the appearance except inasmuch as it continues to indicate the affordances of an object.[6]

Closed onto itself, the logic of the binary has no object but logic *(autology)*. The immersed player, it could be said, comes to resemble an automaton or, better, an autistic.[7] Flows of logic pass back and forth between player and computer, shutting out the rest of the world.[8] (Cybernetics is the art of steering through flows, regulating one's passage.) The player narrows her field of vision, her range of expression, her vocabularies of word, gesture, and thought. Attention is tunneled. Immersed, the player adopts repetitive motions, distances herself from her own body to the point that she foregoes sleep and nourishment. Sociability abounds in gaming, but mostly *through* the computer, other people as interlocutors and interactors mediated by the digital code. The player thereby replaces her own "sentient cognition with the blank hum of computation."[9]

These habits of body, mind, affect, and behavior are also symptoms. Limited social interaction, limited communication, repetitive motions, hyperfocused attention, alienation from the body, reduced or atypical sensory response, impaired sleep, narrow verbal fluency, interaction largely confined to an internal world isolated from the real world: these symptoms define autistic spectrum disorders. Immersed gamers are not generally autistic. Rather, I am suggesting that gaming and autistic spectrum disorders be studied side-by-side. If immersive gaming involves nonrepresentational modes of cognition, perhaps research in autism would do well to investigate intelligences that are not based on representations. (Autistic savants tend to excel in areas that do not rely on representational thinking, such as music.)

Existing research only hints at a relationship between immersive gaming and autism: John Charlton and Ian Danforth reported at the 2008 conference of the British Psychological Society that, according to their study, people addicted to gaming were "not classifiable as having Asperger's syndrome but share some of the same characteristics because they find it easier to empathize with computer systems than other people."[10] While it is not clear what it would mean to empathize with a machine that has no pathos, my analysis of the immersed gamer suggests an alternate formulation, in which the gamer refuses representation and retreats from the representational world in favor of an algorithmic world where even affect courses along logical and predictable pathways. (Perhaps this is indeed a kind of empathy, a feeling together along with the computer and game.) If this autology feels antihuman or unsympathetic, note that the claim need not be understood as a privation. The immersed player, beyond representation, exercises other cognitive and corporeal habits, complex logics that convert representational significance into strategic action.

Of course, representation always returns, the actual intrudes once again into the digital. Something might at any time break the trance, a telephone, a fire, an urge. Instead of exhausting appearances in formulas that relate them to behaviors, some games maintain the tie between appearances and their representational referents, such that the player must continue to think about what sorts of objects are in the game and how they might behave if they were real. This kind of strategic thinking, wherein representations offer clues to the relationship between appearance and behavior, characterizes the learning phase of a game. Players learn to play by divining behaviors through trial and error guided by representation. A good game keeps the player learning, and it is in learning to play that she connects the interface to a wider world. If it looks like a person, try shooting it in the head; you can probably kill it in just one shot. What appears to be a mirror on the wall may well reflect the beam of your laser gun, allowing you to shoot both in front of and behind you. That coin you could not flip might be perfect for the pay phone you need to use.

Even when a game maintains its connection to the world beyond it, play still presupposes the radical division between appearance and behavior. Meaning in a game may be complex, but it also narrow, defined by the binary boundaries of the code, the prescription of objects that constitutes the game and determines its play. This foreshortening of the virtual world is what makes it a world; while the fantasy of virtual reality has long embraced the idea of a plenary reality built from digits, the key to world-making is not to fill the sensorium but to occupy the player, erecting radical limits that define the totality of her world. Having no other world, the virtual ersatz becomes the player's only world, orienting her body and thoughts to the interface.

Violence, whose notoriety in video gaming is so prevalent as to dominate the popular discourse on gaming, takes on a new meaning in this analysis. If representations are secondary, a means to an end (learning to play), then game violence should not be understood primarily in relation to the real violence whose appearance it mimics. Rather, violence serves as a parodistic or hyperbolic confirmation of the closed circuit of the player-game. Designers inject increasingly extreme violence into games in part to demonstrate precisely that this violence is not real, to foreground the radical break between appearance and behavior that characterizes games. At the same time, this violence may be a response to the alienation from the world that threatens dedicated gamers. That is, game designers may be attempting to shock players back into reality, to remind them, using brutality and its evident lack of consequence, that though they are playing a game, there is also a real world out there.

Notes

1. This account of the operation of the semantic engine of Infocom games is a bit simplified, but not misleadingly so. For a detailed analysis of the development of semantic engines in the context of computer gaming, see Noah Wardrip-Fruin, *Expressive Processing: Digital Fictions, Computer Games, and Software Studies* (Cambridge, Mass.: MIT Press, 2009).

2. Charles Bernstein, "Play It Again, Pac-Man," *Postmodern Culture* 2, no. 1 (September 1991): §53. Emphasis in original.

3. Many contemporary programming languages are not object-oriented. But elsewhere I argue that the invention and reinvention of the object is the core innovation in the progress of computer languages. Programming always uses objects, even if it is not always explicitly oriented toward them.

4. Ted Friedman, "*Civilization* and Its Discontents: Simulation, Subjectivity, and Space," in *On a Silver Platter: CD-ROMs and the Promises of a New Technology*, ed. Greg Smith (New York: New York University Press, 1999), 136.

5. Matthew Fuller generalizes this claim about representation on the computer. He notes that the metaphors prevalent in computing (desktop, icon, hand pointer, and so on) rapidly lose their value and become impediments to efficient computing. "Software will need to be seen to do what it does, not to do what something else does." Fuller, *Behind the Blip: Essays on Software Culture* (Brooklyn, N.Y.: Autonomedia, 2003), 100.

6. No doubt this collapsing of appearances into iconic pointers happens in nongame contexts as well. Real soldiers must forget that they are shooting at human beings and experience the battlefield as a field of signs of opportunity, markers that allow the translation of learned strategy into immediate tactic. But a good soldier must remain open to the possibility that appearances will exceed their reduced meanings as symptoms of behavior. Smoke surely means something, but not always fire.

7. I do not believe that this comparison in any way denigrates people who exhibit an autistic spectrum disorder (ASD), but I apologize should this discussion of autism cause offense. My aim is not only to point out the provocative similarities between immersive gaming and ASD but to suggest that such ways of being may symptomatize sophisticated nonrepresentational modes of cognition. Current research focuses on gaming as a potential aid and possible harm to people with ASD, and I am here indicating another path for research.

8. The hermetic world internal to the game will have a very different character depending on whether the flows of affect and logic pass through other players or only a single player and her computer.

9. Friedman, "*Civilization* and Its Discontents," 136.

10. John Charlton and Ian Danforth, press release from the British Psychological Society, http://www.bps.org.uk/media-centre/press-releases/releases$/annual-conference-2008/computer-game-addicts-like-people-with-aspergers.cfm (accessed December 1, 2008).

Tsuge Yoshiharu and Postwar Japan: Travel, Memory, and Nostalgia

In 1968, the manga monthly *Garo* published a highly successful special issue featuring the work of Tsuge Yoshiharu (b. 1937).[1] Far from reveling in his growing popularity, however, the artist quite literally tried to run away from it. Faced with his own commercial success, this painfully shy man felt tremendous angst, eventually deciding in September of that year to drop everything and flee to Kyūshū. There he intended to lead a new, anonymous life with a female fan whom he knew only through the letters they had exchanged.[2] Perhaps predictably, this plan fell apart after a mere two weeks, and Tsuge returned to Tokyo, where he spent much of 1969 on hiatus, working only as an assistant to another manga artist. Nonetheless, Tsuge's escape attempt reveals the degree to which this artist struggled—both in his life and his work—to secure a place for himself in a radically transforming society.

The early death of his biological father and his mother's remarriage to an abusive man contributed to the conditions of extreme poverty in which he grew up during the years of the Asia-Pacific War and the immediate postwar.[3] In fact, to support his family, he began working odd jobs in his early teens, eventually missing his entire middle school education. By his late teens, Tsuge had found his calling: drawing manga allowed him to use his artistic talent

> FAR FROM REVELING IN HIS GROWING POPULARITY, HOWEVER, THE ARTIST QUITE LITERALLY TRIED TO RUN AWAY FROM IT.

and to work alone, a boon for a man who found all contact with others painful. In 1955, Tsuge made his debut as a freelance artist for rental manga books. Although he published numerous works over the following decade, he continued to struggle financially, occasionally even selling his blood at a blood bank just to survive.[4]

Meanwhile the medium of manga was undergoing a drastic transition. In the early 1960s, the market for rental manga books began to collapse as weekly publications rapidly expanded their readership. As a result the manga art form, once deemed marginal and insignificant, gained a new legitimacy. Some authors adjusted to the changing market and made considerable commercial gains. Tsuge, however, took a different path. In 1965, after giving up his own career as a rental manga author, Tsuge began working as an assistant to manga artist Mizuki Shigeru, publishing his own short pieces in his spare time.[5] Rejecting the larger and hence more lucrative market of the weeklies, he chose *Garo,* a monthly magazine more open to experimental works, as the main medium for his art. There he found a niche, albeit temporarily, and, with a score of highly acclaimed short pieces that appeared from 1965 to 1968, Tsuge finally attained financial stability even as he expanded the boundaries of manga expression.

However, Tsuge did not feel completely comfortable with his own success, for it forced him to climb out of the social class to which he was accustomed. While benefiting from financial stability, he tried hard to adhere to his working-class identity, rejecting the pretense of being what he felt he was not. In the second half of the 1960s, his search for his lost identity in the midst of financial success led him to various locations in Japan: he sought an environment where he could capture the shadows of the disappearing past. By deliberately staying at shabby inns, he indulged in the fantasy that he was a castaway in postwar society. The comfort that he found in these experiences, he later claimed, satisfied his desire for self-denial.[6] Tsuge's works that are based on his trips strongly suggest that he sought a piece of the past that he had lost. The shabby inns were attractive precisely because they offered him a life for which he felt a strong affinity. Echoing this experience, his stories from the second half of the 1960s are often set in rustic locales that have been left behind by the economic growth of contemporary Japan and feature protagonists who arrive at an unspecified location in the country as if to reconfirm their affinity with the fast-disappearing world of rural Japan. Yet, just as Tsuge in real life realized the impossibility of living his

fantasy, the protagonists in his fiction are invari-ably aware of the distance that separates them from the object of their nostalgia. Tsuge's angst-filled travelers thereby remain in a constant state of unease, never succeeding in blending into the fictional world.

Tsuge's fast-growing fame was a paradoxical outcome of his desire to remain unaffected by progress a while longer: the more earnestly he expressed his tenuous relationship with the past through his work, the harder he was thrust into the commercial world by his success. Although

> THE DRASTIC CHANGES IN TSUGE'S WORK IN THE LATE 1960S AND THE EARLY 1970S ATTEST NOT ONLY TO THE ARTIST'S CONTINUING STRUGGLE WITH CONTEMPORARY SOCIETY BUT ALSO TO THE PACE AT WHICH HIS IMAGINARY SPACE WAS COLLAPSING.

difficult for the artist himself, this uneasy relationship with contemporary society was a source of creative tension from 1965 to 1968, a period in which he published a string of widely praised short works.

Among these works was "Gensenkan shujin" (Gensenkan master), one of Tsuge's best-known works, which first appeared in 1968. When compared with his later travelogue manga, "Gensenken shujin" still operates in a space where the forces of commercialism have not completely overcome the author's fictional world. While intimating that an encounter with the present will be inescapable, the work only suggests the tragic consequences that will result. By the time Tsuge published "Yanagiya shujin" (1970, Yanagiya master) and "Riarizumu no yado" (1973, A "rustic" inn), he had lost his tenuous ties to his fictional world and was keenly aware of this loss. In these two later works, loss then appears as an inescapable condition under which Tsuge's characters travel. The success of his work brought more than financial reward to the artist of humble origin: the awareness of his complicity in the commercial world drove him out of the comfort of his own fantasy world. Although his characters keep returning to the same imaginary realm, they appear to experience increasingly greater discomfort with each return. Ultimately the discomfort of Tsuge and his characters was also a response to a society that had rediscovered and commercialized the rustic country. The drastic changes in Tsuge's work in the late 1960s and the early 1970s attest not only to the artist's continuing struggle with contemporary society but also to the pace at which his imaginary space was collapsing. The juxtaposition of three works from this period, "Gensenkan shujin," "Yanagiya shujin," and "Riarizumu no yado," will demonstrate how Tsuge struggled with this crisis in his artistic life. Using the motif of travel, Tsuge Yoshiharu expressed his angst over the drastic transformation of Japanese society.

"GENSENKAN SHUJIN," OR THE
PREMONITION OF LOSS

Although Tsuge was threatened by the waves of commercialization that swept Japan in the late 1960s, it was still possible in 1968 for him to imagine a fantastic realm independent of contemporary society. In "Gensenkan shujin," it initially appears that the author has managed to catch the shadow of the past just as it is disappearing in a desolate hamlet completely left behind by progress. However, it gradually becomes clear that the comfort the protagonist finds in this location is actually ridden with deep fear and anxiety about revealing his outsider status. "Gensenkan shujin" intimates that the protagonist arrives at the scene only to destroy his own fantasy world; his belated arrival exposes his pretense that he is somehow part of the long-gone past. Tsuge's nostalgic dream ends in nightmarish fashion with his protagonist rendered immobile, as if the slightest move would completely destroy his imaginary world.

"Gensenkan shujin," opens with the protagonist's arrival in a small, desolate hot spring hamlet, a place with which he instantly feels a strong affinity (Figure 1).[7] Black and gray tones dominate the scene, with the darkness rendering an impression of the hamlet as completely enclosed within itself. Everything there appears to have been quietly decaying. The only people that he encounters—even the ones who are playing children's games—are the elderly women of the hamlet who sit in the darkness of night.[8] At a cheap confection store that caters to these child-like elderly people, the proprietor remarks on the protagonist's resemblance to the master of the nearby inn, Gensenkan, and volunteers the story of how he came to settle there.[9] According to her, the man who is now called the master *(shujin)* of Gensenkan arrived at the run-down inn some time ago and became sexually involved with the inn's deaf and mute mistress. Ever since then, he has lived there as her husband. After hearing the story, the protagonist declares that he too must go to Gensenkan, disregarding the words of the elderly people who gather around him, warning that if he goes there something catastrophic will happen. In the end, he arrives at the entryway of Gensenkan, facing the master and mistress of the inn.[10] He takes steps toward the couple, whose faces are stricken with fear. The story ends with a frame in which the protagonist appears with a long-nosed goblin *(tengu)* mask on his face.[11]

There are several key visual codes in the story that punctuate this rather opaque narrative. The features of the man who is later known as the master of Gensenkan are clearly portrayed except in a sequence in which he has a

FIGURE 1. Entry scene from "Gensenkan shujin" (1968), by Tsuge Yoshiharu.

brief talk about former lives with the elderly maid at the inn. Here, the conversation starts with the man's question about the deaf woman:

> Man: Was she born like that?
> Maid: It must be destiny from her former life.
> Man: Former life? What do you mean by former life?
> Maid: It is a mirror.
> Man: Do you believe so?
> Maid: Yes, because we could not live without a former life.

The maid goes on to insist that, were it not for former lives, humans would all be ghosts.[12] At this point in the conversation, the man's face suddenly turns into a featureless silhouette. Sensing the man's ghostly existence, the maid becomes fearful. Reflected in the mirror of his former life, the man appears merely as a dark void. His featureless face reveals that he has lost all ties with the past, ties that are still found in the hamlet.

On the contrary, although the story establishes the striking resemblance

between the two characters through the store proprietor's words, the master's double appears only in dark silhouette, except when he faces the master at the very end. Even when he does appear in the light, his face is covered with a goblin mask that he has purchased earlier at the confection store. The newcomer insinuates himself as a ghostly shadow on the surface of a world that belongs to a former time. The reader is reminded that the master is a ghostly figure in search of the past that has anchored his existence in this hot-spring hamlet. While he may have found his "former life" within this community that has been forgotten at the margins of society, he is still faced with an imminent end to his dream of embracing the past. His dark double arrives from the outside to remind the Gensenkan master that he is a mere imposter in the timeless world of the hamlet.

The master indulges in a nostalgic dream through his sexual relations with the middle-aged mistress, who is dressed in a kimono and wears her hair in a traditional Japanese style. Through the sexual relations that the master initiates (he forcefully demands sex and the mistress consents), he literally inserts himself into the scene of nostalgia. The corpulent sexual figure dressed in traditional attire—the feminine embodiment of his nostalgic desire—is almost completely deprived of speech and makes herself available to the masculine master from the outside. (The only word that she manages to articulate is "*heya de*" [in the room], which she writes on a bath wall, acquiescing to the man's demand.) By sexually consuming her, the man becomes the "master." As he consummates his sexual relationship with the mistress, the master is shown wearing a goblin mask on his face just as his double does at the conclusion of the story (Figure 2). The goblin's nose in the shape of an

FIGURE 2. Consummation scene from "Gesenkan shujin" (1968), by Tsuge Yoshiharu.

erect phallus announces his determination to recover his masculine identity as the master of his own nostalgia within this community where no other males appear to exist. (The object of nostalgia is almost always feminine.) Yet his happy union with the nostalgic world is about to be disrupted by the encounter with his double.[13]

The protagonist belatedly arrives at the scene as a shadow of the Gensenkan master, mocking his pretense that he is the sole master of nostalgic memories. The goblin mask that he buys at the store reminds the reader that the very masculine identity the master gained at Gensenkan lacks originality. The double arrives as an emissary from the outside, where even the objects of nostalgia are being commodified in the marketplace. The couple is frightened to face the double, sensing that their union is about to be opened to outside forces. The arrival of the double, a repetition of the original encounter, intimates that the event will soon be endlessly repeated in the marketplace. That is, the feminine object of nostalgic desire will be made available to anybody with the means to purchase it. The nostalgic union is an ephemeral dream that lasts only until the arrival of postwar Japan's economic development.

"YANAGIYA SHUJIN"

It was still possible for Tsuge to situate his protagonist within the space of nostalgia in "Gensenkan shujin," though the story ultimately declares that he is about to be evicted from the space. By the time Tsuge resumed publishing his work in 1970, the situation surrounding his angst-filled traveler seems to have changed drastically. In "Yanagiya shujin," one of the first works he published after his ill-fated attempt to escape his newly found success, there is little pretense that the relationship with the lost past is recoverable. Unlike in the 1968 work, the sexual act through which the protagonist recovers his male identity is safely contained in the protagonist's fantasies, and the author is far more self-reflective about his own fantasies. While describing the inevitable and painful separation from his fantasy world only in premonitory fashion in 1968, Tsuge seems to have accepted the inevitable end two years later. The high degree of self-reflectivity distinguishes "Yanagiya shujin" from Tsuge's earlier work: the author returns to his fantasies as if to confirm that there is absolutely no place for him within them. The protagonist—Tsuge's alter ego—is constantly aware of the distance that separates him from the object of his nostalgia. He is even portrayed as a farcical figure, caught in repetitive returns to the past.

"Yanagiya shujin" repeats many of the themes found in "Gensenkan shujin." Visiting the rustic hamlet, the protagonist stays in a rundown eatery where he finds an object of sexual interest. The dark tone that dominates the work and the protagonist who appears in black silhouette in many frames are reminiscent of the scenes from "Gensenkan shujin." Yet the author adds another layer to the story: he anchors it in the protagonist's present state of mind by framing it with opening and closing scenes that are situated in the author's present time. By portraying the movement between the everyday realm and the imaginary world, the story strongly underlines the latter's unreality. The fantasies are contained as fantasies, never to be fully admitted into everyday life.

The story opens with a scene in which the protagonist visits a nude studio on a back street of Tokyo. There a naked woman exposes her private parts to him, listlessly naming each part with Tokyo's landmarks: "This is Shiba Park. This is Tokyo Tower, and Waterworks Bureau. Hama Detached Palace. Tokyo Gas."[14] Sitting in front of her, the man who resembles the author shows utterly no interest in the scene (Figure 3). While the landscape of Tokyo is sexualized through the juxtaposition with the woman's body parts, it is completely devoid of sexual allure. The opening scene establishes that it is impossible for the protagonist to recover his male identity by embracing the corrupt object of nostalgia. The man finds no connection with the metropolis in the woman's figure. He eventually turns his back to the woman, noticing the theme song of a popular movie series, *Abashiri bangaichi* (1965–72, A man from Abashiri Prison), playing from downstairs.[15] The series romanticizes the marginal identities of the inmates of the penitentiary in Abashiri, Hokkaidō. Urged by the song, Tsuge's protagonist suddenly flees the scene and jumps on a train heading east.[16]

While the protagonist eventually finds himself at a desolate hamlet across Tokyo Bay, the story cuts in a flashback to the nude studio a few frames later. The crosscutting of the two scenes informs the reader of the protagonist's depressed state as he arrives at his destiny on a rainy night. Obviously he has visited the woman at the studio multiple times. Although she shows concern for him, she cannot provide the comfort he may be seeking. The dimly lit space of the studio appears to stand for his interior, and the conversation with the model goes into a downward spiral, ending with her self-denunciative statement: "I am hopeless." The woman asks if he is addicted to sleeping pills, commenting: "it makes you no good." When he asks her, "no good at what?" she replies by describing his general decline in energy, but her comments insinuate that the man is impotent.[17] In the dimly lit room of the nude studio, the

protagonist is not even allowed to indulge in sexual fantasy. He must escape the city in order to recover what he has lost there.

Cutting back to the hamlet where the protagonist has disembarked from the train, the story traces his footsteps for the next twenty-four hours. Alone at the station, he inquires how to reach the beach, though it is late at night. In order not to raise the station employee's suspicion, he intimates that he is staying in the hamlet overnight.[18] After finding accommodation at the local eatery, Yanagiya,

FIGURE 3. The woman displays her "Hama Detached Palace," from Tsuge Yoshiharu's "Yanagiya shujin" (1970).

the man exchanges words with its female proprietor and her daughter, who is in her mid-twenties, while speculating about the latter's sexual encounters with local youths.[19] Much as in the case of "Gensenkan shujin," the sexual fantasy serves as a medium through which to pull himself closer to the scene of nostalgia. From the moment of flirtatious conversation between the protagonist and the young woman, the scene suddenly cuts to a frame that portrays the dark exterior of the decrepit wooden building in the rain.[20]

That night, the man lies on his futon unable to fall asleep, conscious of his own being. His heightened sense of self in the unfamiliar environment is expressed through the contrasting images of him and the interior. While the protagonist is portrayed with relatively simple lines, the inside of the room is drawn in obsessive detail with numerous lines. The nature of the contrast becomes clearer a few pages later when Tsuge portrays the man's encounter with a local woman who peddles clams (Figure 4). In contrast to the woman—who appears in etching-like, three-dimensional images—the protagonist stands as a flat figure, lacking depth. He also appears as a dark void—a silhouette figure—in other frames, making it clear that the man does not belong in the world he desires to return to. Excepting the peddler dressed in traditional work attire, nobody in the story possesses a visual affinity to Tsuge's nostalgic land, whose landscape is described in obsessive detail.

Away from Tokyo, the protagonist allows himself to indulge in a sexual fantasy involving the young woman at the eatery. Triggered by her inexplicable behavior in the middle of the night—she looks into his room with her

お客さんこれから海へ行きなさるかね

FIGURE 4. Thick description of the peddler, from Tsuge Yoshiharu's "Yanagiya shujin" (1970).

nightwear provocatively opened at her breast—he plots out a fantastic narrative that begins with a sexual encounter with her and ends with his settling there as master of the eatery.[21] Yet his imagination is safely contained as a fantasy. The actual scene of the sexual encounter is prefaced by the man's own retrospective commentary that he had been indulging in a fantasy. In "Yanagiya shujin," the sexual desire that will never be satisfied symbolizes the distance between the protagonist and the object of his fantasy: he is alienated from the site of nostalgia even before he arrives there. In "Gensenkan shujin," it was still possible for the protagonist to wrap himself with his own fantasy, though his own double appears to shake out of the dream-like space. Two years later, Tsuge could not find even the tiniest space in his own fantasy for such a drama. At the culmination of the protagonist's fantasy is an image of him and the innkeeper's daughter as a middle-aged couple standing in front of Yanagiya. The protagonist imagines himself as a figure in a snapshot with faded colors: he is buried in the chores of everyday life, and there appears to be absolutely no sexual tension between him and the woman, and hence no connection between the protagonist and this particular location.[22]

A year later, the man returns to Yanagiya, hoping that the daughter somehow remembers him. Nothing has changed at Yanagiya, and the woman appears to have no recollection of him.[23] Unable to establish a connection to the locale, he again appears as a deep void against the scenery. Disappointed, he purchases a bag of clams from the peddler and heads toward the beach. It is here in the darkness of night at the beach—where his shadowy existence is no longer conspicuous—that the protagonist finally seems to find temporary comfort. As in some of Tsuge's well-known works from the late 1960s and the early 1970s, the sea sets the stage for the narrative's resolution. In the liminal space of the beach (the physical threshold between land and water), the man takes a break from his anxious search for a place where he belongs. He seems to find temporary solace in being on the deserted beach with a

stray cat. Lying on the sand, he sings the theme song of *Abashiri bangaichi*, signaling that he has found his own *bangaichi* (the land with no address), or a space where he temporarily severs all ties with contemporary society.[24] He will soon leave this location and return to everyday life in Tokyo, from which he will try to flee periodically. Yet his escape is destined to fail because the chasm that separates him and his dream destiny is too large for even his fantasy to fill.

In two short years, Tsuge had come a long distance from the drama of "Gensenkan shujin." In that story, after being rudely awakened from a half-sleeping state by his double, the antihero is still compelled to return to the fantastic world, where, although he may physically reach the longed-for locale, he can never blend into its scenery. If the focus of Tsuge's early works was on the process through which a character comes to this realization, the narrative of "Yanagiya shujin" revolves around the self-conscious state of the angst-filled traveler. It appears that, as he became more self-reflective about his own desire and the frustration that it brought, Tsuge barely continued to produce his work. After publishing "Yanagiya shujin," Tsuge did not publish another work for almost two years, spending much of his time traveling.[25] While he eventually resumed publishing, he never reestablished intimate relations with his own fantasy world. As his fantasy lost its historical grounding, Tsuge began to examine himself as a fantasy object. By introducing autobiographical elements into his stories, he consciously confused the boundaries between his fiction and his life, as if to convert his everyday existence into fantasy. Thus, in these later stories, travel merely provides the stage for Tsuge's deep contemplation of his own inner world.

THE REALISM OF POVERTY: "RIARIZUMU NO YADO"

In the 1973 work "Riarizumi no yado" there is not even a pretense that the male protagonist is in search of emotional ties with the site he visits. The motive for his travel is purely commercial: he travels in order to hunt for themes for his work. While in a desolate fishing community of Aomori, the most northern part of Japan's main island Honshū, the protagonist stumbles upon a brilliant idea that he will set his stories at the cheap inns that cater to merchant travelers, a formula that will allow him to spend less on accommodations while cashing in on the recent travel boom.[26] If his counterparts in the previous two works are seeking a potential refuge in a run-down inn and

eatery, the man in "Riarizumu no yado" sees the inns merely as cheap, exotic objects waiting to be commercially exploited.

As a complete outsider, he casts a cold and calculating gaze on the hamlet and its people. The work's title frame is explicit about the symbolic distance that separates the author and the lives of the residents (Figure 5). On a small, unpaved road leading to a sea covered with clouds, the protagonist stands holding a camera, looking down on a local man stooped with the weight of the firewood on his back. The local man appears to look up slightly, noticing the gaze of the camera. A thatched shack and fishing paraphernalia conspicuously fill the background immediately behind the traveler. A life that lags behind the rest of Japan's economic progress and is burdened with poverty has become something totally alien and exotic to the protagonist, who stands there as a curious outsider. His invasive gaze is physically and symbolically mediated through the camera's lens.

The author is keenly aware of his complicity in the commercial boom that has exoticized Japan's countryside.[27] The frame is portrayed through the third eye, which attests to the author/protagonist's keen self-awareness of his own intruding ethnographic gaze.[28] He hunts for nostalgic worlds purely for commercial gain.

Unlike in Tsuge's previous travel manga, the name of the hamlet the man visits is provided along with information on the surrounding region. This geographical specificity reduces the fantastic quality of the work. Unfortunately, he finds himself staying in a family-run inn of the most wretched quality. The place is run-down, cold, and unsanitary. The room in which he stays is in the midst of the family's living quarters. The dinner they serve is most unsatisfactory.[29] Later, in the bath, he realizes that he is the last one to bathe and that the water in the tub is filthy after all the family members have used it.[30]

Infuriated by the conditions of the inn and with himself for choosing the place, the protagonist decides to go to bed early. While lying on the futon, he hears the family's fifth-grade son reading his school textbook out loud. It is an excerpt from Akutagawa Ryūnosuke's "Kumo no ito": "Buddha stood on the edge of Lotus Pond, quietly watching the whole hubhub . . . Kandata received a punishment proportionate to his merciless mind that was bent on letting nobody else escape Hell . . ."[31] In Akutagawa's fable, Buddha looks into the Lotus Pond where he finds the notorious criminal Kandata suffering in Hell, and remembers the man's one good deed—sparing a spider's life. For that, Kandata is given a chance: Buddha casts a string of spider web aimed at him. Kandata finds the string and climbs up hoping to escape from Hell. However, realizing that thousands of others are also clinging to the string beneath

him, he yells at them to get off, afraid that the string will break with their weight. The story ends when Buddha, disappointed by Kandata's selfishness, cuts the string off just above him, letting all the hopefuls fall back into Hell.[32] After hearing the passage, the artist lies quietly on the futon in the darkness.[33] Although far from prosperous, he is not condemned to stay in the dire poverty that he finds at the inn. His self-righteous anger is mirrored in the selfish motive of Kandata, who tries to save only himself.

リアリズムの宿

FIGURE 5. The ethnographic gaze in Tsuge Yoshiharu's "Riarizumu no Yado" (1973).

In the last frame of "Riarizumu no yado," the author comments on the halting way the boy reads the textbook. This is particularly poignant when considered against Tsuge's own youth, when he had to skip many days of elementary school and his entire middle school education. Lying silently in the darkness of the room, the author appears to recognize his own arrogance. He is deeply ashamed that, much like the selfish criminal, he has cursed his fellow human beings, who happen to live in wretched conditions, for their selfish behavior. He is also reminded that the objects of nostalgia are beautiful only through one's sweet reminiscences. This 1973 work thereby demarcates the distance that separates the author and the "riarizumu" (realism) of the poverty that he has escaped. "Riarizumu no yado" mocks his goal of simultaneously rejecting and benefiting from his good fortune. Fully ensconced in a new class, the author is no longer able to find his place in the corners of Japan left behind by economic progress.

CONCLUSION

In the five years from 1968 to 1973, Tsuge covered a great distance in his fantastic travels. At the end of the 1960s, he was still able (albeit barely) to imagine himself in the fantasy world of yesterday. However, in a matter of only a few years, he was no longer able to indulge in his own nostalgia. The

dramatic shift of Tsuge's position in relation to his nostalgic objects reflected the change in the larger Japanese society and its relation with the past. Under the regime of a high-growth economy, the remote countryside had been incorporated into the modern space of postwar Japan as an exotic tourist attraction. In this symbolic transformation of Japan's countryside, Tsuge's angst-ridden travelers are rudely awakened from their dreams.

In Tsuge's travel works we find the figure of the author himself: he is condemned to live the life of a ghost in a capitalist society, where even the past is manufactured and merchandized. With no more comfort in nostalgia, he can only hope to sustain his being in a self-reflective gaze, and he eventually finds refuge in the self-enclosed space of semiautobiographical works that are set in the everyday life of the recent past. Since the publication of "Riarizumu no yado," Tsuge has never replicated the emotional intensity demonstrated in his late 1960s and early 1970s work, an intensity engendered by his own desperate efforts to work through the trauma of Japan's radical transformation.

...

Notes

1. In 1968, for example, the poet Amasawa Taijirō boldly declared: "For our arts, the year of 1968 must be remembered for the emergence of a strange manga artist, Tsuge Yoshiharu." Amasawa Taijirō, *Sakuhin kōiron o motomete* (Theorizing text acts) (Tokyo: Seidosha, 1985), 195.

2. Tsuge Yoshiharu, *Hinkon ryokōki* (Journey of poverty) (Tokyo: Shōbunsha, 1991), 11–31.

3. Tsuge's father died in 1942, and his mother remarried in 1946. "Tsuge Yoshiharu nenpu" (Biographical chronology), in Tsuge Yoshiharu, *Tsuge Yoshiharu shoki kessaku tanpenshū* (Early masterpieces of Tsuge Yoshiharu), vol. 1 (Tokyo: Kōdansha, 2003).

4. His brother Tadao worked at a blood bank after he graduated from junior high school. Yoshiharu went there to sell his blood. Tsuge Yoshiharu, *Tsuge Yoshiharu zenshū* (Complete works), supplementary volume (Tokyo: Chikuma Shobō, 1994), 183–85.

5. In the mid-1960s, Tsuge worked as an assistant for Shirato Sanpei. However, he found the work too demanding and quit in a week. Adachi Noriyuki, "Tsuge Yoshiharu to Mizuki Shigeru," in *Tsuge Yoshiharu no miryoku* (The appeal of Tsuge Yoshiharu), ed. Rekishi to Bungaku no Kai (Tokyo: Bensei Shuppan, 2001), 34.

6. Tsuge, *Tsuge Yoshiharu shoki kessaku tanpenshū*, 1:283.

7. For discussions of Tsuge's works, I refer to *Tsuge Yoshiharu zenshū* (Complete works), vols. 5 and 6 (Tokyo: Chikuma Shobō, 1994).

8. Ibid., 6:33.

9. Ibid., 6:34–36.

10. Ibid., 6:55.

11. Ibid., 6:57.

12. Ibid., 6:42.

13. The literary critic Shimizu Masashi criticizes Tsuge for foreclosing his narrative by an encounter with a doppelganger: Shimizu argues that a complex tale of existential crisis (much like the one Dostoevsky offered in *The Double: A Petersburg Poem*) should unfold after this encounter. My contention is that there was no such deeper layer to the story. Tsuge was not allowed to escape into the inner realm of his self, as his later works suggest. For Shimizu's discussion of "Gensenkan shujin," see *Tsuge Yoshiharu o yomu* (Reading Tsuge Yoshiharu) (Tokyo: Gendai Shokan, 1995), 96–102.

14. Tsuge, *Tsuge Yoshiharu zenshū*, 5:148–50.

15. Ibid., 5:151.

16. Ibid., 5:153–55.

17. Ibid., 5:158–59.

18. Ibid., 5:161–62.

19. Ibid., 5:164.

20. Ibid., 5:167.

21. Ibid., 5:172–73.

22. Ibid., 5:175.

23. Ibid., 5:177.

24. Ibid., 5:184–86.

25. Tsuge Yoshiharu and Gondō Susumu, *Tsuge Yoshiharu mangajutsu* (The manga art of Tsuge Yoshiharu), vol. 2 (Tokyo: Waizu Shuppan, 1993), 164.

26. Tsuge, *Tsuge Yoshiharu zenshū*, 5:192.

27. With the help of the advertising agency Dentsū, Japan National Railway launched a successful campaign entitled "Discover Japan" in 1970. The campaign emphasized the exotic beauty of traditional Japan. Marilyn Ivy provides a detailed cultural analysis of the campaign in her book, *Discourses of the Vanishing: Modernity, Phantasm, Japan* (Chicago: University of Chicago Press, 1995), 34–48.

28. Fatimah Tobing Rony deploys the concept of the third eye to illustrate colonial subjects' double consciousness—revulsion and identification—toward cinematic representations of the colonial other as savage natives. Tsuge's split gaze also expresses his revulsion at and identification with the impoverished country scene. As a former "native" of the "other" Japan, he is keenly aware of the problematic nature of his gaze. *The Third Eye: Race, Cinema and Ethnographic Spectacle* (Durham, N.C.: Duke University Press, 1996), 4–5.

29. Tsuge, *Tsuge Yoshiharu zenshū*, 5:207.

30. Ibid., 5:208.

31. Ibid., 5:209–10.

32. Akutagawa Ryūnosuke, *Akutagawa Ryūnosuke zenshū*, vol. 3 (Tokyo: Iwanami Shoten, 1996), 208–14. This story has been translated many times into English. For example, see "The Spider Thread," in *Rashōmon and 17 Other Stories*, trans. Jay Rubin (New York: Penguin, 2006), 38–41.

33. Tsuge, *Tsuge Yoshiharu zenshū*, 5:210.

YUKA KANNO •••

Implicational Spectatorship: Hara Setsuko and the Queer Joke

What does it mean to have evidence of someone's sexual activities? of their sexuality? How can one even begin the assumption of that kind of knowledge except through the structures of phantasmatic projection?

—Irit Rogoff, "Gossip as Testimony: A Postmodern Signature"

The joke is the textual instance, which often seems most coercive in its production of reading effects.

—Mary Ann Doane, *Femmes Fatales: Feminism, Film Theory, Psychoanalysis*

To fans of the now classic Japanese cinema of the late 1940s through the 1960s, the name of Hara Setsuko is always evoked with a certain nostalgia. For the younger generation who discovered the "good old Japan" of her postwar films, she is a privileged object of nostalgia, a locus of an imaginary longing for something they never experienced. The myth of this actress as "a goddess of postwar democracy" and "an ideal daughter of the middle class family" is also associated with the name Noriko, given to three separate yet parallel characters Hara plays in the films of Ozu Yasujirō: *Late Spring* (1949, *Banshun*), *Early Summer* (1951, *Bakushū*), and *Tokyo Story* (1953, *Tōkyō*

> I WAS STRUCK BY HARA SETSUKO, NOT SO MUCH BY HER LEGENDARY BEAUTY AS WITH WHAT I CAN ONLY NOW CALL A "QUEER" FEELING.

monogatari). These three films, along with Hara's Garbo-esque disappearance, cemented her image as the timeless and quintessential Ozu actress in Japan's national fantasy.

Like many Ozuphiles, I have my own initiation tale. As a latecomer to Tokyo film culture, I watched this trilogy for the first time in the early nineties at Ginza's Namikiza theater.[1] That tiny run-down theater, a now-destroyed landmark of Japanese cinema art houses, also introduced me to Naruse Mikio, nourishing my pleasure and imaginary nostalgia. Like many others, I was struck by Hara Setsuko, not so much by her legendary beauty as with what I can only now call a "queer" feeling, and the onscreen manner in which she evoked a seemingly conservative image of femininity. There was something odd, uncanny, and extravagant about the actress: the way she refused to marry, then suddenly changed her mind, and the extremely intimate manner in which she touched other women's bodies. The next two films of the Noriko trilogy continued to awaken the same feelings. Only now and retrospectively can I make sense of such an "illegitimate" sentiment that I strongly felt but was unable to then form into meaning.

This essay explores the possibility of queer spectatorship by "implication," in which I take up the Noriko trilogy as an intersection of film, actress, and audience. By implication, I want to address the historicity of the present viewer, whose specificity is no less important than that of the past text. Instead of recreating the unified, closed, past world of the text and the spectator of the time, I insert my "now" with its desire to read the past film. My arguments for bridging the historical and temporal gap between the Noriko texts and the present condition are indebted to the notion of *renrui* (implication) proposed by Tessa Morris-Suzuki, who calls up the responsibility of those who "have not stolen land from others, but who live on stolen land."[2] Therefore, what I do here is reconstitute the queerness of the past film text and the Noriko character *in the present*. Rather than confining the meanings of the past text to its contemporaneous spectator, it is my hope to open it up to the present spectator, thus making the former relevant to the latter. The term "implication" signals such a temporal and historical specificity of reading. Conversely, I am interested in the ways in which the rereading of the Noriko text helps present-day spectators to imagine a past queer spectatorship.

Within film studies, the disciplinary master narrative of the 1980s "paradigm shift" around spectatorship theory is typically cast as a move from institutional theories (both apparatus and textual) to historical or empirical

studies of reception.³ Not only are the text and the viewer severed within this narrative, but the spectator is also divided into the conceptual and real. Following the lead of Judith Mayne, I use the term "spectator" to signify the point of tension between the cinematic subject and the film viewer, as it undoes the clear-cut distinction between address and reception.⁴ *Early Summer* offers a compelling example of such spectatorship in reconnecting the text and the viewer: instead of their relationship as the "resisted" and the "resisting," the film suggests that the viewer is part of the text and the text part of the viewer. To this point, I will add that an implicational spectator does not exist prior to the text, and only emerges as a result of a certain reading formation. Just as contemporary queer subjectivity is informed by past queer texts, lives, and experiences, the past is also already reconstructed from our present perspectives for our present desires.⁵ Breaking the temporal horizon of the unified world of the past text and audience, I conjure up the past spectator as retrospectively reconstituted with queer desires.

In her lifetime, Hara Setsuko starred in six Ozu films, but more than anything else, her star persona was inseparable from the Noriko character that she repeated three times in the early stages of their collaboration. In 1949, Hara played her first Noriko role in *Late Spring,* in which the character lives with a father for whom she cares so much that she continues to refuse the marriage arranged by her aunt. Two years later, Hara performed her second Noriko role in *Early Summer.* Living in a large family consisting of parents, a brother, a sister-in-law, and two nephews, Noriko is constructed again as someone who is indifferent or reluctant to get married. This trilogy closes with Ozu's most well-known film, *Tokyo Story.* This time, in a shift from the previous two films, Hara plays a widow who has lost her husband in the war. In addition to its focus on her reluctance to marry, the trilogy also marks the visual absence of Noriko's husbands, in the past, present, and future. Her decision to marry as the concluding device in the narratives of the first and second films is paired with the complete absence of her future husbands. In the third film, the husband is already dead, and his picture in her apartment is too small to see. Scholars and critics have tended to pass off the Noriko trilogy as stories about the family or, more specifically, the dissolution of the Japanese middle-class family as an inevitable consequence of modernization. Despite the widespread attention paid to the loss of Japan's "traditional values" in Ozu films, little has been given to the intimacy portrayed among female characters, even though it constitutes a critical dimension of the "family" experience. Affective ties among women and female networks in the trilogy manifest themselves as friendship (i.e., Noriko's with her best friend

from high school) and kinship (among Noriko, her sister-in-law, mother-in-law, and aunt).

Beside female networks, *Early Summer* is a brilliant text that complicates the relationship between stardom and fandom. As I will more closely examine later, this film constructs Noriko's character as a fan of Katharine Hepburn. It is also the first Japanese film to suggest the possibility of a transnational circulation of the queer icon Hepburn beyond its American context. The scene in question begins with the conversation between Noriko's boss, Satake (played by Sano Shūji), and her best friend, Aya (Awashima Chikage). When asked about Noriko's relationship, Aya says that Noriko has perhaps never had a boyfriend and seems uninterested in romantic relationships, except for one previous obsession with collecting the photos of Katharine Hepburn. Assigning Noriko a narrative position as a Hepburn fan is ironical considering that Hara was at the peak of her stardom in 1951, finally eradicating her longstanding reputation as a *daikon joyū,* or radish actress (the Japanese equivalent of a "ham"), with her award-winning performances as the cold beauty in Kurosawa Akira's *Idiot* (1951, *Hakuchi*) and the worn-out housewife in Naruse Mikio's *Repast* (1951, *Meshi*).[6] Only at this point did her popularity begin to match her critical success. The inversion of the star–fan relationship in *Early Summer* is even more striking when we think of Hara's aloof and distanced star persona. Hara Setsuko as a star text thus invites ambivalent identifications and desires.

The self-regulation of the "Ozu criticism" industry has too long suppressed the possibility of new readings of his films.[7] Beyond the existing and limited interpretive frameworks of auteurism or of Ozu as an alternative modernist, there is far more to be *read* in the Noriko trilogy.[8] The discourse of stardom and fandom embedded in the trilogy points to the necessity of situating these films not in the framework of Ozu as a modernist but rather in what some film scholars have called the vernacular experiences of modernity, in that stardom and fandom in film culture constitute a critical part of the modern experience, especially in their affective dimensions.[9] Yet various erotic implications in the vernacular experiences of Japanese modernity have been largely overlooked, as those of the Noriko trilogy are given only one interpretation. The pioneering work of Donald Richie and Satō Tadao attests to this tendency to see an idealized nature of heterosexual love in the figure of Hara/Noriko, and this framework remains unchanged.[10] And yet, careful examination of *Early Summer* suggests another way of reading the trilogy, one with the deep ambivalence of Hara/Noriko *with* and *against* heterosexual relations and institutions. By calling the Noriko trilogy "the image of bliss,"

Satō has argued that events surrounding the marriage of Noriko are the ideal course of heterosexual romance. However, the image of bliss embodied by Hara in her nonromantic Noriko character is rather coextensive with queer bliss in her much more intimate and affective relationships with her female friends and relatives.[11]

Thus, I want to offer a reading of Hara Setsuko and her Noriko role through and against the popular memory and the national-cultural narrative of ideal Japanese femininity.[12] Curiously, the peak of Hara's popularity occurred at the time Japan's new constitution became effective and the previously state-sanctioned gender ideology ceased to operate. The Noriko trilogy illustrates a spectrum of female agencies in the aftermath of this national gender discourse. As Barbara Satō astutely points out, the figure of Noriko reveals the contradictions inherent in the concept of the Japanese feminine.[13] Being "modern" and "Japanese" at the same time, Noriko problematizes the logic of either/or, which becomes, I argue, her allegorical force.[14] Furthermore, Hara Setsuko serves as a nodal point from which unexpected queer networks are woven through a variety of cultural texts, figures, and spectators colluding to stimulate queer imaginations.

THE QUEER PEDAGOGY OF KATHARINE HEPBURN

Early Summer establishes the now twenty-eight-year-old Noriko not only as a Hepburn fan but also as a devotee of Hepburn in her most queer persona, the pre–*Philadelphia Story* Hepburn of the 1930s, whose persona played a critical role in the formation of lesbian cultural memory in the United States and Europe.[15] Hepburn's lesbian allure operates in many forms, but in particular the tomboy, the cross-dresser, and the independent women that Hepburn embodied in her early films, often characterized and described in terms of sexual ambiguity, work to form the magnetic field of such seduction. Her strong erotic and identificatory appeal constitutes a "pedagogy" par excellence, one of a shared fantasy through which Hepburn's films become meaningful in popular lesbian memory.[16] Hepburn's pedagogical effect also implies that sexuality is something to be learned and is not a given. The star text of Hepburn associated with sexual ambiguity does not solely signify homosexual and heterosexual oscillation. This sexual ambiguity reveals a female gender dimension in which Hepburn acts out "femininity" through her relations with sisters and friends. Andrew Britton argues that her films "more often depict supportive 'and potentially' lesbian relationships with other women,

whether within the family or in the context of a female community."[17] The Hepburn text thus illuminates an ambivalent, hesitant, and yet continued terrain of female community and lesbian relationships, cross-dressing, and same-sex eroticism.

Debora Bright instantiates such a queer pedagogy of Hepburn in her work. Her photo collage reflexively creates the visual space in which a cinematic spectator transforms into a subject of desire, a lesbian subject, by inserting herself into the virtual frame of the Hollywood film still.[18] In one photo, Bright, a jealous lover of Hepburn, rewrites her position from a mere spectator to that of her lover, activating an imaginary sexual encounter between the two. The photo illuminates a queer strategy of rereading, and rereading as rewriting, commonly practiced by queer film fans and critics. It shows a crucial spectatorial mechanism by which "reception is driven by desire."[19] Heterosexual narrative closure and visual pleasure can be refashioned in this manner for lesbian desires that structure the film differently.

Re-signification is another name for the textual poaching of heteronormative narratives and visual pleasures of classical Hollywood cinema: Greta Garbo, Katharine Hepburn, and Bette Davis are such major components of queer, gay, and lesbian spectatorship that without them there would be no queer film history. As Roland Barthes has claimed, when one reads, one already writes.[20] Re-signification as both rereading and rewriting becomes, I argue, a critical methodology and an epistemology for queer scholarship.

In 1934, a year after its original release in the United States, *Little Women* (George Cukor, 1933) premiered in Japan, and the introduction of Katharine Hepburn to Japanese screens caused a sensation.[21] A few months later, the film magazine *Eiga no tomo* (Film's friend) featured a six-page article on the film, along with a roundtable discussion consisting of ten high school girls and four male critics and journalists.[22] The comments made by these mostly middle-class and well-educated girls articulate the effects of the film and of Hepburn. One participant said she favors the film because of the employment of the new written language for the female first person, with a new character for "I" (私) substituting for the old "I" (妾) in the Japanese subtitles, which was supervised by Yoshiya Nobuko, an "out" lesbian novelist and an icon of girls' culture. Some of the girls described Hepburn as "virile" or "strong" while another declared, "it's a strange face, but I like it." Meanwhile, critics and journalists had an opposite reaction. Hasumi Tsuneo, an influential film critic at that time, raved about *Little Women* as "the kind of film that even the strictest boarding school master would approve of. The film contains filial piety, ideal sisterhood, and love for your neighbor, just like in the Imperial Rescript on

Education." Hasumi's morally inclined appraisal leaves the other, much more "dangerous," subversive meanings of Hepburn's role completely uninvestigated. While these professional male critics translated the moral lesson from sentimental Victorian girls' fiction into a local context supporting ideal femininity, the high school girls responded to the film with an acute critical eye anchored in specific social and historical circumstances. Their comments also suggest that they read in the film and the character Jo, played by Hepburn, possible ways of being feminine outside of the cultural prescription of what a woman should be. What is even more interesting, in the very same issue of the magazine is a contrasting reaction from male critics and journalists to such "androgynous" women; whereas they praise Hepburn's "androgynous" appeal, they do not accept the "androgyny" and cross-dressing performance of Japan's all-female reviews, Takarazuka and the SSK (Shōchiku Shōjo Kagekidan). Juxtaposed with other forms of gender performance and sexual coding in the same period, the double positioning of Hara Setsuko/Noriko as a star and a fan can be considered an integral part of a larger queer visual network in postwar Japan.

But what is the specific mode of Hara/Noriko's spectatorial engagement with Hepburn? Let me return to the scene in which Noriko's best friend Aya visits her at work, when Hepburn's name is heard for the first time. The conversation between Aya and Noriko's boss begins in the absence of Noriko:

Satake: How about Noriko . . . with Manabe?

Aya: She seems to be indecisive.

Satake: Can you ask her?

Aya: Me?

Satake: I don't understand. . . . Does she have an attraction to anyone?

Aya: What do you think?

Satake: Sometimes she does, other times not. She is strange. Has she been always like that?

Aya: Yes, she has.

Satake: Ever been in love?

Aya: Don't know, but probably not. At school, she liked Hepburn, and collected her photos this much [showing the thickness with her fingers].

Satake: Who is Hepburn?

Aya: An American actress.

Satake: She is a woman. Is she a pervert/queer [*hentai*]?

Aya: No way! [laugh]

Satake: You never know. She is so strange. . . . Why don't you teach her?

Aya: What?
Satake: All sort of things.
Aya: What things?
Satake: Don't pretend.
Aya: Do not talk to me like that. That is so rude.

In this scene, the camera eavesdrops on their gossip, framing them from a low left angle, while avoiding the usual frontality. Instead of its famous politeness and reservation, the camera and microphone become accomplices to the curious spectator listening in on the gossip. When the camera frames Satake in front looking straight ahead, it is as if to urge the cancellation/dissipation of the literal word *hentai* (pervert) being thrown at Hara/Noriko, followed by his oddly high-pitched laughter.[23]

Two film critics, Robin Wood and Alexander Doty, suggest the possibility of lesbian spectatorship in this scene. The queer icon of Hepburn, they point out, circulates transnationally, beyond the United States, to the Japanese audience.[24] Wood reads lesbianism in the figure of Noriko, assuming that Noriko identifies herself with the Hepburn of the 1930s, who embodies the active, self-assertive, and rebellious young woman.[25] He even goes so far as to claim that *Early Summer* is corrective of the happy endings in most of Hepburn's films. Noriko's lesbianism, Wood argues, is based on her identification with Hepburn in terms of female bonding and rebellion against the male order. Although this argument posits Noriko's lesbianism as asexual in nature, in its affinity with political lesbianism in the narrow sense of the term, Wood also demystifies Noriko's status as an embodiment of happy heterosexual love. He writes: "the films provide absolutely no evidence that she is sexually attracted to men; she tends to treat the men she likes—Hattori in *Late Spring*, the man she marries in *Early Summer*—as friends."[26] This remark points to a fundamental problem of lesbian representability and its perception. Lesbianism requires absolute facts and evidence, while heterosexuality does not. Hara's image in her Noriko characters is shaped precisely within the sexual-representational matrix in which the lesbian appears as negativity: one cannot be a lesbian unless there is evidence of such sexual desire or perhaps practice. As a naturalized institution as well as an official social reality, heterosexuality secures its public position through being everything and nothing at once. Likewise, the hermeneutic traditions of the Noriko trilogy are also built on such sexual presumptions. Ingrained so deeply in both narrative and visual economies, nonmarked heterosexuality often powerfully frames what and how we see and don't see. Within that framework, how

does it become possible to imagine nonnormative sexual desires? Does the presentation of genital-involved sexual acts, prevalent in recent popular rep-resentations, really prove anything about sexuality? As I will argue in the following pages, illegitimate sexual desires are often figured through passing or trivial forms. The problem of Wood's reading rather resides in identification, which inevitably involves the desexualization of lesbianism. Why must Noriko's devotion be identification but not desire?

> INGRAINED SO DEEPLY IN BOTH NARRATIVE AND VISUAL ECONOMIES, NONMARKED HETEROSEXUALITY OFTEN POWERFULLY FRAMES WHAT AND HOW WE SEE AND DON'T SEE.

TO READ DESIRE DIFFERENTLY

In the essay, "Hara Setsuko," Donald Richie describes Hara's appeal for both men and women: "she had become an ideal: men wanted to marry someone like her: women wanted to be someone like her."[27] His formulation most accurately speaks of the distinction between identification and desire, and their split along gender lines, which has characterized psychoanalytic discourses on the primacy of same-sex identification at the cost of same-sex desire. In terms of cinematic spectatorship, psychoanalysis has undeniably provided the dominant conceptual framework for constructing the "spectator" as a subject position through identification. In his seminal work, Christian Metz has distinguished two kinds of cinematic identifications: the primary with the projection situation itself, and the secondary with the filmic characters.[28] And yet, the kind of identification Richie refers to raises other questions, because it relates not only to the apparatus or fictional character but to both gender identification *and* sexual desires within the star–fan relationship. There is a double movement here: one's possible identification (or disidentification) with the Noriko character involves another identification with Hara herself. If one of the problems inherent in the early theorists of cinematic identifications (such as Metz and Baudry) lies in the "transcendental subject" regressively drawn deep into the comfy seat of the movie theater, another one exists in the clear-cut separation of identification and desire. On this point, I am in line with feminist film critics who challenge the polarization of desire and identification in favor of much more unstable, unpredictable, and shifting spectatorial positions.[29] Richie's view represents what Butler calls the "heterosexualization of desire" in that desire requires opposite-gender

identification. This logic perpetuates the "natural" nexus of gender, sex, and sexuality, and typically sustains the supremacy of gender from which desire or sexuality derives as secondary.[30] Under this logic, gender identification becomes a condition of sexuality and erotic practice. Contrary to the account of Hara by Richie, film and women's magazines then demonstrate a much more ambivalent reaction to the actress.[31] Gaps and discordance among critics, journalists, and fans inform us of how her idealized image as both an object of desire and identification is retrospectively constructed from a present nostalgic viewpoint.

The Noriko text suspends the spectatorial position assigned by "either" identification "or" desire, which often consolidates a gender split. This is neither the "happy limbo of non-identity" nor "over-identification" when Hara/ Noriko's desire moves from one location to another, so does our own.[32] Her erotic mobility cannot be anchored, since it is generated only in circulation. Its mode of apparition is also unpredictable but leaves its trace in visuality: at times in friendship and at others in kinship, as a Hepburn fan, or as a daughter who refuses to leave her father. In response to the erotic mobility created and circulated throughout the trilogy, our queer desire and subjectivity emerges, while dislocating the textual and spectatorial times.

Although Hara Setsuko's queer apparition should be situated within the global circulation of queer meanings, we also need to pay attention to the ways in which they become translated within local contexts. Alexander Doty cites the name of Hara Setsuko as an example of an "international" lesbian cult for Hepburn.

> The association of certain Hollywood stars with lesbian culture appears to
> be international. For example, a scene in the Japanese film *Early Summer* . . .
> has Noriko, the central character, being discussed by her boss and her best
> friend. When the friend mentions that Noriko likes Katharine Hepburn,
> the boss matter-of-factly asks if Noriko is a lesbian.[33]

Strictly speaking, the word used by Satake is not *lesbian* but *hentai* (pervert), and her sexuality is not necessarily pronounced "matter-of-factly." However, the queer shadow of Noriko's sexuality conjured by her boss is immediately obliterated, literally, by his own laughter. Judith Butler once defined queerness as "a problematic eruption of sexuality" and in this sense, sudden enunciation of Noriko's nonnormative sexuality is nothing but queer.[34] To the definition of queerness as "eruption," we also want to add "disappearance." For the moment Noriko's queerness is suggested, it is already gone.

FAILED JOKE: QUEER APPEARANCE AND DISAPPEARANCE

Now let me turn to the structure, the form, and the mode of queer appearance and disappearance in order to explore the effects and meanings of the odd joke scene in *Early Summer*. That Satake's utterance of *hentai* unexpectedly highlights the sexual dimension of Noriko is precisely, according to Freud, the purpose of a joke. An "obscene joke," as Freud describes, brings into prominence sexual facts and relations through speech; it is a type of tendentious joke.[35] The structure of an obscene joke is identical to "smut" in the joke-work in that they share the same purpose: the exposure of the sexual differences. As an obscene joke is a psychic process between three persons, gender dynamics play a crucial role in Freudian joke theory. These dynamics are allocated in a two-to-one formation: an insistent man as a joker, a "passively" listening man, and a resisting woman as the object of the joke. The success of the joke depends on whether or not the joker is able to produce pleasure for the listener at whom the very joke is aimed.[36] The exposure of a sexual difference as the purpose of the joke gives only two people (the talker and the listener) its pleasurable effect. Then at whom is the pleasure of the joke scene in *Early Summer* aimed? In the ambiguous shift of the object from Noriko to Aya, it seems to be the cinematic spectator as the listener for whom the effect of the joke is directed, and who is excluded from the joke scene itself. In effect, Freud describes a person who laughs at smut as an "invisible" agent witnessing an act of sexual aggression as if he were at the scene. But does *Early Summer* produce such an effect successfully?[37]

By juxtaposing Freudian joke theory with Sedgwick's queer theory, the seemingly heterosexual nature of Satake's joke, encompassing the whole spectrum from sexual aggression to seduction, points to a more complex configuration of desires.[38] In other words, Sedgwick's theory allows us to reformulate Freudian joke-work as a scenario of homosocial desire, precisely in its double bind of homophobia and homoerotics.[39] If a triangle is the key structuration masking male homoerotic desires, must an exchange of laughter or pleasure between two men always occur "at the expense of women?"[40]

The joke in question appears as a conversation between Satake and Aya in Noriko's absence, and this is the moment in which the imaginary listener is called to the scene. Here Satake's joke reveals changing gender dynamics because the person occupying the second and the third position constantly shifts. When the triangular structure of the joke in the psychoanalytic narrative is read with Sedgwickian queer theory, the supposedly heterosexist joker

fails to conceal his homoerotic desire. Note that Satake's crack is actually triggered by the inquiry about his old college friend, Manabe. What Satake wants to *know* has more to do with Manabe than Noriko's sexuality per se, as joke theory might suggest. This scene therefore marks Satake's social and sexual desire. From a Sedgwickian perspective, Satake's remark is structured by homosocial/homosexual desire, with Noriko as an object of trafficking between men, while the film clearly marks Satake's obsession with Manabe here and there. Throughout the film, Satake continuously and compulsively refers to the name of Manabe: "he is a better golfer than me," "he is better looking than me," or "would you marry me if I were him?" These persistent citations and comparisons cue his imaginary replacement with Manabe, or his desire "to be" him. Besides, if Satake constructs Noriko as queer through her fandom of Hepburn, and in particular through her act of collecting photos, then what prohibits us from calling him *hentai* when he also collects Manabe's photos and even carries them around? By mirroring Satake's desire as Noriko's for Hepburn, the film secretly turns him from the joker into the object of the joke.

Traversing the spectrum of the obscene joke from sexual aggression to seduction, the target of Satake's remark also moves from Noriko to Aya. The insinuation of Aya's maturity and Noriko's immaturity reminds us of the ways Hara Setsuko's nickname, "eternal virgin," projects the national fantasy of the shōjo (the girl), who implies, to borrow the brilliant expression of Jennifer Robertson, "heterosexual inexperience" and "homosexual experience."[41] Satake's social and sexual desires for male bonding are generated and maintained through the exchange of Aya, as well as by the simultaneous appearance and disappearance of Noriko as a queer woman. The film skillfully demonstrates the combination of homophobic erasure and heterosexual assault in the course of the dialogue, and therefore becomes a manifold textual manifestation that dramatizes the differences of both sexuality and gender. This observation comes from that fact that, in both content and mode of enunciation, Satake's joke does not seem to succeed in producing the pleasurable effect in the third listener at whom the joke is aimed. If the joke succeeds only when the third person enjoys its pleasurable effect, then what position is the spectator to take in order to "get" it? Or are we to take a different kind of pleasure from its failure? A debate between two feminist film scholars, Mary Ann Doane and Tania Modleski illuminates this point.[42] For both, the joke is

related to the pleasure of its reading as well as to the question of sexual difference. In "Film and Masquerade: Theorizing the Female Spectator," Doane argues that Robert Doisneau's photograph "Un Regard Oblique" (1948) perfectly encapsulates the cinematic narratives of the female gaze and its negation, and "displays insistently, in microcosm, the structure of the cinematic inscription of a sexual differentiation in modes of looking."[43] The feminine presence as a free-floating gaze with her desire silenced in the photograph, according to Doane, constitutes a "dirty joke." Doane writes, "Doisneau's photograph is not readable by the female spectator—it can give her pleasure only in masochism. In order to 'get' the joke, she must once again assume the position of transvestite."[44]

Compared to the critical attention given to masochism and transvestism as the only positions available for the female spectator, and the criticism toward heterosexism inherent in such arguments, little focus has been placed on the joke itself, an equally important part of Doane's essay.[45] Doane argues that a female spectator drags because she wants to get it, and, without getting it, she would not experience spectral pleasure. By pointing out Doane's confusion between the getting and receiving of such pleasure, Modleski asks if it is truly a critical experience for the female spectator.[46] In response, Doane reasserts the joke-work of Doisneau's photograph as an operation of the structural exclusion of the woman; the joke can only be "got" at her expense. Furthermore, Doane reframes the difference between "getting" and "reading" as a question of temporality by repeatedly stating, "it is all a question of timing."[47] While "getting" assumes the automatic reception in which the joke's effects are instantaneous and the comprehension and pleasure coincide, "reading" constitutes a critical act taking place "*in a second moment*—a moment made possible by feminist theory."[48] Doane's writing on the temporality of the joke reflects the very historicity of feminist film theory at this particular moment of 1988, and its strong desire to read *differently*, "even if this entails a violence against the set norms of criticism, a rewriting of the critical questions."[49] The refusal of an instantaneous pleasure to be gained from a joke at the cost of women resonates with the historicity of the feminist enterprise: a matter of timing is a matter of history, since the temporality of reading is already embedded in the historicity of the reader. But what is our (or my) desire at this historical moment? Do we still have the same desire to read the text and the joke differently? Most definitely. The relationship between temporality and historicity is an even more critical issue in our practice of reading films, particularly so when it comes to excavating past film texts and resignifying them from and for the present. So the question is, *how* do we read differently?

Although Doane draws a clear line between the critical act by the spectator informed by feminist theory and the automatic reception by the "other" audience (like herself when she is "off guard"), a spontaneous rejection, informed by feminist theory or not, can be a critical act. Feminists are not only always informing but are also informed by the audience and learn something from its spontaneous reaction. Joking is a fundamentally contradictory act in that it simultaneously searches for and denies difference. Before reaching any near place of difference, it cancels out the very attempt to see that difference by laughing it away. Not to "get" a joke is itself a resistance to this male bonding that can occur only at the expense of women.[50] Aya's anger as an automatic response to Satake's joke thus already constitutes a critical gesture in refusing its pleasurable effects. The joke scene in *Early Summer* thus reveals simultaneously the search for sexual difference and its inevitable failure. A joke must be told to someone else, as Freud would have it. The most remarkable textual effect, through which Noriko is invoked as queer, is its power of transmission—creating circular movements of sexual desires among the filmic characters and for the spectators. It is this textual force, condensed in the brief moment of the joke scene, that spills over to the extrafilmic territories, making connections among women such as Hara Setsuko, Katharine Hepburn, Yoshiya Nobuko, and *jogakusei* (schoolgirls) who would not have encountered one another otherwise. It is this queer female network that the Noriko text frames without directly exposing it.

..

Notes

1. The Namikiza theater was an art house in the Ginza district of Tokyo, which ran specifically Japanese films since 1954. This landmark of Tokyo film culture closed on September 22, 1998, with a program of *Late Chrysanthemum* (1954, *Bangiku*) and *Mother* (1952, *Okaasan*), both directed by Naruse Mikio.

2. Tessa Moris-Suzuki, *Hihanteki sōzōryoku no tame ni: Gurōbaru jidai no Nippon* (For the critical imagination: Japan in the global age) (Tokyo: Heibonsha, 2002), 57–58.

3. On the development of spectatorship theory in film studies, see Judith Mayne, *Cinema and Spectatorship* (London: Routledge, 1993).

4. This spectator, simply put, negotiates. "Negotiation" has long been the critical term in reception studies developed under the influence of cultural studies; see, especially, Stuart Hall, "Encoding/Decoding," in *Culture, Media, and Language,* ed. Stuart Hall et al., 108–19 (London: Hatchingson, 1980). The concept occupies the central position for many feminist film theorists who critique the monolithic determinism of the cinematic apparatus in favor of the much more dynamic interplay between the viewer and the film. See Judith Mayne, *Cinema and Spectatorship* (London: Routledge, 1993); Saitō Ayako, "Joyū wa

teikōsuru" (The actress resists), in *Eiga joyū: Wakao Ayako* (Film actress: Ayako Wakao), ed. Yomota Inuhiko and Saitō Ayako, 111–249 (Tokyo: Misuzu Shobō, 2003).

5. On the constructionist perspective on the past, see the work of George Herbert Mead, "The Nature of the Past," in *Selected Writings,* ed. Andrew J. Reck, 345–54 (Indianapolis: Bobbs-Merrill, 1964).

6. *Hakuchi,* dir. Kurosawa Akira (1951); translated as *The Idiot,* subtitled DVD (Criterion, 2008); *Meshi* (Repast), dir. Naruse Mikio (1951), DVD (Tōhō, 2005).

7. See Mitsuhiro Yoshimoto, "Logic of Sentiment: The Postwar Japanese Cinema and Questions of Modernity" (PhD diss., University of California, San Diego, 1993).

8. The issues around gender and sexuality in these films have not been critically examined until very recently. As an example of recent rereading efforts, see Catherine Russell's "Three Japanese Actresses of the 1950s: Modernity, Femininity, and the Performance of Everyday Life," *CineAction* 62 (2003): 34–45.

9. See Miriam Hansen, "Fallen Women, Rising Stars, New Horizons: Shanghai Silent Film as Vernacular Modernism," *Film Quarterly* 54, no. 1 (2000): 10–22; Zhang Zhen, "An Amorous History of the Silver Screen: The Actress as Vernacular Embodiment in Early Chinese Film Culture," *Camera Obscura* 16, no. 3 (2001): 229–62.

10. See Donald Richie, *Ozu* (Berkley and Los Angeles: University of California Press, 1974), and Satō Tadao, *Ozu Yasujirō no geijutsu* (The art of Yasujirō Ozu) (Tokyo: Asahi Shinbunsha, 1978).

11. In the chapter titled "Shifuku no imeeji" (The image of bliss), Satō Tadao argues that the ways in which the Noriko character decides to marry her neighbor without such ritualistic complications as confession are the most ideal for a man and woman to achieve their love. Satō, *Ozu Yasujirō no geijutsu,* 155–56.

12. Yomota's 2000 book on the two major film actresses provides the best example today of this national-cultural narrative of Hara Setsuko: Yomota Inuhiko, *Nihon no joyū* (Japanese actresses) (Tokyo: Iwanami Shoten, 2000).

13. Barbara Sato, *The New Japanese Women: Modernity, Media, and Women in Interwar Japan* (Durham, N.C.: Duke University Press, 2003), 2–4.

14. David Bordwell also notes Noriko's double role as the embodiment of the modernity principle and Japanese tradition. See his *Ozu and the Poetics of Cinema* (Princeton, N.J.: Princeton University Press, 1988).

15. *The Philadelphia Story,* dir. George Cukor (Roew's, 1940), DVD (Warner Home Video, 2000). On the importance of Katharine Hepburn in lesbian subculture in the United States, see Amy Villarejo, *Lesbian Rule: Cultural Criticism and the Value of Desire* (Durham, N.C.: Duke University Press, 2003); Andrea Weiss, *Vampires and Violets: Lesbians in the Cinema* (London: J. Cape, 1992); Patricia White: *Uninvited: Classical Hollywood Cinema and Lesbian Representability* (Bloomington: Indiana University Press, 1999); and Jackie Stacy, *Star Gazing: Hollywood Cinema and Female Spectatorship* (London: Routledge, 1994), among many others.

16. On the pedagogy of Katharine Hepburn, see White, *Uninvited,* 37–47.

17. Andrew Britton, *Katharine Hepburn: The Thirties and After* (Newcastle upon Tyne, U.K.: Tyneside Cinema, 1984), 49.

18. Debora Bright, "Dream Girls," in *Stolen Glances: Lesbians Take Photographs,* ed. Tessa Boffin and Jean Fraser, 150–54 (London: Pandora Press, 1991).

19. Ibid., 152.

20. Roland Barthes, "The Death of the Author," in *Image/Music/Text*, trans. Stephen Heath (New York: Hill and Wang, 1977), 142–48.

21. *Little Women*, dir. George Cukor (RKO Radio Pictures, 1933), DVD (Turner Home Entertainment, 2001).

22. *Eiga no tomo* (Film's friend), September 1934: 60–64.

23. By the term *hentai*, Satake implies Noriko's female homosexual desire. As I will discuss later, I find it appropriate to describe Noriko's unexpected apparition of non-normative sexuality as queer, following Judith Butler's definition of queerness as a problematic eruption of sexuality. Judith Butler, *Bodies That Matter: On the Discursive Limits of "Sex"* (New York: Routledge, 1993), 176.

24. Robin Wood, "Resistance to Definition: Ozu's 'Noriko' Trilogy," in *Sexual Politics and Narrative Film: Hollywood and Beyond*, 94–138 (New York: Columbia University Press, 1998).

25. Ibid., 123.

26. Ibid., 124.

27. Donald Richie, "Setsuko Hara," in *Different People: Pictures of Some Japanese* (Tokyo: Kodansha International, 1988), 12–15.

28. Christian Metz, *The Imaginary Signifier: Psychoanalysis and the Cinema*, trans. Celia Britton, Annwyl Williams, Ben Brewster, and Alfred Guzzetti (Bloomington: Indiana University Press, 1982); Jean-Louis Baudry, "The Apparatus: Metapsychological Approaches to the Impression of Reality in Cinema," *Communications* 23 (1975), reprinted in *Narrative, Apparatus, Ideology*, ed. Philip Rosen, 299–318 (New York: Columbia University Press, 1986).

29. See Jackie Stacy, "Desperately Seeking Difference," in *Female Gaze: Women as Viewers of Popular Culture*, ed. Lorraine Gamman and Margaret Marshment, 450–65 (London: The Women's Press, 1988); Valerie Traub, "The Ambiguities of 'Lesbian' Viewing Pleasure: The (Dis)articulations of Black Widow," in *Body Guards: The Cultural Politics of Gender Ambiguity*, ed. Julia Epstein and Kristina Straub, 305–28 (New York: Routledge, 1991), among others.

30. Noreen O'Conner and Joanne Ryan also trace the ways in which psychoanalysis has not allowed the coexistence of sexual desire and identification on the premise that real desire is only possible between a woman and a man. See Noreen O'Conner and Joanne Ryan, *Wild Desires and Mistaken Identities: Lesbianism and Psychoanalysis* (London: Virago, 1993).

31. Richie, *Different People*, 12.

32. Mary Ann Doane defines overidentification as the female spectator's inability to fetishize the image of the woman (and the female character) because of the lack of distance between seeing and understanding. In other words, she is too close to the image of the same gender to balance knowledge and belief, a necessary condition for fetishism. Overidentification also explains the situation in which women only identify with women but cannot desire unless they masquerade. Doane, *Femmes Fatales*, 24.

33. Alexander Doty, "Whose Text Is It Anyway?: Queer Cultures, Queer Auteurs, and Queer Authorship," in *Queer Cinema: The Film Reader*, ed. Harry M. Benshoff and Sean Griffin (New York: Routledge, 2004), 20, 29–30.

34. Butler, *Bodies That Matter*, 176.

35. Sigmund Freud, *Jokes and Their Relation to the Unconscious,* trans. James Strachey (New York: Norton, 1960).

36. Freud writes: "smut is like an exposure of the sexually different person to whom it is directed. By the utterance of the obscene words it compels the person who is assailed to imagine the part of the body or the procedure in question and shows her that the assailant is himself imagining it. It cannot be doubted that the desire to see what is sexual exposed is the original motive of smut." Freud, *Jokes,* 98.

37. Ibid., 97.

38. Eve Kosofsky Sedgwick, *Between Men: English Literature and Male Homosocial Desire* (New York: Columbia University Press, 1985).

39. It is interesting to see the way in which Satake's homophobia is addressed to female and not to male homosexuality, as in Sedgwick's theory. Also, Sedgwick's queer theory itself is largely built on the psychoanalytic mode of thinking through the work of René Girard. Queer theory and psychoanalysis run in circles around the joke.

40. Shoshana Felman, *What Does a Woman Want? Reading and Sexual Difference* (Baltimore: The Johns Hopkins University Press, 1993), 96.

41. Jennifer Robertson, "Gender-Bending in Paradise: Doing 'Female' and 'Male' in Japan," *Genders* 5 (1989): 56.

42. See Doane, *Femmes Fatales,* and Tania Modleski, *The Women Who Knew Too Much: Hitchcock and Feminist Theory* (New York: Methuen, 1988).

43. Doane, *Femmes Fatales,* 31.

44. Ibid., 32.

45. I found only two works that extensively or partially developed Doane's argument on the joke. One is Tania Modleski's *The Women Who Knew Too Much,* and the other is Jennifer Hammett's essay "The Ideological Impediment: Feminism and Film Theory," *Cinema Journal* 36, no. 2 (1997): 85–99.

46. By situating "anger" instead of "pleasure" as a critical experience for the female spectator, although admitting the difficulty of accepting anger as the feminist strategy for spectatorship because of the historical association of "negative" emotion with femininity, Modleski argues that "feminist film theory has yet to explore and work through this anger." Modleski, *The Women Who Knew Too Much,* 24.

47. Doane, *Femmes Fatales,* 51.

48. Ibid., 41

49. What is also revealing about Doane's insistence on the pleasure of getting the joke is her own anxiety about being read as a humorless feminist, because of the very historicity of the feminist enterprise.

50. Shoshana Felman claims that "if the joke is an exchange of laughter or of pleasure between two men at the expense of women, women are completely justified to put themselves in a position to miss the joke." Felman, *What Does a Woman Want.*

War for Entertainment:
The Sky Crawlers

ANDREA HORBINSKI

Oshii Mamoru, director. *The Sky Crawlers*
(Sukai kurora). Subtitled DVD. Sony, 2009.
ASIN B001VBM0Z0.

One of the premier auteurs of anime, Oshii Mamoru has won awards, the hearts of fans, and the respect of critics and scholars the world over. His 2008 film *The Sky Crawlers,* based on the 2001 novel of the same name by Mori Hiroshi, breaks with some of the director's previous methods of storytelling while retaining his essential worldview.

Set in an alternate modern Europe, *The Sky Crawlers* follows several Kildren, eternal adolescents who are reborn after death, ostensibly losing their memories of their previous incarnation. The Kildren are fighter pilots for the Rostock company, which is under contract to Europe to fight a "war as entertainment" against the North American–contracted Laurent corporation and its own immortal pilots. As part of this perpetual war game, pilot Kannami Yūichi is assigned to a small coastal Rostock base in England under the command of female ace pilot Kusanagi Suitō. Kannami eventually realizes that he is the reincarnation of one Kurita Jinrō, a past lover of Kusanagi whom she murdered and whose plane she now orders him to fly.

"Kusanagi" is of course the surname of the cyborg protagonist of Oshii's seminal film *Ghost in the Shell,* and a war game is central to his live-action film *Avalon*; in *The Sky Crawlers* the director exercises both his antiwar sentiments and his preoccupation with the nature of existence. Oshii told *Wired* magazine at the release of *Ghost in the Shell 2: Innocence* that in his view

"the 'I' is not just one person, but the sum of everything you love—your dog, your wife, your child, your computer, your doll. This led me to the conclusion that the self is empty. What is essential is this network of connections."[1] In contrast to the idea of the self as the central core of an independent existence, a networked self is necessarily fragmentary and provisional, predicated on others. *Innocence* depicts this idea from the perspective of the empty center, its protagonist Batou, while *The Sky Crawlers* explores it from the perspective of the web. Like reloading a computer from a backup external hard drive, reborn Kildren become the same people they were in previous lives, falling back into old relationships under new names: their physical mannerisms, personalities, and connections with others remain unchanged, since their bodies are physically identical to their former selves.

In *The Sky Crawlers,* Oshii takes up a perennial motif of his fellow auteur Miyazaki Hayao—flight—but with a difference. Whereas for Miyazaki's characters, as Patrick Drazen has noted, flying is an intimate activity that deepens their interpersonal relationships on the ground,[2] in *The Sky Crawlers* flight is explicitly marked as a separate, inimical sphere: when airborne the pilots speak English, while on the ground they speak Japanese almost exclusively. Precisely because of this alienating difference, it is debatable whether flight grants the Kildren a temporary escape from or a temporary union with their selves: when a civilian asks Kannami where he keeps leaving his heart, he replies, "Maybe in the sky." Since Oshii believes the self is fundamentally empty, what exactly does Kannami mean? Certainly when flying, the Kildren draw on their lifetimes' accumulated physical memories and unconscious skills, which may be the "heart" Kannami means, but since each

Kildren's combat skills are fundamentally personal, it seems more likely that their hearts lie in the divisions they make with others in the sky, flying, fighting, and killing—together.

Nor is flying the only aspect of the characters' isolation. People consistently refuse to make eye contact, and shots are framed to leave characters halfway out of the camera's view. Less subtly, the inability or unwillingness of the Kildren on the base to touch or even to acknowledge the head mechanic's basset hound marks their isolation not only from normal humans but from each other, especially given Oshii's famous love for his basset hound, Gabriel. (Dogs modeled after Gabriel appear in almost all of Oshii's works.) The head mechanic, a middle-aged woman who has known Kusanagi for years, is a normal human who will eventually die, but she does form meaningful connections, particularly with the dog (in one shot she holds the animal in her arms in the same pose as Batou does his dog at the end of *Innocence*). Stephen T. Brown has argued that humans' "relations with dogs may be a possible way [. . .] outside of ourselves"; *Innocence* and *The Sky Crawlers* suggest that the essential precondition for this transformative human–dog relationship is mortality, or perhaps memory.[3]

When Kannami first reports to Kusanagi, she asks why he has arrived earlier than expected; he replies, "The sun was too bright . . . " Kusanagi wonders whether he has quoted Camus before they are interrupted. Kannami's remark is indeed drawn from the beginning of Albert Camus's existential novel *The Stranger*, when the protagonist Meurseault is taking part in his mother's funeral procession: "The glare from the sky was unbearable. [. . .] I felt a little lost between the blue and white of the sky and the monotony of the colors around me [. . .]. All of it . . . was making it hard for me to see or think straight. [. . .] After that, everything seemed to happen so fast, so deliberately, so naturally that I don't remember any of it anymore."[4]

Meurseault could be describing the Kildren's

lives as well as his own. Toward the end of the film, Kannami admits to another ace pilot, Mitsuya, that he cannot really tell whether he is awake or asleep; like most Kildren, he protects his sanity by letting his memories fade, forgetting across reincarnations. Kannami is not much bothered by the indeterminate nature of his existence, but it distresses Mitsuya: "I'm not sure that I've really experienced anything— there's no sense of solidity at all!" she laments.

Another thing troubling Mitsuya is the existence of Kusanagi's daughter Mizuki: Kusanagi, a child herself, has borne a child who is not a Kildren, whose father may in fact be the Teacher. The Teacher, who was Kusanagi's superior when he flew for Rostock, is Laurent's ace of aces and the only adult combat pilot on either side; despite the fact that he himself can die, it is always the Kildren who engage him that are shot out of the sky. Kannami at one point asks Kusanagi whether something like "destiny, or limits" will change if he shoots down the Teacher, but she responds flatly that no one can shoot him down and that the existence of an indefatigable enemy is necessary for unending war.

War is a central theme of *The Sky Crawlers*, and Kusanagi, who has survived for an extraordinarily long time (other pilots whisper that she has learned how to intervene in people's destinies), delivers the film's most developed meditation on its nature. War, she tells Kannami, "imparts an essential sense of reality to humans; the feeling that someone somewhere is fighting is a critical reality that absolutely cannot be faked." Moreover, Kusanagi argues that people will forget the meaning of peace if they are not reminded of the misery of people who actually die in war, though it is precisely because the war between Rostock and Laurent is a game that the two companies killing each other's personnel is lawful. Kusanagi thus begs the question: if the war that provides the critical objective reality is itself fundamentally fabricated, a contract conflict with no real passion or *casus belli*, does anything in the world have objective

reality? Is war for entertainment, fought between immortal combatants, really war?

Certainly Kusanagi's speech suggests that peace would be meaningless, if not impossible, without war; Kannami and Meurseault would probably respond that the world's objective reality is beside the point, the main thing being experience itself. The fact that the Kildren's primary experience is violence, and that according to Kusanagi, they "must kill in the sky to feel that we are truly alive," suggests that violence itself is the ultimate source of legitimacy; even contracted for entertainment, its authority is absolute.

War, then, is the touchstone of existence, just as death is the touchstone of adulthood; the Kildren are eternal children not because they cannot or will not grow up (though they do not) but because they do not die. Despite their youth, the Kildren engage in adult behaviors such as drinking to excess, chain-smoking, patronizing prostitutes, and parenthood, while adults in the film act childishly. After an adult insults Kusanagi, Kannami wonders aloud whether "humans who might die any day really need to grow up?" The film thus questions exactly who among the people it depicts really can be considered "adult" but gives no clear answers; the Teacher, invisible except for the black jaguar on his plane, may be the only true adult, the gatekeeper and the avatar of the only true reality: war in the sky.

Yet despite such grim implications, *The Sky Crawlers* does not end entirely hopelessly. Just before he decides, "I'll kill my father" and seeks out the Teacher, Kannami muses that "even on the same old road, you can tread new ground. Even if it's the same old road, the scenery isn't the same. Can't things just be that way?" Kannami's statement is remarkably Buddhist, and the movie can plausibly be read as a Buddhist allegory, with the Kildren caught in an endless karmic loop of reincarnation, unable to break free of the cycle of suffering and violence into enlightenment, that is, adulthood and death.

But the premise of Buddhism is that enlightenment can be obtained, even if arduously and across many lifetimes: the cycle of rebirth and violence *can* be broken. Kannami tells Kusanagi as much in their last conversation, when he looks into her eyes and says that, rather than killing herself, she should "live until something can be changed." Though Kannami's attempt to change something ends in his death, when a pilot with Kannami's distinctive way of striking a match arrives on the base in the film's final sequence, Kusanagi breaks the established pattern of their relationship by meeting his eyes and greeting him with the words "I've been waiting for you." In *The Sky Crawlers,* Oshii Mamoru suggests that even empty, networked selves can connect with each other, that even the undying can change; the answer to Kannami's question, against the odds, is yes.

Notes

1. Charles C. Mann, "The Giants of Anime Are Coming," *Wired* (September 2004), http://www.wired.com/wired/archive/12.09/anime.html (accessed November 27, 2008).

2. Patrick Drazen, "Sex and the Single Pig: Desire and Flight in *Porco Rosso,*" *Mechademia* 2 (2007): 194–98.

3. Steven T. Brown, "Machinic Desires: Hans Bellmer's Dolls and the Technological Uncanny in *Ghost in the Shell 2: Innocence,*" *Mechademia* 3 (2008): 247.

4. Albert Camus, *The Stranger,* trans. Matthew Ward (1946; New York: Vintage, 1988), 16–17.

Volition in the Face of Absurdity

BRIAN RUH

Oshii Mamoru, director. *The Sky Crawlers (Sukai kurora).* Subtitled DVD. Sony, 2009. ASIN B001VBM0Z0.

In 2001, Oshii Mamoru directed *Avalon (Avaron),* his last film with screenwriter Itō Kazunori.

Oshii had worked with Itoh on most of his films since *The Red Spectacles* (1987, *Akai megane*). Once Oshii stopped using Itoh for scripts, he began writing and directing his own films, such as *Ghost in the Shell 2: Innocence* (2004, *Inosensu*) and *Tachigui: The Amazing Lives of the Fast Food Grifters* (2006, *Tachiguishi retsuden*). However, *The Sky Crawlers* (2008) marked a new point in Oshii's films—with this film, he was adapting someone else's novel (written by Mori Hiroshi) and working with a young screenwriter named Itō Chihiro.[1] Although she had no background in the anime industry, Itoh had previously written scripts for *Crying Out Love, in the Center of the World* (2004, *Sekai no chūshin de, ai o sakebu*, directed by Yukisada Isao; also known as *Socrates in Love* in the English translation) and the film adaptation of the Mishima Yukio novel *Spring Snow* (2005, *Haru no yuki*, directed by Yukisada Isao). Her work on the latter is what originally drew Oshii's attention. This change of screenwriters may indicate a change in direction for Oshii's filmmaking toward the less solipsistic. *The Sky Crawlers* is similar to a number of earlier Oshii films but unique in its approach to the subject matter.

Many of Oshii's films involve a protagonist trapped within a physical or social world, who needs to break from a cyclical monotony or a persistent illusion. This is probably most evident in *Urusei Yatsura 2: Beautiful Dreamer* (1984, *Urusei yatsura 2: Byūtifuru doriimaa*), one of Oshii's earliest feature films. In *Beautiful Dreamer*, the main characters become stuck in a looping cycle of dreams because of an innocent wish one of them inadvertently made. Similar loops, either real or metaphorical, also appear in *Avalon*, *Ghost in the Shell* (1995, *Kōkaku kidōtai*) and *Ghost in the Shell 2: Innocence*, but the one film that may be the most like *The Sky Crawlers* in its overarching theme is *Patlabor 2* (1993, *Kidō keisatsu patlabor the movie 2*), which concerns a world where Japan profits economically from the violence inflicted by other countries, particularly the United States. Although Japan has

seemingly been at peace since the end of World War II, *Patlabor 2* Oshii questions whether such profit taking truly qualifies as living in peace.

In all of the preceding films, the protagonist escapes from the cyclical or illusory world in some way. In *The Sky Crawlers*, though, the main characters are young teen pilots who have never known anything but flying and fighting. They have only hazy memories of their pasts and know they have no future, since they will never age. They are called Kildren, and they fight on behalf of a large corporation that is fighting another large corporation for the entertainment of many. Theoretically, such circuses are designed to both pacify the populace and prevent "real" war from breaking out between the countries. Nevertheless, the war of the Kildren is very real to them. In the end, in spite of the attachments he forms with his fellow pilots, particularly with commanding officer Kusanagi, protagonist Kannami is unable to escape the fate of the Kildren and perishes in battle. However, throughout the film Oshii has left clues that imply that the Kildren come from some sort of cloning program and that even after they die, some version of them will return to fight again.

Ironically, *The Sky Crawlers* may just be one of Oshii's most hopeful films. He certainly seems to view it as such. In the promotional materials for the film, Oshii is quoted as saying "I don't want to give young people a hollow sense of justice or a clichéd pep talk. As a filmmaker, I'd like to show them a small and quiet but truthful hope with this movie."[2]

Throughout his films, Oshii constantly references and quotes from other works of art and literature, and *The Sky Crawlers* is no exception. One way to understand the thrust of the film is to reading the film in the context of Albert Camus's *The Stranger* (1942), which Kannami references when he introduces himself to his superior officer Kusanagi. When she tells him that he has arrived earlier than she expected, he replies, "The glare of the sun was unbearable." In response, Kusanagi knowingly smirks

at his reference to the end of Camus's novel, whose protagonist Meursault tells the jury that he killed the Arab "because of the sun."[3] In using this reference, Kannami indicates that the timing of his arrival was not due to any particular forethought but rather to the vagaries of the world surrounding him. Likewise, it is only toward the end of *The Stranger* that the imprisoned Meursault really begins to feel alive, taking delight is such seemingly trivial matters as the changing colors of the sky as afternoon transitions to dusk. In the end, the condemned Meursault is waiting alone in his cell for the fateful morning when he will hear the footsteps of the guards finally coming to take him to the guillotine. Similarly, the Kildren in *The Sky Crawlers* are condemned to a life of eventual death in the cockpits of their planes, knowing they cannot and will not ever grow old. Unlike the ace fighter daredevils so often depicted in such films, the Kildren are not particularly adventuresome and, if anything, seem bored by their lot in life. Oshii seems to compare this to our contemporary existence in a postmodern capitalist world, rhetorically asking, "Isn't this comfortable life that we have achieved simply a monotonous purgatory that doesn't end until we die?"

However, Oshii asserts that, even so, suicide is not the way to escape from the purgatory of life. He illustrates this in the climax of the film, when prior to his death attempting to shoot down an opposing pilot, Kannami realizes that small changes in one's life can be the most celebrated. In voiceover, he acknowledges that they metaphorically walk down the same road every day, yet "even if the road is the same, you can still see new things. Isn't that enough to live for? Or does it mean that it isn't enough?" In this way, Oshii is echoing another of Camus's works: his essay "The Myth of Sisyphus," published within months of *The Stranger*. In it Camus considers the Greek myth of Sisyphus, who was punished by the gods by being forced to roll a large boulder to the crest of a hill, only to have it roll back downhill, over and over, eternally.

However, Camus considers that, rather than being tormented forever by the futility of his goal, Sisyphus would find satisfaction in the act of performing his eternal task.[4] As in Camus's essay, in *The Sky Crawlers*, Oshii makes "the consciousness of the absence of remedy for the discontents of existence the reason for living—and ultimately for resisting as well."[5]

One can question whether the film is truly hopeful. Indeed it is an indictment of contemporary capitalistic systems that seemingly provide stability while facilitating constant injustices. Oshii wrote:

> Today's children may not know what to do with their futures, which seems indefinite and everlasting to them. Perhaps the offspring of modern consumerism, they are aware that there's no need to become adults. Couldn't we say that they are destined to live their entire life as children?[6]

It is ironic that a film about children engineered to fly fighter planes has spawned its own video game, which in turn has spawned its own manga. Although the film seems to point away from an overinvolvement in a hypermediated world, the marketing of such ancillary products seeks to reinscribe the viewer as an active consumer. This is par for the course in the anime industry, where successful franchises will be marketed to eager otaku. *The Sky Crawlers* therefore seems to be both skeptical and hopeful about whether we can truly find our way away from these illusions.

In the end, it may matter little whether the film is optimistic or pessimistic, but rather whether it accurately maps the interiority of contemporary media consumers. Like it or not, we are all participant-observers in a battle that almost none of us chose. It is a battle larger than any of us, and we will invariably die making the effort to change. Although this is an unavoidable fact for all living beings, we can become

more aware of the battle and, in the process, decide to affect change and find our own happiness within these constraints.

Notes

1. No relation to Itō Kazunori.

2. Oshii Mamoru, "Message from Mamoru Oshii," Production I.G [sic] Web site, 2008, http://www.productionig.com/contents/works_sp/64_/s08_/000843.html (accessed October 31, 2009).

3. Albert Camus, *The Stranger,* trans. Matthew Ward (New York: Vintage International, 1989), 103.

4. Albert Camus, *The Myth of Sisyphus,* trans. Justin O'Brien (London: Penguin, 2000).

5. David Carroll, "Rethinking the Absurd: *Le Mythe de Sisyphe,*" in *The Cambridge Companion to Camus,* ed. Edward J. Hughes (Cambridge: Cambridge University Press, 2007), 57.

6. Oshii, "Message from Mamoru Oshii."

The Past Presents the Future: *Toward the Terra*

PAUL JACKSON

Yamazaki Osamu, director. *Toward the Terra (Tera e)*. TV series. 24 episodes (2007). 6 subtitled DVDs. Bandai Entertainment, 2008. ASIN B0019H6IUE, ASIN B0019H6IUO, ASIN B001D25LS0, ASIN B001D25LSA, ASIN B001I25MHU, ASIN B001I25MI4.

Ironically, for a genre largely defined by its forward vision, many recent examples of science fiction anime strive to recreate the past in their retro depictions of the future. *Toward the Terra,* the 2007 televised series, is one example. Based on Takemiya Keiko's manga (1977–1980), Yamazaki Osamu's adaptation is superficially faithful to its source, right down to the occasional bell bottoms and bouffant perm, but, in emulating the grand space operas of the 1970s and '80s, Yamazaki neglects one of Takemiya's most prevalent influences: the "superman" stories of the American science fiction pulps. By

doing so, he ultimately renders the series curiously incomplete, laying signposts that lead to frustrating dead ends throughout. Yamazaki's series, however, is not the first adaptation of this manga. *Toward the Terra* was more successfully brought to the screen as a feature film in 1980. Animated by Tōei Dōga, the studio behind *Space Pirate Captain Harlock,* and directed by Onchi Hideo, the film remains a highlight of a prodigious period of science fiction anime. So, do the 2007 series' shortcomings reflect poor handling of the original manga, or has Takemiya's vision of the future itself become a thing of the past?

This future follows the depletion of Earth's natural resources when humans have spread from one solar system to the next, erecting vast metropolises of towering skyscrapers. Raised, spiraling roads encircle slender buildings, each topped with convenient landing pads. At street level, citizens travel on moving conveyer belts. A network of supercomputers, each connected to Grandmother, a central hub housed in a cavernous womb deep below Terra's surface, regulates every aspect of human existence. Children are conceived and born artificially, raised by foster parents, and, at age fourteen, subjected to a mental ("adult") examination to determine their suitability for the adult world. A deviant gene, however, threatens Grandmother's authority. "Mu" are born, look, and act like their human peers and neighbors but gradually develop latent psychic abilities. Fearing their powers, the human government systematically persecutes the Mu, eradicating them upon detection. But for all their perceived differences, the Mu and humans share a common goal: to return to Terra.

Antecedents

This scenario recalls countless similar science fiction futures that predate it. Specifically, the idea of a mutant race of advanced human beings has been explored innumerable times before *Toward the Terra* (and indeed since). In his essay for the journal *Science-Fiction Studies,*

Brian Attebery explains: "From the late 1930s through the mid-50s, a remarkable number of science-fiction writers took up the notion that humans will give birth to their own superior replacements."[1] Under the watchful eye of editor John W. Campbell Jr., these superman stories proliferated in the pages of *Astounding Science Fiction*, home of the leading science fiction writers of the era, including Isaac Asimov and E. E. "Doc" Smith, author of the *Lensman* series (itself adapted into an anime feature in 1984). Campbell was especially fond of stories in which the mutants' superiority took the form of psychic abilities, and he repeatedly encouraged his writers to explore this facet of the superman tale.

The original manga of *Toward the Terra* has specific similarities with A. E. van Vogt's novel *Slan,* perhaps the most well known of the Campbell-era superman stories.[2] Both feature young mutants on the verge of adulthood and facing persecution. Van Vogt's novel opens with Jommy Cross desperately clutching his mother's hand as they are pursued by government assassins. As he is hurriedly led through thronging crowds, Jommy and his mother converse psychically, each intuitively responding to the other. Eventually separated from his mother, Jommy later learns of her execution and begins to plan for a future in which mutants are no longer hunted. In *Toward the Terra,* Jomy Marcus Shin, the series' similarly named central protagonist, is a boy on the eve of his fourteenth birthday who sadly bids his mother farewell, knowing that he will likely never see her again after his "adult" examination. During this test, Jomy's psychic abilities begin to manifest as one of Grandmother's computers tries to strip him of his memories. As Jomy frantically attempts to cling to his past, a powerful Mu appears, leading to Jomy's eventual escape.

Fathers and Mothers

Although under different circumstances, both Jommy and Jomy are torn from their mothers' protection. But whereas Van Vogt's Jommy

is driven by the memory of his father (because he has been directed to continue his father's research), Jomy's father is all but absent from his thoughts; he fixates on his mother instead. Early in the series, Jomy wanders the Mu ship disoriented and unable to control his newfound abilities well enough to repel the Mu's continuous presence in his mind. His thoughts turn to his mother for comfort, and the Mu collectively experience his contentment, which fascinates them. Herein lies *Toward the Terra*'s main divergence from *Slan* and the established superman narrative. Attebery observes: "The story of superman is always that of a super man: advancement is always seen in terms of the superior male and his struggles, and the features that define his superiority are precisely those which differentiate him from women."[3] Takemiya, however, layers the superman tale with images of motherhood and ultimately suggests that the Mu's evolutionary advancements represent a step toward a more homogenous gender experience.

Pursuing Jomy and the Mu is Keith Anyan, a brilliant human prodigy. Like Jomy, he, too, is occupied by thoughts of an absent mother. Keith is unable to recall his past, but, unlike his contemporaries, this memory loss is not a result of his adult examination; he is a child of science, born and raised without human contact. Here the matriarchal computer system that governs humanity is appropriately named. In both the original manga and the feature film, it is revealed that a blind seer living among the Mu is Keith's genetic mother. Keith's character is balanced on this axis; he is torn between conflicted loyalties to his two mothers, human and Mu. However, in the 2007 series, Yamazaki denies Keith's Mu heritage and, as a result, simplifies his character, overlooking essential motivations that underlay his actions throughout the series and culminate in his death in the closing scenes.

These themes of motherhood become more explicit midway through the series. Having escaped Grandmother's grasp, the Mu declare

the planet Naska their new home. Yamazaki reimagines the old-fashioned idyll of Onchi Hideo's 1980 film as a barren, dusty red planet on the fringes of explored space. The Mu slowly begin to build a society free from Grandmother's indoctrination. Basic botanical facilities and functional residences allow a number of the younger Mu to live on the planet's surface despite the thin atmosphere and harsh conditions. On Naska, the Mu return to an uninhibited way of life: children are conceived naturally and raised by their birth parents for the first time in generations.

Motherhood Supreme

In a pivotal scene of Takemiya's *Toward the Terra,* a Mu child is born under natural circumstances for the first time. Overcome with emotion, the expectant mother is unable to control her psychic abilities. She cries out, piercing the isolation field that surrounds her, causing the gathered Mu to experience her labor pains and later the contentment of motherhood. The scene recalls the phenomenon of couvade syndrome (or sympathetic pregnancy). Cases of couvade are fairly widespread; expectant fathers can experience back pains, cramps, and morning sickness among other symptoms. In the most extreme cases, men have even been known to develop swelling stomachs during their partner's pregnancy. In the late nineteenth century and early twentieth century, Rev. John Batchelor spent time living in an Ainu habitation in Hokkaidō and recounts, somewhat bemusedly in his book, *The Ainu of Japan,* how following childbirth "the father had to consider himself very ill, and had, therefore, to stay at home, wrapped by the fire. But the wife, poor creature! had to stir about as much and as quickly as possible. The idea seems to have been that life was passing from the father into his child."[4] In *Toward the Terra,* the Mu's psychic abilities capture a similar experience in a brief moment where the Mu intimately share the experience of childbirth. This is the first

indication of a more homogenous gender identity that is further developed throughout the remainder of the series.

The children born of two Mu parents develop abilities that far outstrip those of previous generations. Their psychic potential manifests itself much earlier; they can live outside of a planet's atmosphere and can even trigger growth at will.

The firstborn and most prominent of the new Mu children is given an appropriately unisex name: Tony. Like Jomy and Keith before him, Tony is soon haunted by an absent mother. As a toddler with intelligence far beyond his years, Tony confronts Keith Anyan, incarcerated on a ship above Naska. Sensing contempt from the prisoner, Tony tries to kill him. However, his actions inadvertently free Keith, who pierces Tony's young body with a shard of glass. Believing that her son is dead, Tony's mother is overcome with grief. Her body can no longer contain her psychic abilities, which erupt in a destructive flame that clings to her skin before burning out like a brilliant, but brief, signal flare. Tony is now motherless.

Tony grows at an accelerated pace into an androgynous young man, but Takemiya and Yamazaki ultimately imagine the Mu children very differently. Takemiya illustrates Tony with flowing red hair, striking eyes, and a slender frame. Yamazaki takes this template and further beautifies Tony, almost in parody of Takemiya's pioneering works of *shōnen'ai* (boys' love) manga. This ill-conceived acknowledgment of Takemiya's work is evident throughout the 2007 anime adaptation including the opening sequence, which features Jomy racing, arms open, toward his former Mu mentor, another man. Typical of how the series features signposts to dead ends, the sequence promises an intimate embrace that never materializes. Similarly, Keith's relationship with Jonah, a young male Mu who is his military subordinate, is suffused with the same repressed desire that characterizes many works of *shōnen'ai*. Unfortunately, without the backstory of Keith's genetic

mother, his relationship to Jonah is rendered opaque: Why would he work so closely with a boy whose race he is intent upon annihilating?

Incorporeal Gender?

By the climax of Takemiya's manga, Tony, along with his Mu siblings, has forsaken his physical form to leave Terra as an incorporeal being. Here, it is not Jomy who is the series' superman but Tony who reaches this pinnacle. True to Attebery's prescription, mankind has given birth to its own superior replacement on Naska in a far more literal sense than the previous generations of Mu in Grandmother's society. But, unlike the mutants of the Campbell era, Tony is not defined by what differentiates him from women but by the characteristics he shares with them: his appearance and his abilities. Moreover, by forsaking his physical form, he has also abolished procreation as we understand it. The anime adaptations, however, gradually become further removed from this ending. In Onchi's feature, Tony leaves Terra as a physical being; in Yamazaki's series, he does not depart at all but remains as Jomy's successor.

Takemiya's themes remain as appealing now as ever, but her particular brand of melodramatic space opera clearly belongs to a different era of science fiction. In her divergences from the classic superman tales, Takemiya proposes that to evolve we must first return to the ways of generations past; living off the land and conceiving children naturally. The past presents the future. Yamazaki's attempts to remold *Toward the Terra* into a contemporary series simply muddies the clarity of the original premises and plot resolutions. Perhaps *Toward the Terra*'s recreation of the classic space opera signals a new lease on life for a dying genre—the charred phoenix feathers that sit beneath the perch of an unmade classic—like the lackluster giant robot.

Notes

1. Brian Attebery, "Super Men," *Science-Fiction Studies* 25, no. 1 (March 1998): 62.

2. Although, to my knowledge, Takemiya hasn't cited *Slan* as a direct influence on her work, she has professed an admiration of the writings of Robert A. Heinlein, another *Astounding Science Fiction* luminary, suggesting that Van Vogt's novel would have been within her frame of reference. Interestingly, *Slan* has been referenced in a number of other anime science fiction series: episode 10 of *Legend of Galactic Heroes*, for example, features a character reading the novel; in episode 7 of the original *Dirty Pair* series we learn that one half of the eponymous duo is also a fan of the book; while the official Web site of *Gunbuster 2*, a series featuring its own race of supermen (and women), charts the history of superman narratives, acknowledging *Slan*'s importance. "SF Columns," *Gunbuster 2* series Web site, http://www.bandai-ent.com/h/gunbuster2/sf/index.html (accessed July 22, 2010).

3. Attebery, "Super Men," 62.

4. John Batchelor, *The Ainu of Japan* (London: Religious Tract Society, 1892), 44.

トレンド
Torendo
Wherein the Author Documents Her Experience as a Porcelain Doll

LISA BLAUERSOUTH

It's five o'clock on a Saturday night and we're running late. I'm rushing around, only mostly dressed. My wife, Teri, pokes her head out of the bathroom and asks me if she should straighten her hair or spike it up. I shout, "I found it!" And she gives a cheer from our tiny bathroom. I quickly slip my errant petticoat under my floral, ruffled skirt, smoothing it down reflexively. I catch a glimpse of myself in the mirror and grin: we're into a new subculture, and it's good fun.

My off-white knit socks are modestly pulled up over my knees and hidden underneath my bell-shaped, delicately patterned skirt. I pin a large cameo at my throat and smooth down the ruffles on the shirt. I grab my hair-bow and

little wrist gloves as Teri comes strutting out of the bathroom in her knickers, knee socks and a ruffled high collared shirt, all picked specifically to coordinate with my outfit. She waits impatiently for me to pin a similar cameo brooch on her. I think about my growing closet full of strange subculture clothing and decide that this may, in fact, be the oddest one yet. I grin at Teri; the inherent ridiculousness of what we're wearing makes me happy. As we head out the door to our tea party, I wonder, *where did this come from?*

The teahouse is full of older ladies in pairs and larger groups wearing big red hats, all talking animatedly. Our group comes in—thirteen women in their mid-20s all dressed up like Victorian dolls, complete with parasols and white gloves and elaborate hairstyles—and the tearoom hushes for a moment. Some wear cake-shaped hats; one has an adorable black bunny on her arm—it's her purse. We are told by other patrons that we look like the old porcelain

dolls from their long-past childhoods, the ones their mothers never let them play with. They are amazed by these young women who have invaded their lonely lacy-linen-and-teacup ghetto, and they remark how *nice* it is that these youngsters are so polite and so beautifully dressed up. Their eyes glaze with memories as they gently touch our lace, coo at our dresses, and compliment our hats. They wonder where we came from, what "show" we're doing, and where we got our pretty clothes.

There are those who don't talk to us, but we catch the smiles and amused, sometimes confused looks from the waitstaff and other customers in the teahouse as they talk about us in quiet tones. We ignore those sidelong looks, secure in the knowledge that *we* look like we belong here among the Victorian floral wallpaper and delicate mismatched china.

To those who ask, we explain that we're *not* in costume; that this is a type of fashion, a subculture. That yes, some of us wear these sorts of

FIGURE 1. Under a parasol, the author and her partner at Minnehaha Falls, Minnesota, 2009. Photograph by Drayke Larson, www.photosynthetique.com.

clothes every day. The little old ladies inevitably ask what this fashion is called: "Lolita," we say. "This is Lolita."

They are polite but puzzled, and there is a momentary pause while they silently wonder if this is some sort of sexual fetish. In Japan, where the fashion originated, Nabokov's book *Lolita* is less known, less of a problem. In the West, the book's pedophilic associations haunt our community.

One of the blogs I follow had an anecdote from one of the contributors. She wore one of her Lolita outfits to school and was called down to the office. The principal had a problem with her outfit; he thought that it was "some kind of fetish wear." The Lolita in question pointed out that she had less skin showing than any of her female classmates. (She *was* covered, from the top of her high-necked dress over a petticoat and bloomers, to her knit tights and matte Mary Janes). Then she told him that if he saw anything sexy in what she was wearing she'd be *quite* worried about him.

There's the rub right there—our culture sees anything that grabs attention and shows off its *otherness* as a bid for sexual attention. It is also an undeniable fact that our culture objectifies little girls as sexual forbidden fruit. Combine the two, and Lolita seems designed to make people think the worst.

So, when these polite ladies in their funny red hats start to look uncomfortable and wary, I understand. I wonder what it says about me that I identify as a Lolita—and that I use the term myself.

At our table we are settling in and chattering about what everyone is wearing and checking out the location. Samm, our queen bee, has on something from her new line. The girl next to me in the adorable cherry-print dress paid over $300 for it, and that didn't include the shipping from Japan. It's a limited-edition print from a brand-name shop called Baby, the Stars Shine Bright. The other girls have exclaimed over it—apparently it is collectible and rare. Another

girl is wearing a "Victorian Maiden" jacket that she has decided to sell—she'll let it go for $240. (She bought it for $300.) She likes it, but doesn't wear it enough. The bunny purse I was admiring earlier cost nearly $200.

Teri and I are the odd ducks out; we share a small smile and roll our eyes, but in a good-natured way. We don't really fit into the traditional model for Lolita. I'm wearing a Goodwill shirt, my skirt has been modified from

FIGURE 2. The author and her partner as Lolis at Minnehaha Falls, Minnesota, 2009. Photograph by Drayke Larson, www.photosynthetique.com.

a second-hand square-dancing skirt, and the petticoat I have on started out as a flower girl under-skirt that I bought at a garage sale. Teri is also wearing Goodwill and Target. And we're proud of it. We don't begrudge our fellow Lolitas their expensive clothes, but we might be a little smug about it. I mean, we look really good, and our total combined cost is less than about 40 dollars—and most of that was for shoes.

Lolita subculture, at its worst, is a materialistic, classist, and racist hobby. The sheer amount of money that can be spent on clothes, shoes, accessories, and other paraphernalia is astounding—and for some, a necessary component of the subculture. Many women involved in Lolita see the brands and money involved as way of keeping score and maintaining rank. The brands from Japan go for about $200 to $300-plus per dress, with rare fabric prints and limited-edition pieces running into the thousands. Online forums are filled with people who want to get into the fashion but don't have the money and, hence, fear that they will do it *wrong*. These are often the same people who believe with all their frilly little hearts that *anything* from Japan is automatically better. And anything that *isn't* from Japan is Not-Lolita.

I look around the tearoom at our little Minnesota enclave, and I can't help notice that we are, like much of Minnesota, primarily Caucasian. This is not unusual—even many of the Japanese Lolita models are white (or are digitally altered to look like it). Not only has Lolita appropriated the look of Victorian little girls and porcelain dolls, but it has internalized a strict Victorian hierarchy, enforced with vicious online forums, scathing critique, exclusion, outright bullying, and racist screeds on how certain races just don't *do* Lolita.

Six years ago, when I was introduced to the idea of Lolita, I was only aware of the aesthetic. I've always been into subculture fashion, costuming/cosplay, and Victoriana. This seemed to be a perfect combination of those hobbies and interests, and I wanted in. I went online

to see what this was all about—and was a bit horrified. I didn't much care to join up with the larger community; the drama and politics and materialistic obnoxiousness that filled the online communities really turned me off. I was just interested in the frilly dresses.

Eventually, however, dressing up for just myself was not enough. I'll admit I'm vain; I *like* showing off. And regardless of what was going on online, I knew I looked good, and I also knew from experience with other fashion-heavy subcultures that fashion will *always* come down to those unique personal touches. So I ventured out and found the Minnesota Lolitas, good-naturedly called the "Rufflebutts" and led by designer Samantha Rei.

Samantha has been fighting the good fight for years now. Her designs are, in my opinion, much better than anything coming out of Japan. She specializes in custom work, and her designs make allowances for the bigger hips and boobs of the Western woman. Her designs also tend to be more mature and elegant, which is good news for those of us who want to look slightly less like a walking cupcake. And, most importantly for Teri and I, she is slightly more economical than her Japanese counterparts—so it's a good thing that I think her work is better than theirs, too. She's also a very visible black woman among all of us white girls, exposing those folks who feel that Lolita has a "correct" race for the fools they are.

As I'm putting a bit of milk and sugar in my tea, Samm is saying that Teri and I do thrifty Lolita *right*. She says this with some amount of relief in her voice, and I think I know what she means. We may be cheap, but we treat Lolita *exactly* like we do any other fashion trend. It's particularly frustrating for her as a designer and a hopeful trendsetter to deal with people who devalue what she does as "costume."

Lolitas are generally sensitive to the distinction between costume and fashion, just like the goths or the punks before them. Want to annoy a Lolita? Ask what costume party she is going

to. For many of us, these dresses are as much or more a part of our everyday wardrobe as jeans and t-shirts are. The idea that people "dress up as" a Lolita is a little offensive to those who *are* Lolita. There is some merit to this—especially since folks who see Lolita as a costume are far less likely to pay attention to the basic, underlying ideals behind the subculture.

For most of the Lolitas, there is a huge difference between "costume" and "fashion," but not for me: that is because I define *all* fashion as costume. Dressed in Lolita, I get more polite, I'm better at small talk, and I allow myself to squee about adorable shoes. With Lolita, the sheer *otherness* is part of it, its positives and negatives and shallowness; I get to explore parts of me that normally don't get much airtime.

The teahouse meet-up is winding down. We're all going our own ways. Teri and I pick our way back to the car and I stuff my skirt back inside. I'm still thinking about why I do this—and as I look at myself in the overhead mirror, with a seatbelt crushing my outfit, I think about how I never thought about the practicalities of wearing dresses like this when I was eight. And it hits me. The Lolita ideal is partly what my eight-year-old self wanted to be when I grew up: a princess/ballerina/actress/model who goes on magical, awesome adventures and attends fancy tea parties with my One True Love. And on top of that, I get to remind myself that adulthood is just what happens when you live on your own—there isn't a set way of doing it.

FIGURE 3. The author and her partner at Minnehaha Falls, Minnesota, 2009. Photograph by Drayke Larson, www.photosynthetique.com.

CONTRIBUTORS

BRIAN BERGSTROM is a PhD candidate in East Asian languages and civilizations at the University of Chicago, where he is completing a dissertation examining representations of youthful criminals in Japanese literature and popular culture. His previous publications include an article on the proletarian woman writer Nakamoto Takako and translations of short stories by Hoshino Tomoyuki.

LISA BLAUERSOUTH is completing her MFA in creative writing at Hamline University. She is an eclectic writer, with projects ranging from an ongoing webcomic called *Godseeker,* to weird short stories, to nonfiction and academic works. This is her first traditionally published work.

ADEN EVENS teaches philosophy, new media, and game studies at Dartmouth College. His current research explores the ontology of the digital, the ways in which digital technologies and the culture surrounding them defy expectations regarding the typical behaviors of worldly objects.

ANDREA HORBINSKI is the editorial assistant for *Mechademia.* She was a 2007–8 Fulbright Fellow to Japan at Doshisha University in Kyoto, where she studied hypernationalist manga. She is a PhD student in history at the University of California, Berkeley.

ITŌ GŌ is a manga critic and associate professor in the Department of Manga at Tokyo Polytechnic University. He is also a lecturer at Musashino Art University, Waseda University, and Amusement Media Sōgō Gakuin.

PAUL JACKSON is studying for his masters degree in film studies. His writing on anime has appeared on the Web site *Midnight Eye.*

YUKA KANNO received a PhD in visual studies from the University of California, Irvine. Her research interests include Japanese visual culture, discourse of the actress, and queer film criticism. She is working on a book about lesbian representation in Japanese cinema.

SHION KONO is associate professor of literature at Sophia University, Tokyo. He has published articles in the *Journal of Japanese Studies, Monumenta Nipponica, Nihon kndai bungaku,* and *Shisō Chizu.* He cotranslated Hiroki Azuma's *Otaku: Japan's Database Animals* (Minnesota, 2009) with Jonathan E. Abel.

THOMAS LAMARRE teaches East Asian studies, art history, and communication studies at McGill University. His books include *Shadows on the Screen: Tanizaki Jun'ichirō on Cinema and Oriental Aesthetics, Uncovering Heian Japan: An Archaeology of Sensation and Inscription,* and *The Anime Machine: A Media Theory of Animation* (Minnesota, 2009).

FRENCHY LUNNING is professor of liberal arts at the Minneapolis College of Art and Design, editor-in-chief of *Mechademia,* and codirector of Schoolgirls and Mobilesuits: Culture and Creation in Manga and Anime (SGMS), an annual workshop at the Minneapolis College of Art and Design. She is preparing an exhibit on Tezuka Osamu for the Weisman Art Museum and is executive producer for Moving Walkway Productions.

CHRISTINE L. MARRAN is associate professor of Japanese literature and cultural studies at the University of Minnesota. She is working on a book on ecocriticism, philosophy, and the nonhuman in Japanese literature and film.

MIYADAI SHINJI is professor of sociology at Tokyo Metropolitan University. In the 1990s, he became a leading social critic with his commentaries on youth culture and new religions, especially on *enjo kōsai* (compensated dating). He is author and coauthor of numerous books in Japanese, including *Sabukaruchaa shinwa kaitai* (Dismantling the subculture myth) and *Nippon no nanten* (Difficulties of Japan).

MIYAMOTO HIROHITO is associate professor in the Department of Global Japanese studies at Meiji University. In addition to a series of essays on prewar manga, including studies of transportation in manga, of war and Norakuro, and the sources of Tezuka Osamu, he is coauthor (with Natsume Fusanosuke) of *Manga no ibasho* (Manga sites). He is the director of Nihon manga gakkai and has served on the planning committee for the Kita-Kyūshū Manga Museum.

LIVIA MONNET teaches Japanese literature, cinema, and visual culture; animation theory; gender studies; and comparative literature at the University of Montreal. Her essays on animation have appeared in *Japan Forum, Science Fiction Studies, Mechademia,* and book anthologies. She is writing a book on media installations by contemporary women artists.

MIRI NAKAMURA is assistant professor of Japanese language and literature at Wesleyan University. She is completing her manuscript on the rise of the uncanny in modern Japan.

MATTHEW PENNEY is assistant professor of history at Concordia University, Montreal. His research focuses on images of war in Japanese popular culture.

EMILY RAINE is a PhD student in communications at McGill University. She is a senior editor and regular contributor to *Worn Fashion Journal.*

BRIAN RUH is the author of *Stray Dog of Anime: The Films of Mamoru Oshii.* He is a PhD candidate in communication and culture at Indiana University.

KUMIKO SAITO received her PhD in comparative literature from Pennsylvania State University and teaches Japanese at Bowling Green State University. Her recent publications include articles on shōjo manga, Japanese cyberpunk, cute culture in postwar Japan, and background arts in videogames. Her current book project focuses on women's perceptions of self, sexuality, and gender roles in Japanese popular fiction and visual media, including manga and anime.

RIO SAITŌ received her BFA with focus on photography from University of Minnesota and an MFA, with photography, from Minneapolis College of Art and Design. She teaches Japanese art and culture at the College of Visual Arts in St. Paul, Minnesota.

CATHY SELL is a PhD student in translation studies at Monash University in Australia. She recently completed a two-year research term at Kyoto Seika University and the Kyoto International Manga Museum in Japan.

JAMES WELKER is a postdoctoral fellow in Asian studies at the University of British Columbia. He is coeditor and translator (with Mark McLelland and Katsuhiko Suganuma) for *Queer Voices from Japan: First-Person Narratives from Japan's Sexual Minorities.* His research focuses on queer shōjo manga, the lesbian community, and the women's liberation movement in Japan in the 1970s and 1980s.

YOSHIKUNI IGARASHI is associate professor of history at Vanderbilt University, specializing in modern Japanese culture studies, especially the radical transformation of Japanese society in the late 1960s and 1970s. He is the author of *Bodies of Memory: Narratives of War in Postwar Japanese Culture, 1945–1970.*

CALL FOR PAPERS

The goal of *Mechademia* is to promote critical thinking, writing, and creative activity to bridge the current gap between professional, academic, and fan communities and discourses. This series recognizes the increasing and enriching merger in the artistic and cultural exchange between Asian and Western cultures. We seek contributions to *Mechademia* by artists and authors from a wide range of backgrounds. Contributors endeavor to write across disciplinary boundaries, presenting unique knowledge in all its sophistication but with a broad audience in mind.

The focus of *Mechademia* is manga and anime, but we do not see these just as objects. Rather, their production, distribution, and reception continue to generate connective networks manifest in an expanding spiral of art, aesthetics, history, culture, and society. Our subject area extends from anime and manga into game design, fan/subcultural/conspicuous fashion, graphic design, commercial packaging, and character design as well as fan-based global practices influenced by and influencing contemporary Asian popular cultures. This list in no way exhausts the potential subjects for this series.

Manga and anime are catalysts for the emergence of networks, fan groups, and communities of knowledge fascinated by and extending the depth and influence of these works. This series intends to create new links between these different communities, to challenge the hegemonic flows of information, and to acknowledge the broader range of professional, academic, and fan communities of knowledge rather than accept their current isolation.

Our most essential goal is to produce and promote new possibilities for critical thinking: forms of writing and graphic design inside as well as outside the anime and manga communities of knowledge. We encourage authors not only to write across disciplinary boundaries but also to address readers in allied communities of knowledge. All writers must present cogent and rigorous work to a broader audience, which will allow *Mechademia* to connect wider interdisciplinary interests and reinforce them with stronger theoretical grounding.

Due dates for submissions for future *Mechademia* issues

January 1, 2012 Mechademia 8: Tezuka: Manga Lite
January 1, 2013 Mechademia 9: Masculinities: Military and Criminal
January 1, 2014 Mechademia 10: Parallel Universes, Possible Worlds, and Counterfactual Histories

Each essay should be no longer than five thousand words and may include up to five black-and-white images. Color illustrations may be possible but require special permission from the publisher. Use the documentation style of the *Chicago Manual of Style,* Sixteenth Edition. Copyright permissions must be sought by the author; forms will be provided by the *Mechademia* staff.

Submissions should be in the form of a Word document attached to an e-mail message sent to Frenchy Lunning, editor of *Mechademia*, at frenchy_lunning@mcad.edu. *Mechademia* is published annually in the fall.

Please visit http://www.mechademia.org for more information.